Picasso

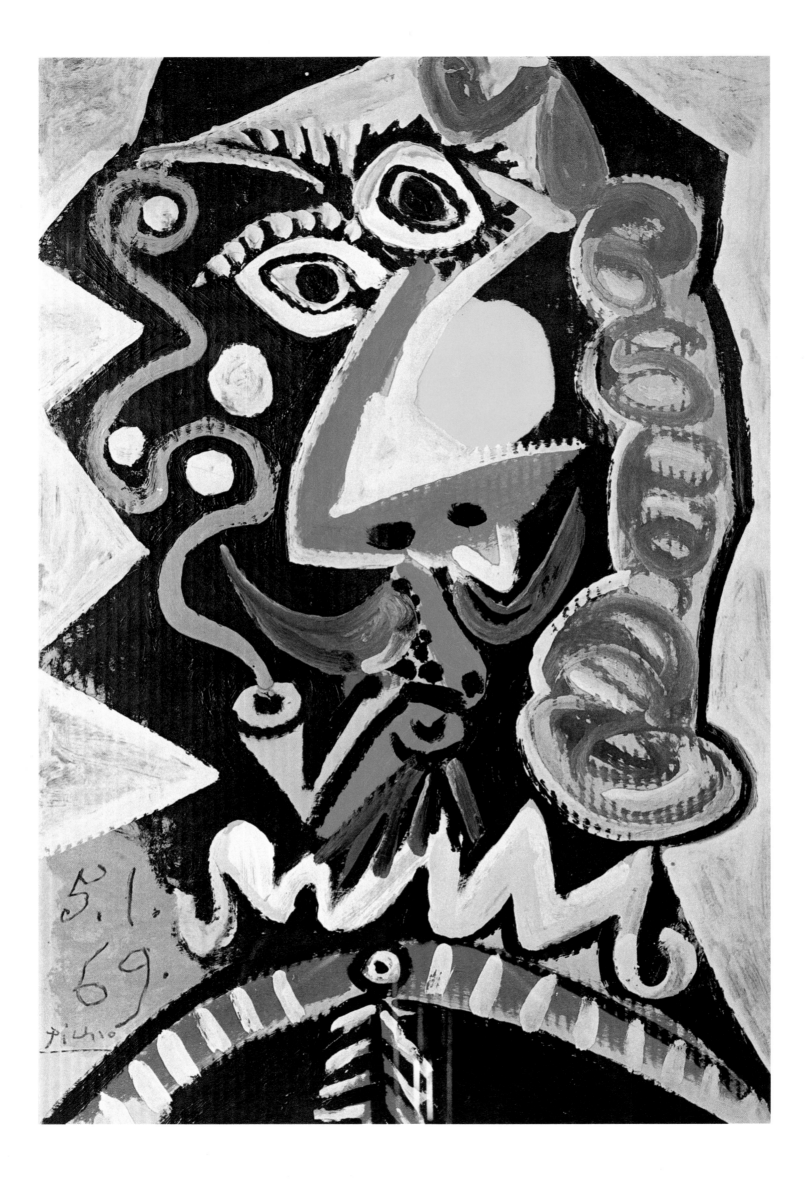

Klaus Gallwitz

THE HEROIC YEARS

ABBEVILLE PRESS · PUBLISHERS · NEW YORK

WHAT I SAY TO YOU
DOES NOT CHANGE ME
I DO NOT GO FROM THE BIGGEST
TO THE SMALLEST
LOOK AT ME
FOR ME PERSPECTIVE DOES NOT WORK
I HOLD MY PLACE
AND YOU CANNOT MOVE AWAY FROM IT
THERE IS NOTHING AROUND
ME ANY MORE
AND IF I TURN AWAY NOTHING
HAS TWO FACES
NOTHING AND MYSELF

PAUL ÉLUARD

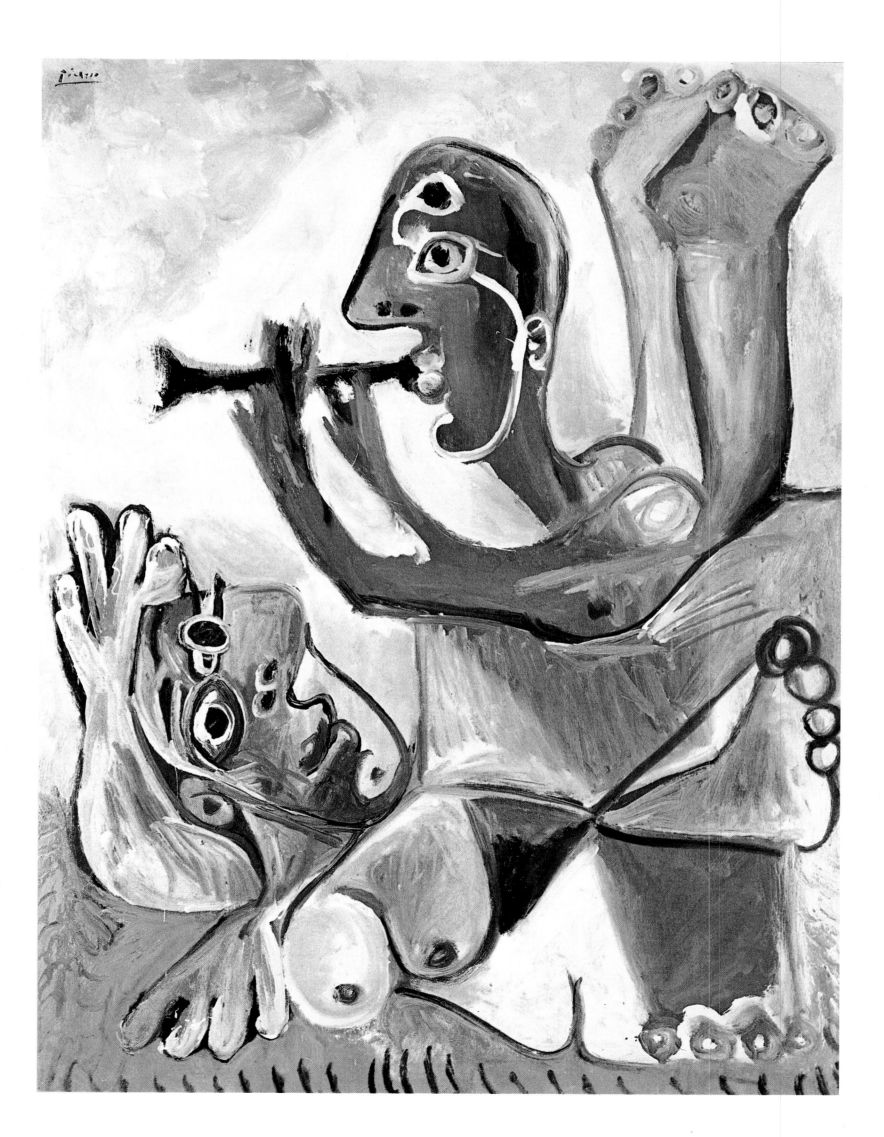

Foreword to the New Edition

The author and publisher present a revised and expanded new edition of *Picasso Laureatus,* which first appeared in German in 1971 and was published that year in English as *Picasso at 90.* It was dedicated to the artist and dealt with his paintings since 1945. Between 1970 and 1972 Picasso painted – with interruptions – 201 pictures; more than 150 graphics appeared during approximately the same period as well. After his death, in the summer of 1973, these 201 paintings were exhibited in the Palais des Papes in Avignon. A new final chapter deals with the paintings and graphics Picasso produced until his death, and thus illuminates the artistic development manifested in his later work. In spite of the interval between the first and the present edition, the author and publisher consider it appropriate to revise rather than to make fundamental changes in this classic text. But because the new last chapter encompasses the artist's final years and assesses his production from that perspective, the publishers think it appropriate to retitle the English-language edition.

Coedited by Xavier Schnieper and Robert Schnieper

Graphics by Hans F. Kammermann

© 1985 for the illustrations by Pro Litteris, Zurich

© 1971 and 1985 Book Edition by Verlag C. J. Bucher GmbH, Munich and Lucerne

© 1985 Abbeville Press, New York, N.Y.

Library of Congress Cataloging in Publication Data

Gallwitz, Klaus.

 Picasso, the heroic years.

 Translation of: Picasso laureatus

 Reprint. Originally published: New York : Putnam.
1971.

 Bibliography: p.

 Includes index.

 1. Picasso, Pablo, 1881–1973. I. Title.

[ND553.P5G2813 1985] 759.4 84-24397

ISBN 0-89659-531-5

Printed and bound in West Germany.

Contents

Transparent Masks

Reflections on Picasso's Personality

Four lines from a fifteenth-century Spanish poet, the Marquis of San-
tillana, once came to my mind as a key to the phenomenon of Pablo
Picasso. They are from the *Comedieta de Ponça* and catch the essence of
the Málaga painter with striking aptness:

> He heard the secrets of philosophy
> And the heavy footsteps of nature;
> He discovered the intent of its purity
> And saw into the depths of poetry.

We might think these lines had been written about Picasso if we
were not forced to admit that they apply equally well to Rembrandt or
Goya. For these extraordinary painters have indeed "hearkened to"
philosophy and—what is more surprising—to nature too.

In 1913 Guillaume Apollinaire wrote:

This Malagueno bruised us like a brief frost. His meditations bared
themselves silently. He came from far away, from the rich composition
and the brutal decoration of the seventeenth-century Spaniards...

His insistence on the pursuit of beauty has since changed everything
in art...

The great revolution of the arts, which he achieved almost unaided,
was to make the world his new representation of it...

A new man, the world is his new representation. He enumerates the
elements, the details, with a brutality which is also able to be gracious.
New-born, he orders the universe in accordance with his personal
requirements, and so as to facilitate his relations with his fellows.*

Picasso may be thought of as a ship which never allowed itself to be
diverted from its course. Capricious and bizarre as this course might
have seemed to others, it undeviatingly followed its path to its desti-
nation. One landing that it made was on the amazing continent of
Guernica. This painting is the sublime expression of that anger which
looms so large in the Spanish character.

*Guillaume Apollinaire, *The Cubist Painters,* translated by Lionel Abel. New York: 1962, pp. 21—23.

In *Guernica* Picasso reached down to his most profoundly Spanish roots. This led critics to compare him to Goya, and to link the two names through the common traits of passionate anger and a sense of kinship with the Spanish people. Although there is little superficial resemblance between Picasso and Goya, the parallel is justified. It is not painterly in nature—for as painters they have nothing in common—but poetic and Spanish. It resides in their spirit and time, in their blood and pulsebeat.

Guernica! What a monument of truthfulness and masterly skill! Those of us who watched it emerging step by step saw the struggle it cost the painter to press his poetry to the ultimate nakedness achieved in the mural. Our suggestions—such as they were—were inconsequential beside the sureness of the artist's instinct. But Picasso himself shrank from the terrible truth his hands revealed. He tried to hide it from the eye, to clothe it with cutouts of colored paper. "What do you think?" he would ask us. Wordlessly we said no. The pure white, the gray, and the black of *Guernica* answered for us. Little by little the experiment was reduced to one tiny scrap of paper, a red tear of blood. Picasso moved it about against his figures' eyes. Obstinately, and with a hint of childish mischief, he refused to relinquish it entirely. Finally the tear disappeared. And *Guernica*—white, gray, and black—remains for all time an undying testimony of art. Here the painter has professed his purest, most brutally naked, most poetic truth. This is what sets *Guernica* apart from the fiery brilliance of Picasso's other pictures. This shockingly naked thing haunts us with the disturbing question of its anxiety.

André Malraux called Picasso the most extraordinary destroyer and creator of form of our time, perhaps of all time. He was right. More than half a century of painterly, sculptural, and graphic activity confirms it. We may consider the process of creating and destroying form from the two aspects of the painter's activity. First he destroys form in nature and second he re-creates it in a new visual way in his work. This applies to Picasso's own painting as well as to the works of other artists that he evokes for us through his reinterpretation.

When we look at a large number of works by Picasso, we are struck by his critical understanding of painting. His distorting, often willfully caricaturing hand points to a transforming, remolding, and re-creating

of all the history of art. It is not only in Picasso's most recent period of breathtaking variations and fascinating juggling of themes, borrowed, say, from Delacroix or Velázquez, that this critical aspect of his art reveals itself. It was already present in his early efforts, when he made his own versions of paintings and drawings by Toulouse-Lautrec. From the first, in Picasso's inmost creative genius, there was a critical attitude to life which faced up to his own vision of it and accepted without faltering the risks inherent in expressing that vision. One might say that the gift for magic with which Picasso is so abundantly endowed keeps us under its spell precisely because of its constant revelation. His destructive and creative vitality stems from an innate, zestful obsessiveness, as if he were possessed by a demon. The most amazing thing about this painfully tortuous struggle is its transparency.

"The reputation of an artist or writer," said Paul Valéry, "is ultimately no more than the sum of all the misunderstandings connected with his name." The reputation distorts his personality as much as it corroborates it. Art history offers no more striking proof of Valéry's statement than Picasso. His strongly profiled personality as a creative artist is marked by a complex and contradictory "sum of misunderstandings" connected with his name. To mention Pablo Picasso is to open the gates to a flood of misunderstandings. His time, which loves the sensational, could not do without him; his vital personality provided the characteristic, unique symbol it needed. Now that fame and an almost scandalous cult of personality have produced the utmost in senseless responses and questionable interpretations, it is time to ask what constitutes the unmistakable essence of this personality and how we are to explain it, considering the almost unmanageable bulk of his work in painting and sculpture.

Years ago André Malraux asked the question: "What will remain of Pablo Picasso's magnificent work when the magic genius of its creator can no longer sustain it by his power of personality?" Malraux later provided his own answer when he called Picasso a "creator and destroyer of his own forms."

This offers a clue to the meaning and nature of Picasso. The apparent contradiction in producing forms that are at once destructive and

constructive symbolizes his essence. It manifests itself through incessant change. And furthermore this process of shaping and reshaping is as realistic as it is fantastic. If we apply the distinction between the primordial and the merely original suggested by a contemporary of Picasso, the Spanish poet Antonio Machado, we might say that Picasso in his historical nature is the most primordial and the least original creative artist of his time. Yet his vision *does* lead to the future. This, in effect, is another way of saying that his lively, tradition-rooted spirit *seems* revolutionary. It seems so because it *is* revolutionary. How else could it seem so?

Picasso has often said that his work has no logical sequence in time. This is true. Like Lope de Vega, he "follows his own lead" and is always in the present. Which, it would seem, might be said of every work of art, since painting "simultaneously yields everything it has," as the seventeenth-century Spanish theoreticians of the Baroque said. But this does not presuppose that what has already been done in painting can be repeated. A set of pictures by the same hand can be put into chronological order for purposes of critical evaluation, and it is easy to succumb to the temptation of making this the basis for explaining the meaning of a work of art. In Picasso's case this method leads back to him in spirals, corroborating only Picasso himself.

Picasso once gave the young painter Manuel Ángeles Ortiz the advice to "paint what passes through your head without stopping to think whether it's good or bad," meaning that he should do it naturally and spontaneously, without theorizing. This is how he always paints himself. Hence his naturalness and spontaneity, his truthfulness and clarity. To the painter, as to the poet, "what passes through your head" means just that, as opposed to what stays there. Art that does not pass through the head is an impossibility, but by the same token art that stays there is equally impossible. The first symptoms of stagnation in the brain and the consequent paralysis of imagination caused Picasso to give up Cubism; this is what has kept him from venturing into so-called abstract art and why he never completely broke away from Surrealism, that liberator of living forms. Even when we probe to the very bottom

of Picasso's painting and sculpture, we find that abstraction is foreign to it.

In a pen portrait of Pablo Picasso, a work of friendship, I once referred to him—he was working on *Guernica* at the time—as the angry Picasso. Now I understand why the rage, the anger, the frenzy which the revolt of the Spanish generals and the civil war aroused in the painter erupted from the depths of his earlier self-absorption like a geyser, drenching his art. I said then: "In order to get angry one must first have known self-absorption. Similarly one must first get angry if one is ever to be enthusiastic later." As Unamuno said, enthusiasm is rapture.

We may find our way through the labyrinth of Picasso's gigantic work by means of this finest of threads on which his soul hangs and with which his magical nature weaves its webs—the thread of an invisible Ariadne, who identifies herself with the monster which fascinates her. In this "monster of Picasso's labyrinth" being and doing, thought and action, are identical. Picasso paints "with his heart in his hand," more so even than Goya and in quite a different way. And what trembles in his hand because of the beating of his heart is the real or unreal life captured in the work of art.

Apollinaire's remark on Picasso's impact quoted in the introduction to this essay: "His insistence on the pursuit of beauty has since changed everything in art," is memorable for its aptness, although in its time it was thought to smack of aestheticism. This statement in which the poet championed his painter friend scarcely has a surprising ring today in view of the artist's relentless search for beauty and its consequence: the tranformation that he had imposed on painting. Apollinaire added: "A new man, the world *is* his new representation." That is, he created it anew by presenting it to us in a new way.

Apollinaire added another, rather ambivalent characteristic. He called Picasso an heir to Spanish Baroque art of the seventeenth century, a period overflowing with compositions and decorative ornament that he described as "brutal." The brutality he pointed to (it is actually the expressive intensity of Spanish "realism" in art rather than brutality) is nothing else than the violence he cited in Picasso's art: "a brutality which is also able to be gracious."

The poet was not deceived by his critical intuition. Indeed his perception of Picasso as an inheritor of the Spanish Baroque seems even more relevant in the late work. The formal realism of *Las Meninas,* Picasso's invented portraits conjuring up the seventeenth century, resumes the Spanish Baroque tradition with its realism that might be called poetic. A few names will suffice as illustrations: Velázquez and Murillo in painting, Cervantes and Gongora in poetry.

José Ortega y Gasset said of Velázquez that he painted ghouls. Goya did too. And Picasso. How often painting looks to us like a ghostly illusion of reality! The gift of perceiving the pictorial forms of life that Baudelaire ascribed to Victor Hugo can also be found in the magician Picasso. Masks which unmask, because they are transparent. We can therefore say of Picasso what Baudelaire said of Victor Hugo: "... the most gifted of all, the one most obviously chosen to reveal the secret of life."

This secret scintillates in all the pictures, lithographs, and even sculpture that Picasso's hand has created. Like Midas, he transforms everything he touches—but into life instead of gold, giving it the trembling, shuddering quality of all that is vital.

At a seance Victor Hugo heard the voice of a mysterious personage claiming to be Death, who announced that every spirit performs two tasks in his existence, one as a human, the other as a ghost. This is true of every artist, writer, or thinker, who in his creative role performs the ghostly task. Hence every intellectual creation of man seems to us illusionistic. The visages of painting and poetry, prose and music, are all transparent masks, and this is true of the creations of Picasso more than any other. But in what way? There is only one answer: as the self-assertion of the person who wears a mask in order to reveal his real self through a paradoxical disguise (that is to say, to reveal the truth of masks).

"The best mask is the face," said Nietzsche. The real physiognomy of art embodies itself most naturally in this way. No one has captured art as personally as Picasso—not even Michelangelo or Rembrandt or Velázquez. How plain, clear, and evident to the eye is the philosophical truth (the erotic truth and the delight in it) of Picasso's painting!

In answer to Malraux's question: What will remain when the living personality that so intensely created and sustained this work is gone? I would say: that which has survived of the most personal works of Rembrandt, Velázquez, and Goya—an incomparable phantasmagoria, a wondrous world of phantoms. That which endures in the poetic characters created by a Cervantes or Shakespeare, a Lope de Vega or Calderón, a Tolstoi or Dostoevski. Yet, speaking of the human being, we should not forget that his cultivation of art is ultimately nothing but what we call "culture." Art is inseparably bound to a tradition, something as transient as it is present.

Poetry has been defined as "a form of flight"—which is the exact opposite of a flight from form. He who flees form escapes life and dies. He who gives his flight—his personal flight—form will survive in this form, even if he dies. As Hugo said, a great spirit perishes in his human work to survive in the work invented by his imagination, his phantom work. It often seems to me that any attempt to scrutinize the personality of a painter, writer, or musician or of a thinker is futile unless it is rooted— phantomlike—in his work itself, which in turn has its ground in its creator. In a word, an artist's work remains inaccessible to us unless we open ourselves to its "ghostliness."

The more genuine a writer or painter is the more his personality will seem to mask and unmask itself, thus revealing the "trembling mystery" of life. I am speaking of a particular reality and nature: those of the painter or writer which he claims for himself. I am speaking too of a philosophical truth, that is to say—and I wish to stress this—an erotic wisdom and an erotic desire.

All art is poetic or creative language; all its utterances say the same thing. Precisely for this reason every artist or writer must say it personally, in his individual way. His own "will to form" is his style, his ghostly personality and embodiment. In the art of painting the invisible frontier of Being is suddenly illuminated; it comes alive in such dazzling clarity that our spirit is "transported with wonder and delight," as though we found ourselves in a hellish or heavenly abyss.

We apply the word "genius" to Picasso's personality as we apply it to the personalities of certain other painters—Goya, Velázquez, Rem-

brandt, or Tintoretto—because of his art, because of the marvelous violence which does not suppress our tragic horror in the presence of death but transports our spirit to delight by the erotic truth of its form. Before our wondering eyes this angry Andalusian Picasso cuts the same crazy capers invented by Don Quixote to prove that he was in love—self-absorbed, consumed by anger and enraptured, like the Don, by the tragic affirmation of life and by love.

When we reflect upon Picasso's personality and work, what most astonishes us is his erotic acceptance of life: the primordial power of his incessant self-fulfillment, made manifest in the work itself. We recognize this, whether we look at the work as a whole or in its various phases, revealed through individual pictures that relate to his personal life. Picasso's longevity has enabled him to achieve a complete œuvre. We are therefore in the privileged position of being able to study it down to its last ramifications while witnessing the most recent phase, in which the personality that created this body makes its final self-affirmation.

We can now speak of three periods: self-absorption, anger, and finally enthusiasm or rapture. It is as though there were three successive Picassos, alway different yet always the same, who always remain true to themselves. This is not, let it be noted, an enrapturement with himself but a state of "being outside oneself" in the literal sense. The same thing happened to Velázquez, Rembrandt, and Goya.

We may single out specific pictures which elucidate these three periods in an especially important way. Any of the best Cubist paintings (the *Three Musicians,* for instance, or the group portrait of *Les Demoiselles d'Avignon*) will give us an overall impression of the early, self-absorbed Picasso. For the next period, the angry Picasso consumed by rage, there is no better example than the masterful *Guernica*. And finally, for the enthusiastic, enraptured Picasso (in whom, in my opinion, the work as a whole and the personality are most purely embodied) we might choose the magnificent *Meninas* series.

But these paintings should not lead us to forget that Picasso, thanks to his vitality and the marvelous erotic upsurges pervading all his periods, has created masterworks in many media. We encounter

examples in his drawings, lithographs, and sketches and especially in his sculpture. Picasso's personality often seems to show itself most plainly, most expressively, in these complementary areas of his work. We feel that no hand has ever possessed a greater gift of wonder, of revealing in one single decisive stroke the mystery of life in all its profundity. This mystery manifests itself in love, and that is why Picasso says yes to the explosive eroticism, whose clear form and incorruptible truthfulness refine it in the eye of the viewer.

For me no Picasso embodies the Picasso image more completely, none appears so authentic, genuine, and "extreme," as the Picasso of the late 1960's. "Extreme" in the Spanish sense means perfection at its most sublime, at its highest. In his phase of enthusiasm or rapture, this Picasso surpasses himself, reveals his fundamental fiery love without restraint, and thus attains his ultimate, highest, most truthful self-expression by transcending the limits of his elemental anger to penetrate into the realm of divine rapture. The spectrum of Picassos ranges from the one who begins to discover the secrets of philosophy and "hear the heavy footsteps of nature," while seeking nothing but his form and finding it in the reality of his vision, through the one who has fathomed the abyss of poetry. The most perfect, absolute, authentic Picasso, the Picasso par excellence, it seems to me, is the latest one.

In the latest period of Picasso's art it is as if he had tried to cast off the devices by which the painter both masked and mirrored himself. And it seems to me that his last phase of irrepressible enthusiasm, of erotic and vital yes-saying, is a self-affirmation. For the mirror's depth does not lie in the invisible secret its shadows conceal, but in the luminous picture it reveals to us. Like life itself.

Art is the mirror of life because it has torn away death's sinister mask of horror, which, like a domino mask covering the eyes, plays with ambiguity by half masking the living face to heighten the shadow of death upon it.

We might say that Picasso's art in the end presents his own maskless face because, as Nietzsche suggests, this face is his best mask.

JOSÉ BERGAMÍN

Frontispiece
Head of Man with a Mustache
Tête d'Homme moustachu
5.1.1969
Oil on board, 37.8 × 25.35 inches

Illustration page 5
Serenade
L'Aubade
18.6.1967
Oil on plywood, 63.2 × 47.6 inches
Galerie Rosengart, Lucerne

1
Head of a Woman
Tête de Femme
22.7.1969
Oil on paper, 25.5 × 19.7 inches

2
Cupid and Musketeer
Amour et Mousquetaire
27.2.1969 IV
Oil on canvas, 50.7 × 34.7 inches

3
Man and Child
Homme et Enfant
21.2.1969 III
Oil on canvas, 63.2 × 50.7 inches

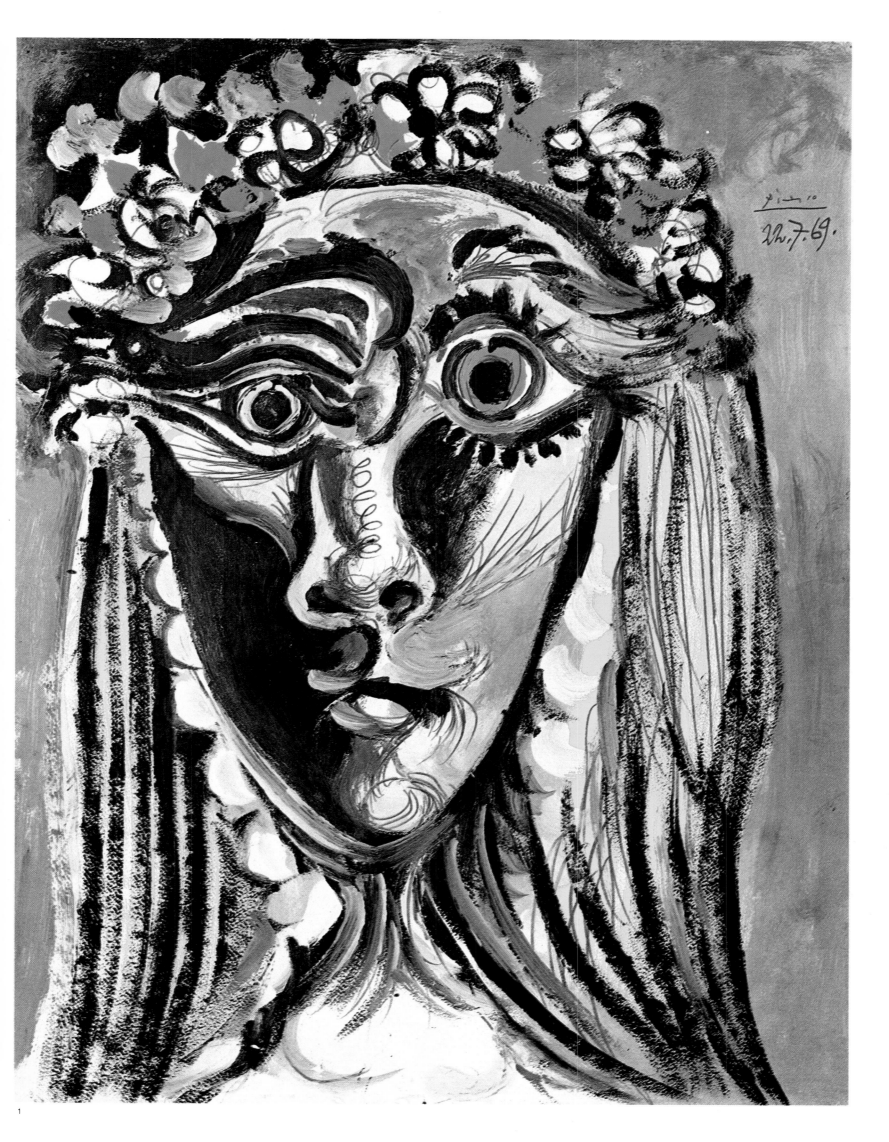

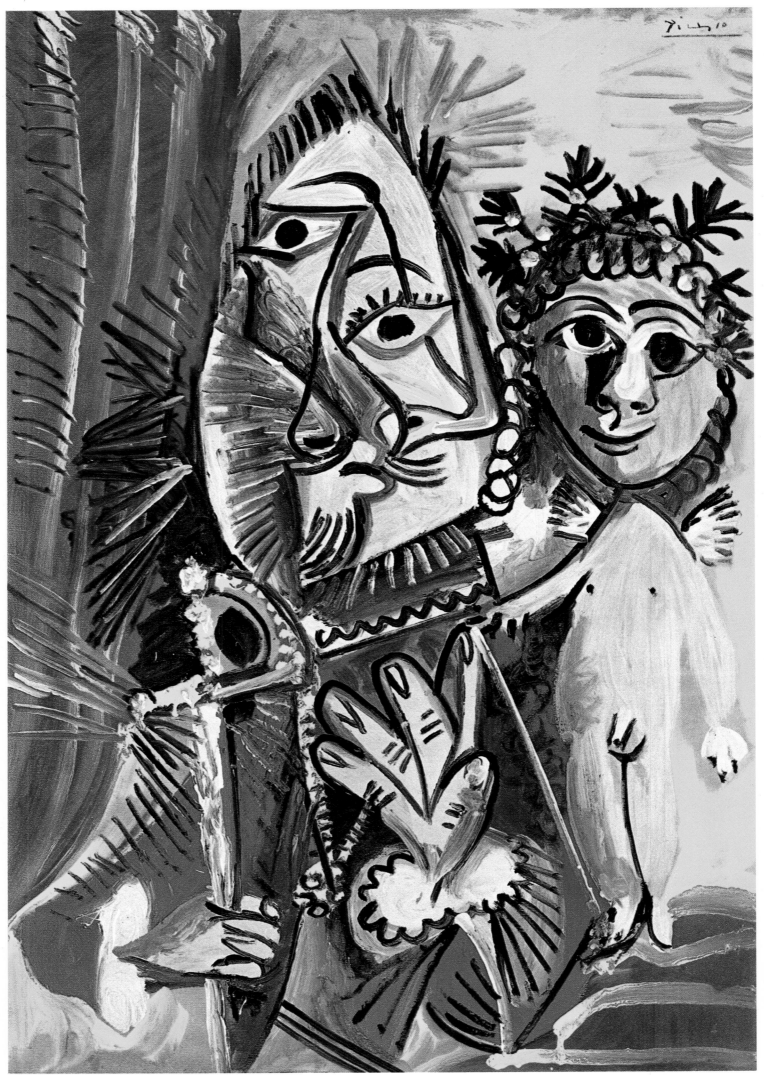

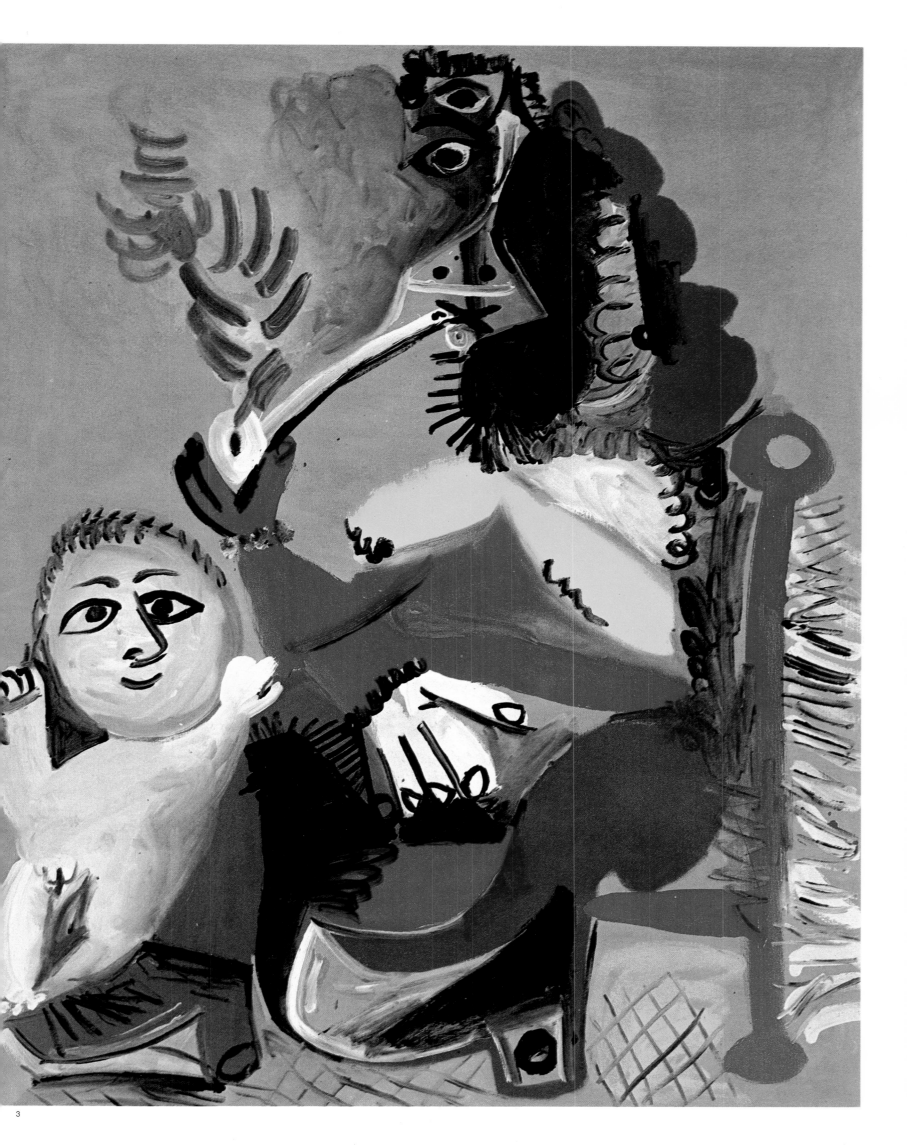

3

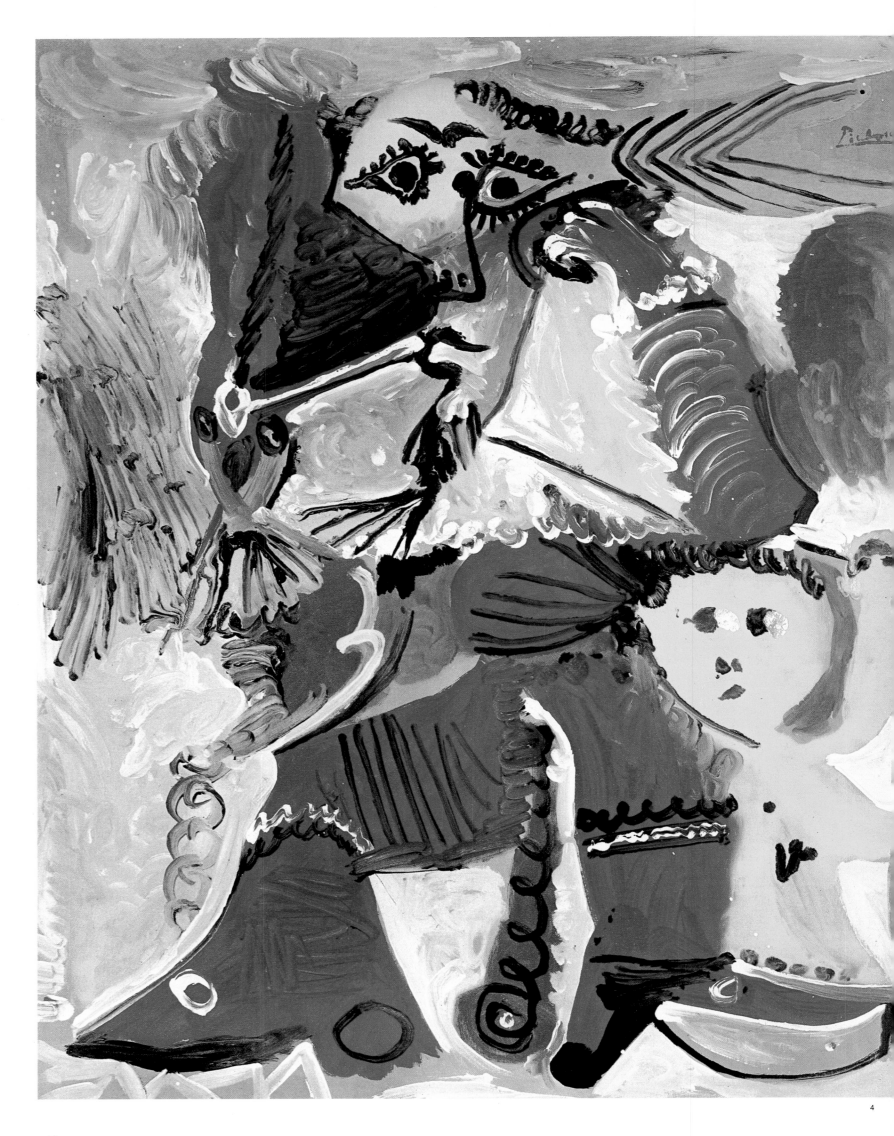

4

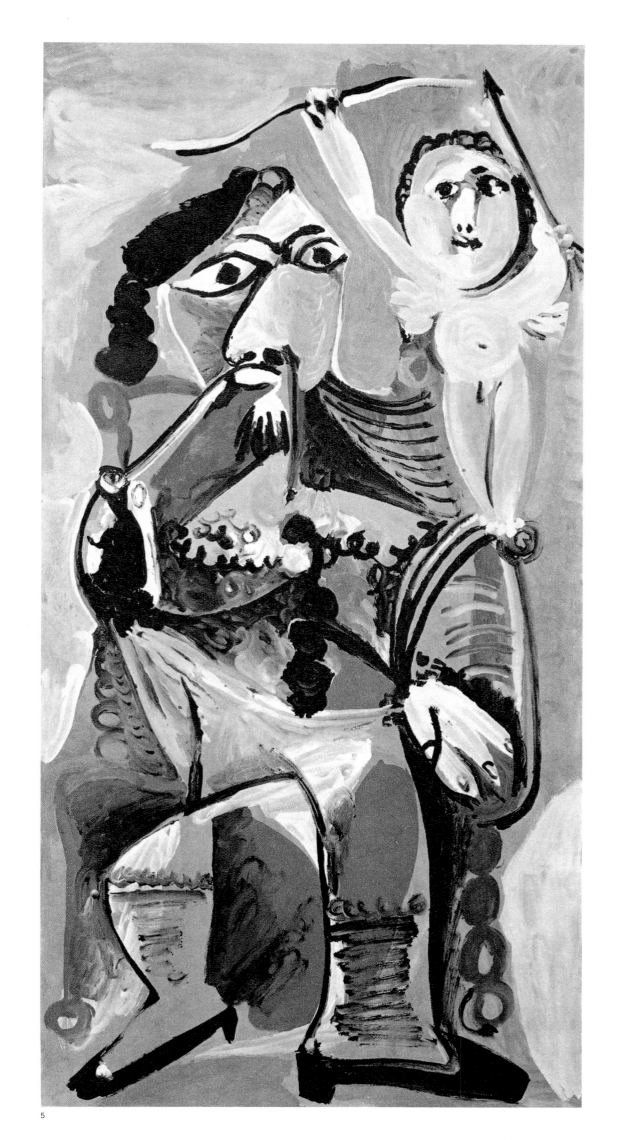

4
Rembrandtesque Personage and Cupid
Personnage rembranesque et Amour
19. 2. 1969
Oil on canvas, 63.2 × 50.7 inches
Galerie Rosengart, Lucerne

5
Man and Cupid
Homme et Amour
17. 2. 1969
Oil on canvas, 76 × 26.1 inches

5

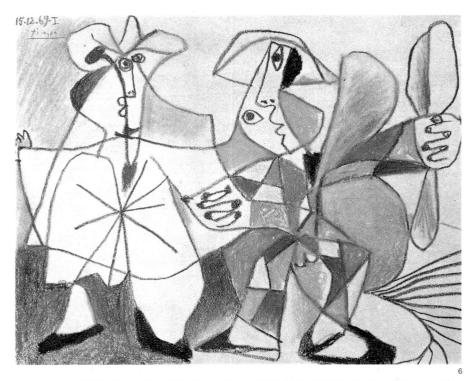

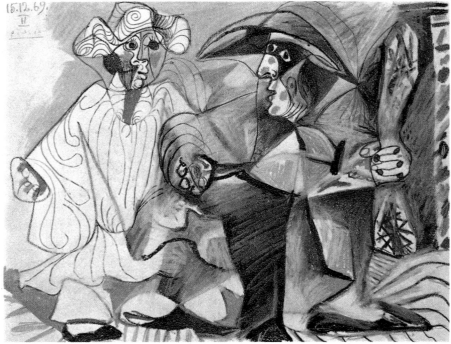

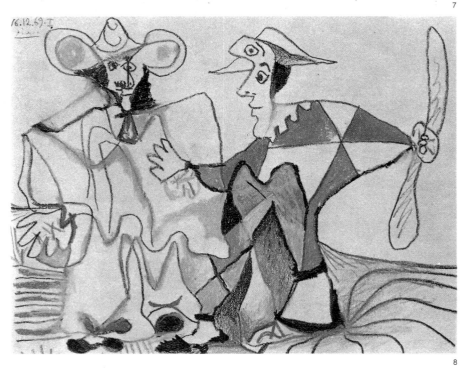

6
Colored chalk 15.12.1969 I 12.7×16 inches

7
Colored chalk and crayon 15.12.1969 II 12.7×16 inches

8
Colored chalk 16.12.1969 I 12.7×16 inches

9
Colored chalk and crayon
16.12.1969 II 12.7×16 inches

10
Colored chalk 16.12.1969 III 12.7×16 inches

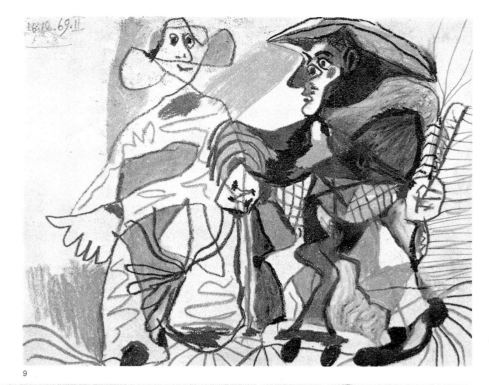

9

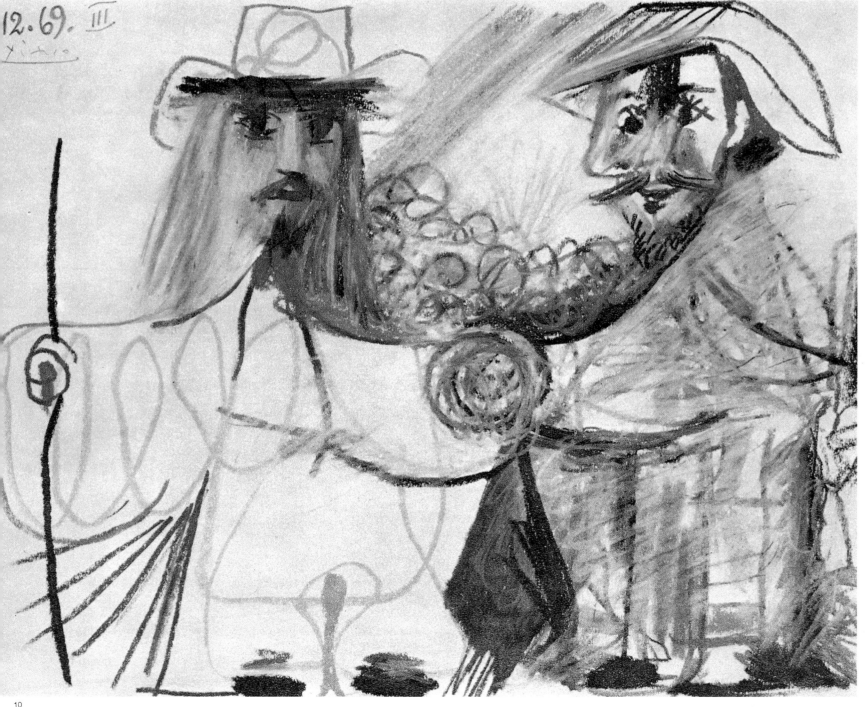

10

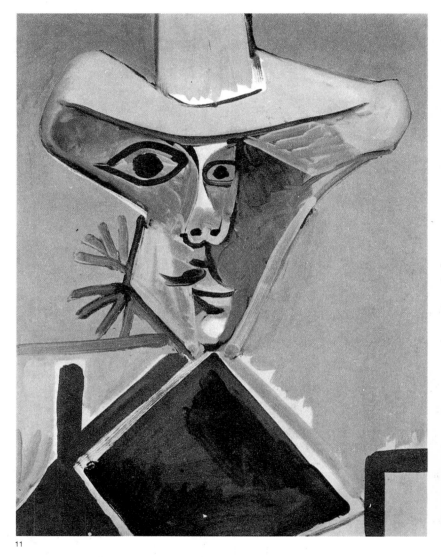

11

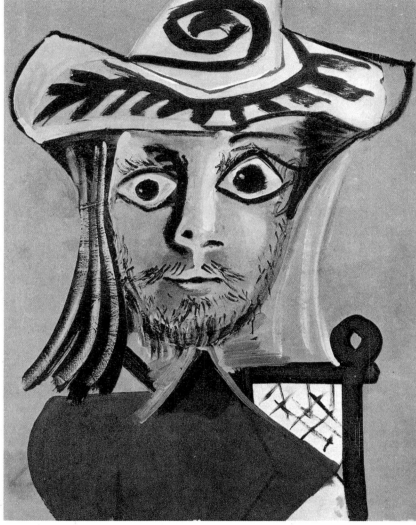

12

1 1
Bust of a Man Buste d'Homme 17. 10. 1969 III Oil on canvas
45.2 × 34.7 inches

1 2
Bust of a Man Buste d'Homme 17. 10. 1969 III Oil on canvas
45.2 × 34.7 inches

1 3
Bust of a Man Buste d'Homme 17. 10. 1969 I Oil on canvas
45.2 × 34.7 inches

24

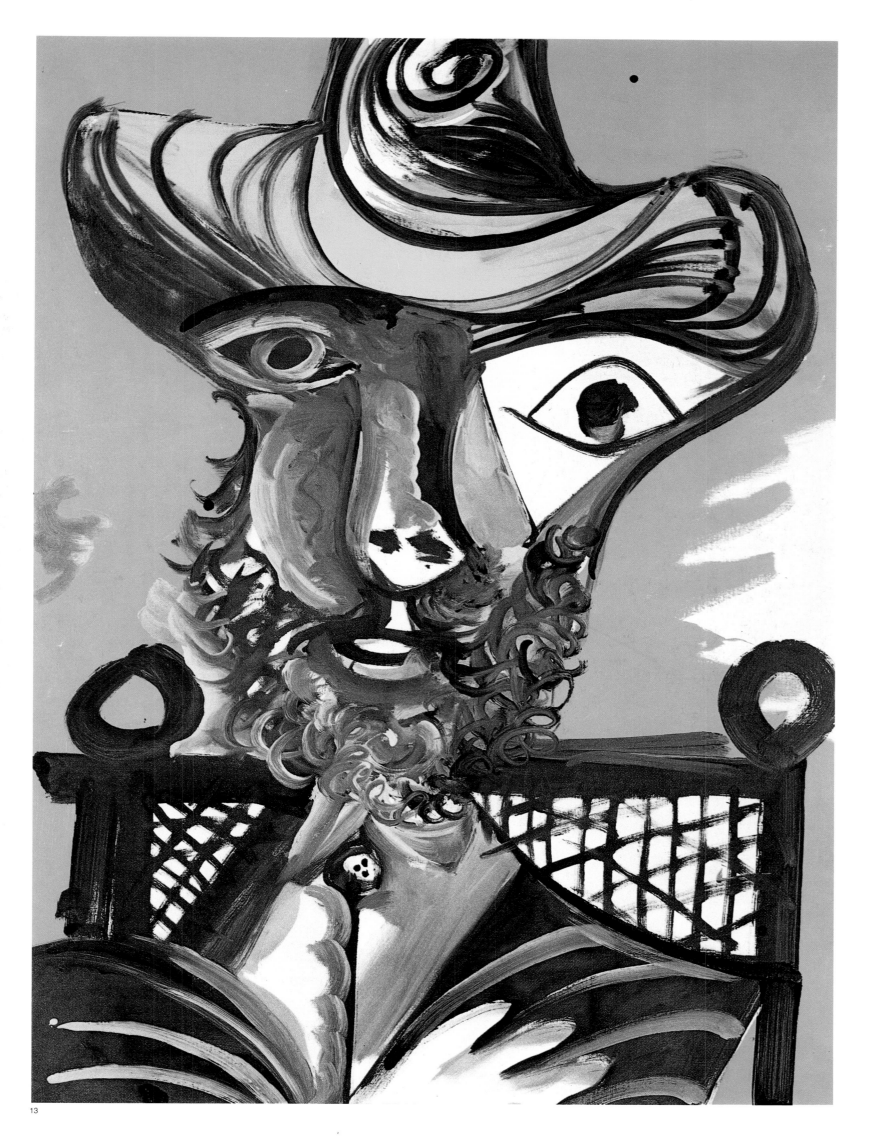

13

25

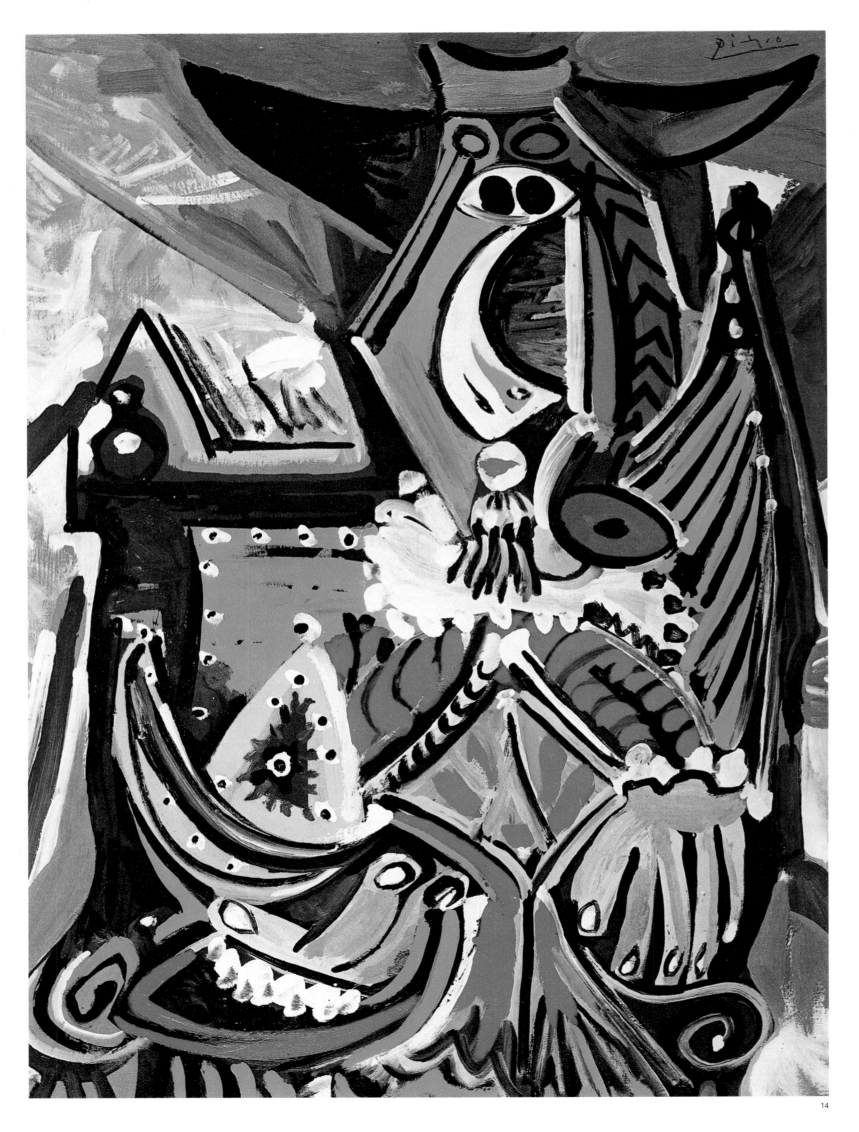

Picasso

For Daniel-Henry Kahnweiler
from Klaus Gallwitz

The Summer after the Death of Picasso is the title of a little play published in 1969 which deals with a time still to come. Imagination delights in suggestive subjects of this sort, for, as events of recent years remind us, a "happening" of this magnitude can be effaced from the memory of contemporary observers surprisingly quickly once it has occurred. No sooner had the assassination of President Kennedy or the moon landing been announced, listened to on radio and watched on television, than it vanished into history, displaced by headlines of third- or fourth-rate importance. On the other hand the appearance of Halley's comet, which had no ascertainable effect on the affairs of this planet, is said to have held our parents' and grandparents' interest for a considerable time. The worldwide publicity of today makes it almost impossible for us to concentrate on natural events or human destinies for more than a moment. But Picasso's long life and universal fame permit us to use his name as a sort of benchmark for the passage of time.

Picasso's early periods can be counted off like geological formations. Here we are on firm ground. Only when we visualize the historic gap which separates us from his Blue or Rose periods, for instance, or from Cubism, do we realize that two generations have come to maturity since that time and that the young painter who made his start in Paris in 1900 could be the grandfather or even the great-grandfather of the Picasso of today.

For seventy years Picasso's name has been synonymous with our century. He has now reached his ninetieth birthday—although there is no indication that he pays any heed to our commemoration of dates or to the tributes of world opinion. This is probably because Picasso has identified himself with virtually all the potentialities and conflicts of our century. No other artist so embodies the optical age; no one else is such a prototype of the *augenmensch*—the visual man. Capacity for abstraction and for intellectual and political awareness, engagement of the senses, directness of communication—all the most desirable qualities in our pursuit of individual freedom—are encompassed in the name Picasso. That the most forceful character the twentieth century has yet produced should be an artist is one of the few mitigating paradoxes of our time.

While his presence is still with us, it is hard to say exactly why we find Picasso so exciting. In all the judgments that emerge from the countless criteria, evaluations and contradictions, we may perhaps discern one common factor. No one, whatever he may think of Picasso, would presume to refer to him in terms such as "passé," "outdated" or "played out." While he may force us into endless predicaments, any discussion of him is invariably open-ended.

14
The Man with the Golden Helmet
L'Homme au Casque d'Or
8.4.1969
Oil on canvas, 56.9×43.5 inches
Galerie Rosengart, Lucerne

The name of this Spaniard is linked with Paris. The city's myth became his myth, first in the bohemianism of the Bateau-Lavoir, later in the aura of Diaghilev's Russian ballet and the journal *Minotaure,* later still in that of the World Exposition of 1937, for which he painted *Guernica.* Even before the outbreak of World War II Picasso was an exile who had taken the losing side, an emigrant barred from returning to Spain. He sent *Guernica,* his prophecy of the European disaster, to New York, on indefinite loan to the Museum of Modern Art.

Picasso has lived through three generations in our century. His world fame has

15

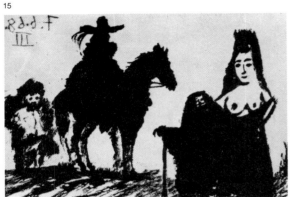

16

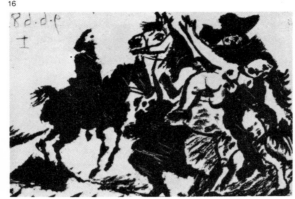

17

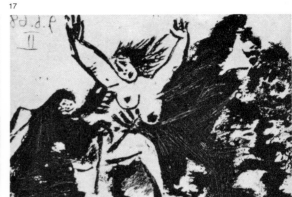

demanded that he declare his support of causes, that he take a stand on issues. In the meanwhile the market for his works, for which higher and higher prices are offered, is insatiable. Tributes and attacks grow more generalized as they come to serve nationalistic and ideological ends. Picasso has indeed become "public property."

He himself has reacted to all this—and offered new provocations. Since leaving Paris he has returned only for short visits. Even the splendid exhibitions organized by official France in honor of his eighty-fifth birthday could not lure him back to the capital. But he sent his works, old and new, and they were seen by almost a million people—an unprecedented triumphal procession.

Never had France done such honor to a living artist. Small wonder, then, that there should be some bitterness about Picasso's seemingly capricious distribution of his favors in recent years. In 1970 he honored the Avignon Festival with an exhibition of a whole year's output of paintings, yet he has presented the major portion of his works to the Barcelona Museum, making it the greatest Picasso gallery in the world. People stare at his house in the Midi, wondering what new blows or happy surprises may be forthcoming.

Even the historians of trivialities, so generous with sensational news items, cannot conceal the fact that the last twenty-five years constitute one of Picasso's richest periods. Never has his productivity been so high—in painting, sculpture, drawing, and graphics. The work of his "old age" shows no decline. Neither Rembrandt nor Goya nor Delacroix broadened his scope so impressively in the latter part of his life. The characteristic color accents, the freeness of the drawing, and the multilevel diversity of expression prove ever more clearly that this man is a unique phenomenon. The early revolutionary, the hero of Cubism, the moralist of the 1930's, now emerges as the victor who has never stopped destroying his own myth. It is upon one of his latest paintings, a head whose eyes are the eyes of Picasso, that the laurels of this nonagenarian rest.

Yet a potential misunderstanding concerning the late works discussed in this book needs to be clarified. Numerous as they are, they are far less widely known than the work of earlier periods. The well-trodden roads stop at the point where color reproductions and postcards cease to be available. The acrobats of the early period and even some of the Cubist paintings have long been favorite items with interior decorators, but they mark the limits of the average man's adaptability, so far as Picasso is concerned. People are slow to approach this artist, so often ridiculed as

15
Aquatint 7.6.1968 III 2.3×3.3 inches

16
Aquatint 9.6.1968 I 2.3×3.3 inches

17
Aquatint 9.6.1968 II 2.3×3.3 inches

"When I paint, I always try to give an image people are not expecting and, beyond that, one they reject. That's what interests me. It's in this sense that I mean I always try to be subversive. That is, I give a man an image of himself whose elements are collected

"mad," because it is difficult to realize, on the basis of his art, that he is a contemporary, not a grandfather.

The term "late work" is overhung by a curious conceptual cloud of unexpressed associations such as perfection, maturity, and transcendence. This confuses our standards of evaluation and arouses false expectations which, like the promises of the so-called early works, we do not begin to recognize until later. Nevertheless art history long ago established criteria which, cautiously applied, do characterize certain parallels in the late work of great painters.

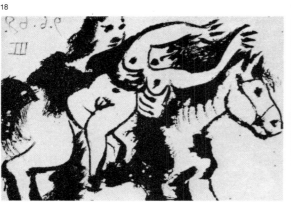

18
Aquatint 9.6.1968 III 2.3×3.3 inches

19
Aquatint 9.6.1968 IV 2.3×3.3 inches

20
Aquatint 9.6.1968 V 2.3×3.3 inches

This phenomenological analogy seems not to apply to Picasso. His first paintings, made at the turn of the century, have a tired, fragmented, contrived look. Their line and color have something of the world-weariness of the *fin de siècle* and of literary Symbolism, which is reflected in the stylized poses of the circus artists he painted. Nor does the work of the last twenty years show the slightest trace of the serenity, simplification, and synthesis that are often supposed to characterize mature style.

Picasso's exploration of new subjects and the intensity of his creativity alone show him to be more productive today than ever before. In less than six months (from March 16 to October 5, 1968), at the age of eighty-seven, he produced 347 drawings and a year later 150 paintings. The vigor of his line has kept pace with the increasing directness of his artistic statement. It is as though old age were rebelling against a generation which would like to regard the gesture of rebellion as the prerogative of youth. Picasso worships and imitates youth as fervently as he rebels against it. His unflagging work stems from a compulsion to justify himself in his own eyes, to safeguard his life through his art. His bearded "genius," often bent with years, weak and fanatical, frequently seems to have the features of the aged Faust. The lengthening shadow of Picasso's long life shows up ever more plainly the remarkable relief of his late work, which reveals no signs of decline.

We can as yet barely discern the scope of Picasso's most recent period; its landmarks are still undistinguishable to the general public. Today paved roads lead to Van Gogh and Gauguin; Monet and the late Renoir have penetrated the general consciousness, just as the early Picasso has. His acrobats are part of "classical" modernism—in which even Cubism now has its recognized place, though often only by virtue of its lyrical subject matter of guitars, wineglasses, and playing cards. Picasso's neoclassical period (around 1920) will have a harder time becoming popular, for the infallible index of popularity is still the commercial availability of colorful postcards and prints. Clearly only the works of the periods we have mentioned can win acceptance as "world art." On either side of the paths which, thanks to commercial publicity, have opened up children's rooms and interior decorating to Picasso lurks the still suspicious figure of the "mad" artist, who must obviously remain ununderstandable so long as he persists in being a contemporary rather than a grandfather. Probably no artist has ever been called mad so often and so insistently as Picasso. To be sure, no other artist has

from among the usual way of seeing things in traditional painting and then reassembled in a fashion that is unexpected and disturbing enough to make it impossible for him to escape the questions it raises.''

(GILOT)

made this century his own in such an unequivocal yet ambiguous way. Not until after World War II, toward the middle of the century, was this fact recognized and accepted.

Even more remarkable is the fact that although Picasso was a top-flight celebrity for many years, ranking with statesmen and film stars like Churchill and Chaplin, knowledge of his work remained fragmentary, casual, and inexact. As a magician, jack of all trades, clown and conjuror, he had become an object of extravagant

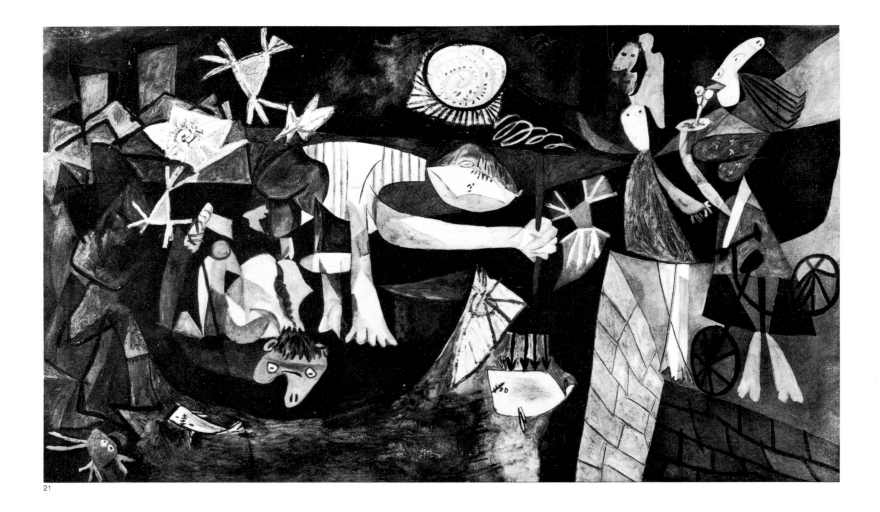

21

21
Night Fishing at Antibes
Pêche de Nuit à Antibes
1939
Oil on canvas, 83.1 × 134.55 inches
The Museum of Modern Art, New York

reverence or criticism. What his friends and close associates had to say about him became more intimate; journalistic banalities became even more banal. His prices, at first "reasonable" enough, spiraled from year to year, strengthening speculative motivations for buying. The paintings of his postwar period quickly found purchasers all over the world, usually private collectors, while the museums were still making desperate efforts to acquire a "classic" Picasso. The result is that apart from certain specific themes or artifacts like the Vallauris-painted ceramics, the work of the last few decades has still not been properly evaluated. For example, the series of fifteen variations on Delacroix's *Women of Algiers* (Plates 157 ff.) could be seen in its entirety only during the year following its production, from 1954 to 1955. After that the pictures were scattered throughout various continents, sometimes in inaccessible collections, before anyone thought of publishing them as a series. It now seems quite impossible that the series can ever be reassembled, particularly since several of the pictures have dropped completely out of sight. Another thematic group, the fifty-six paraphrases of Velázquez's *Las Meninas* (Plates 175 ff.), was kept together only because Picasso presented the whole set to his Barcelona museum. We are in the paradoxical position of having a far less comprehensive view of the so-called late work than its closeness in time would imply, while Picasso's early years can already be seen in the clear light of history.

Picasso as a phenomenon is more obscure and has been less searchingly studied than the voluminous literature on him would suggest. This book covers a period of twenty years—the most productive period of his whole life, judging by the number of paintings, drawings, prints, sculptures, ceramics, and illustrations he has created. There has been a steady increase in spontaneity. Picasso's compulsion to work grows more intense; he allows himself less and less time for excursions or travel. Even the visitors and friends he welcomes sense a conflict between the claims of friendship and work. Sometimes this restlessness seems to be the only constant factor in the whole period since World War II. In his work it has rewarded him with fresh insights and materials; in his life it has driven him to ever new departures and changes in his immediate surroundings.

In dealing with a spirit so inexhaustible, so immune to fatigue—an artist who has enjoyed complete mastery of his media—any attempt to define the "late work" must be undertaken with great skepticism. But even in Picasso's case certain data are available which seem to mark the dividing line and which are concrete enough from the biographical point of view.

The last year but one of World War II saw the end of the German occupation of France. In August, 1944, Paris was liberated—and with it Picasso. Journalists and refugee friends, now wearing the uniform of the Allies, hastened to the familiar studio in the Rue des Grands-Augustins, anxious to see whether Picasso had safely survived the critical days of the German withdrawal. Communication had been problematical since the German occupation and even more so since the Allied landings. Picasso, whose paintings had been banned from German museums as "degenerate," had remained in a more or less officially recognized hiding place in Paris while other famous painters such as Léger, Chagall, and Max Ernst sought refuge in America. After several moves in the early days of the war under the pressure of anxiety for the safety of his paintings, he decided to stay in Paris, probably realizing that the vastness of the city would offer him more protection than any other place in France. Nevertheless, the four years of occupation brought constant risks, as well as many hardships and deprivations—an unending source of worry to his friends in the free world.

In the studio was a series of newly painted still lifes of a tomato plant (Plate 23). Instead of a "salute to victory" or an apocalyptic vision of the end of the war, Picasso had been painting a common vegetable, raised by housewives in window boxes or on balconies to supplement their wartime diet. The redness of the fruit was a greeting to all who entered the studio in those August days. Picasso had painted the tomato plant five times, set against his studio window just as his first visitors saw it.

This still life series literally marked the end of the many pictures Picasso painted in Paris during the occupation. Thematically, though not stylistically, it initiates a new period, a radical break with the gloomy, aggressive sadness of the still lifes and women's portraits that preceded it.

The end of his involuntary captivity in Paris gave Picasso new options. He joined the Communist Party and once more exhibited in the Salon d'Automne, contributing over seventy pictures. He turned to what is for him an unusual subject: the city and the *quais* along the Seine. In 1945 he returned to the French Riviera for the first time since his hasty departure from Antibes on the outbreak of war. He exchanged a still life for a house in the Provençal village of Menerbes and gave it to Dora Maar, his companion of many years. All kinds of diverse activities absorbed him. He attended world peace congresses in Breslau, Sheffield, and Rome. The summer of 1946 found him installed in the spacious *Château Grimaldi,* an ancient stronghold in Antibes. In four months he painted one picture after another, leaving them all to the Antibes museum on permanent loan. A year later he began to work in ceramics in the neighboring Vallauris. Before long the abandoned pottery village had become a thriving commercial town. Yet these often conflicting impulses stemmed from a common root: his regained freedom of movement and his decision to live in the South

of France. This choice may originally have been quite unconscious and undeliberate, the result of practical considerations and experiences. Nonetheless he was in fact turning his back on Paris, his lifelong home, from which he had felt more and more alienated every year, especially during the war.

In August, 1939, Picasso had recorded his experience of the South in a night picture. It is a very large one, six feet high and over ten feet wide, a format he used only for important and unusual subjects. While its dimensions do not approach those of *Guernica,* they far exceed those of its equally monumental counterpart, *La Joie de vivre,* painted in the *Château Grimaldi* in Antibes in 1946. *Night Fishing at Antibes* (Plate 21) stands midway between *Guernica*'s indictment of the horrors of war and the glorification of life of *La Joie de vivre*—a major work whose human figures, animals, and landscape express, in a sort of leavetaking, all that Antibes has meant to Picasso. While preserving the genre character of the nocturnal fishing scene (a common sight in all Mediterranean countries), he infused it with a strangely supernatural atmosphere. Looking at this sea under the white light of acetylene lamps and warm moonlight is like looking into a spring from which fabulous creatures of myth and dreams are emerging. This last great night landscape and figure composition seems to be Picasso's testament to the Midi, which he was not to see again for six years. *Night Fishing* foreshadowed his future work like a tremendous backdrop, although he never again combined figures and landscape on an equal footing in an allegorical yet totally realistic theme.

The South of France offers Picasso a different, more intense light, the warmth and Mediterranean landscape and culture which to him mean closeness to his native Spain. The same Mediterranean waters lap the coast at Málaga and Barcelona, where he grew up. With the help of friends, Picasso, who had sworn never to set foot in Franco's country again so long as the dictator lived, found a way to demonstrate his ties with Spain: He presented to the Barcelona museum over fifty variations on Velázquez's *Las Meninas* (Plates 175 ff.). In Provence he could attend bullfights, which reappeared in his work after an absence of thirty years. The new yet familiar surroundings had a lasting influence on him, though by no means a soothing, mellowing or idyllic one. For Picasso, the Midi is not radiant and serene, but, as Paul Eluard put it, "black." Picasso has an elemental understanding of this "blackness"; something in his nature instinctively responds to it. The Côte d'Azur was no retreat for his old age. On the contrary this landscape provided him with the raw materials which fascinated him and from which he fashioned his works: the clay, the hard light of the sky, and the easy, natural movement of the people.

Picasso's postwar life is concentrated within a tiny area, a few square miles in extent, lying between Antibes and Cannes. After four years of enforced immobility in Paris he had a constant urge to move. He kept buying new houses and moving into them, always on a temporary basis, until he finally settled down in a farmhouse near Mougins.

His return to the Midi in 1945 reopened the horizon of nature as a setting for human activity. The clear silhouettes of mountains, the way trees grow, the colors of the sea, bathers on the beach, all aroused a longing for mythological disguise and the avocation of classical antiquity. The ritual of the bullring began to fascinate him again. He felt at home here; once again he took possession of this ancient world, which he loved no less passionately than Van Gogh and Cézanne before him. But Picasso would be the first to "domesticize" this world, to relate it totally to himself and universalize it, for he himself seemed to be one of its protean creations.

None of the factors that influence an artist's work was strong enough to precipitate a radical change in Picasso's painting after the war. His liaison with Françoise Gilot, his extensive traveling, the long summer in Antibes, and many changes in his surroundings produced no immediate change of style. Nevertheless a certain artistic

strategy which now emerged and quickly gained ground indicates the driving impulse behind the late work. This phase would also be marked by the return of familiar themes, often reflections of subjects Picasso had treated before and laid aside for decades. Typically these "readoptions" from his own store of images constantly touched upon new ideas and opened new perspectives; sometimes they even seemed to represent corrected versions of earlier formulations.

Every new picture contributed, consciously or unconsciously, to the destruction of the legends which stand between Picasso and his work. In never-ending series,

"Why do you think I date everything I do? Because it is not sufficient to know an artist's works—it is also necessary to know when he did them, why, how, under what circumstances... Some day there will undoubtedly be a science—it may be called the science of man—which will seek to learn more about man in general through the study of the creative man. I often think about such a science, and I want to leave to posterity a documentation that will be as complete as possible. That's why I put a date on everything I do." (BRASSAÏ)

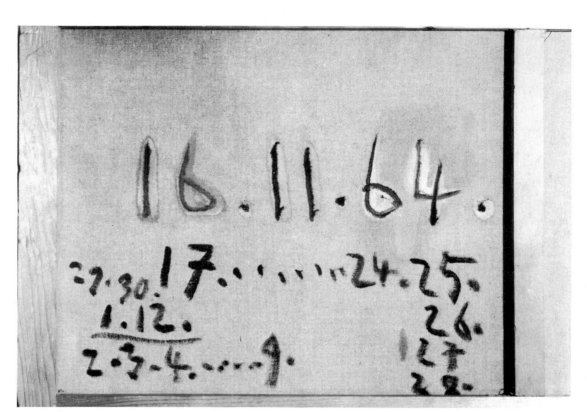

22 Dating on the back of a work

variations, and metamorphoses he lured his viewer from one discovery to the next. He delighted in grimace and mask play. When he wore a mask himself, it hid him and shocked the observer. And this is just what is often so confusing about the reality and legend of Picasso: the ambiguous expression, the contradictions which the artist exploits for his own purposes. Often mask and grimace seem to be a means of effacing his tracks and insulating the private sphere of studio and family from the aimless curiosity of his contemporaries. Without doubt Picasso is a master of this craft too, but it is already clear that his preoccupation with changeability goes far beyond personal masquerade and is an essential element in his art. The bearers or symbols of metamorphosis now reappeared in his work, never to leave it again: the circus performers, harlequins, actors, artists, and *toreros*. This assemblage of "quick change artists" demonstrates Picasso's love of masquerade, even of clowning, which never fails to astonish and amuse the people around him. His liking for the limelight and the public eye can change quite unexpectedly into a sudden retreat from publicity, as though he himself were surprised at the effect his disguise produces.

Picasso's response to audiences, large or small, is another form of the dialogue he engages in with his inventions on canvas or paper. He never needs a model or set because his vast memory contains an almost inexhaustible stock of formal and remembered items. With a sureness which never ceases to astonish, his brush, pencil, or crayon fixes his subject. At a certain unpredictable point the model is forgotten and the picture begins to make its own demands on the painter's hand. It becomes autonomous, and at this point Picasso often pauses momentarily to assess the implications and consequences of his preliminary sketch and decide what corrections

and additions he needs to make. The process continues as the artist and the picture influence one another in a continuous interchange, though to the observer it may look as if only the picture were developing.

Since dialogue plays such an important part in the evolution of Picasso's paintings, he usually has difficulty in deciding how to finish them. The notion of completeness is incompatible with his constant urge to continue. He is always thinking of still another accent or improvement he might add. Finality seems to frighten him, because he associates it with the finality of death. Fear of death is as strong in Picasso as his sense of the preciousness of time. Hence he often finishes a painting only to continue it in a subsequent one. This is especially true during the last two decades, and accounts for the great serial works of his late period.

Time is a constant challenge to Picasso, and his longevity has made him more cautious and at the same time more spontaneous in its use. In 1955, after long resistance to the project, he spent two months working on the film *Le Mystère Picasso* in collaboration with his friend Henri-Georges Clouzot. As the only actor, he painted and drew in front of the camera, whose whirring sound was an audible reminder of the irrevocability of every second that passed. Picasso took this contest with the swift passage of time in his stride, along with the hectic activity of the movie studio. It becomes the thematic signature of his late work and is reflected in his pictures of couples of disparate ages: a young girl with an old man.

As early as the late 1920's Picasso began to date his works, at first with just the year but soon with an exact notation of the day and month. On the paintings these "calendars" were at first inscribed on the back of the stretchers. So far as his graphic works are concerned, the first set on which Picasso consistently recorded the full date and place is the Vollard suite of 1930 to 1937, where this date is legibly engraved on the plate. From then on he rarely departed from this procedure.

The paintings of the late period no longer have the date inscribed on the stretcher but on the back of the canvas itself (Plate 22). The date has become an essential part of the work. In the early days of Cubism Picasso would often hesitate to add his signature to a composition for fear of spoiling it. In recent years, however, every drawing he makes bears not only his name but a large, legible date, sometimes in blurred painterly strokes, sometimes inscribed with calligraphic firmness. Pictures on which he worked sporadically or for several days at a time are dated just as carefully, with meticulous notations of day and month, so that some paintings bear whole columns of figures. If he makes several paintings, drawings, or prints in one day, a Roman numeral denotes the order in which he worked on them, for he often puts one work aside to turn to another. The genesis of many works may follow a parallel course, continually intersecting and overlapping, with apparent gaps and long or short pauses.

This careful record betrays Picasso's tense awareness of the passage of time; he is never unmindful of it, even in his most productive phases when one work swiftly follows another. Far from being a symptom of an overmeticulous love of order, this rudimentary calendar expresses Picasso's profound skepticism about the duration and authenticity of all experience.

Still Life

"We always had the idea that we were realists,
but in the sense of the Chinese who said,
'I don't imitate nature; I work like her.'"

<div align="right">

(GILOT)

</div>

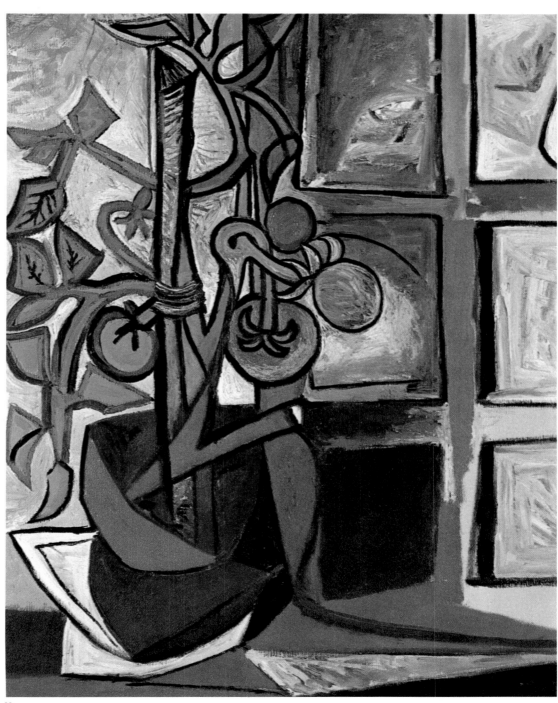

23
Tomato Plant
Plant de Tomate
10. 8. 1944
Oil on canvas, 35.9 × 28.5 inches
Private collection, Switzerland

23

In August, 1944, the studio in the Rue des Grands-Augustins was crammed with paintings and sculptures produced during the Occupation. All summer long, as the Parisians awaited their imminent liberation and every day brought fresh, conflicting news reports, Picasso remained unaffected by the excitement. Calmly and steadily he painted, like an unhurried chess player deploying his limited pieces in ever new combinations. Toward the end of July, 1944, three commonplace objects—a pitcher, a vase, and a piece of fruit—kept changing position on a narrow table. No literary allusion, no reference to adjacent objects, space or the fall of light disturbed the concentration of these late-Cubistic studies, which were in striking contrast to the turbulent events taking place outside. A few days later he made drawing after drawing of a tomato plant and its ripening fruit. Time and place now entered the picture simultaneously, for the five canvases of this potted tomato plant painted in early August show that he had placed it directly in front of his studio window. The treatment of the windowpanes and in one case even the catch of the window shows the growing importance Picasso attaches to meticulous detail. In the late work the private side of his life and the physical reality around him become more and more influential. Of course this does not affect the stature of his paintings or their statement and general artistic claims; nevertheless it is often impossible to disregard the increasingly "private" nature of his subjects, especially when they include his studio and intimate surroundings.

After the anonymous cagelike space of the wartime paintings the tomato plant strikes an almost anecdotal note. The plant, with its twining stems and leaves, is set on a white stand before the window, which in one version is closed, in another half-open. While the subject is not particularly gay in itself, the colors—green, brown, gray, and red—are warm and intimate. It is characteristic that Picasso, with such a rich fund of symbolic potential to draw upon, should have confronted this critical moment of history, whose outcome was still uncertain, with a series of still lifes.

On August 24 there was shooting in his street, and grenades were exploding in the quarter. Picasso was absorbed in his work. Singing at the top of his voice, according to friends, he picked up a reproduction of a Bacchanale by Poussin and confidently painted a gouache after it. Picasso's version of *The Triumph of Pan* (Plate 152) was his reaction to the uncertainty of the hour, a visual counterpart suddenly suggested to him by Poussin's turbulent scene. He stuck closely to the "obvious," "tangible" characteristics of the model which had instantaneously fired his imagination. This was the beginning of what was to become a central practice in his art.

For decades, still-life themes provided Picasso with an unfailing source of material. More than any other subject the still life offers an opportunity for analytical dissection of a limited number of readily changeable forms, and it is no exaggeration to say that one of the most momentous artistic revolutions of this century—Cubism—stated its case in all its forms in the still life. This may explain why right up until Picasso's last phase his still lifes have remained formally more conservative than his figure and landscape compositions. His first still-life renaissance occurred in the mid-1920's, when he expressed his most beautiful coloristic experiences through this medium. These

There are at least seven different versions of the Still Life with Skull *of 1945. The subject had first appeared in Picasso's painting the previous year, when he was modeling his* Crâne. *Despite the skull there is nothing in this "summery" still life of a blue and white jug with cherries and a flower to recall the gloomy, mystical preoccupation with the vanity of life that pervades the wartime pictures.*

The owl appears again and again in Picasso's postwar paintings, as well as in innumerable lithographs and drawings. Owls, pigeons, parrots, and rare tropical birds are completely at home in his house. They have a personal significance for him which sometimes seems to border on superstition.

24
Still Life
Nature morte
13.7.1945
Oil on canvas, 23.35 × 39 inches
Galerie Beyeler, Basle

25
Still Life with Mirror
Nature morte au Miroir
1945-1946
Oil on canvas, 31.6 × 44.85 inches
Perls Galleries, New York

26
Still Life with Coffeepot
Nature morte à la Cafetière
1943
Oil on canvas, 14.8 × 23.8 inches
Galerie Beyeler, Basle

24

25

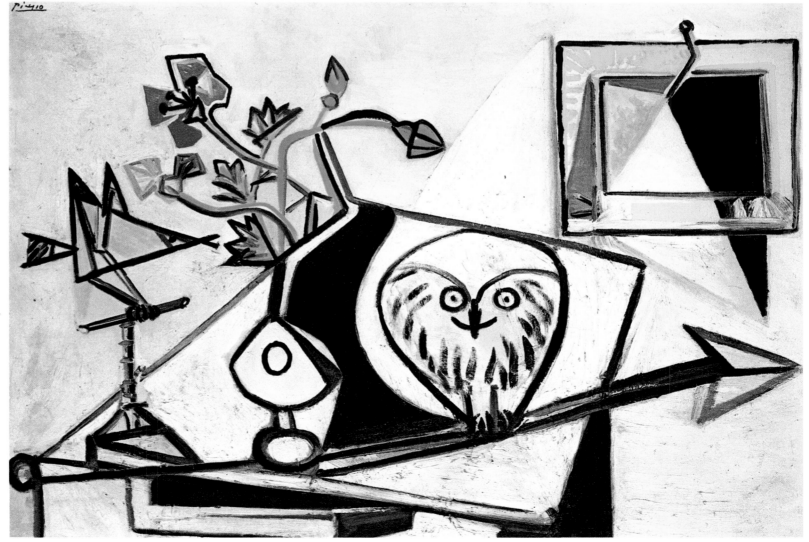

"I paint as I breathe. When I'm working I'm resting. Doing nothing or talking to visitors tires me. It's often three o'clock in the morning by the time I turn my light out."

" My own night lighting is magnificent; I even prefer it to natural light. You must come some night to see it. This light that sets off every object, these deep shadows that surround the canvases and project them-selves up to the beams—you'll find them in most of my still lifes, because they are almost all painted at night." (BRASSAÏ)

27
Still Life on a Table
Nature morte sur une Table
4.4.1947
Oil on canvas, 39×31.2 inches
Galerie Rosengart, Lucerne

28
Still Life with a Candle
Nature morte à la Bougie
1944
Oil on canvas, 23.4×35.9 inches

28

29
Skull of a Goat with Bottle and Candle
Crâne de Chèvre, Bouteille et Bougie
16.4.1952
Oil on canvas, 34.7×45.2 inches
The Tate Gallery, London

30
Skull of a Goat
Le Crâne de Chèvre
12.4.1952
Wash, 19.9×25.5 inches
Wallraf-Richartz-Museum, Cologne

31
The Mandolin
La Mandoline
1959
Oil on canvas, 25.15×31.6 inches
Galerie Rosengart, Lucerne

32
The Mandolin
1959
Oil on canvas, 23.4×28.5 inches
Galerie Beyeler, Basle

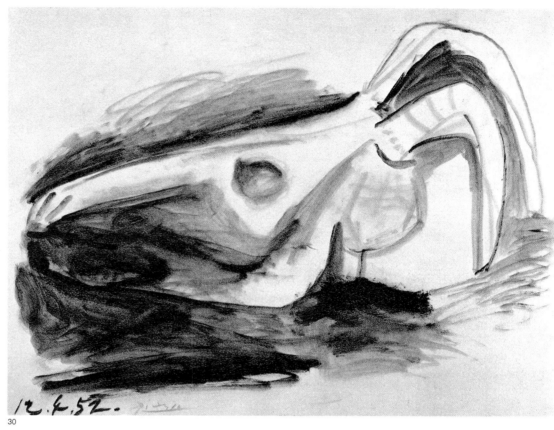

30

29

"I have an absolute passion for bones ... Have you ever noticed that bones are always modeled, not just chipped out? One always has the impression that they have just been taken from a mold, after having been modeled originally in clay. No matter what kind of bone you look at, you will always discover the trace of fingers."

(BRASSAÏ)

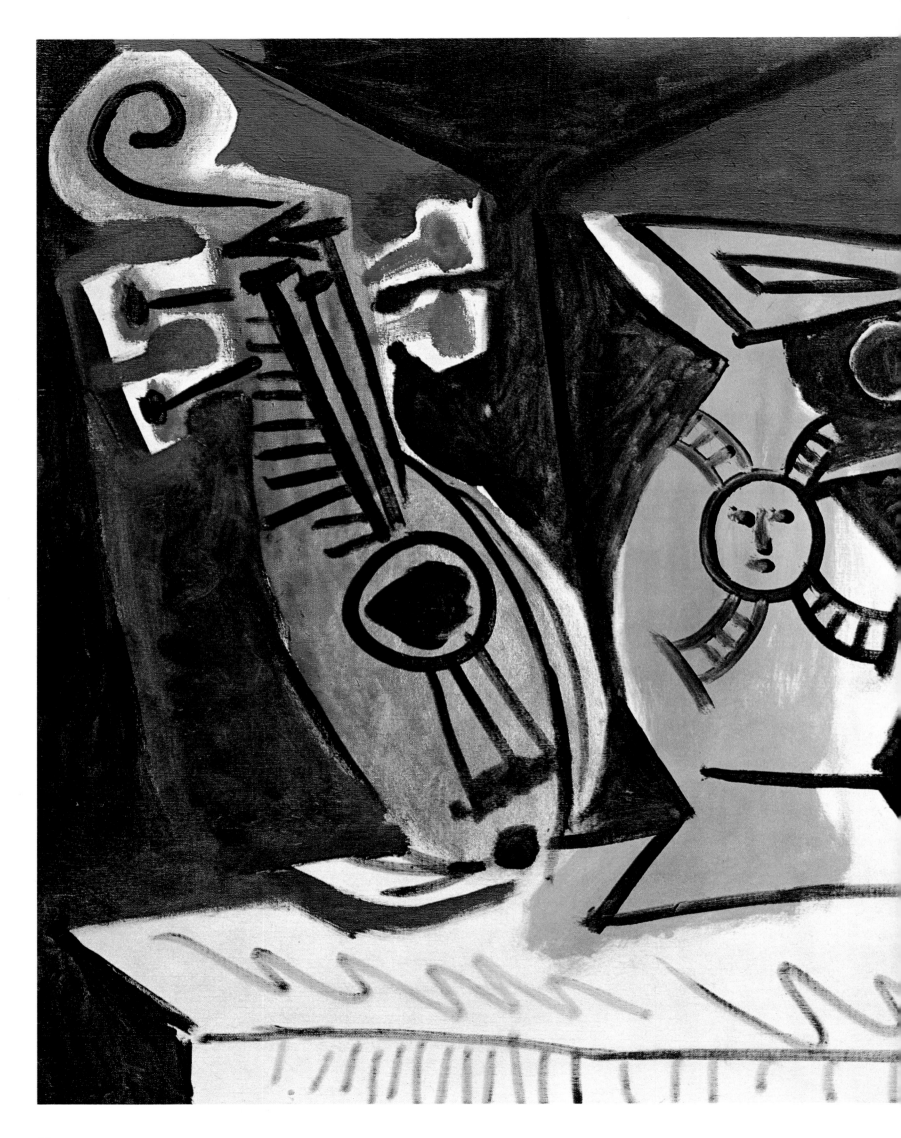

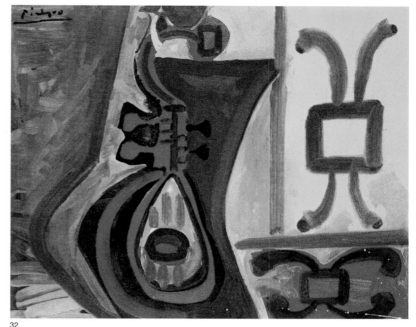

32

31

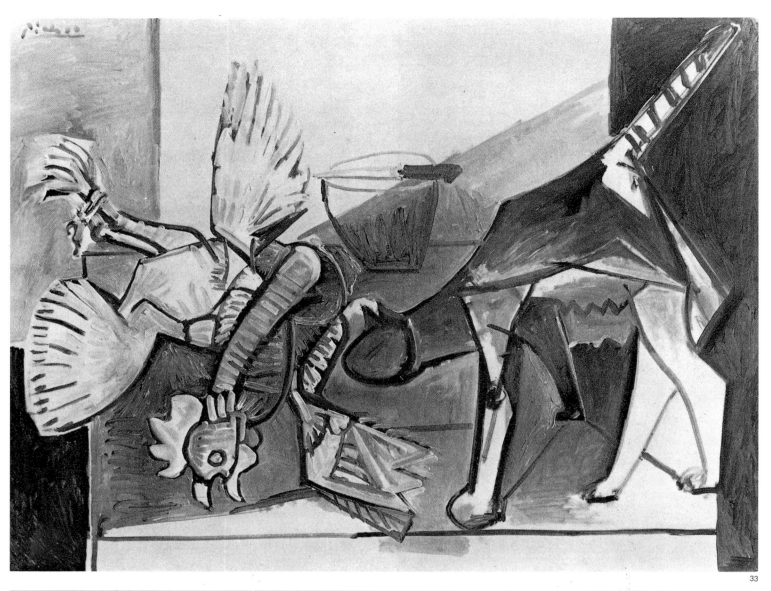

33

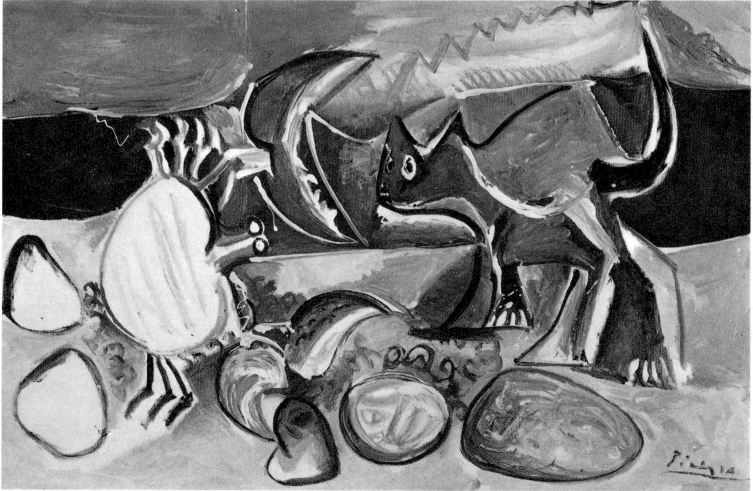

34

46

are among his most balanced and serene compositions; their subjects alone—guitars, fruit, birdcages, and palettes—suggest a musical, classical harmony.

These radiant works, lucidly organized on several levels, are in stark contrast to the gloomy still lifes painted before and during World War II. The skull—at first that of a bull or sheep, later a human one—became the leitmotif of these pictures, whose ascetic rigor and clarity symbolize a world menaced by war. Bones, sausages, leeks, together with knives and forks, stand in their drab colors against the dimness of closed

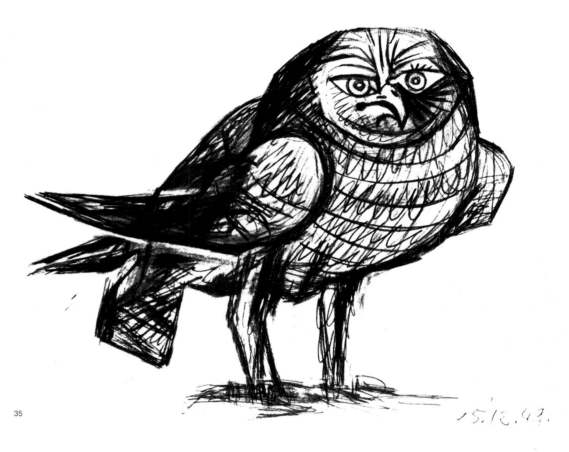

35

windows and heavily shaded lamps, symbolizing "meals" whose macabre, cannibalistic implications are obvious.

The theme of an animal skull with still life persisted until 1952; it is summarized particularly impressively in a series with the skull of a goat (Plates 29 ff.). By 1947, however, the human skull, whose shapes Picasso liked to contrast with a pitcher, had disappeared from the groups of objects, having achieved its most perfect form in a bronze of 1943. Later, especially just before the end of the war, the skull lost its horror, although in March, 1945, it reappeared in ten different versions of a still life with leeks and a pitcher. By July of that year the leek had been replaced by a bowl of red cherries, and the skull, whose black eye sockets now looked more ornamental than sinister, was framed on the other side by a potted plant. The blue pitcher too now struck a cheerful note.

The death's head yielded to a living creature: the little owl which Picasso found, hurt, in Antibes in 1946 and took care of and which, with the pigeons, shared the house with him (Plate 35). Its observant yellow eyes fascinated him, as did its archaic shape, which soon began to appear in his ceramics, lithographs, and paintings in precisely the position which the skull had occupied. The similar shape of the bird's silhouette and its big round eyes make it an appropriate successor to the skull. Picasso's changeable, often superstitious attitude to objects and animals has produced many willful metamorphoses of this sort.

Soon after the First World War a dead bird became the subject of a series of still lifes. During World War II it recurred in the form of a slaughtered cock, with a knife beside it. Its feet are tied together; the throat of this helpless victim had been cut. In a terrifying picture painted in April, 1939, a brutal predatory cat is devouring the bird.

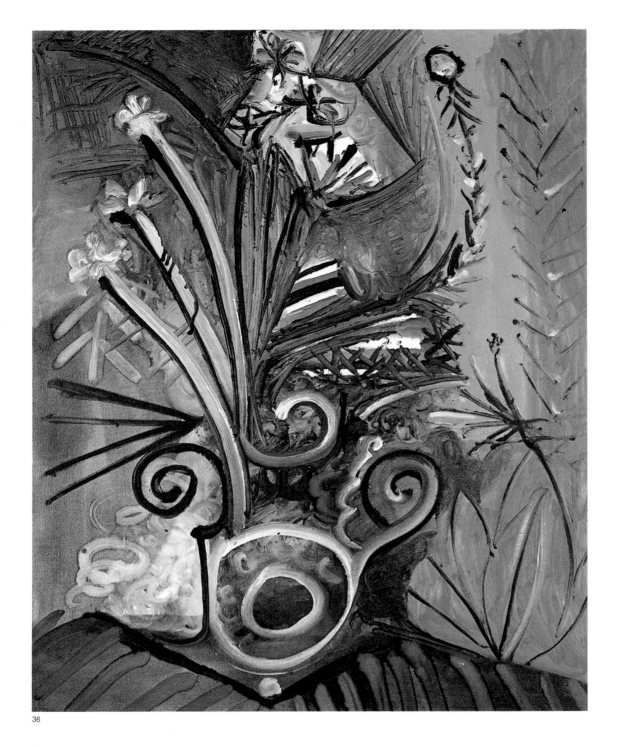

36

Still lifes with bouquets are not very common in Picasso's work. They were a small minority among the muske-teers, pipe-smokers, nudes, and harlequins who inhabited the papal chapel in Avignon in 1 9 7 0. Yet their bizarre, almost baroque gesture is much like that of the figural paintings. Stalks and little excrescences form miniature paraphrases of faces and bodies. The leafy arabesques are a visual equivalent of animalic movement.

37

38

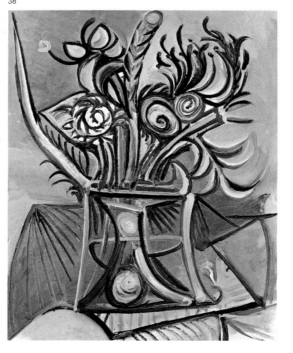

36
Still Life
Nature morte
16. 11. 1969
Oil on canvas, 56.9 × 43.5 inches

37
Still Life
7. 11. 1969 II
Oil on canvas, 56.9 × 43.5 inches

38
Bouquet
28. 10. 1969
Oil on canvas, 45.2 × 34.7 inches

39
Bouquet
27. 10. 1969
Oil on canvas, 45.2 × 34.7 inches

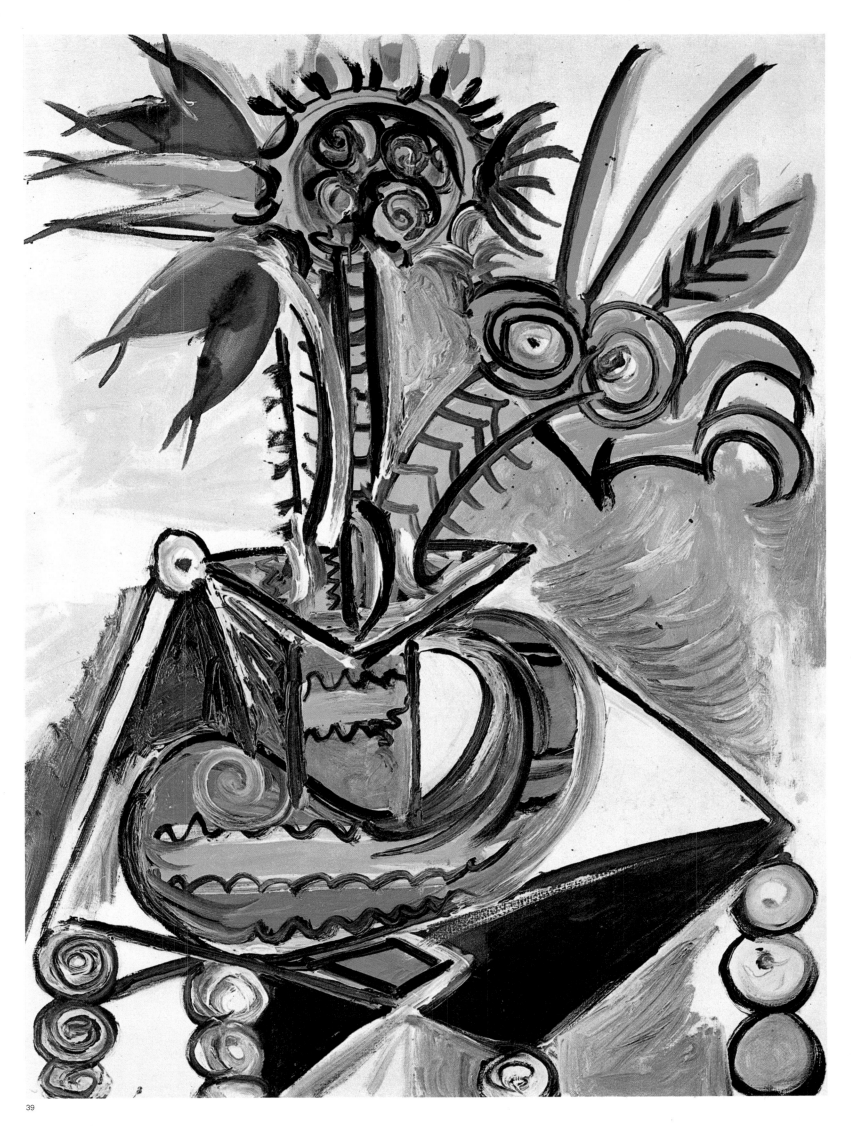

In December, 1953, in a soundless, even more terrifying version of the theme, the cat is stalking the dead cock on a table (Plate 33). The few still lifes Picasso painted after 1947 depict different objects but often retain the menacing, sometimes aggressive atmosphere introduced by the cock, owl, and cat. The animals dominate the modest inventory of the later still lifes; as soon as they appear, this genre, so easy to grasp and so closely contained within its own limits, becomes dynamic. The accent shifts from the quiet passivity of the still life to its dramatic or grotesque potential, transforming it into a lively scene.

As the key figure in this ambivalence between passivity and action Picasso chose the crab, the lobster, or the crawfish—that shelled creature which, clutched in a child's hand, in a composition of 1941 looks like an animalic, squirming bunch of flowers, or which in later pictures lies on a table with its many-limbed apparatus of pincers, claws, and feet. The crab appeared occasionally in still lifes until the mid-1960's, sometimes with fish, sometimes with the predatory cat, which is stalking it, while the crab, its claws extended, seems to be following the cat's movements just as watchfully.

The scenic dynamism of Picasso's late work carries over increasingly into his still lifes. Cat and crab now have their rendezvous in a beach landscape enlarged to the scale of a detail study. The limits of the genre dissolve. It is almost as if the still-life theme had become too abstract or—conversely—had lost its exemplary significance. Figures now play the key role in the paintings and drawings. Even a contemplative scene in the studio is rendered through combinations of figures rather than objects. As the years have passed, Picasso has turned increasingly to situations defined in human terms; he has specialized again in figure painting, repeating in reverse the pictorial evolution of the Blue and Rose periods. But the themes which he treated in a stylized, elegant, poetic, and extravagant manner and which featured inhabitants of the margins of society or circus artists he now presents in anecdotal or dramatic scenes. The "figure still lifes" which preceded the early Picasso's "pure" still lifes have superseded them again in his old age, changing both their thematic and social complexion.

This process parallels the loosening of form, the unexpected juxtaposition of symbols of stenographic clarity and curving arabesques. All changes have been determined by the action of the figures, to whom Picasso allows more and more room, intimacy, and participation. This leaves little scope for the late-Cubist type of still life with objects. Picasso's view of the exemplary human condition is an increasingly sharply focused view of himself.

Landscapes

"One should not go from painting to nature but from nature to painting. There are painters who make the sun into a yellow spot but there are others who through thought and skill make a yellow spot into a sun." (ogoniok magazine, moscow 1926)

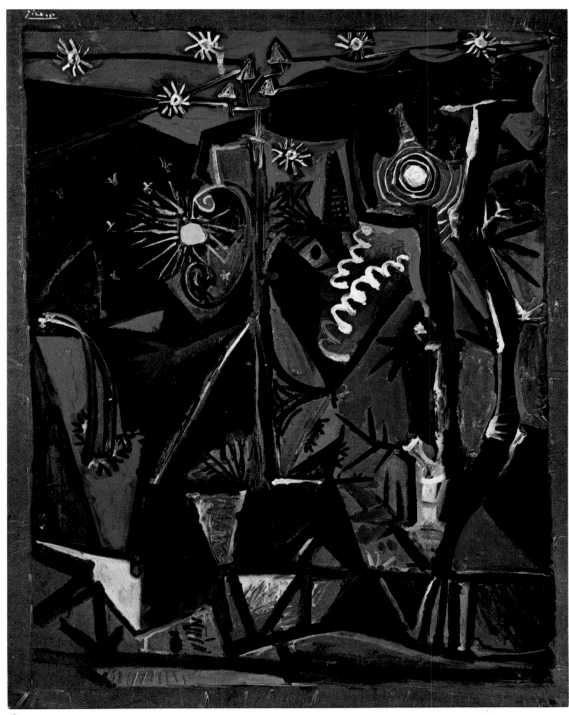

40
Nocturnal Landscape
Paysage nocturne
26.9.1951
Oil on canvas, 56.9×43.5 inches

40

When the Ecole de Paris was at the height of its prestige, the word *paysage* denoted in the French art trade a painting of a certain format whose subject might or might not be a landscape. The name had nothing to do with the theme but merely signified a standard ratio of vertical to horizontal dimension.

Picasso's œuvre includes numerous landscape-format pictures. Many of his still lifes, especially from the 1920's, fall into this category, while his paintings of landscapes are far less numerous, as well as smaller in size.

Only in his late work do small groups of landscapes begin to occur sporadically.

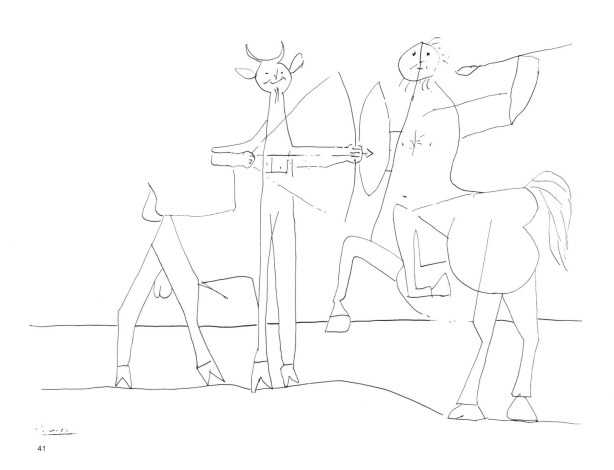

41

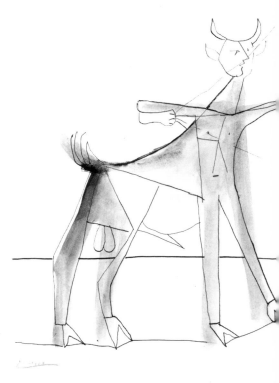

42

They comprise both single paintings and series of four to eight pictures. There are often surprisingly sudden changes of format within a single group. In general, however, the small format prevails—some of these canvases could even be called tiny by Picasso's standards. These abrupt changes are the first thing that strikes us in Picasso's treatment of landscape, setting it apart from all his other themes. They suggest, too, that in his occasional excursions into landscape painting Picasso avoids the formal, coloristic, and thematic challenges that a large format presents, probably simply because he does not "feel" them.

The "pure" landscapes Picasso has painted since World War II can almost be counted on the fingers of two hands. They are restricted to views which are familiar to him because he used to see them several times a day or had noticed them close at hand. He preferred views of this type, which he would "portray" either as a single perspective or panoramically in a whole series of paintings, because for him they had an unmistakable, individual and by no means general character. He was more interested in the specific physiognomy than in the typical qualities of landscape.

Picasso and landscape—the topic could be quickly dismissed if the comparative rarity of landscape did not in itself reveal so much about his art. The genre shows that Picasso is more interested in the pictorial problems than in rendering an impression or a mood. Here again his characteristic urge to correct himself, his need to push beyond what he has already achieved, dictates his working method. He finishes with a subject only when he has exhausted all its variational possibilities.

The small formats Picasso chooses show that he approaches this theme with reservations. Apparently, his interest in landscape is not inexhaustible. Yet some of these tiny pictures, hardly bigger than a man's hand, are among his most beautiful, while the rare large-scale landscapes never entirely conceal his reserved attitude toward "pure" nature.

When we survey Picasso's painting since World War II the landscapes look like enclaves within his tremendously rich range of themes; stylistically there is nothing particularly distinctive about their treatment. The larger ones especially are painted

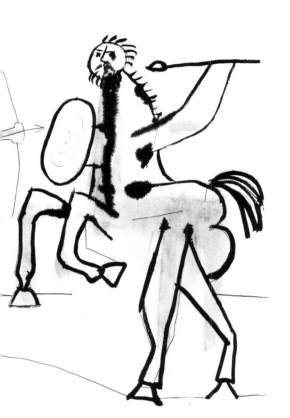

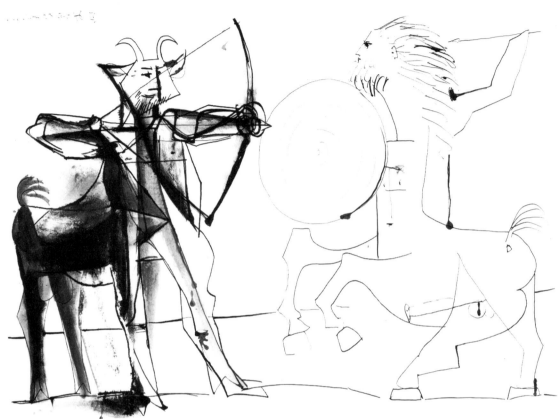

43

somewhat conventionally, as though they had lagged a few phases behind the subjects which currently absorb him. But aside from their rarity and the irregularity with which they appear, these pictures reveal more about their creator than their subject indicates at first sight.

For Picasso nature is a concrete entity, even though he rarely gives it his full attention. His needs are too "natural" for him to reflect about nature. To him it means environment, condition, and especially form. So far as his immediate surroundings are concerned, it means the warm Mediterranean region he has chosen as his home. Houses, trees, and animals are more important to him than an uninhabited stretch of land; for Picasso the latter does not exist without the former. This is a very Latin attitude.

In art the relation of Latin man to uninhabited nature has not changed essentially since classical antiquity. Every building stands out like a part of tradition against the free landscape, which itself often has an architectural quality in the Midi. Interior and exterior are sharply differentiated by the light—a light which intensifies all the plastic elements of the Mediterranean landscape. Picasso's art respects the limits that have prevailed since antiquity. His attitude to landscape is far more conventional than that of Cézanne, a southerner, or the Dutchman Van Gogh, both of whom made many paintings of the Provençal countryside.

Some of Picasso's landscapes suggest that he often merely broadened the confines of his studio. Nature is domesticized. As nonchalantly as he brought the goat, the owl,

These drawings of fighting centaurs were made in Antibes. Picasso was so carried away by this almost documentary treatment of a mythological scene that he made one delightful variation after another. Clear-cut lines and painterly patches of color dramatize the movement, which maintains a fantastic balance between heroism and burlesque.

the dog, and the pigeons into the house, he set up his sculptures in the front garden—including the over-lifesize bronze of Esmeralda the goat, a Christmas present from his family.

The garden of his villa *La Californie,* just outside Cannes, elegantly shaded with palm trees and eucalypti and animated with Picasso's sculpture, is but one example of how Picasso transforms natural space into artistic space. In 1950 the townspeople of Vallauris reached an agreement with him to set up his big *Man with the Sheep* on a commanding site in the town. Picasso also readily accepted their invitation to paint a

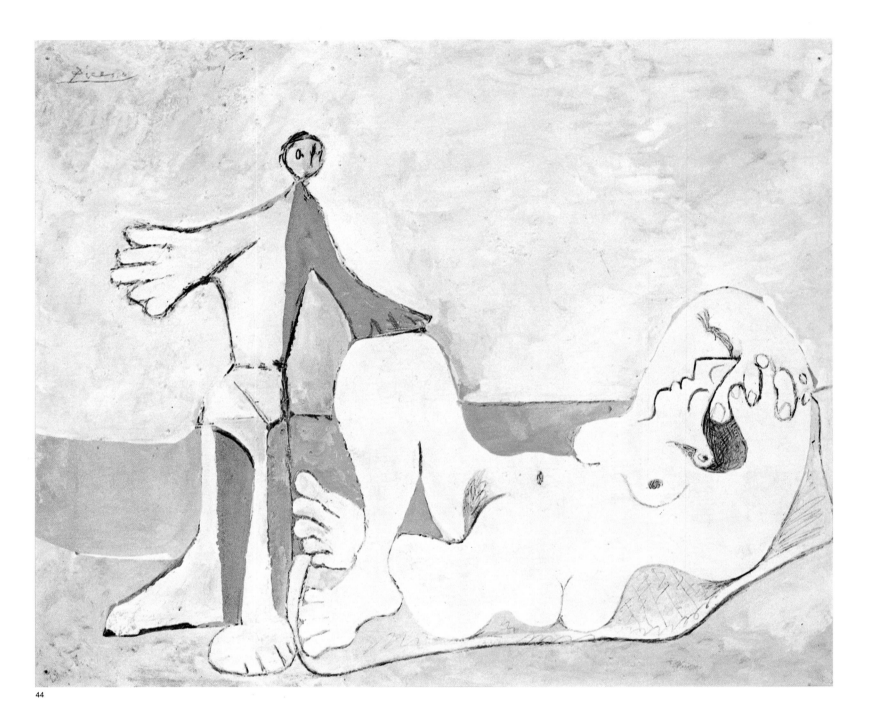

44

"war and peace" cycle for an abandoned chapel in Vallauris which since the French Revolution had housed an olive press. The months he spent on this work brought the seventy-year-old painter new experiences with a recalcitrant old architectural structure which, thanks to his paintings, was to fulfil a new function in the town. The attempt to restore this Chapel of Peace to the public domain is consistent with Picasso's political engagement.

For Picasso city and landscape are scenes of action, not emotional or inward refuges. The great Roman and Romanesque remains of Provence still assert themselves in this way—the bridges, amphitheaters, strongholds, and city gates. The bullfights and popular festivals that Picasso loves to attend in the neighboring villages

continue this unbroken tradition of the "arena." For Picasso too these are monumental spaces where nature, ceremony, and architecture fuse. To him even the vast yet finite expanse of the Mediterranean beaches suggested a stage for mythological scenes.

The *Château Grimaldi* was a prelude. Picasso's first summer in the Midi in 1946 included two stimulating components: the old stronghold and the presence of Françoise Gilot. Already the previous year he had spent some time on the Côte d'Azur, enjoying the sun at Antibes and Golfe-Juan, but had not brought a single

44
Man and Woman by the Sea
Homme et Femme au Bord de la Mer
1961
Oil on wood, 17.9×21.45 inches
Kunstverein, Winterthur

45
Nudes
Personnages nus
27.8.1967
Ink, 22×29.25 inches

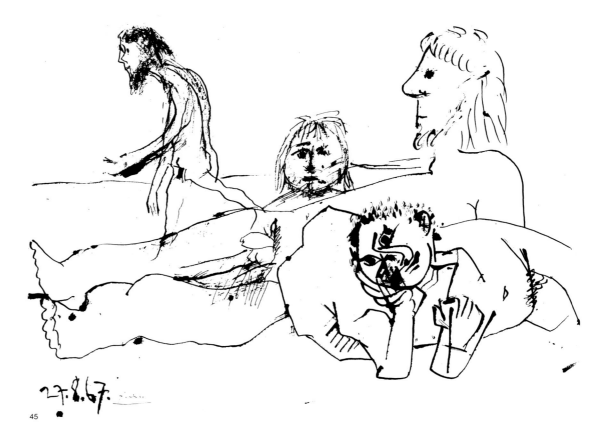

45

Picasso had always loved seashore landscape. After his return to the Midi, its theatrical character stimulated him to go back to mythological subjects and the sort of profane beach scenes he enjoyed with his family on summer mornings.

painting or drawing back with him. The acquisition of the house in Menerbes, a few miles inland, was a first symbolic gesture of laying claim to the Midi as his own, even though he immediately gave the house to Dora Maar.

Now, in July, 1946, he was "at home," temporary occupant of a Genoese palace, master of its huge ancient rooms with thick walls. Within a few weeks he had used up all the fibrocement panels he could lay hands on. *La Joie de vivre,* the summer's major painting, is the center of a carefree Arcadia which Picasso discovered in his daily contacts with the fishermen of Antibes in cafés and markets. It burst forth in a bucolic exuberance of dance and flute playing in a southern panorama of soft blues, pinks, yellows, and greens.

The bullfights, revived in the arenas of Arles and Nîmes and elsewhere in the South of France after the war, fascinated Picasso and his friends. The spectacle of the *corrida* and the entry of his compatriots excited him as much as the ritual of the bullfight itself. Once again every phase of the *corrida* was reflected in his work: the matadors and *toreros,* the bulls and horses, the spectators, the sun and shade over the arena. To Picasso the light and dust of the bullring, like the Arcadian fields of his fabulous creatures from antiquity, have mythological origins. Even before the war he had combined the legends of the Minotaur and the bullfight, with the Minotaur entering the arena and dying in the sand before the horrified eyes of the spectator. For Picasso both places—Arcadia and the arena—represent the great stage of the world. The actors, whether on stage or enjoying the spectacle, are at home on this ground, above which there may be an occasional suggestion of nature and landscape as a stage

setting, sketched in simple lines which nonetheless manage to encompass the whole universe.

Not until much later, in the early 1950's, did Picasso really put his own stamp on landscape without figures. But it still remains an exception, something at his feet or directly before his eyes which forces itself on his attention not through space, extension, and depth but through some special quality in its houses and roofs, through specific trees and mountains. His aim is never to describe landscape in general, to paint

46

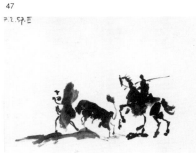

47

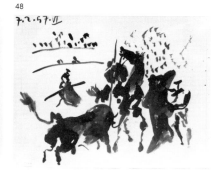

48

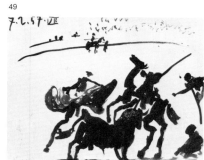

49

its portrait. He is only interested in portraying objects, their position and their movement. Only when the pigeons fly around the house or the lights shine out under the trees, when a fountain spurts or the light models the silhouette of the mountain—only then does the view condense into a picture.

Nature is admitted to Picasso's studio only in its specific and particular manifestations. He collects its grotesque inventions and creations. In its individuality it reaches into his private domain, from which he unexpectedly transposes it into the wider context of his pictures. His goat, his dog, his owl, and his pigeons are the only animals he is interested in. They have free run of his house. Sometimes his brush catches their likeness; sometimes real pigeons' footprints on a wet canvas are the only record of their presence.

46–53
Corrida
7. 2. 1957
II, III, VI, VII, VIII, IX, X, XI
Wash, all 19.9 × 25.7 inches

54

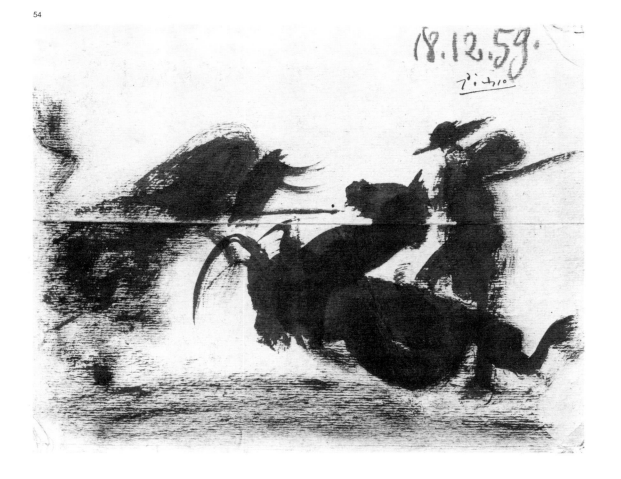

Picasso made many drawings of the corrida, *especially in the late 1950's. In fact this theme constitutes a whole chapter in his art. Although he has never treated it in a painting, the conflict between bull, rider, and horse has held a key position in his work since the 1930's. Paired concepts of cunning and innocence, terror and suffering, force and love, passion and submission, surround this multilevel mytho-*

One place which Picasso recognizes as landscape is the seashore. For years he enjoyed the beaches near Cannes and Vallauris with his family and friends. He would spend the mornings swimming and playing with a few companions or in a larger group. But as the coast became more and more crowded, Picasso felt his privacy increasingly disturbed. In his pictures he still depicts the beach as a playground for swimmers and sunbathers, but in real life he has abandoned it to the crowds of tourists (Plate 44). The subject of the big sketch he made for Clouzot's film was *La Garoupe*, for years Picasso's favorite beach, which he populates with the modern counterparts of

54
The Fallen Horse
Le Cheval renversé
18.12.1959
Wash, 10.1×12.4 inches

55
Corrida Scene
Scène de Corrida
25.2.1960 V
Wash, 7×9.4 inches

classical demigods. Even now the landscape of sea, mountains, and coast becomes worth painting only by virtue of the people who animate it and put it to use. The peaceful pastoral seclusion of *Joie de vivre* is caught in the paradisiac holiday-makers' landscape of *La Garoupe*. But even for this standardized folklore Picasso changes his style several times as he goes along, because he observes that the *beau monde* of the summer season has its own bustling ceremonial. Its demands affect the landscape, which has to be adapted to them.

A few years later Picasso himself was directly affected by these demands. Not without concern he watched the construction of new high-rise buildings outside his windows, and his move to Mougins in 1961 was in fact a retreat from the shore of the Mediterranean, from which in 1946 those pagan figures had emerged to dance on the still deserted beach.

logical, symbolic, folkloric, and literary theme. In a series of ink and wash drawings Picasso exploits a full expressive range. The shadowy patches of color contrast with the white ground, which usually represents the brilliant bullring. The blurred outlines give the sudden action free scope. The splash of black or brown ink introduces tension and the charm of the unexpected into the rather casual composition.

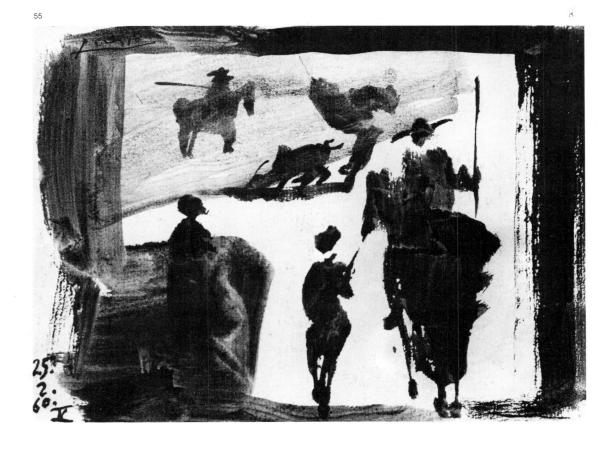

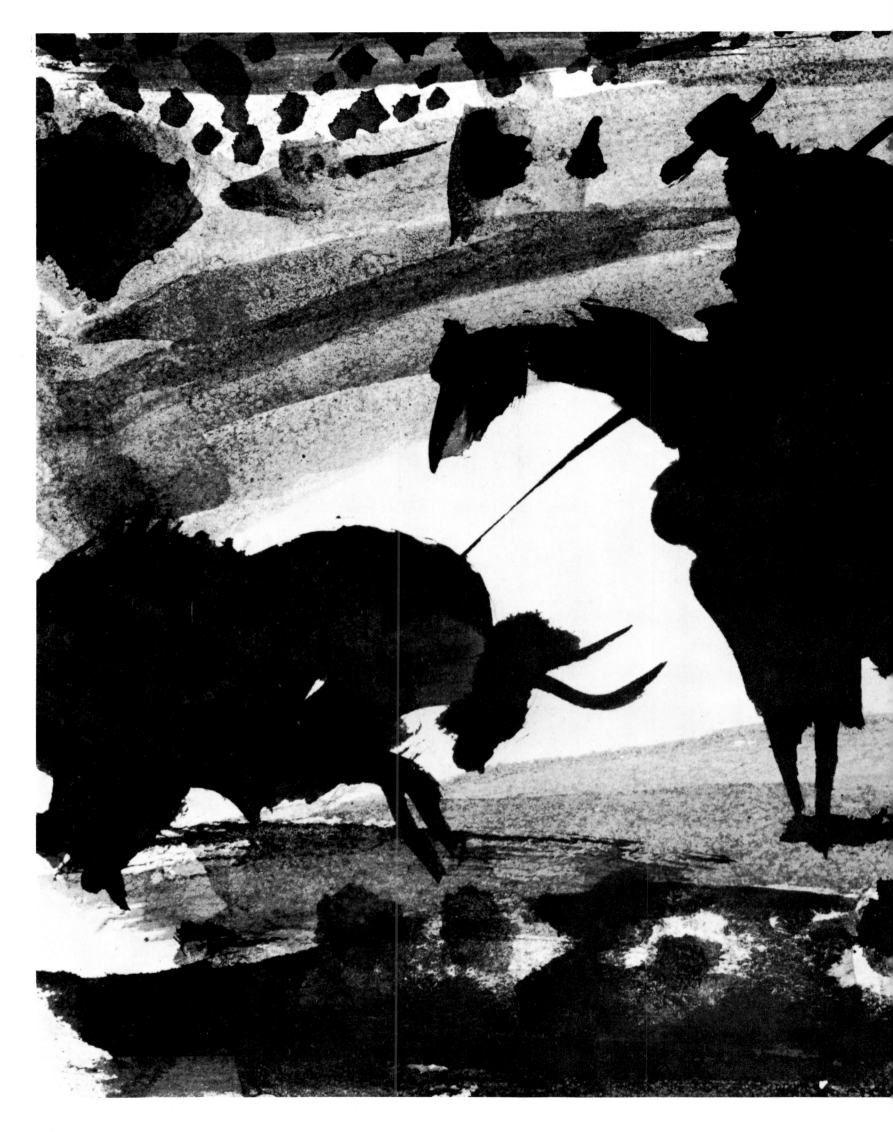

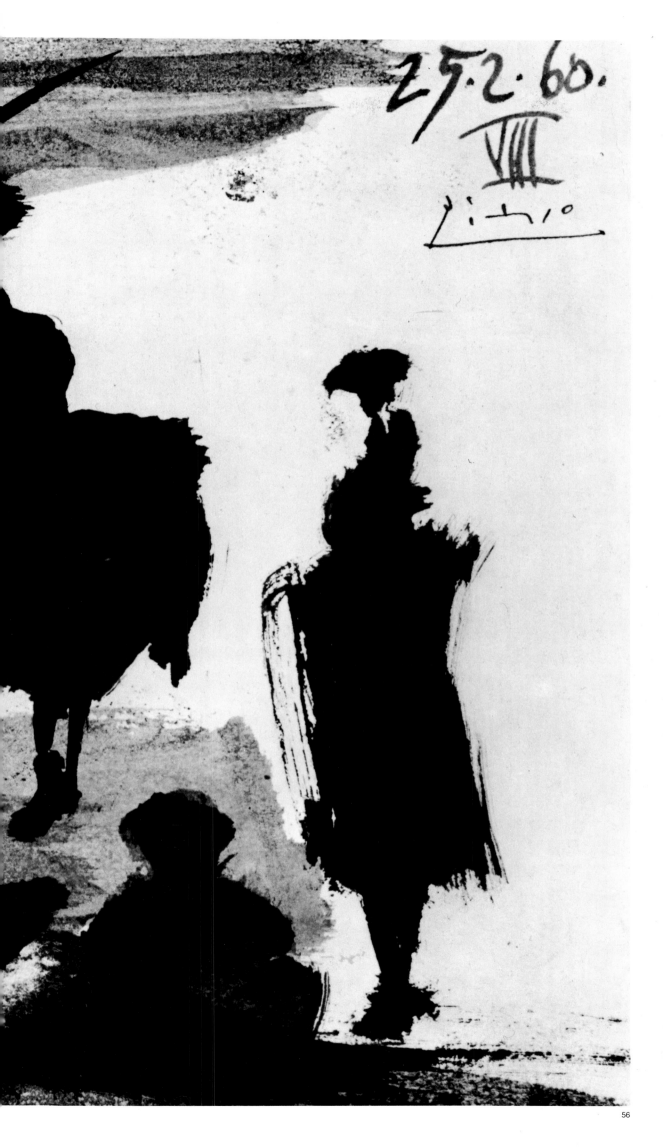

"What I would like," says Picasso, "is to do a corrida as it really is... I would like to do it as I see it... I should like to do it with everything, the whole of the arena, the whole of the crowd, the whole of the sky, the bull as it is and the bullfighter too, the whole cuadrilla, the banderilleros and the music and the man selling paper hats... You'd need a canvas as big as the arena... it's appalling not to be able to do it; it would be magnificent." (PARMELIN)

56
Corrida Scene
Scène de Corrida
25.2.1960 VIII
Wash, 7×9.4 inches
Dr. Walther Berndorff, Cologne

During the war Picasso had made a series of Paris city landscapes—views of Notre-Dame from the Seine, painted between February and April, 1945 (Plate 57). He knew the area from his daily walks, when he would turn out of the Rue des Grands-Augustins into the *quai* of the same name, usually continuing in the direction of the Pont du Carrousel. Some of these small *vedute* are framed by the arch of a bridge, behind which rises the façade of Notre-Dame. The highly profiled outlines of the drawing and the strong colors create a kaleidoscopic effect. Paris looks like a peepshow scene, perfectly preserved but lifeless. This is how the Parisians saw it during the Occupation. Picasso recorded the scene like a souvenir, its crystalline facets gleaming like a beautiful jewel; the dark, opaque colors seem to reflect his long years of anonymous captivity in the city. He has never painted another view of Paris since that spring of 1945.

Vallauris did not appear in his work until five years later, in a view of the little town with its closely clustering houses, whose white gables and dark tiled roofs make a spatial design (Plate 61). The depth of this portrait of a town is in strong contrast to the Paris *veduta,* whose planes are as two-dimensional as a stained-glass window. A compact Cubism, with cablelike telegraph wires, chimneys, and dense balls of smoke, proclaims the busy industrialism of the pottery town. This painting might have been inspired by the early Léger—except that we know that Picasso's work in ceramics, his modeling of vases and plates, led him directly to this plastic style.

Later a two-dimensional style reasserted itself, when he painted the houses against

57
View of Paris
Vue de la Cité de Paris
26.2.1945
Oil on canvas, 28.5 × 35.9 inches

58
Provençal Villa
La Villa provençale
1951
Oil on wood, 23.4 × 28.5 inches

59
View of Vallauris
Vue de Vallauris
12.1.1951
Oil on canvas, 23.4 × 28.5 inches

57

58

the Esterel chain of mountains. Delicate pinks, greens, and blues enhance the tapestrylike effect of these landscapes of the mid-1960's. Gradations of depth again give way to an open, rhythmic construction in which tree, house, and mountain interact without being incorporated in any rigid structure.

Summer themes of trees and the garden and architecture of the house alternate with views from the studio window—personal observations in painted form by the master. Usually, an even daylight pervades the intimate landscapes, but often Picasso was stimulated by a night scene illuminated by the moon and stars or by floodlights in the garden. These views presented themselves quite spontaneously as he worked in his studio late at night. In the little village of Vallauris darkness invaded the studio much more forcibly than in brightly lighted Paris. Just as electric bulbs threw their light on the objects in a still life and changed them, casting long or sharp shadows, natural and artificial lights produced alienating changes in the nocturnal landscape. Picasso was fascinated by these effects. Although for him there was something oppressive

60
Villa with Pigeons
La Villa aux Colombes
14.9.1952
Oil on canvas, 6.2 × 8.6 inches
Collection Dr. Bernhard Sprengel,
Hannover

61
Vallauris by Night
Vallauris la Nuit
7.9.1952
Oil on board, 19.9 × 25.9 inches
Private collection, Switzerland

59

60

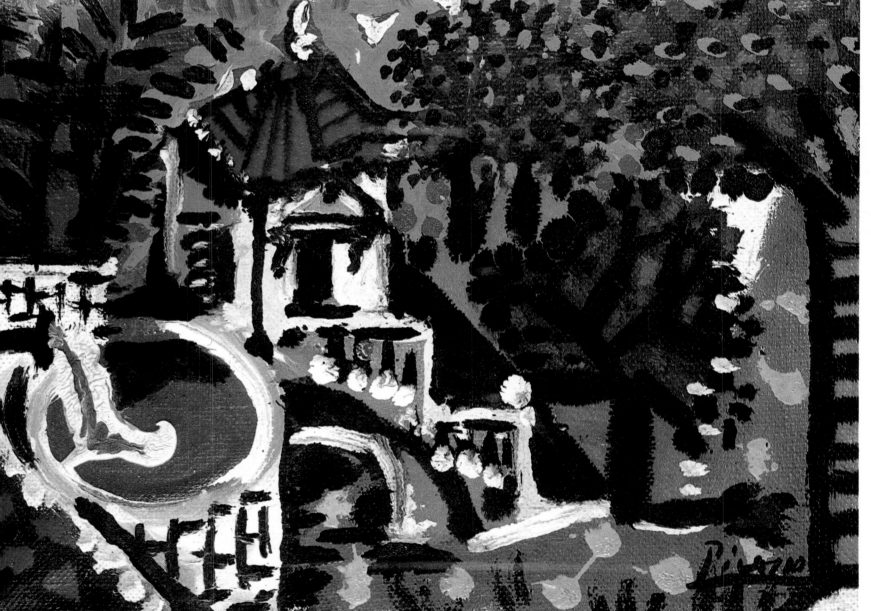

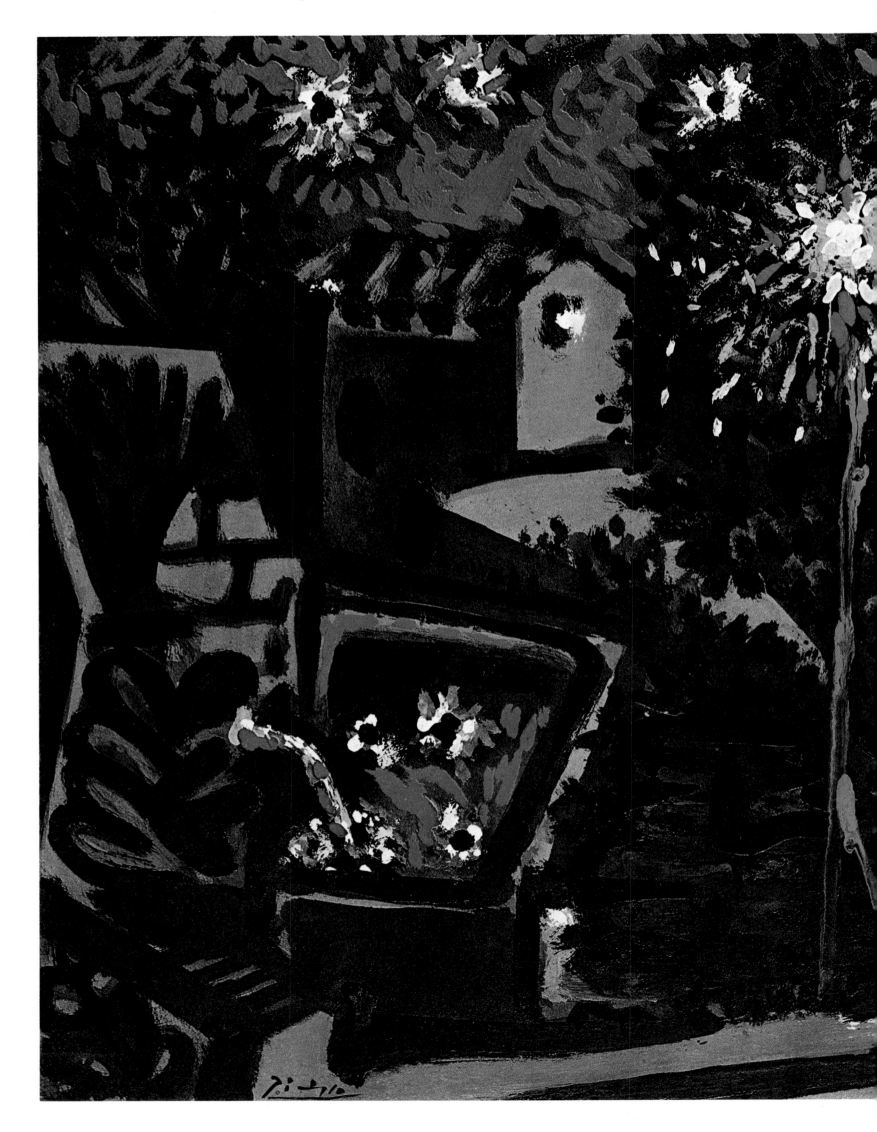

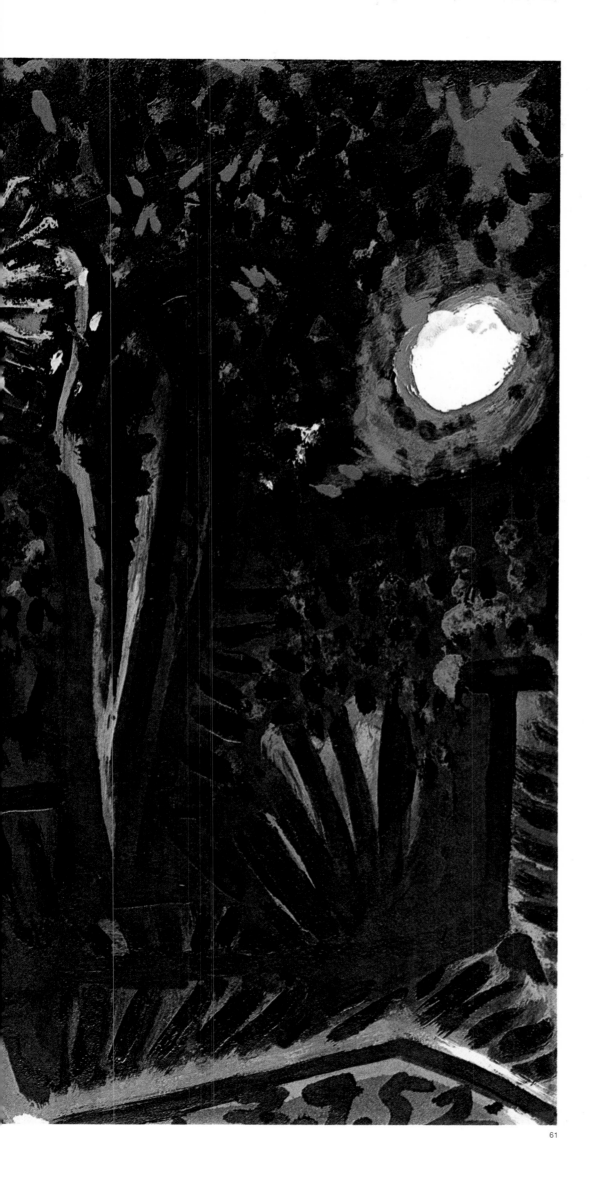

61

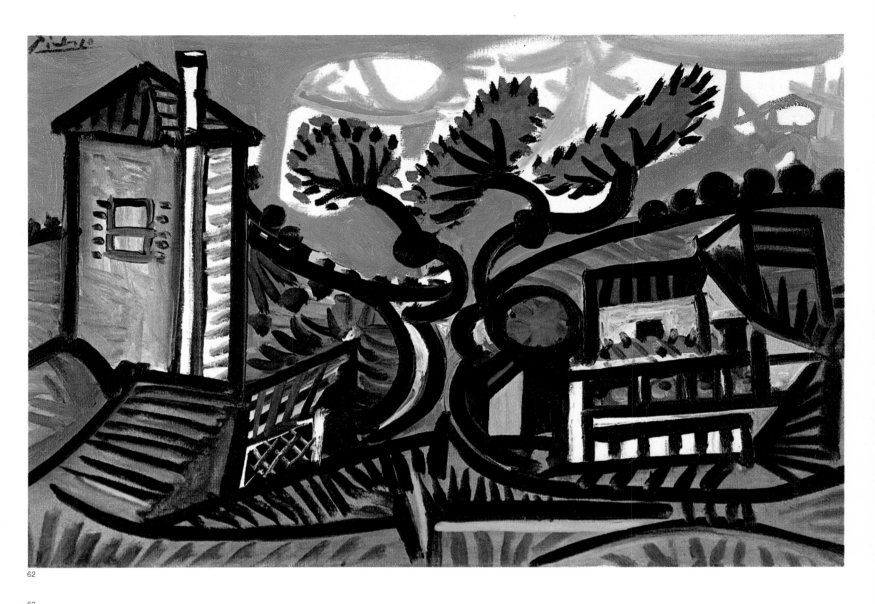

62

63

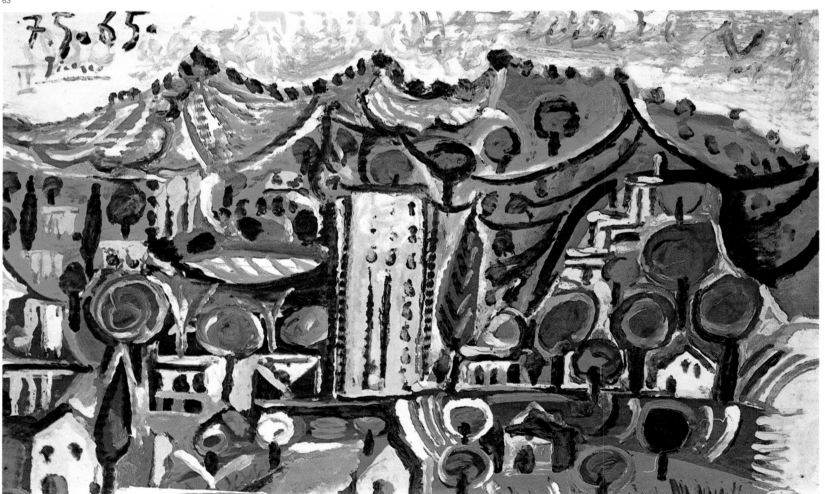

about the deep southern night following the intense light of the day, he repeatedly tackled a night scene with full moon: *Clair de Lune,* a natural spectacle to which he added electric light, so that a garden scene often presents itself in the festive brilliance of several different kinds of illumination, spraying out light like fireworks. Despite the heavy use of black, the bright reflections on water spurting from a spring, on the leaves of a tree and on the windows of the house lighten the colors and the whole aspect of the picture so much that the scene becomes more brilliant and alive than under the glaring light of day. Picasso's night landscapes have none of the

64

melancholy or somberness of the portraits and still lifes he painted just before the end of the war, which appears for the last time in the *Portrait of a Painter, after El Greco* (1950. Plate 156). This is a true "night piece"; Picasso's rendering of nature by night looks playful and luminous by comparison.

The dark, gloomy element in Picasso's pictures expresses associations which have nothing at all to do with natural spectacles. *Night Fishing at Antibes,* which has a landscape setting, is inseparably linked with night through its theme. Although the symbolic allusions to the political tensions of the summer of 1939 are not to be overlooked, the night is full of lights, natural and artificial, which seem to refute its "nocturnalness."

Picasso is "indisposed" for night, just as Rubens (unlike Bruegel) is indisposed to paint a "cold" winter picture. Somewhere there will always be a little fire or an open stable door to suggest the creaturely warmth of a secure hideaway. Picasso never concerns himself with the darkness of night. Through the private limitations he imposes and through lavish illumination he excludes greater darknesses whose concrete nocturnal quality frightens and threatens him.

The tiny picture *Villa with Pigeons* (Plate 60) belongs to the same period as the illuminated night scenes. Here, in the day, the birds seem to have taken on the function of moving light, which is reflected from their plumage as they flutter around the ornamental basin in the foreground and the pavilionlike house in the distance. Apparently it was the pigeons that attracted Picasso to the subject, because the whole composition is so loosely broken up with rapid, delicate flecks of color that we seem to see far more birds than he has actually painted (Plates 218 ff.).

The prismatically composed architecture, solidly and realistically interpreted in the later view of Vallauris rooftops, reached a free, rhythmic resolution in the *Villa with Pigeons,* which is typical of the late landscapes. Bushes and trees, receding planes of

65
The Transformer Station
Le Transformateur
10.6.1953 Oil on canvas, 8.6×10.5
inches

66
The Gardens
Les Jardins
10.6.1953 Oil on canvas, 7.4×10.5
inches

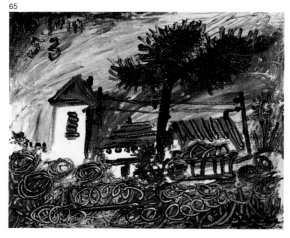

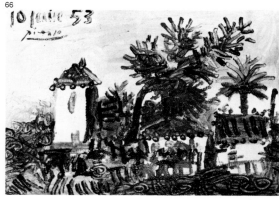

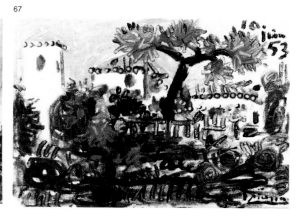

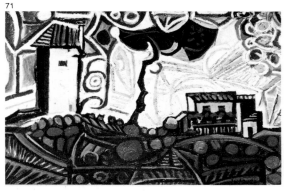

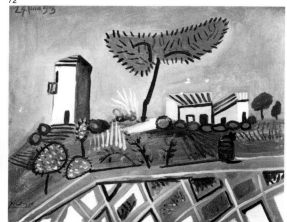

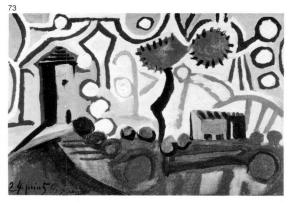

walls and terraces, brickwork and steps, reduce the big late-Cubist form and create a new pattern, both poetic and ornamental, which can even accommodate folkloric details. Intimacy is the reward of this experience with landscape.

Within a few weeks in June, 1953, Picasso painted thirteen variations on the theme of house and tree in a landscape (Plates 65 ff.). He made no preliminary or working drawings. All these small oil paintings differ in composition; at first they are loose and sketchy; their primary aim is to describe the topography. In the fourth of the series the landscape is already acquiring tension. Then, using great black lines, Picasso picked out the outlines in these almost impressionist studies and sketches, sketching in the structural skeleton of all the phenomena they encompass and instantly creating a unified vision where formerly a splendid chaos of profuse vegetation had concealed the spatial pattern. Composition gains the upper hand of subject matter, and soon after he found the clearest possible formulation in a late-Cubist style, ornamental tendencies began to take over. The logic of this free experimentation with elements abstracted from natural forms is akin to that of Paul Klee. Picasso too has plainly exposed the organic components of the little landscape.

But he had not yet reached his goal. Even this metamorphosis was only a transitional stage. In the next phase he suddenly departed from a composition which

67
Pine and Palm
Pin et Palmier
10.6.1953 Oil on canvas, 7.4×10.5
inches

68
Landscape at Vallauris
Paysage à Vallauris
14.6.1953 Oil on canvas, 8.6×12.9
inches

69
Landscape with Pine
Paysage au Pin
15.6.1953 Oil on canvas,
19.5×25.35 inches

70
Gardens at Vallauris
Jardins à Vallauris
15.6.1953 Oil on canvas, 10.5×16
inches

71
The Clear Sky
Le Ciel clair
16.6.1953 Oil on canvas, 10.5×16
inches

72
The Balustrade
La Balustrade
24.6.1953 Oil on canvas, 19.5×23.8
inches

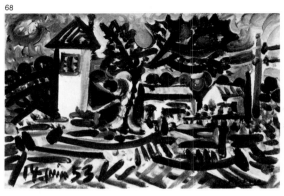

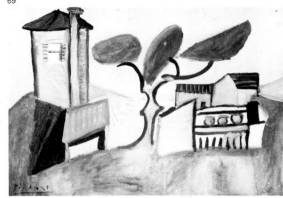

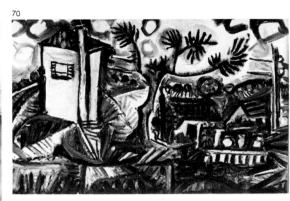

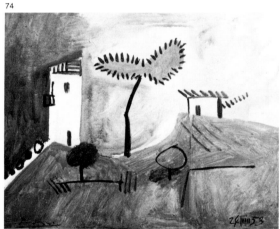

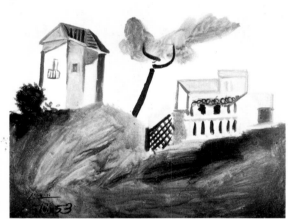

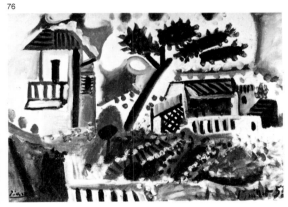

73
The Great Sky
Le Grand Ciel
24.6.1953 Oil on canvas.
10.5×13.65 inches

74
The Hill
La Colline
24.6.1953 Oil on canvas, 19.5×23.8
inches

75
Houses at Vallauris
Maisons à Vallauris
25.6.1953 Oil on canvas, 19.5×23.8
inches

76
Houses and Pine
Les Maisons et le Pin
1.7.1953 Oil on canvas, 12.9×17.9
inches

encompasses all details. The major components—the hill with the tree and the houses to left and right—are now presented in an almost primitive style. This "reduced" landscape demands the elimination of all the details which were hitherto organically incorporated in it. In one version Picasso achieved this by means of a balustrade and parapet whose strong structure fills the foreground. In the last version the balustrade appears outside the only window of the transformer station, which in earlier pictures sometimes had a windowsill but never a balcony.

This free assignment of new roles to the physical objects in his paintings was for Picasso a means of "calculated improvisation." Even the titles of this series express the continuous change and movement of its basic theme. Although Picasso did not compose the titles, which are purely descriptive, they do characterize the specific aspect, the fresh viewpoint of each particular version. In what began as a *Vallauris Landscape* (Plate 65) a local transformer station became the focal center and is therefore mentioned in the title. It was succeeded in turn by the hill, the sky, and the pine tree. In the later variations Picasso used a bigger canvas, and this freed him from the small format and from the limitations of working in series. This change shows how uninterested he is in producing a series as such, and how persistently he exploits everything a subject has to offer to his inventiveness.

Taking one version (Plate 62) of the houses at the foot of the hill as an example, let us reexamine the phenomenon of landscape. In front of the two hills with the tree springing up between them stands the low group of houses and the isolated transformer station. Although there is no literal idyllicism, no herd, animal, or human being, the scene is imbued with strong figural associations. To the left stands the station, erect and solemn, its window and chimney creating a feeling of individuality. The three arms of the pine tree reach skyward in a dancing movement, spreading their twigs like fans, in strong contrast to the austere self-containment of the house. The almost audible house-tree dialogue, accented by the motionless cluster of farm buildings, might be compared to the *saltimbanques,* fauns and girls playing or making music that have always been among Picasso's favorite themes.

As Picasso's painting evolves, landscape is closely associated with new formulations. His next encounter with it is in pictures by Courbet and Manet which inspire paraphrases; it also becomes the setting for the great dialogue between painter and model. At this point it ceases to be a separate category in the sense of an exterior domain as opposed to the interior one of the studio with its inhabitants and objects.

Although Picasso's subsequent houses—*La Californie* in Cannes, *Château Vauvenargues* near Aix, and *Notre-Dame-de-Vie* in Mougins—offered vaster, more diversified views than *La Galloise* in Vallauris, he made little use of them in his painting. The view from his studio at *La Californie* seems to have been his favorite. The coast and the expanse of sea stretching to the Iles de Lerins appear in several pictures, no longer as landscape but as a picture within a picture. The window of the villa, a nesting and perching place for his countless pigeons, provides a firm architectonic frame. Clearly the painter's home base was now indoors, even when he set up a studio in the dining room two floors below and painted the view of the garden by night against the big French windows. But far more fantastic and vigorous than these views of the surroundings of the house are the endlessly varied studio scenes he painted that same year (Plates 134 ff.). Picasso himself named these *paysages d'intérieur.*

The Portrait

"Nature never produces the same thing twice. Hence my stress on seeking the rapports de grand écart: *a small head on a large body; a large head on a small body."*

(GILOT)

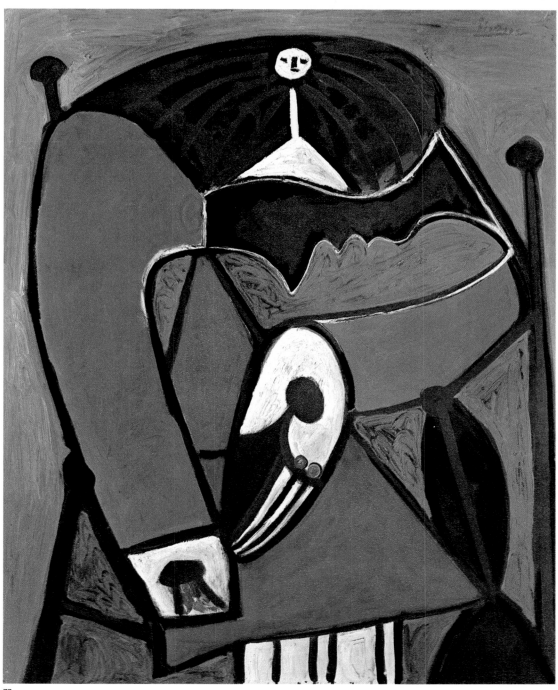

77
Seated Woman
Femme assise
1948
Oil on canvas, 39× 31.6 inches
Galerie Beyeler, Basle

77

In a conversation with his friend Daniel-Henry Kahnweiler on November 9, 1944, Picasso said that there was no formal difference between his still lifes and his figural compositions. He complained that "people notice the crooked noses of human figures, but nothing shocks them in a bridge." And indeed even today few people can believe that Picasso always "portrays" a face, a nude, a still life, or even a landscape exactly as it presents itself to him or as he confronts it. His pictures, whatever their subject, always express his affinity for an individual form. The manner in which it presents itself

78

79

80

81

has a direct influence on Picasso's treatment of it—just as his own presence may affect and alter what he is confronting.

These relations, both visible and invisible, between the artist and his subject, often determine the nature of his portrayal. One thing is beyond dispute: Picasso has always been an exact portraitist, and his most "distorted" portraits are still astonishingly "like." The portraits of Kahnweiler, Ambroise Vollard, and Jaime Sabartés painted in many different periods and circumstances also reveal something else: how many transformations they can sustain. Perhaps the portraits of Sabartés underwent the most—which is hardly surprising in view of his lifetime closeness to Picasso as friend and private secretary. The Cubist portraits of Vollard and Kahnweiler are no less genuine portraits than the ones Picasso painted twenty or forty years later for being at the same time statements of his Cubist style. It can be said of Picasso's portraits that the use of a wide variety of technical and formal media and devices is a sign that the subject is important to him. The independence which form has attained in the twentieth century (to which Picasso made a major contribution) has developed its own way of indicating the importance of a portrait.

As we have said, Picasso often decides whether a portrait is to be a "likeness" or not while he is actually at work on it. The degree of "realism" depends on whether he is working out of his head or (as more rarely happens) has somebody sitting for him—his housekeeper Inès, for instance. This makes it difficult to draw the line between portrait and figure painting. Yet this very ambivalence furnishes new insights into what we might call the manifold geological layers and faults in which Picasso's phenomenal memory presents itself.

The rapid strokes of some sketches catch a typical, sometimes momentary expression. Picasso has a precise gift for mimicry which approaches caricature, though it is generally restricted to drawings and always to male models. One minute a mood or some chance circumstance prompts him to exaggerate, while the next may find him carefully outlining a profile with a delicacy of line that makes it universal and sublime.

78—82
Portrait of Balzac
25.11.1952
I, IV, V, VII, VIII
Lithographs, all 8.6×6.2 inches

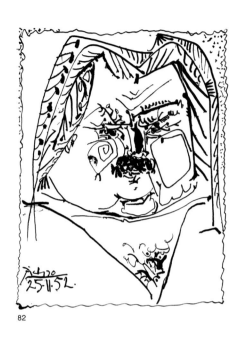

82

In 1952 Picasso made twelve lithographs of Balzac's power-ful head, often completing several in one day (though they were later published separately). Balzac was no stranger to him. In 1927 Ambroise Vollard had commissioned thirteen etchings for his edition of Balzac's Chef-d'œuvre inconnu. Years later, when Picasso was showing Françoise Gilot his etchings, he said of the Vollard suite: "You see this truculent char-acter here, with the curly hair and mustache? That's Rem-brandt... Or maybe it's Balzac; I'm not sure. It's a compromise, I suppose. It doesn't really matter. They're only two of the people who haunt me. Every human being is a whole colony, you know."

See Plates 144–147.

His close friends, acquaintances, and admirers are used to being suddenly presented with their own likeness in a sketch, a hastily made drawing, or sometimes as a dedication or memoir in a book. Not all of these are flattering. Picasso's love of pranks, clowning, and dressing up, and a certain mischievous spitefulness all have a hand in them. Yet his playfulness never leads him to introduce these grotesque elements in portraits of female models. The defiantly humorous drawings of the head of his lifelong friend and secretary Sabartés, the thirty-four portraits of the poet Jacques Prévert sketched from memory, or the likeness on a ceramic plate of the potter Jean Ramie, who for years helped Picasso in his experiments with clay, all catch the precise situation, moment, and expression that mobilized Picasso's hand.

In a series of lithographs even the colossal head of Balzac, inspired by Rodin's statue, is given the features of a visitor to the Vallauris studio. Besides being a brilliant statement of Picasso's imaginative vision of the patriarchal novelist, this synthesis of anecdote and monumentality also represents the interpretation of a nineteenth-century genius by the twentieth-century painter. Picasso himself enjoyed trying his hand at writing occasionally and in his drawings often turned to literary themes and illustrated books by all kinds of authors. He had already established a relationship with Balzac back in the early 1930's, in the etchings for the Chef-d'œuvre inconnu, which Vollard later published. How close he stays to his literary models, how much he appropriates from what he reads, are irrelevant questions. His method of approach, even to the figure of Balzac, is a spontaneous, intuitive one, not a complex, critical process of assimilation.

Picasso's changeable attitude to the portrait in the light of his attitude to his own face is a topic which would bear thorough examination. No other artist—in fact few other people in any field—are confronted with their own photograph so often and in such diverse forms as Picasso. A painter who is particularly sensitive to optical phenomena could hardly be expected to react with indifference to this flood of "images." Picasso's reaction and defense mechanism might well confuse a close observer. Publicity, however intensive, has never exhausted him. He gives it an ironic twist by surprising his public, photographers, or visitors with a bit of nonsense, a pantomime or a masquerade. He pulls faces, sets up jokes, is not ashamed to make a bombastic entrance, thus immediately warding off any attempts to heroicize him. His own physical capacity for change is as immense as that of his art. He is as painfully aware of his fears and profound skepticism about old age as of the wholesale broadcasting of his private life. This is probably one reason why for many years he has shown himself only behind a mask.

Because of these experiences, the portrait does not occupy the secure, not to say favored, place in Picasso's œuvre that it enjoys with other artists. The most striking proof of this is the absence of its most demonstrative form: the self-portrait. Only as a young beginner did Picasso draw and paint himself—not very frequently but so significantly that it comes as a shock to realize that his last authentic self-portrait dates back to 1907, when he had been painting for ten years and was on the way to Cubism. The major work of this new style, Les Demoiselles d'Avignon, was painted in the same year. The famous portraits of 1910 do not include any of himself. Whenever the portrait comes directly, sometimes ostentatiously, to the fore—after the First World War and again toward the end of the Second—it always leads us to people who share his life or with whom he has recently come in contact.

Picasso asks no more than to appear from time to time as a film star, to pose for photographers as the master of Château Vauvenargues or a hero of the bullring, dressed in the splendid costume of the torero. He takes an infinite delight in dressing up. Many people who have known him for years are convinced that his talent for mimicry, his flexibility, and articulateness would have made him a superb actor. From the first, circus artists, clowns, and actors were part of his immediate surroundings in

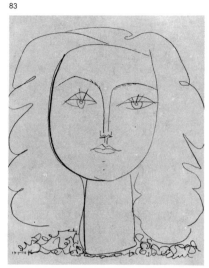
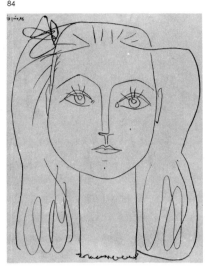
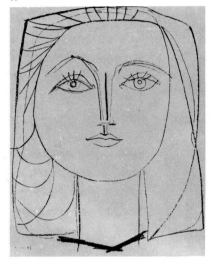
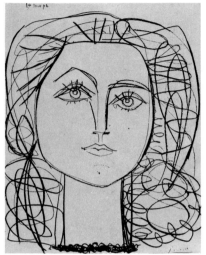

Montmartre. They are the obvious models for the young Picasso, not only because this had been a stock subject ever since Toulouse-Lautrec but also because some of them were personal friends to whom he had been drawn by the similarity of their social situation and his instinctive interest in mime and the performing arts.

Soon the painter turned to a new discovery: the great archaic female figures of his neoclassical period. He continued to work for the theater and for Diaghilev's ballet, but the actors disappeared from his pictures, not to return until the graphic work of the 1950's. His interest in the portrait waned too, while the subjects of "sculptor and model" and "the painter's studio" came to the fore. During the 1920's, for no apparent reason but clearly through some connection, the theme of *saltimbanques* and harlequins gradually broadened into the wider one of artist and model.

Not until the late work (especially the graphics) did Picasso develop the detachment and iconographical techniques that enable him to combine the two themes: the studio and a group of actors. Many pictures now show the actors watching the painter at work in a sort of reversal of roles. Picasso paints the painter as he used to paint the harlequin, not in the same mood or setting but with the same passion—a passion he now communicates to the pictured artist engaged in painting the still model before him. The innumerable versions Picasso made of the artist painting from life gave him adequate scope to present his own equally innumerable and diverse arguments and experiences. The painter is always Picasso himself; the nude model is there only for him. Just as the painter bears no physical resemblance to Picasso, Picasso no longer needs the model. It has come to signify much more than just the subject—the nude; it stands for painting as an art. The authentic self-portrait, which in Picasso's youth could still enter into a camaraderie with circus artists in melancholy yet conscious naïveté, has now been absorbed in this larger context, which influences all of Picasso's late work.

Every year Picasso spends in Vallauris, Cannes, Vauvenargues, and Mougins broadens the range of objects, animals, and domains "portrayed" in his paintings. A forcefully articulated old Baroque cupboard at *Château Vauvenargues* has the same

83
The Lace Collar
Le Col de Dentelle
14.6.1946
Lithograph, 23.4 × 19.1 inches

84
The Bow in the Hair
Le Nœud dans les Cheveux
14.6.1946
Lithograph, 24.6 × 18.3 inches

85
The Hairnet
La Résille
14.6.1946
Lithograph, 24.6 × 18.3 inches

86
Woman with Long Hair
Femme aux Longs Cheveux
14.6.1946
Lithograph, 24.6 × 18.3 inches

87
Woman with Large Curls
Femme aux Grosses Boucles
14.6.1946
Lithograph, 24.6 × 19.1 inches

88
Woman with Smooth Hair
Femme aux Cheveux lisses
14.6.1946
Lithograph, 24.6 × 18.7 inches

89
Woman with Curled Hair
Femme aux Cheveux bouclés
14.6.1946
Lithograph, 23.8 × 17.9 inches

90
Large Woman's Head
Grande Tête de Femme
14.6.1946
Lithograph, 24.6 × 18.7 inches

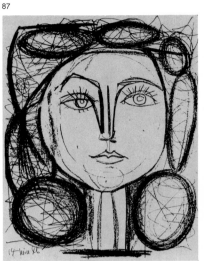 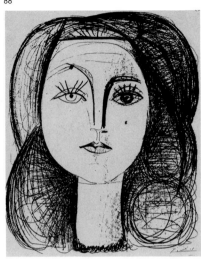 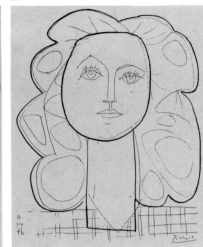 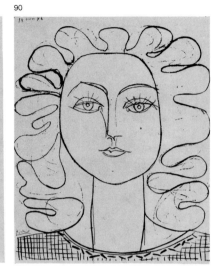

In one day, June 14, 1946, Picasso made eight of the series of nine lithographs of Françoise's beautiful head. The big sheets show the oval face and the shining eyes depicted in clear, brilliant strokes which change the woman's face into an oval moon- and plant-form, until finally, on the last print, made on June 15, Françoise appears as the sun, the source of light.

Head with a Halo
La Tête aux Rayons 15.6.1946
Lithograph, 20.7 × 17.5 inches

power to inspire paintings and drawings as *Le Buffet du Catalan,* the sideboard in the restaurant near his Paris apartment where he regularly used to eat. The owl, which first appeared in his postwar still lifes and a little later figured independently as a model in some of the lithographs, was quickly followed by the pigeons and then by sundry other inhabitants of the house: the goat and the dogs, who even in Picasso's pictures enjoy the run of the house. But while the dogs always accompany some larger motif or human figure, or are only ornamental, the goat was immortalized in bronze: Her lifesize monument was to be seen, along with its living model, in the garden of *La Californie.*

The place allotted to a living creature in a picture is determined not by its physiognomy but by its physical vibrations. Picasso's children, his son Claude and his daughter Paloma, established their own right to a place in his pictures. He painted them at play or sitting in their little chairs. Sometimes Françoise is there too, drawing or reading. Jacqueline's place in many of his pictures will be her favorite rocking chair. Even Picasso's unsuspecting gardener ends up on canvas, with his wife and daughter, caught while Picasso is talking to him one day in the studio. If it were not for the evidence of eyewitnesses, the key to these pictures would soon be lost beyond recall. The portrait of a visitor to the studio soon vanishes from memory, especially when the only things Picasso leaves unchanged are fragments like a bow in his daughter's hair which caught his fancy.

Picasso's young family, through its constant presence, demanded much of the painter's time and attention. Picasso devoted himself to his children, and the family portraits, the pictures of Claude, Paloma and Françoise, reflect the tremendous energies typical of the household. They inspired him and at the same time forced him to explore his relationship to his personal environment. The mother and child theme, which he had treated in a universal, almost mythical vein even after the birth of his eldest son Paolo in 1921, now reflected only his private sphere of life. In his works striking details predominated over the typical element; calligraphy and color asserted themselves more strongly.

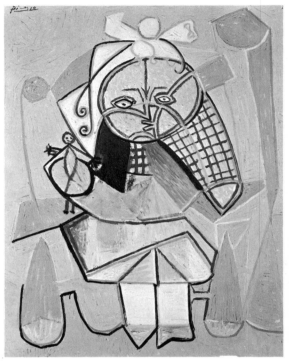

91

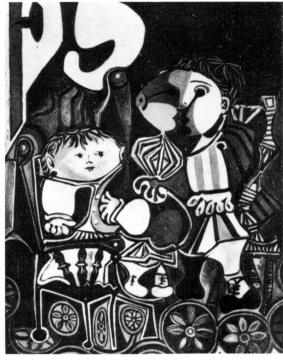

92

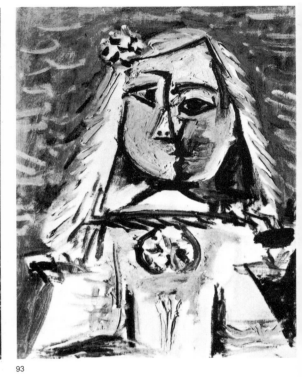

93

In the year of Claude's birth, 1947, Picasso painted several pictures of his concierge's daughter (Plate 91). These anticipate the furious vigor of his drawings and paintings of Claude and Paloma. A yellow chair stands behind the child like a halo. Her head is as smooth and round as that of a plastic doll. The portrait, presented in rigorous front view, suggests the stiffness of a mannequin or a toy, like the one the child holds in her hand. In an ironical reversal of roles, the doll seems more alive than the little girl; it is the toy, not the child, that Picasso portrayed as naïve and childish. Later he took every opportunity of watching his own children at play. He made toys for them out of wood and paper. Paloma's dolls had her own facial features, making it easy for Picasso to shift from one level of reality to another, as children do in their play.

His attitude to children is very much like his attitude to animals. His point of departure in the children's late portraits is the childish vitality of the motor activity through which they express themselves. Like the animals in his art, these are independent living beings. Nonetheless all the portraits of Claude and Paloma record a concrete situation, the children's age and temperament and their fraternal relationship. In the double portraits Claude's big head is painted firmly and clearly, while Paloma's face still looks delicate and soft (Plate 92). Soon the little girl's features become more pronounced and the nursery loses its generalized character. Like some barbaric goddess, Paloma holds the tiny doll with her own face which her father had made for her.

In the course of three generations Picasso's portraits of children have changed just as radically as his paintings of other subjects. The elegiac, frail look of the circus children of the Blue period has disappeared, along with the classicistically bourgeois tone of the portrait of his older son Paolo with his donkey (1923) and the serenity of

91
Little Girl with a Doll
La Fillette à la Poupée
1947
Oil on canvas, 35.9×28.1 inches
Perls Galleries, New York

92
Claude and Paloma
20.1.1950
Oil and Ripolin on plywood, 45.2×34.7 inches

93
Las Meninas, the Infanta Margarita
Les Ménines, l'Infante Margarita
4.9.1957
Oil on canvas, 13.65×10.5 inches
Picasso Museum, Barcelona

94
Las Meninas, the Infanta Margarita
Les Ménines, l'Infante Margarita
6.9.1957
Oil on canvas, 17.9×14.8 inches
Picasso Museum, Barcelona

95
Portrait of Madame H.P.
1952
Oil on plywood, 58.5×39 inches
Edouard Pignon, Paris

96
Portrait of Madame H.P.
1952
Oil on plywood, 57.3×44.85 inches
Marlborough Gallery, London

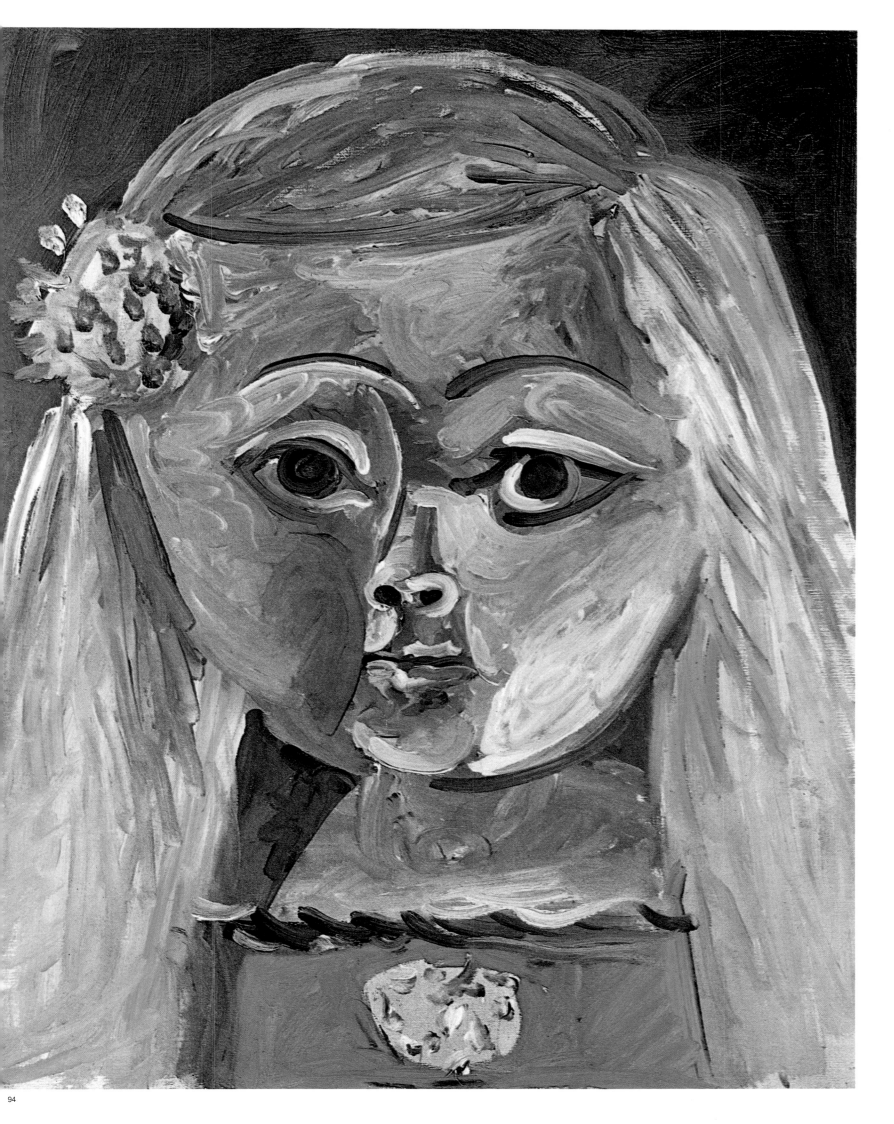

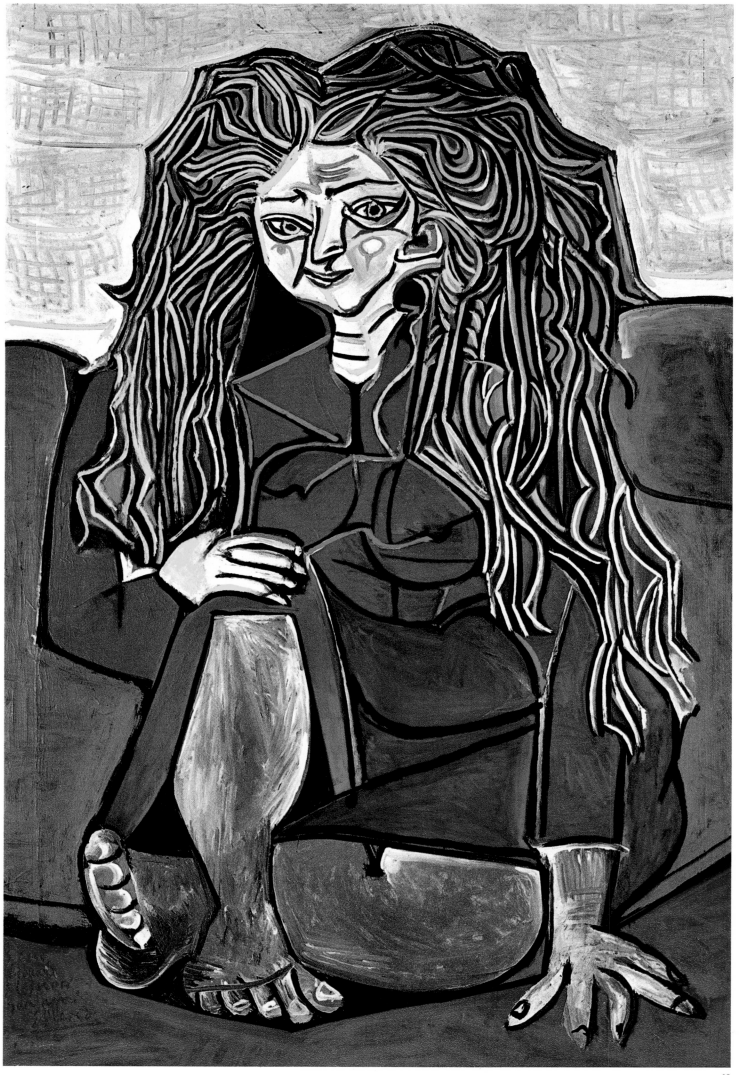

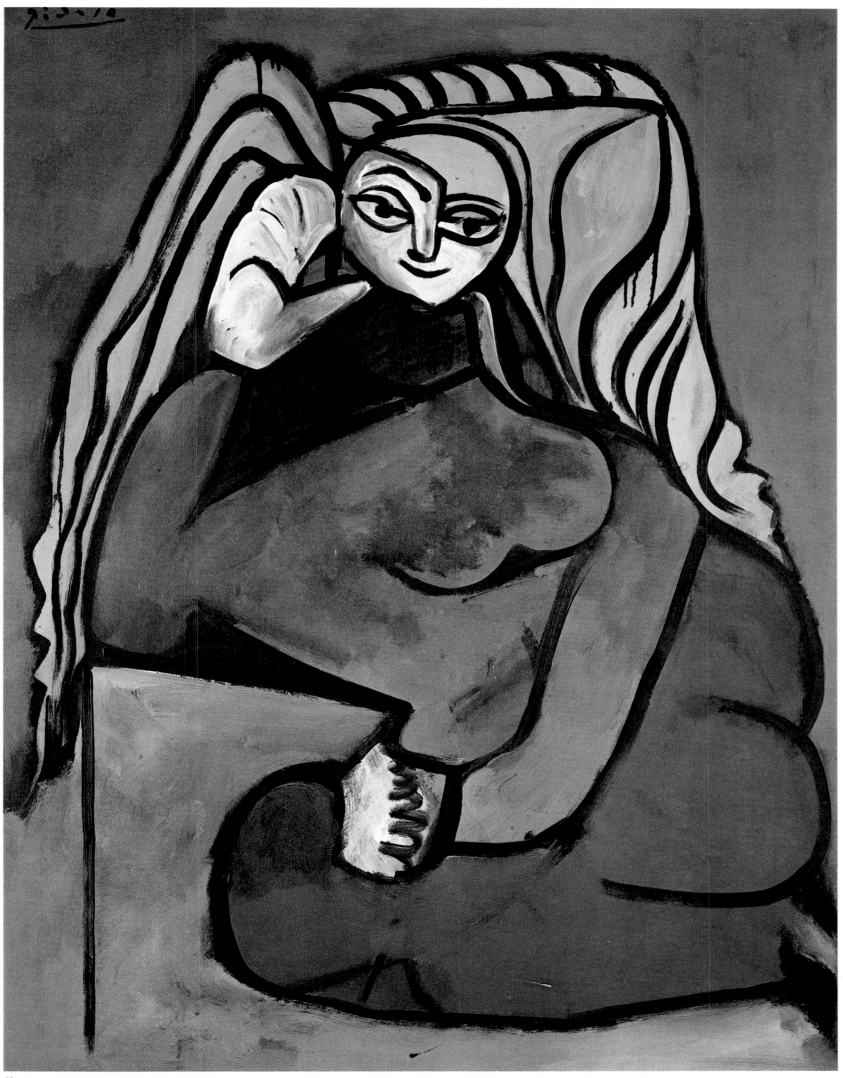

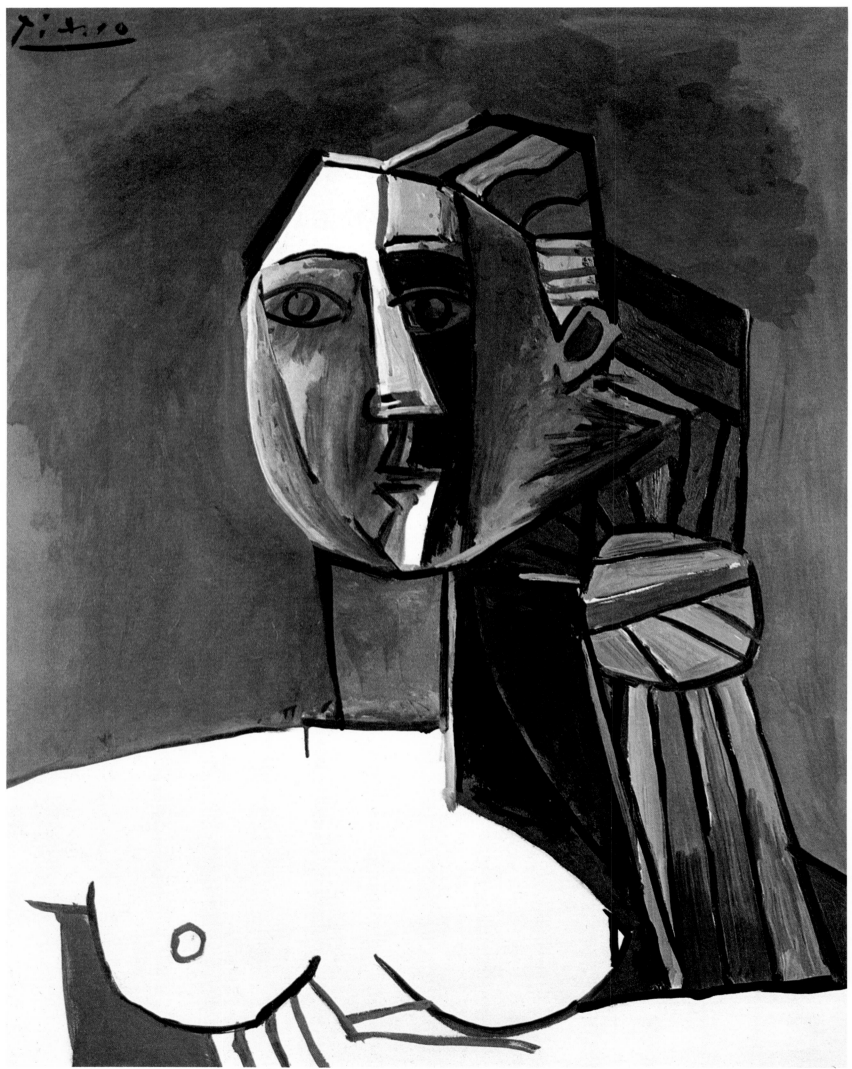

97

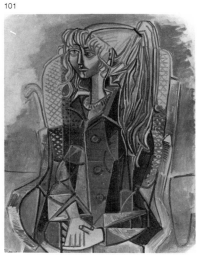

98
Portrait of Mademoiselle D. (Sylvette)
27.4.1954
Oil on canvas, 39×31.6 inches

99
Portrait of Mademoiselle D. in Profile
Portrait de Mademoiselle D. de Profil
29.4.1954
Oil on canvas, 39×31.6 inches
Collection Graindorge, Liège

100
Portrait of Mademoiselle D.
30.4.1954
Oil on canvas, 31.6×25.35 inches

101
Portrait of Mademoiselle D. in a Wicker
Chair
Portrait de Mademoiselle D. dans un
Fauteuil d'Osier
4.5.1954
Oil on canvas, 45.2×34.7 inches

97
Bust of a Woman
Buste de Femme
10.7.1953
Oil on canvas, 31.6×25.35 inches
Collection Angela Rosengart, Lucerne

the one he painted of his daughter Maja in 1938. His later children, Claude and Paloma, occupy an important place in his painting for two years, but their portraits are never romantic or idealized. Instead, Picasso stressed their playfulness, an attribute which extends to their whole environment. The pattern of flowers and stars on the tiled floors of *La Galloise* is enlarged into wheellike elements which Picasso incorporated in the composition as a primitive design.

He depicted his youngest children, like everything else that comes his way, directly and without the least suggestion of prettiness, like household idols to whom the painter too sacrifices. His family life in Vallauris with Françoise, Claude, and Paloma, the fun he had with them on the beach and at home, carried over into the studio, fusing with the physical reality of pictures, sculptures, furniture, and souvenirs—the whole organic chaos he creates around himself. The children rush up to him, noisy and irreverent, unconsciously filling every corner of *La Galloise* with the reserves of youthful life so indispensable to Picasso.

When Claude and Paloma were already big and no longer figured in Picasso's painting, an elaborately dressed little girl appeared in one variation after another. At first she is accompanied by all kinds of other figures; then, in another series, she is alone, sometimes with a dog at her feet; then she appears again with other people in the painter's studio. The studio, however, is not Picasso's but that of Velázquez, and the girl is not his daughter Paloma but the Infanta Margarita of *Las Meninas* (Plates 93 f., 177 ff.). Picasso had undertaken to paint the portrait of Velázquez's portrait of a princess. There is no historicizing intent of any kind. All the variations are natural and intimate, as though the Infanta had dropped into the studio to pose for the artist and give him the opportunity of painting these beautiful impressions of a young girl.

The emancipation of the individual within the general is particularly striking in Picasso's paintings of women, a subject which has absorbed him more than any other and which is certainly the most important one in his whole œuvre. All the phases of his painting are dominated by the fascination which women hold for him. Kahnweiler was right in saying that all Picasso's pictures of women are portraits. Even if we cannot always decipher the features, even when Picasso deliberately veils or distorts

the relation to a specific model, these pictures more than any others are keys to his painting. Women are the leading actors in his scenic compositions. Yet their pictures can also reflect human conditions divested of all individual character. When he portrays woman crying, sleeping, stretching out her hands, fleeing, or loving, the portrait of a specific model is often retained through many of the various states and drafts of the picture, until the artist finally renounces likeness altogether or suggests it in a new, more general way. The borderline between women's portraits and anonymous figure compositions is incomparably more fluid than in the case of men's portraits.

102–110
Portrait of Mademoiselle D. (Sylvette)
All oil on canvas except 109

102
18. 5. 1954 I 31.6 × 25.35 inches

103
18. 5. 1954 31.6 × 25.35 inches

104
19. 5. 1954 35.9 × 28.5 inches

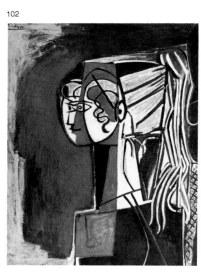
102

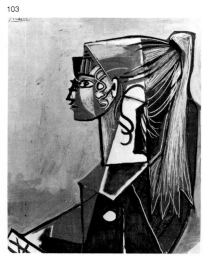
103

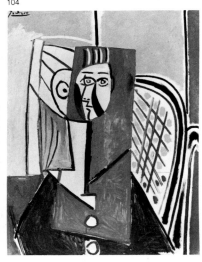
104

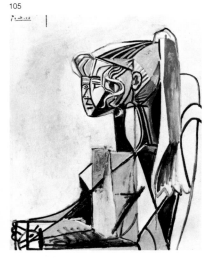
105

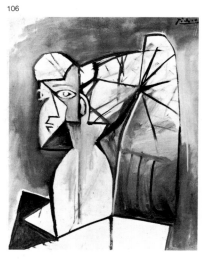
106

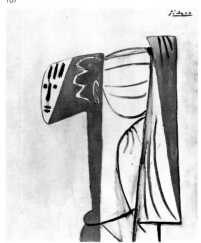
107

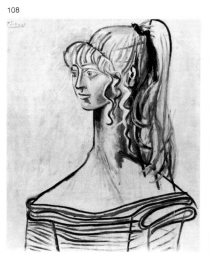
108

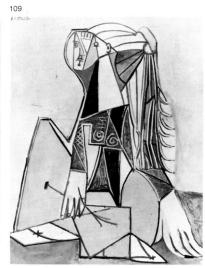
109

Picasso paints series of women's portraits just as he does of still lifes and landscapes. In recent years either Françoise or Jacqueline has shared Picasso's house most of the time. He sees them just as he sees all the other objects around him which he loves and which are as indispensable to his life as to his painting. This is why portraits of women occur more frequently and more often in series than portraits of men. During World War II Picasso would always paint women in one certain corner of his studio in the Rue des Grands-Augustins. They were chosen—and perhaps this can be said of no other subject except the still lifes—to symbolize "prevailing conditions." Picasso saw them as imprisoned creatures.

With the end of the war this type portrait gradually disappeared. For a few years Picasso had been making occasional drawings which indicated that a potentially new concept of the portrait was somewhere lying dormant. Using Françoise as a model, he had already experimented with transforming a face from a portrait into a symbol of a plant or sun. The 1946 series of nine metamorphoses of Françoise's face (Plates 83 ff.) was among the first lithographs he did after the war and ranks with his most

105
20. 5. 1954 39 × 31.6 inches

106
23. 5. 1954 28.5 × 23.4 inches

107
24. 5. 1954 28.5 × 23.4 inches

108
30. 5. 1954 28.5 × 23.4 inches

109
19. 4., 22. 5., 4. 10. 1954
Oil on wood, 50.7 × 37.8 inches

110
3. 5. 1954 31.6 × 25.35 inches
Kunsthalle, Bremen

111
Seated Woman in Turkish Costume
Femme accroupie au Costume turc
1955 Oil on canvas, 44.85 × 34.7 inches
Perls Galleries, New York

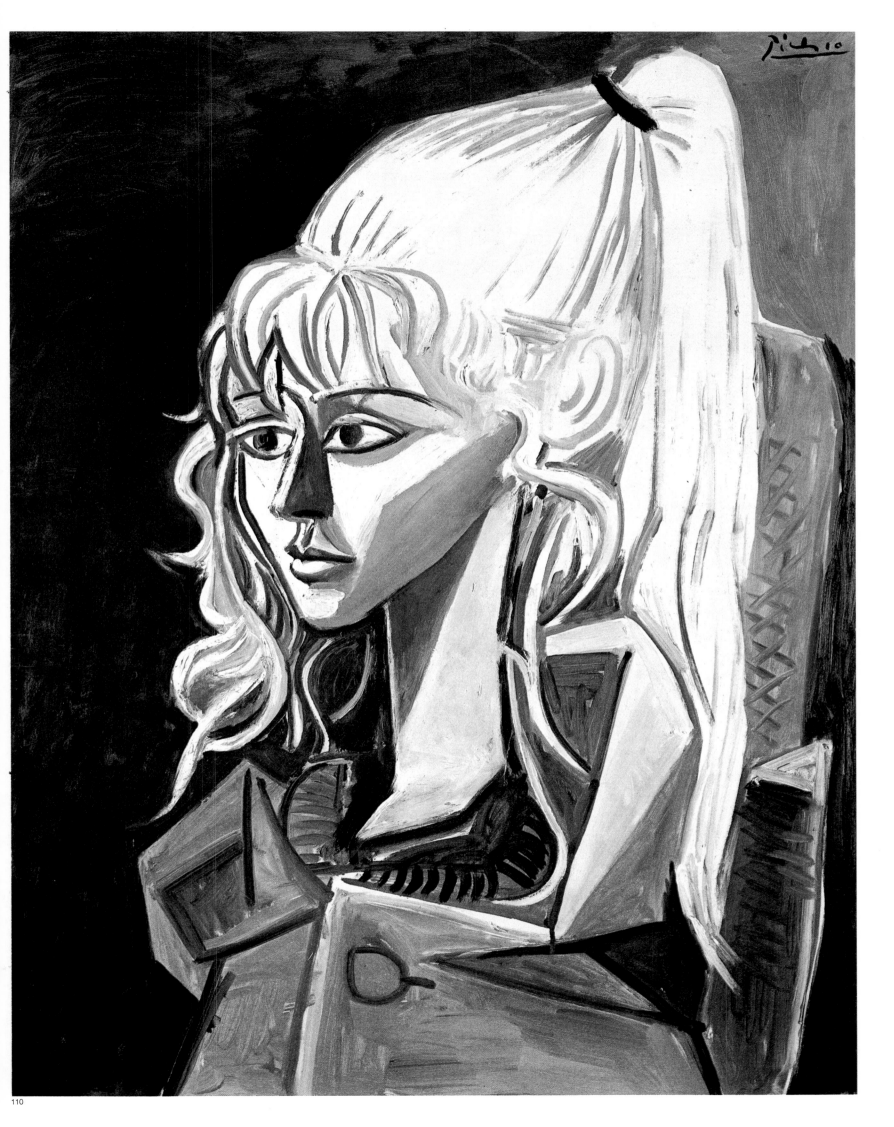

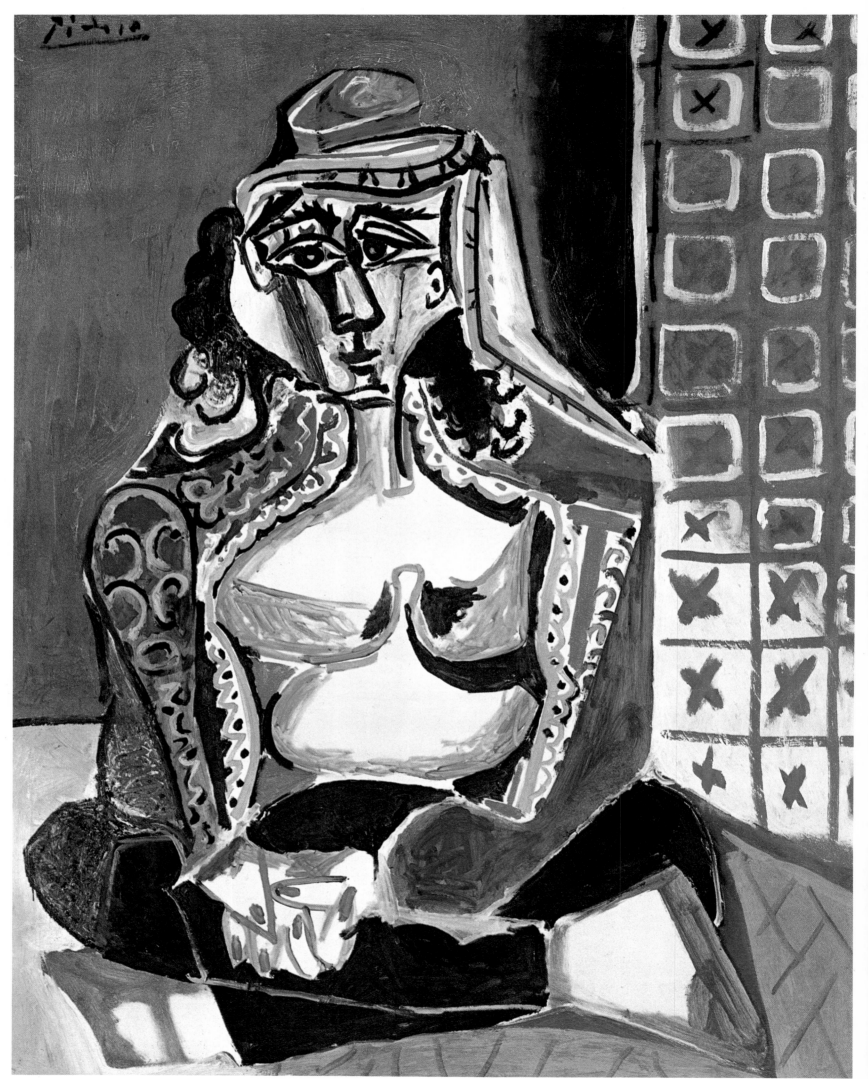

111

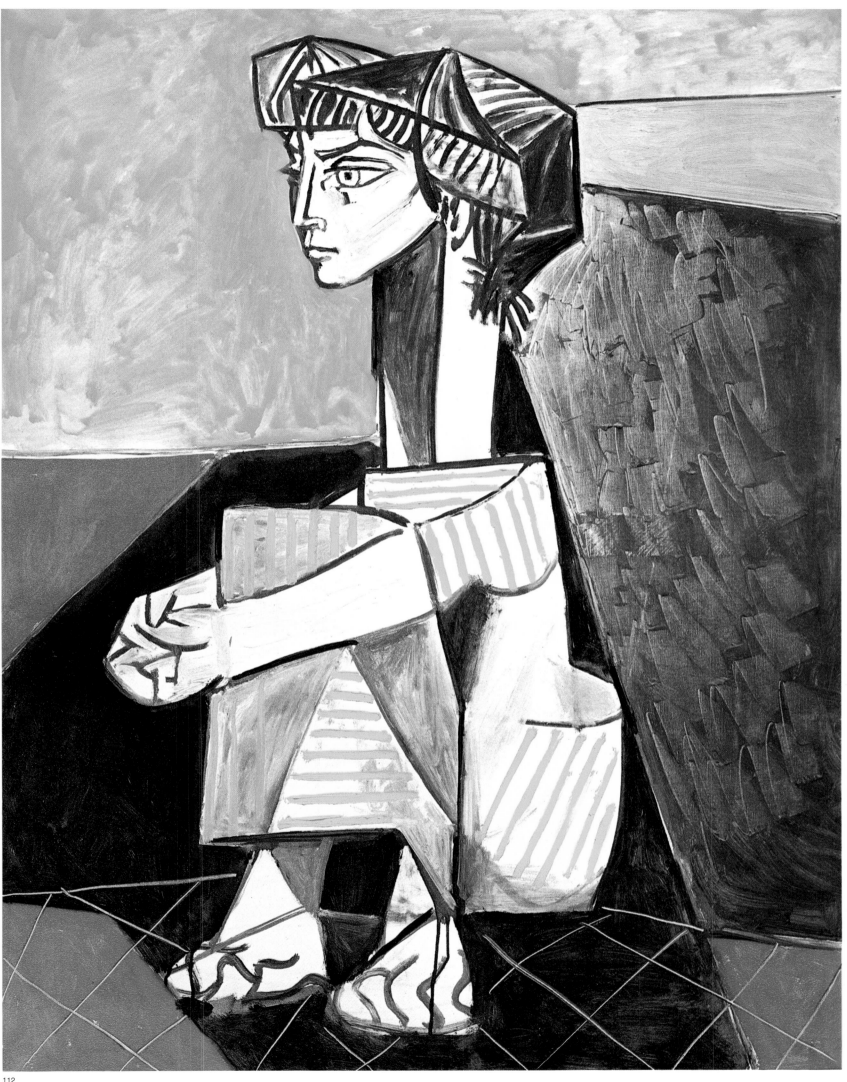

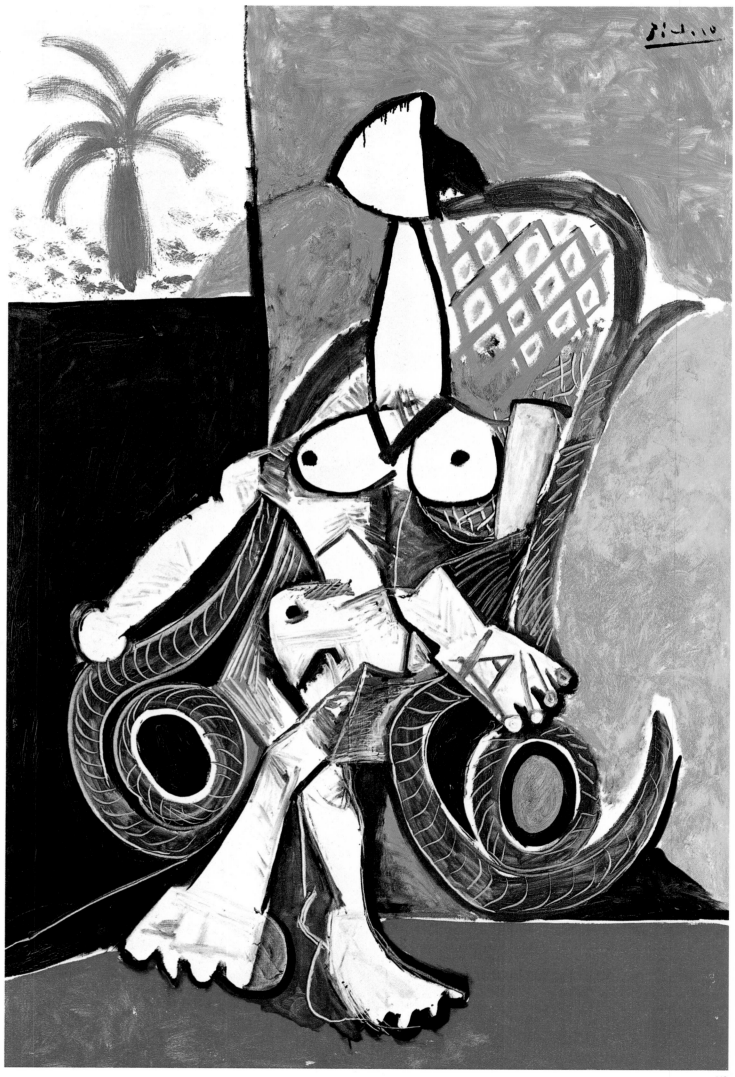

113

"Whatever the source of the emotion that drives me to create, I want to give it a form which has some connection with the visible world, even if it is only to wage war on that world. Otherwise a painting is just an old grab bag for everyone to reach into and pull out what he himself has put in. I want my paintings to be able to defend themselves, to resist the invader, just as though there were razor blades on all surfaces so no one could touch them without cutting his hands."

(GILOT)

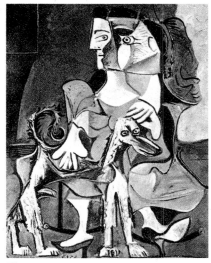

114

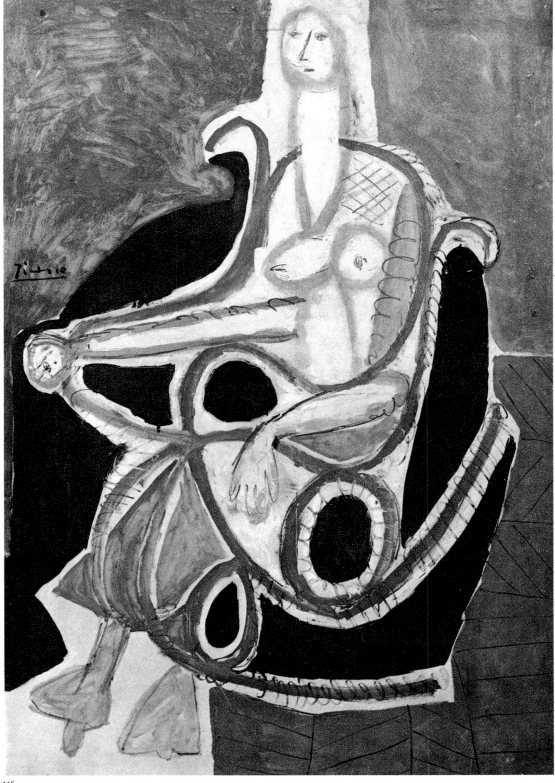

115

112
Jacqueline with Joined Hands
Jacqueline aux Mains croisées
3.4.1954
Oil on canvas, 45.2 × 34.7 inches

113
Nude Woman in a Rocking Chair
Femme nue au Fauteuil bascule
1956
Oil on canvas, 76 × 50.7 inches
Galerie Beyeler, Basle

114
Woman with Dog
Femme avec Chien
1962
Oil on canvas, 62.4 × 50.7 inches

115
Woman in a Rocking Chair
Femme au Fauteuil bascule
25.3.1956
Oil on canvas, 76 × 50.7 inches

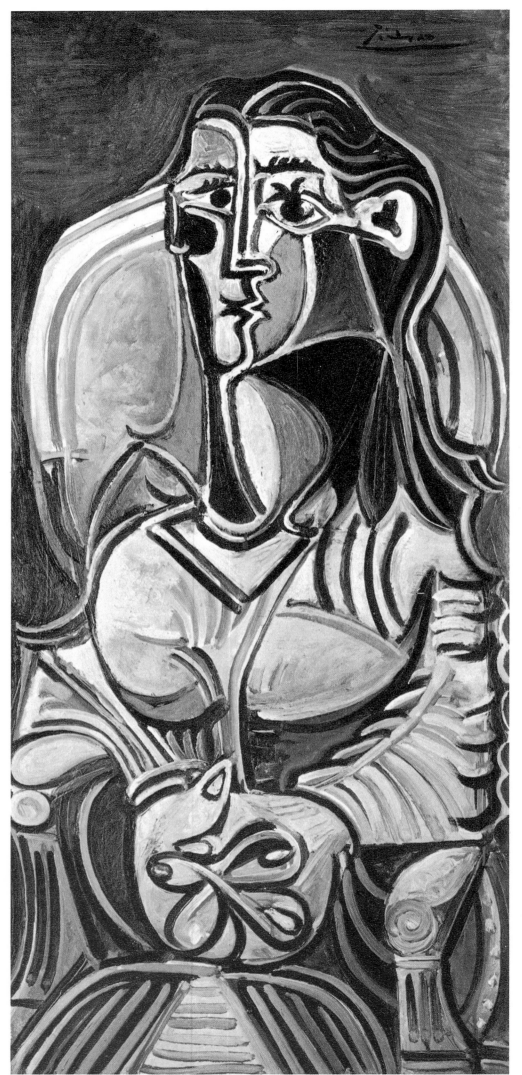

116

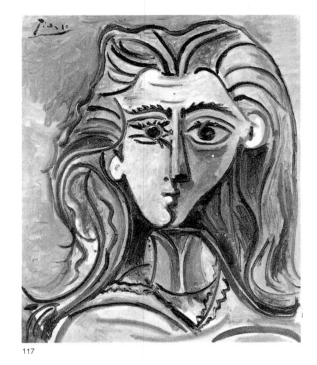

117

"It's all very fine to paint a portrait with all the coat buttons and even the buttonholes, and the little highlights on the buttons. But watch out!... There comes a moment when the buttons start flying in your face..." (PARMELIN)

116
Seated Woman with Joined Hands
Femme assise aux Mains jointes
4.12.1960 Oil on canvas, 42×19.2 inches
Collection Dr. Bernhard Sprengel, Hannover

117
Head of a Woman in Gray
Tête de Femme en Gris
10.3.1960 I Oil on canvas, 25.35×21 inches
Collection Forberg, St. Moritz

118
Woman in a Blue Armchair
Femme au Fauteuil bleu
3.4.1960 Oil on canvas, 50.3×37.8 inches
Galerie Rosengart, Lucerne

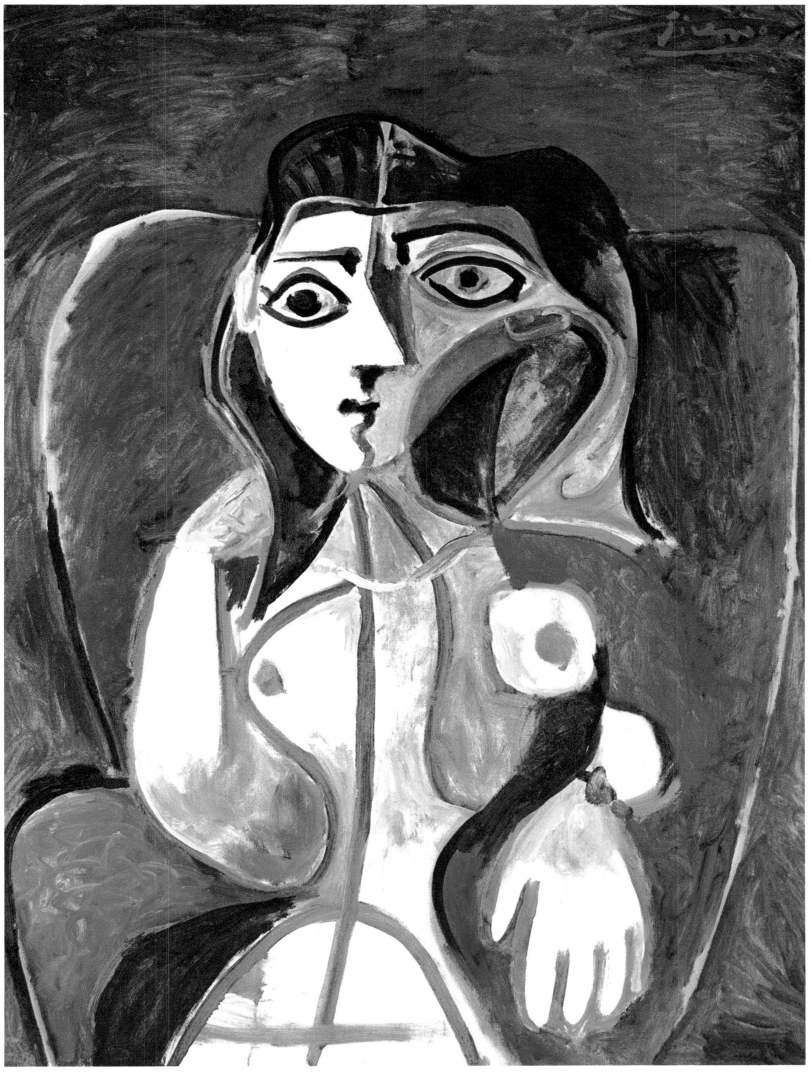

important works. In vigorous strokes he sketched over and over again the outlines of her head, hair, and neck. The ornamental clarity and symmetry of the lines supports the architectonic structure of the face, seen in front view. The shining eyes remain almost unchanged, until on the last sheet the head itself becomes a brilliant sunburst like a halo, transfiguring the portrait of Françoise into a timeless mask.

The portraits of the next few years show stylizing processes which dissolve individual forms. In most of the heads of women Françoise is identifiable only by a sweater which figures in many pictures or by her hair, loose at first but later done in a bun. Spindleshaped, leaflike, and flowerlike forms give these pictures an attenuated, fragile look. They have a new elegance, missing from Picasso's work for a long time. Often he did not restrict himself to the face but portrayed the whole figure in great swinging forms. All aggressive traits have been eliminated from these often cool, sovereign pictures (though they later reappear in the portraits, including those of children).

Soon, however, the floating, unsubstantial planes yield their determining function to thick lines ending in knotlike forms, which give the pictures an archaic feeling. These lines crisscross the surface of a head like canals or engraved lines, creating the optical quality of a flat relief. Picasso explained this new departure to his friend Kahnweiler as an attempt to eliminate all perspective illusion; he carefully avoided intersecting lines. The structure of the portraits and figures derives entirely from their relief character. The strong graphic accentuation of the knotted lines suggests archaic face-painting and is intended to intensify the facial expression.

Nonetheless it would be wrong to assume that this indicates a stylistic change. It soon becomes clear—and this applies to every phase of the late work—that Picasso immediately assimilates every new formal insight and achievement into his art. He never uses them as ends in themselves but incorporates them in his stock of forms, accumulated over the decades, where they are at the disposal of every new intention. The simplifications and economies which are often criticized in Picasso's late pictures and drawings usually represent no more than the elimination of systematic composition in favor of a direct statement.

In the portrait of his friend Hélène Parmelin, Picasso turned to the forceful, clear presentation of a strong temperament (Plates 95 ff.). He therefore rigorously confined the whole figure within the architecture of the seated pose, to which the loose profusion of yellow hair adds a Baroque touch. In another version the body rests comfortably in a diagonal plane; the head is supported contemplatively on the hand. Instead of being depicted in strands, the hair is blocked in a few big undulating lines. Madame Parmelin did not pose for either of the portraits. A trivial occurrence, a chance injury to her hand forcing her to wear a bandage, must have inspired Picasso's second version, which is almost a new creation. An insignificant accident, a mere nothing, reflected in a change in the features of his friend, was enough to inspire a newly formulated portrait of equal significance.

In strong contrast to these two lively portraits prompted by first-hand impressions are other women's heads, and sometimes torsos, whose common feature is an unsensual austerity. This series began in 1952 and continued, with interruptions, until the

"I'm always hearing the word development. *People keep asking me to explain how my painting has* developed. *For me art has neither past nor future. If a work of art is not permanently alive in the present it's not worth considering... Art doesn't develop out of itself. People's ideas change, and their mode of expression changes along with the ideas. When I hear people talking about the development of the artist I always feel as if they were seeing him between two mirrors which repeat his reflection ad infinitum and taking one series of reflections for his past and the other for his future, while he himself represents his present. They don't realize that they're all the same pictures, except on different levels."* (THE ARTS, 1923)

119
Seated Woman with Green Scarf
Femme assise à l'Echarpe verte
28. 3. 1960
Oil on canvas, 76× 50.7 inches
Michael Hertz, Bremen

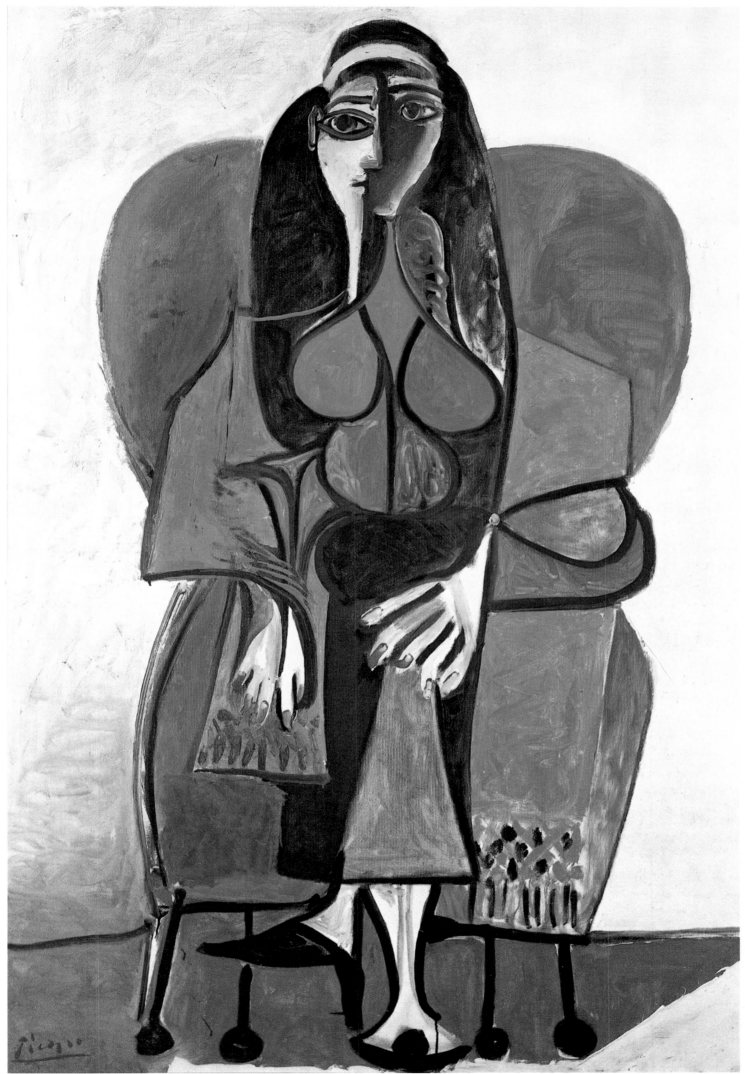

119

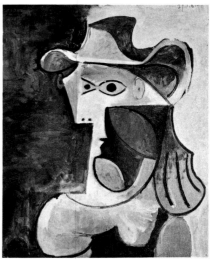

120

summer of 1953. Picasso keeps reverting to this type, hoping to find a formulation that will liberate him. His persistent repetitions produce an increasingly resolute expression and a sharper confrontation of the viewer. The stark, economically outlined front view, combined, in some versions, with a pure profile of face and torso, gives these portraits a penetrating incisiveness. It derives entirely from the effective asceticism of means: few colors (usually ranging only from brown or gray to black), empty backgrounds, often with parts of the picture standing out as if spotlighted in flat planes of striking white, so that the light, naked breasts drawn against the chalky ground make a contrast with the dark face. The painterly restraint and formal severity intensify the feeling of still melancholy. While the resemblance to Françoise emerges only in details, it is an outward proof that these portraits are linked with a personal development which was to separate Picasso from his companion of many years.

Although these heads of women are landmarks in Picasso's changed personal situation, they are not nearly as famous as the set of portraits, painted in the spring of 1954, of Mademoiselle David, whose first name, Sylvette, immediately conjures up the vivid image of a young girl with a long neck on narrow, sloping shoulders, a classical face, straight nose, and thick blond hair in a ponytail (Plates 98 ff.).

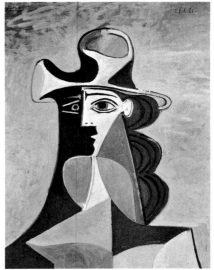

121

Picasso had got to know the girl near Vallauris, and in two months, between April and June, made more than thirty drawings and paintings of her. Sylvette herself posed for them, inspiring a series the stylistic range of which is unusually wide. The pictures are generally limited to gray tones and almost without exception show the girl in full to three-quarter profile, in every conceivable style from an almost imitative naturalism to a highly abstract variation of a simplified Cubism. The portraits concentrate so single-mindedly on the youthful head that the individual features become subsidiary to the type into which Picasso condensed them.

What makes the Sylvette portraits remarkable is that through Picasso's paintings this young girl came to typify a whole generation. Young people recognized themselves in these portraits when they saw them in exhibitions or reproductions. The ponytail (which was not an invention of Picasso's) and Sylvette's high carriage of the head became fashionable styles "à la Picasso." For the first time since the war one of Picasso's portraits had become the idol of a rising generation.

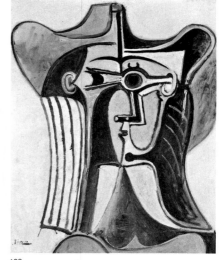

122

In that same summer of 1954 Jacqueline Roque made her appearance in Picasso's pictures. As often happens when a new figure or theme emerges which touches him very deeply, he immediately tried to make sure of these impressions in various ways and at the same time take possession of the theme artistically. Every one of these multifarious portraits of Jacqueline not only presents a new formal concept but also opens up new psychological realms, reflected outwardly through posture, glance, and color. In Jacqueline, Picasso found the portrait "figure" which would pervade his pictures in the coming years, sometimes recognizably characterized, sometimes used ambiguously. Through her presence in his life she is present in his art too. His typical way of personalizing the content of his paintings extends to her, and in 1958 she became his wife. The year in which he got to know her was his last year in Vallauris. The scene of his work and of their life together would be the villa *La Californie* in Cannes, *Château Vauvenargues* near Aix-en-Provence, and later the farmhouse *Notre-Dame-*

120—123
Woman with Hat
Femme au Chapeau
Galerie Rosengart, Lucerne

120
27. 1. 1961 Oil on wood, 38.8×31.3 inches

121
28. 1. 1961 Oil on wood, 45.2×34.5 inches

122
19. 12. 1960, 30. 7. 1961
Oil on canvas, 39×31.6 inches

123
27. 1. 1961 Oil on wood, 45.6×34.7 inches

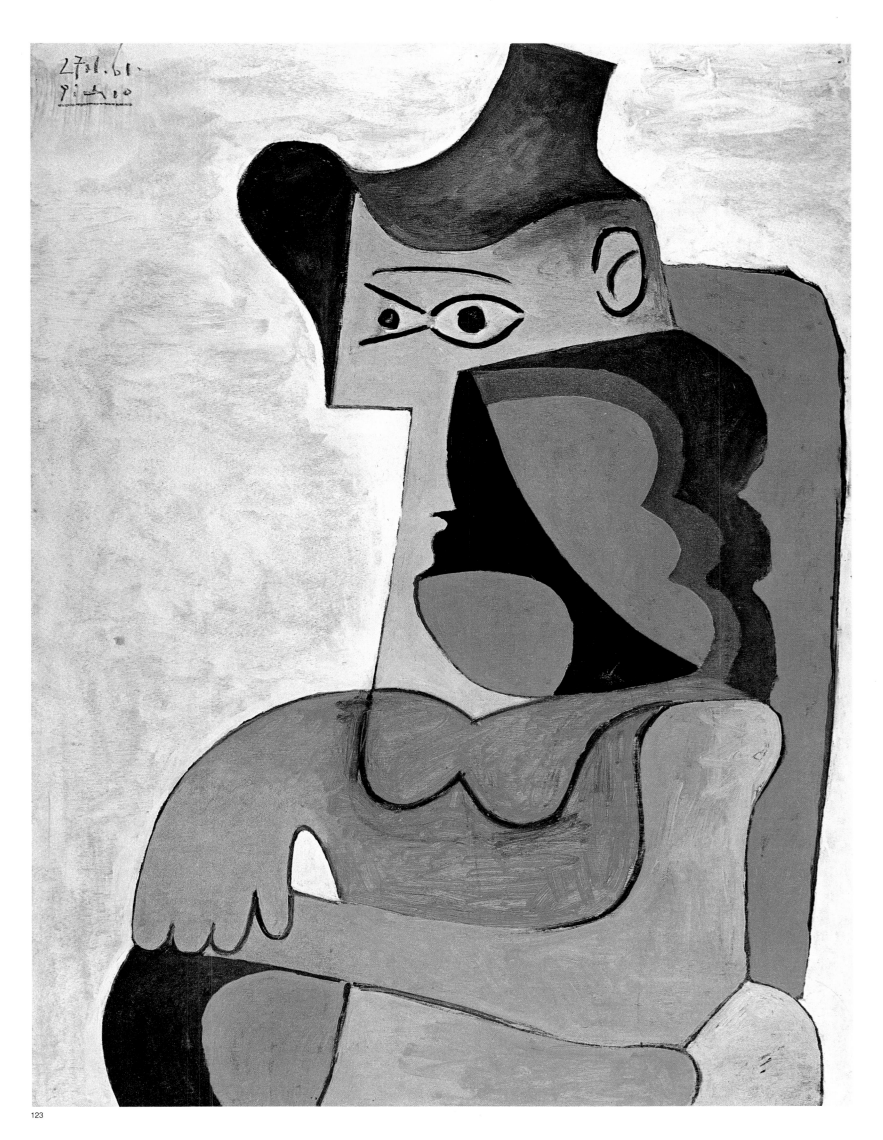

27.1.61
Picasso

123

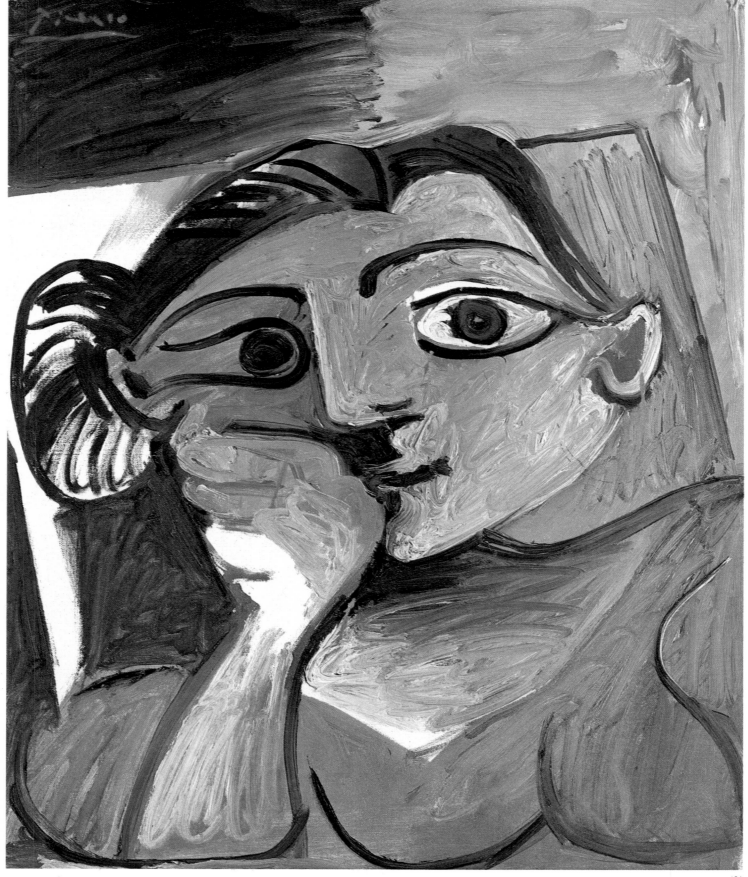

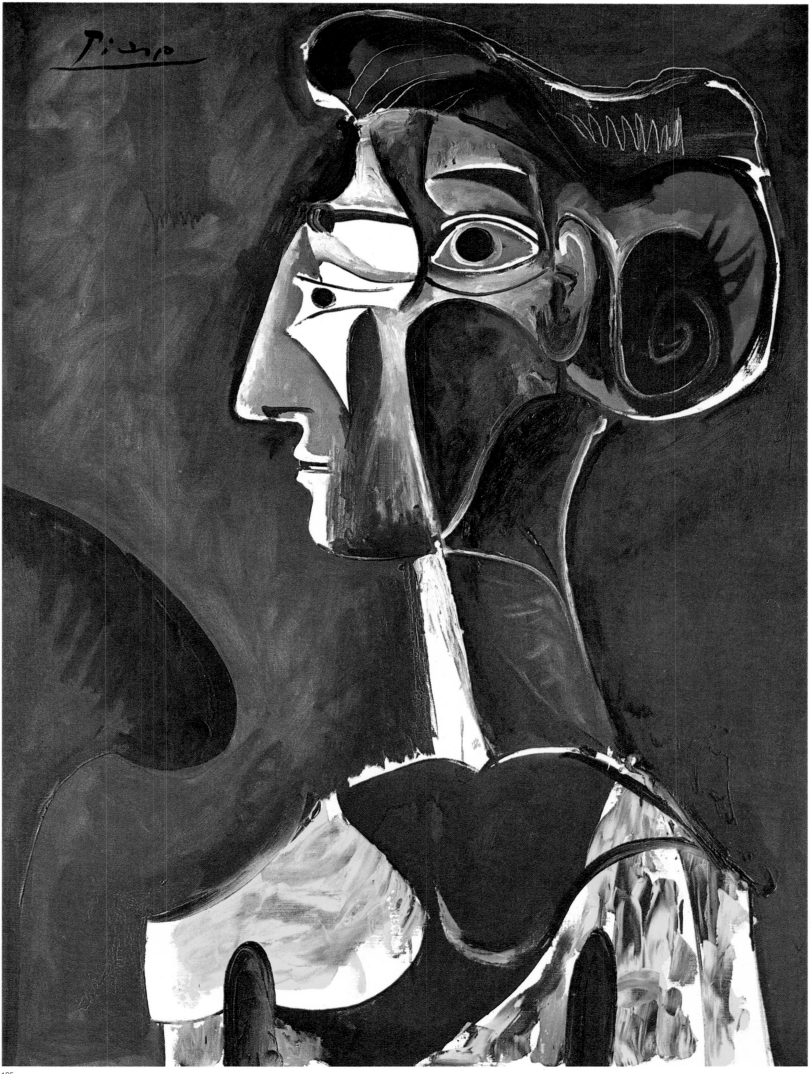

125

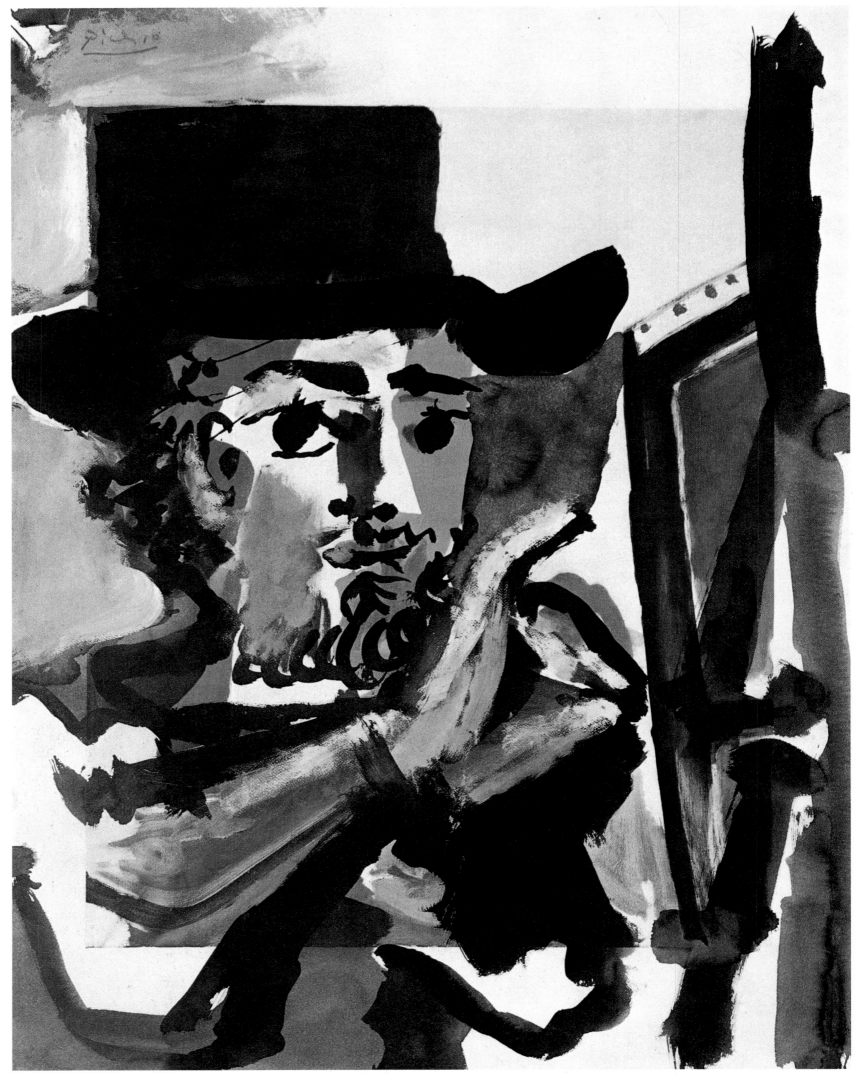

126

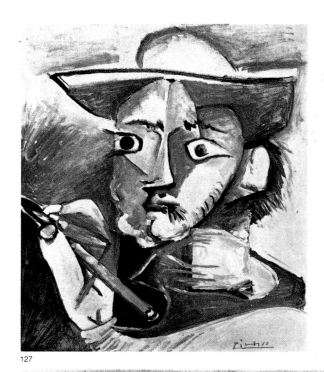

124
Woman Resting Her Head on Her Hand
Visage appuyé sur une Main
3.12.1962 Oil on canvas, 23.8×19.5 inches

125
Great Profile Grand Profil
7.1.1963 Oil on canvas, 50.7×37.8 inches
Collection Nordrhein-Westfalen, Düsseldorf

126
The Painter at Work Le Peintre au Travail
1964 Gouache and wash, 38×29 inches
Walter Bareiss, Greenwich, Connecticut

127
The Painter with Hat Le Peintre au Chapeau
1965 Oil on canvas, 28.5×23.4 inches
Galerie Beyeler, Basle

128
Self-Portrait Autoportrait
26.1.1965 Oil on canvas, 25.35×21 inches
Kunsthalle, Bremen

129
The Painter at Work Le Peintre au Travail
10.10.1964 I Gouache and wash, 38×29.25 inches

127

"Portraits of myself are very rare. I have never been too concerned with my own face." (BRASSAÏ)

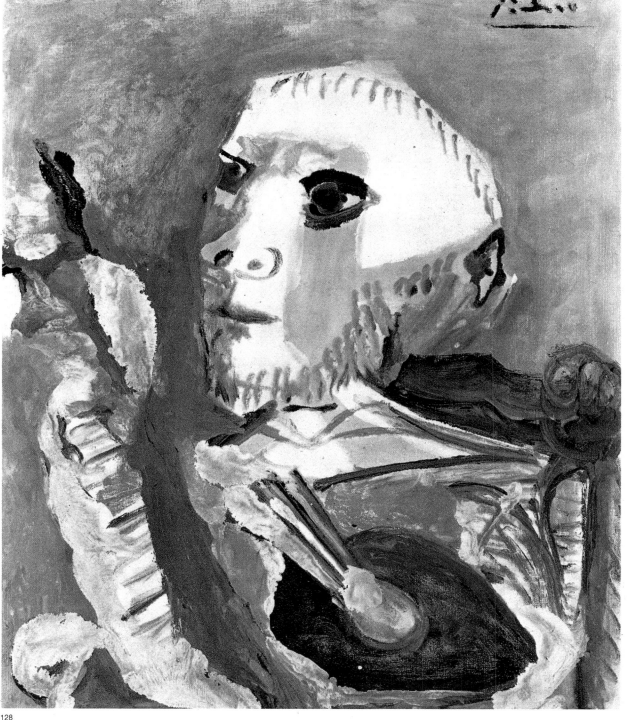

128

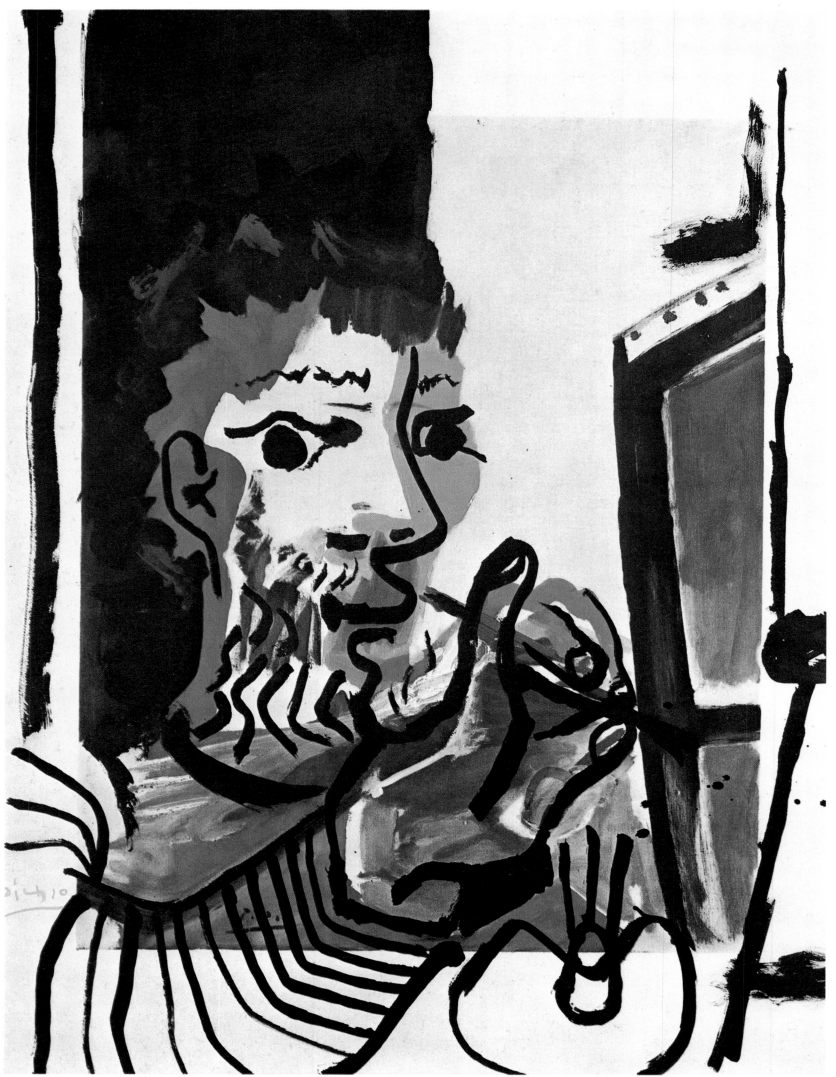

129

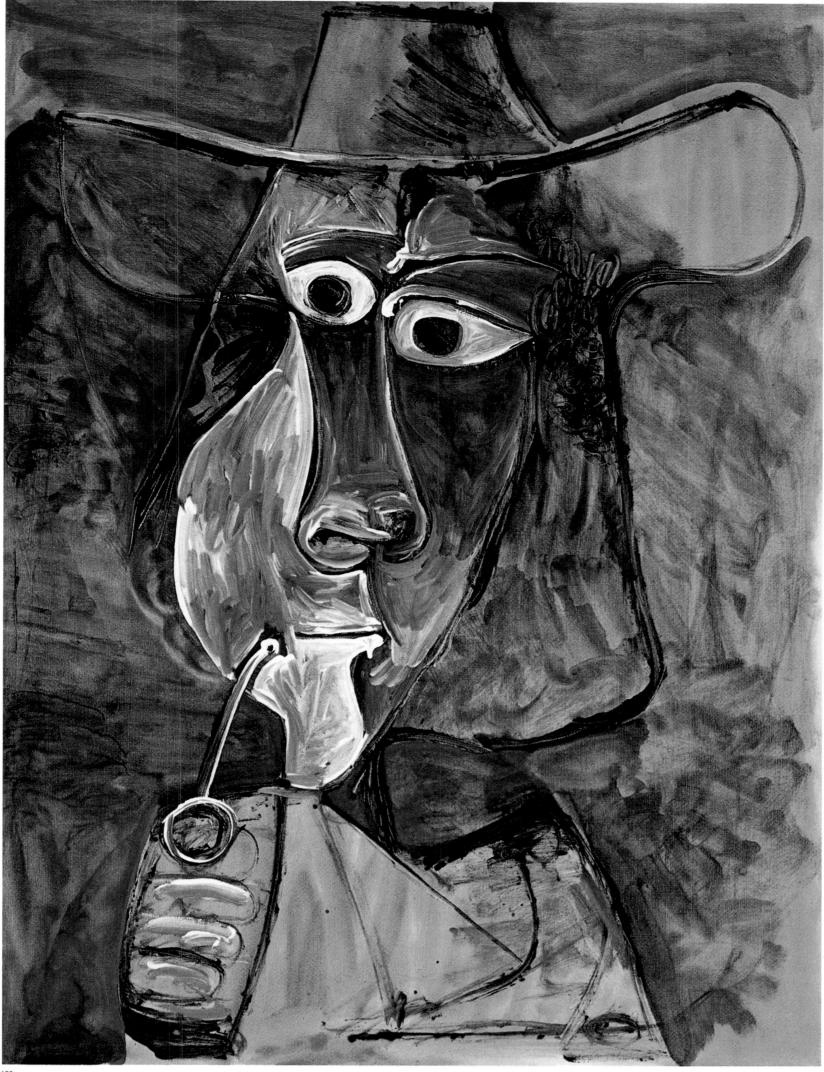

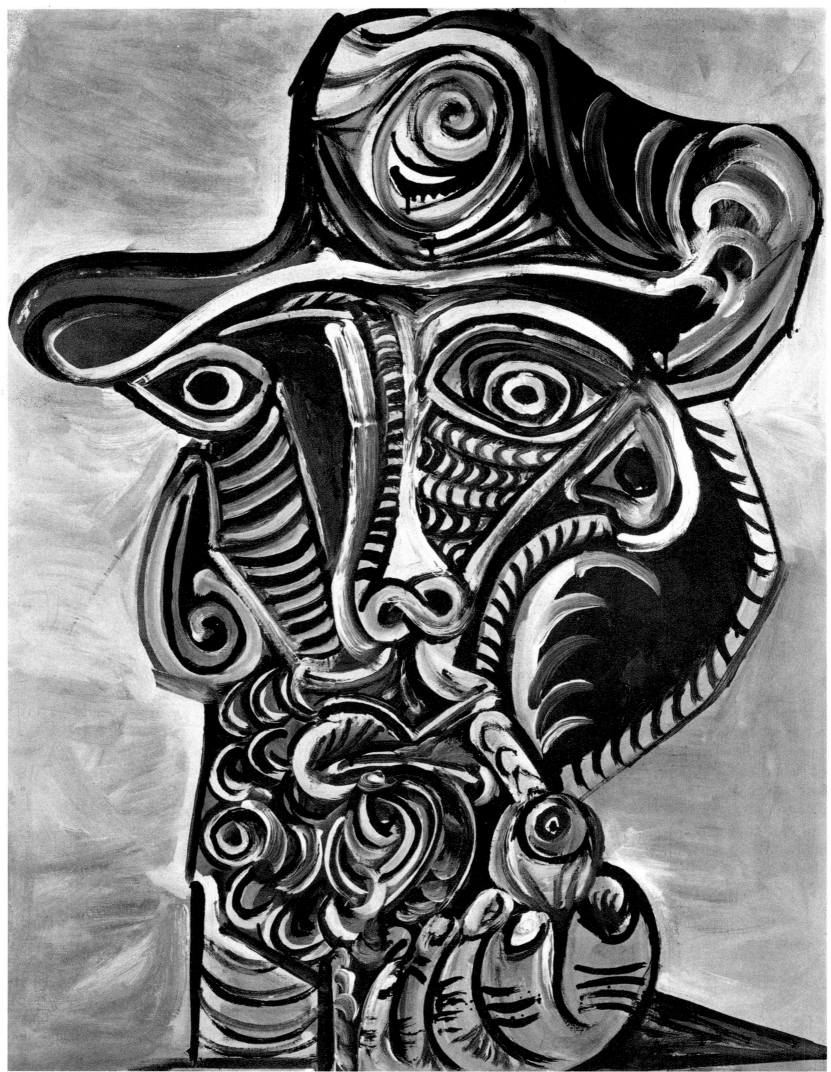

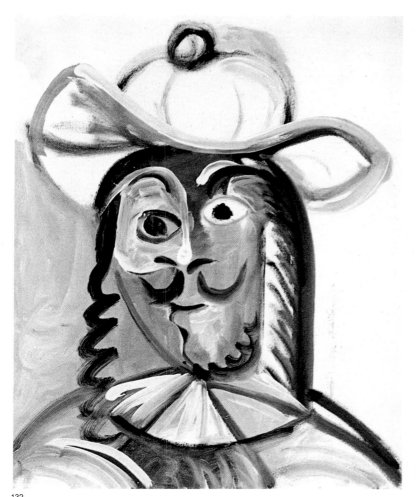

132

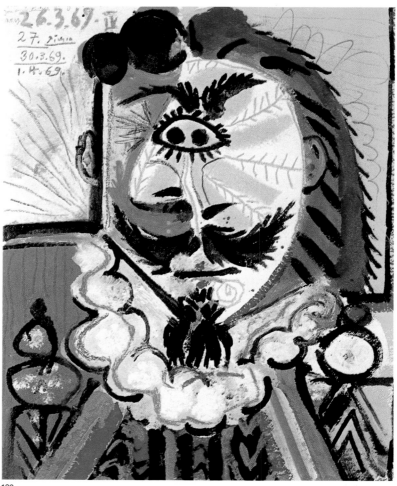

133

de-Vie near Mougins, since the smaller *La Galloise* in Vallauris had been Françoise Gilot's place.

The early portraits of Jacqueline typically show her with legs drawn up and hands clasped below the knees (Plate 112). Over and over again we see her with crossed arms or folded hands—immediately identifiable by her profile and grave eyes. A frequent "sign" of Jacqueline is the old rocking chair (Plate 115) in the studio. Here she posed for the first portrait; from then on this chair, one of her favorite places, would betray her presence even in pictures which suppress all individual references. Later, in 1960, Picasso preferred to paint her in a blue chair (Plate 118), sometimes with Kaboul, their Afghan hound. In addition to strongly situational paintings, he again produced series in which he took some general theme with rich developmental possibilities and proceeded to broaden and transform it. Often the way Jacqueline did her hair or the clothes she wore inspired new pictures, which sometimes paid so little attention to the wearer that they are more like elaborate costume studies whose style and richness totally absorb the portrait. A Polish jacket of Françoise's had already inspired one of Picasso's most beautiful lithographs. The traditional peasant dress of Arles which he discovered with Jacqueline gave him the opportunity to paint her in folk costume. He had already painted her in Turkish dress, and these pictures are

directly linked with his variations on Delacroix's *Women of Algiers*, which he began toward the end of 1954. According to one of Picasso's friends, Jacqueline's startling resemblance to one of the seated Moorish women inspired this series, and it is true that the *Women of Algiers* suite was followed by some portraits of her *au costume turc* (Plate 111), whose thematic details can be traced back to Delacroix's work.

To list all the portraits of Jacqueline is a fruitless undertaking, because the traces of identity are elusive—and indeed sometimes escape us altogether, although the "legibility" of the situation and its biographical content are usually beyond question. Sylvette was a model—an exemplary one in fact. She came and went, and each of the eighteen variations of her portrait bears the model's features. Jacqueline, on the other hand, is always there. She passes through the studio while Picasso is working and sees him painting without his taking any notice of her. And precisely because she is not posing she also appears in his pictures as a part of the interior, to which she belongs organically like an object which inhabits the room and distinguishes it by its presence. If we think of Delacroix's *Women of Algiers* as a figure-still-life, a picture in which the women assert their presence in the room with the quiet self-evidence of physical objects, we shall more readily understand Picasso's discovery that this exactly describes Jacqueline's bearing. For Picasso she provides the link with Delacroix; the frequently noticed resemblance to one of the Algerian women seems to be a later, superimposed accent.

Jacqueline's pronounced features, which Picasso shaped with almost plastic forcefulness in his early portraits of her, reappear throughout the 1960's. Picasso changed his distance, got closer to her, and the closeness is reflected in her eyes and her whole face. Then we find her enthroned in her chair again, obviously "entranced," stroking the Afghan hound at her side. This subject inspired several repetitions in which Picasso himself set the stage; he painted Jacqueline with the dog and then eliminated the dog. The domestic scene of Jacqueline with the animal takes on a more general erotic significance. In contrast to these paintings, other pictures of Jacqueline of the same period have a mysteriously soulful expression recalling Fayum mummy portraits.

Shortly after this Picasso returned to a familiar theme: artist and model, which brings to an end or changes the significance of the portrait and the women's figure paintings. Picasso slipped into the role of painter, Jacqueline into that of model. But the partners are no longer recognizable: The dialogue leaves all private motives, experiences, and reflections far behind; the ever-changing combinations soon reveal the painter's conversation with his model to be an exemplary self-examination. This is why the painter's own portrait bears no sign identifying him as an individual but only the attributes of his trade: palette and paintbrush. But as he works at the easel the old painter still reveals his presence, achieving a symbolic self-likeness which no mirror could equal.

Studio-Pictures

"There has to be a rule even if it's a bad one because the evidence of art's power is in breaking down the barriers. But to do away with obstacles—that serves no purpose other than to make things completely wishy-washy, spineless, shapeless, meaningless—zero."

(GILOT)

134 The Studio L'Atelier 1956 Oil on canvas, 34.7 × 43.2 inches Collection Victor W. Ganz, New York

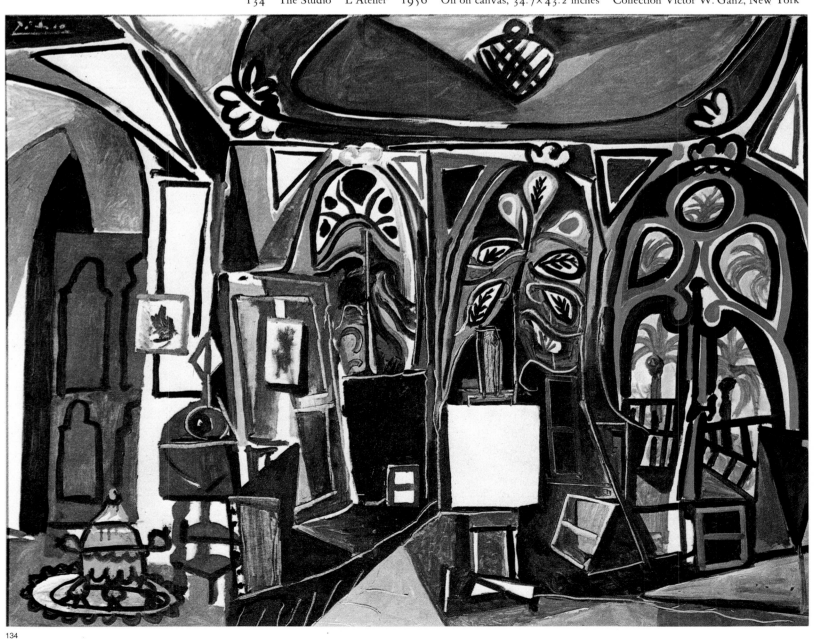

134

"Before I came here...this lower floor was used as a workshop by a weaver, and the upper floor was an actor's studio—Jean-Louis Barrault's. It was here, in this room, that I painted *Guernica*."* Françoise Gilot remembers Picasso introducing her to his studio in the Rue des Grands-Augustins with those words. To Picasso, whose most recent move took place only a few years ago and whose life since World War II is signposted by a whole series of different place names, favorable surroundings for living and working are an absolute necessity. For all his mobility and occasional restlessness, his need for stability of place is so pronounced that for a time he kept buying houses and properties and refusing to sell them again, even when he had no further use for them. He is equally conservative in his attachment to material possessions.

Moving was a trying experience for the whole household, especially Picasso himself, who would watch with an eagle eye to see that nothing that he considered indispensable was mislaid. He alone supervised the assignment of everything to its place. No one was allowed to interfere with this "order." Although few people could begin to find their way around in it, Picasso would blame everybody else if his memory, usually so reliable, failed to recall the whereabouts of some hoarded object—even if it was only a pencil. His move to *La Californie* was one of the most formidable undertakings of the whole postwar period because he had accumulated more pictures, folders, packages, sculptures, packing cases, tools, and materials, in addition to household furniture, than he had ever moved in one lot before.

A few years later, when he acquired the isolated old *Château Vauvenargues* near Aix-en-Provence, trucks drove up with load after load of furniture bought to fill its great rooms. From his storehouses in Paris came pictures he had not seen for many years. The sculptures from *La Californie* found a new home under the stone staircase leading up to the main entrance of the *château*. The process was repeated when he moved into the old hermitage of *Notre-Dame-de-Vie* near Mougins without giving up or even vacating his former properties. His inexhaustible, inventive collector's talent went hand in hand with increased productivity, so that he was constantly faced with an undeniable need for more space. When his quarters became too cramped or too crammed with new works, he would change them—reluctantly, for they meant more to him than just a skin which he could cast off from time to time.

Picasso's studio has its picture-history. As early as the 1920's it provided the background for some still lifes set against its window, with interweaving plane and spatial elements. Picasso's discovery of the studio as a space of spaces first enabled him to bring the still life out of its Cubist limitations into painterly and atmospheric freedom, and this gave the still lifes of this period their particular beauty. The first studio he painted was not his own but that of the milliner whose window faced his on the Rue de La-Boétie. Shortly later, however, the painter's own studio appeared, thanks to the theme of painter and model which now began to occupy him. Neither studio nor painter and model was individualized. In his etchings for Balzac's *Chef-d'œuvre inconnu* Picasso had made obvious references to his literary model, and in the "Sculptor's Studio" sequence from the Vollard suite he retained the allegorical, semiclassical framework. Two interiors with young girls drawing (1935) specify the theme. During the war (1941) the three ages of man appear in the artist's studio, which otherwise does not figure in the works of this period.

For years Picasso had been forcing the seated women in his pictures into anonymous, narrow, closetlike spaces, although he had no reason to feel cramped in his Paris studio. Not until 1943 did he paint the first portrait of his studio, seen only as a segment but still identifiable. We see the windowpanes familiar to us from the still lifes of this period, the view of neighboring houses compressed into one-third of the painting, and the radiator under the windowsill, with an enormous heat duct

134 a

"*I always aim at the resemblance. An artist should observe nature but never confuse it with painting. It is only translatable into painting by signs. But such signs are not invented. To arrive at the sign, you have to concentrate hard on the resemblance. To me, surreality is nothing, and has never been anything but this profound resemblance, something deeper than the forms and the colors in which objects present themselves.*"

* Françoise Gilot and Carlton Lake, *Life with Picasso* (New York: McGraw-Hill, 1964) p. 17.

branching out of it in a great curve which dominates the vertical dimension. The merest trace of walls meeting at a corner suggests the interior space without actually giving it a place in the picture, which is dominated by the heat duct, the ribs of the radiator, the closed casement windows, and the barrier of façades and roofs across the courtyard: an uneasy, blocked situation made even more oppressive by the general abrupt cutting off of shapes. It is clear from every detail that this is Picasso's studio, even though a dingy towel is the only sign of human habitation in this corner of a city apartment which looks as if it were inhabited by demons.

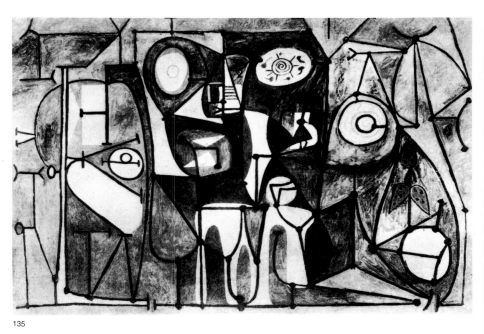

135

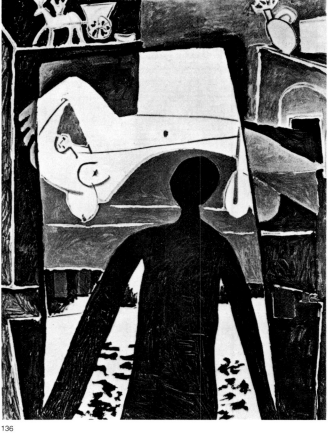

136

134a
The Studio Window
La Fenêtre
1943
Oil on canvas, 50.7 × 37.8 inches

135
The Kitchen
La Cuisine
9.2.1948
Oil on canvas, 68.25 × 97.5 inches

136
The Artist's Bedroom in the Villa La California
La Chambre à coucher de l'Artiste dans sa Villa La Californie
29.12.1953
Oil on canvas, 50.7 × 37.8 inches

After the war Picasso painted his first "real" interior, the kitchen in the Rue des Grands-Augustins. This broad-format picture is almost twice the size of the *Studio Window* (Plate 134a) and stands at the opposite end of Picasso's formal range. The former is painted in a Cubist manner, while the kitchen picture is constructed out of signlike lines. We have seen the same development in the portraits of this period. When Picasso was working on *The Kitchen* (Plate 135), he defined the difference to Françoise Gilot: "If one occupies oneself with what is full: that is, the object as positive form, the space around it is reduced to almost nothing. If one occupies oneself primarily with the space that surrounds the object, the object is reduced to almost nothing. What interests us most—what is outside or what is inside a form?"*

Picasso used the model of the kitchen to present what is outside, the shape of space, whereas in the *Studio Window* he was still using Cubist technique to create the shape of the object. *The Kitchen* is the actual working model from which he acquired the formal insights that enabled him to make the studio-picture, the interior, a subject in its own right.

We know that the studio in the Rue des Grands-Augustins was painted white—a cube of space. Some caged birds and three Spanish plates on the wall were the only strong touches of color. This cool, almost graphic scene attracted Picasso, who declared: "I'm going to make a canvas out of that—that is, out of nothing." As often

* *Ibid.*, p. 219.

happens in the late work, when he is on the brink of a new theme or a pictorial discovery, he restricts his treatment to a few colors, often to gray alone. The elimination of color permits total concentration on the drawing and modeling of bodies, planes, and space. In complete contrast to Matisse, who composed his pictures entirely of colors (and in this respect was primarily a painter), Picasso, when he confronts a crucial task, relies on line and the hand that draws it before he turns to color. His graphic talent is so resourceful that with brush and wash alone he can achieve the most painterly effects, often surpassing coloristic ones.

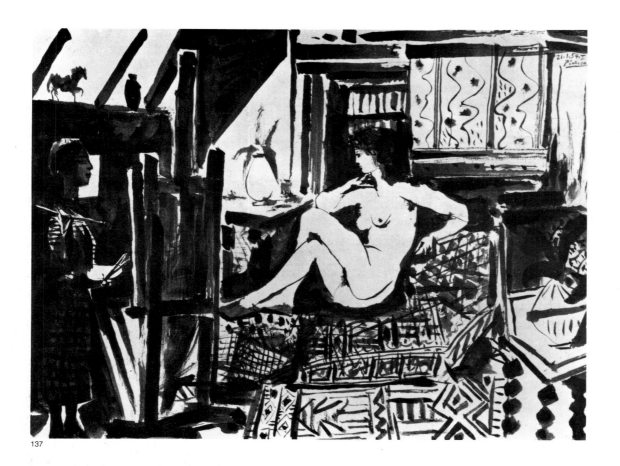

137

"...I don't want there to be three or four or a thousand possibilities of interpreting my canvas. I want there to be only one and in that one, to some extent, the possibility of recognizing nature, even distorted nature, which is, after all, a kind of struggle between my interior life and the external world as it exists for most people. As I've often said, I don't try to express nature; rather, as the Chinese put it, to work like nature. And I want that internal surge—my creative dynamism—to propose itself to the viewer in the form of traditional painting violated."

(GILOT)

In *The Kitchen* he began, as usual, with a grid of construction lines marking off the space. The disclike forms of the plates assert their dominant position in the picture: The birds flutter around them in a sort of *volière* formed by the network of lines. A few articles of furniture denote that the theme is an interior. This produces exactly the effect Picasso described to Françoise: "When you look at Cézanne's apples, you see that he hasn't really painted apples, as such. What he did was to paint terribly well the weight of space on that circular form. The form itself is only a hollow area with sufficient pressure applied to it by the space surrounding it to make the apple *seem* to appear, even though in reality it doesn't exist. It's the rhythmic thrust of space on the form that counts."*

Although it was some time before the studio-picture began its vigorous growth spurt, the method of approach had now been formulated. In the duress of the war years Picasso certainly could not have thought of his studio as "free space." Even after the war things were not much better, for his sojourn at the *Château Grimaldi* was no more than an episode. He went there as a guest and was far too interested in the revival of life outdoors and on the beach to find full satisfaction in his temporary working quarters. Vallauris did not lead him into the interior dimension either: *La Galloise* was not very big, his work was interrupted by a lot of traveling, and the pull of the ceramic *atelier* of his friends Suzanne and Georges Ramié, like that of

137
The Studio
L'Atelier
21.1.1954 I
Wash, 9.4×12.5 inches

138
Nude in the Studio
Nu dans l'Atelier
30.12.1953
Oil on canvas, 34.7×45.2 inches

* *Ibid.*

Mourlot's lithographic workshop in Paris, was stronger than the pull of the painting studio.

The renaissance of the studio-picture occurred when it was linked—as had already happened once before—with the "painter and model" theme. One motif contributed to the stronger profiling of the other, and this time it was the painter and model theme that supplied the initiative. In the winter of 1953 to 1954, in his first real burst of creativity since Françoise Gilot's departure, Picasso produced some eighty drawings

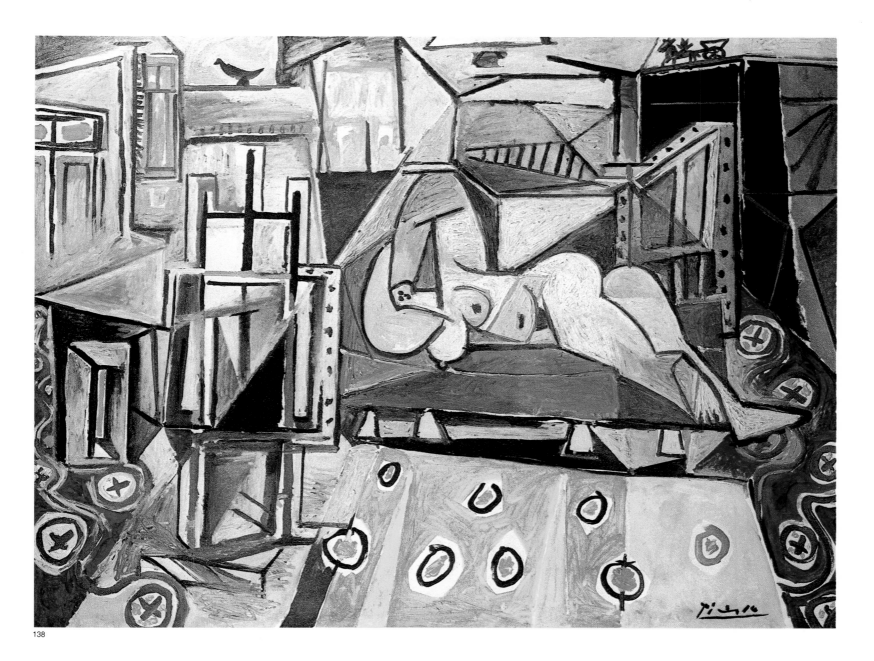

138

of this subject. In this profusion of drawings, the paintings of the same period, which can be counted on the fingers of one hand, look like isolated blocks. He painted two pictures of Paloma at play, two of a reclining nude with the shadow of the artist falling upon her as he stands at the window (Plate 136), and one of the reclining nude alone in a spacious interior. They were all closely linked with his state of mind, which that winter fluctuated between retrospective restlessness and ironic aloofness. The imaginary shadow shows that the nude is imaginary too. But the topography of the room has an almost obtrusive austerity which Picasso must have sensed in his deserted house. For the first time he painted the inside of *La Galloise,* where he now lived alone. Later, when his friend David Duncan, the photographer, was unable to puzzle out the meaning of this "shadow portrait," Picasso in an outburst of irritation provided the context: "That was our bedroom. You see my shadow? I had just turned away from

the window. Can you see my shadow now, and the sun falling on the bed and the floor? Can you see the toy cart on the dressing-table and the little vase on the mantel?" A few days after he painted this picture, the poignant situation was clarified in the full-scale scene depicted in *Nude in the Studio* (Plate 138). The shift from bedroom to studio, or the broadening of the one into the other, immediately objectivizes the aesthetic relationships too. A few attributes remain in their places: the cart and a little sculpture of a bird on the mantel, but the familiar pattern of the tiles and a rug now interpenetrate as do various perspectives in the rooms of *La Galloise*. Furniture, window, and views surround the central composition, developed in depth, of the reclining nude on the sofa. The easel occupies the painter's place in the foreground. The picture, with its richly variegated color and drawing, already presents in schematic form the major elements out of which Picasso would compose *The Women of Algiers* a year later. Moreover, the disposition of space would serve as a model for the studio-pictures he would paint in the larger villa of *La Californie*.

In these few pictures Picasso—almost as an afterthought—has recorded the interior of *La Galloise* just as he recorded its exterior and immediate surroundings in the landscapes he painted some months before. The more literally he treated certain landscape motifs, the more concrete his still lifes and the more filled with presence his portraits became, the more his interiors profited from the free presentation, based on vision, of their objective content. Picasso himself profited from the move to *La Californie* in Cannes in 1953. Here the interior picture really achieved its full development, making all earlier versions look like mere preliminaries. The studio has never been so obviously the center of Picasso's work as during the first years with Jacqueline in Cannes. The many rooms, high ceilings, big French windows, paneled walls, and ornamental plasterwork gave Picasso a sense of spatial ease such as he had never enjoyed before. He invented the name *paysages d'intérieur* for his studio-pictures of *La Californie*.

This concentrated treatment of the interior landscape of the studio, found only in the late work, is closely associated with *La Californie*. He offset the wild landscape outside and the thick-walled rooms inside with portraits of Jacqueline and figure groups painted in starkly contrasting black, yellow, and red. He painted the huge Baroque sideboard and the black and white Dalmatian, Perro. These paintings composed of stable individual forms have their counterpart in the paraphrases of Manet's *Déjeuner sur l'Herbe* (Plate 224), which Picasso began in Vauvenargues. These variations, in colors again reduced to green, black, and white, matching the austere surroundings, are a far cry from the balanced *paysages d'intérieur*. Even in the comfortable house of *Notre-Dame-de-Vie* not far from Cannes, to which Picasso moved in 1961, the studio-picture did not come back to life. The smooth, unpicturesque rooms did not tempt him to turn them into pictorial stage sets. New tasks and subjects crowded in upon him—as happened every time he moved.

Picasso's œuvre lacks the continuity of a stylistic evolution unaffected by the subject matter. For him consistent work is always associated with a specific goal which he has in mind, although it is not necessarily important for him to reach it. "To finish a thing is to kill it, to take away its life and soul," he once told Sabartés. Stylistic criticism

The series of studio-pictures was painted in conjunction with The Women of Algiers. *Picasso calls them* paysages d'intérieur. *The studio is flooded with light. The contrast between the coolness of the room and the heat outside is suggested in the colors. The studio-pictures were painted at* La Californie; *we recognize its bizarre windows and the palm trees in front of the house.*

"I treat painting just as I treat objects. That is, I paint a window in exactly the same way as I look out of it. If an open window looks wrong in a painting I close it and draw the curtain, just as I would in my own room."

(CAHIERS D'ART, 10, 1935)

139
The Studio
L'Atelier
23.10.1955 II
Oil on canvas, 76×50.7 inches
Galerie Rosengart, Lucerne

140
Woman in the Studio
Femme dans l'Atelier
5.4.1956 II
Oil on canvas, 34.7×45.2 inches
Collection Dr. Bernhard Sprengel, Hannover

141
Woman in the Studio
2.4.III, 8.4.1956
Oil on canvas, 43.5×56.9 inches
Galerie Rosengart, Lucerne

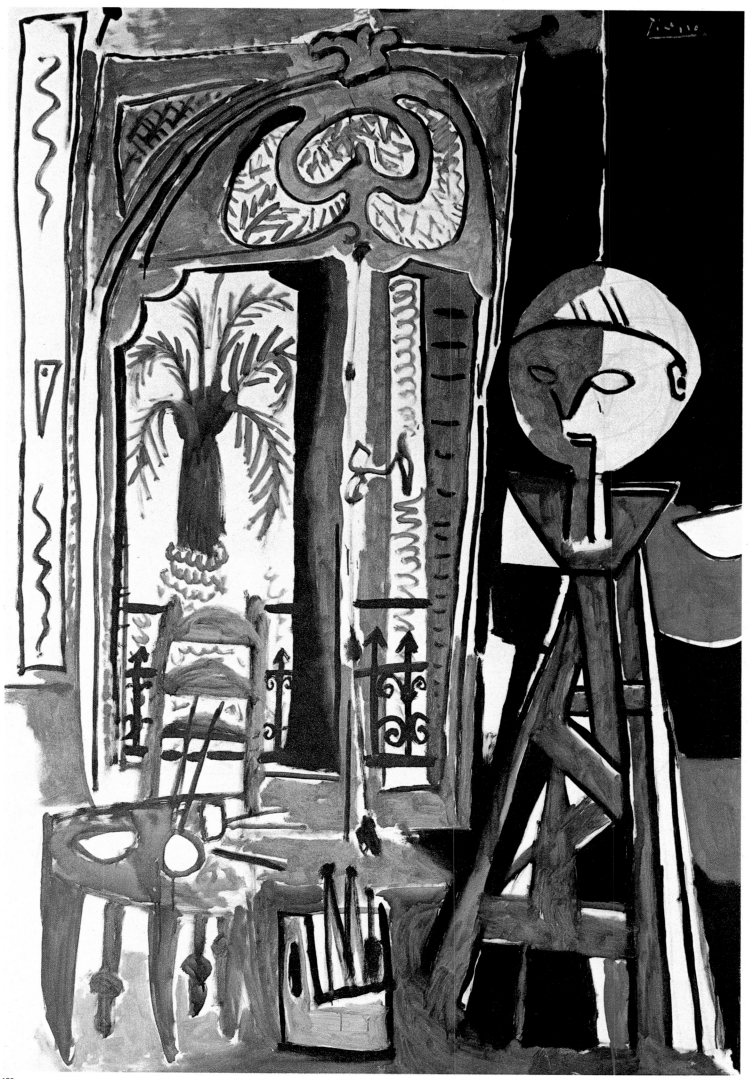

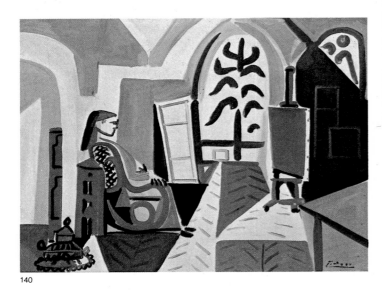

140

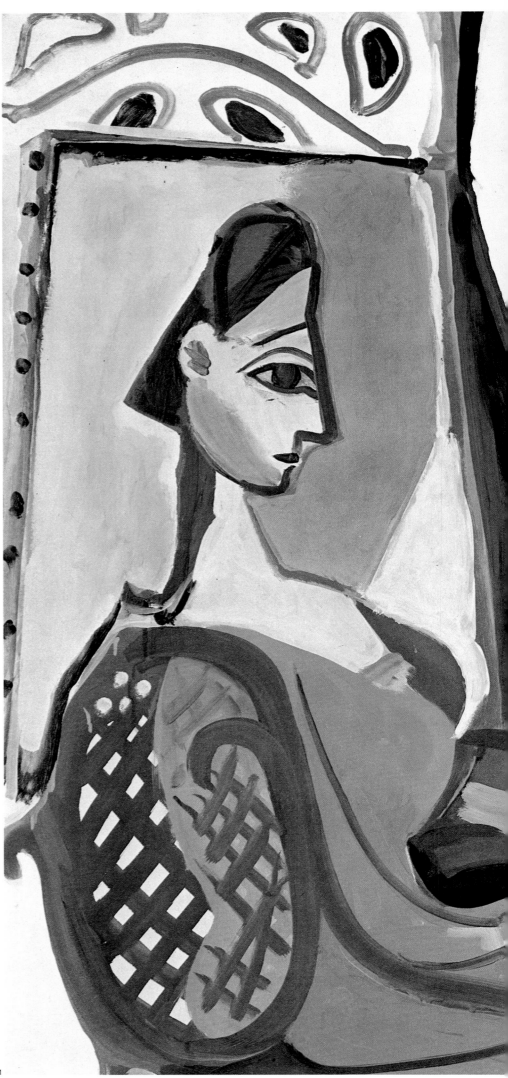

141

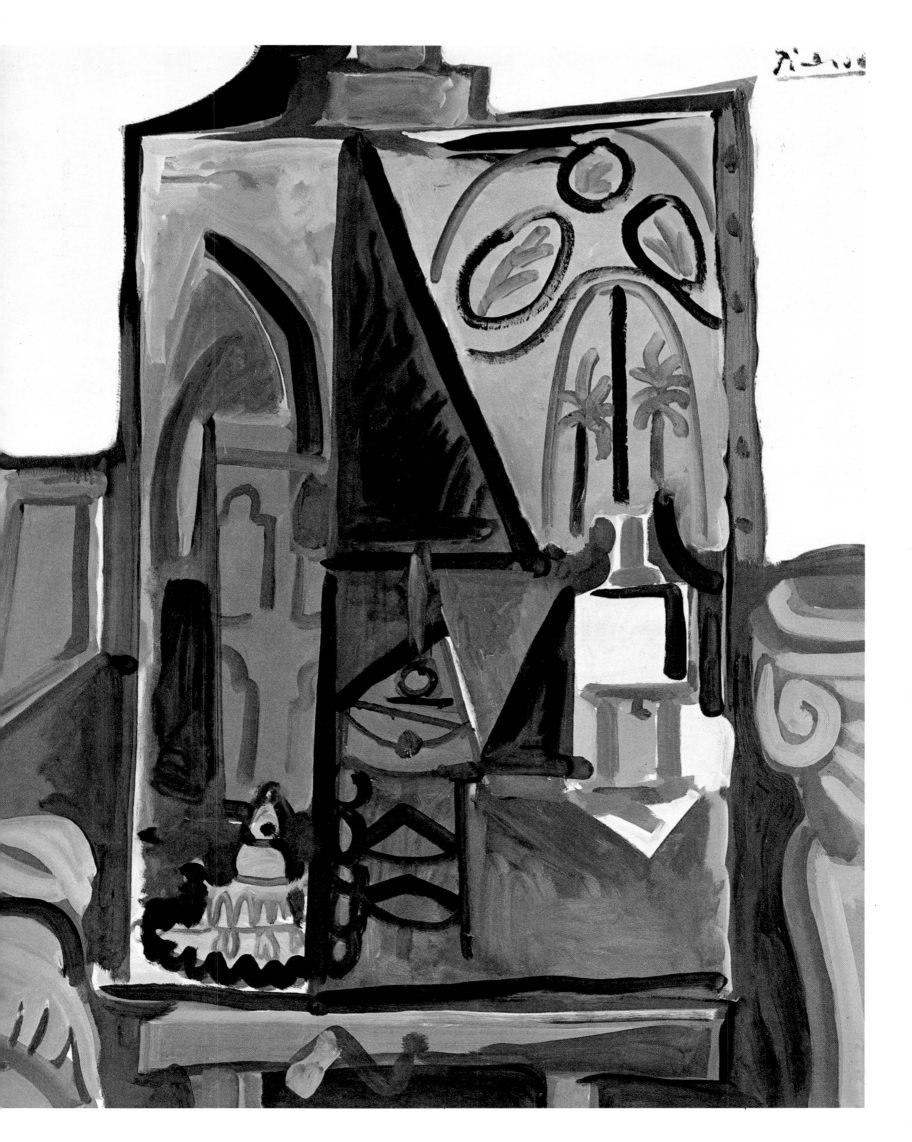

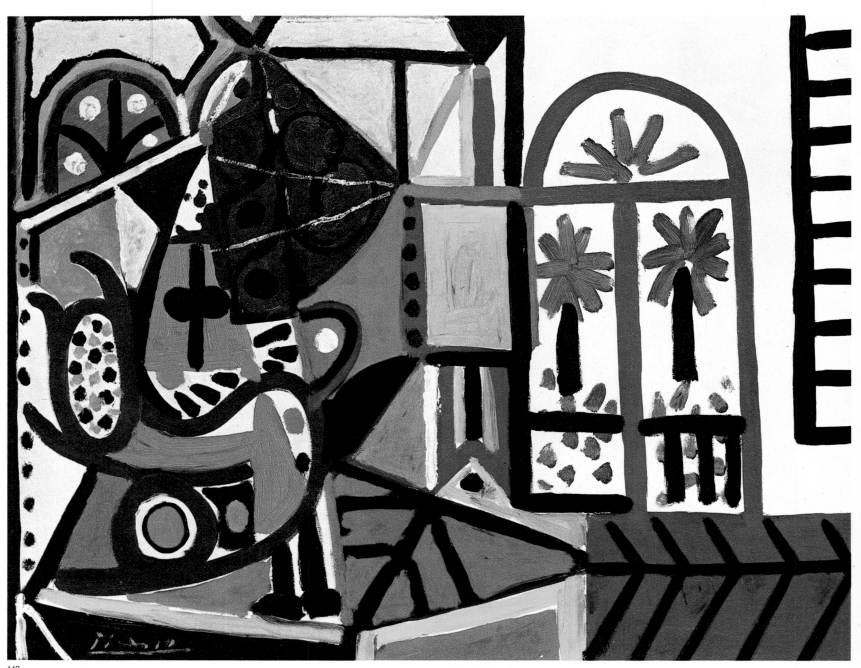

142

*The numerous "interior land-
scapes" Picasso painted after
he moved to* La Californie *late
in 1955 show three phases of
his effort to simplify the
spatial relationships, which in
the end are reduced to a
pattern of delineating brush-
strokes. As the spatial element
vanishes, the formal accents
emerge more clearly—the
French window with its* art
nouveau *frame, the palm trees
in the garden, the rocking
chair in the foreground, the
easel and canvas, sometimes a
piece of sculpture or a samo-
var. On the other hand he
devoted less than a month to
the empty studio—and during
that time he also worked on the
pictures of women in Turkish
dress. The overall view of the
studio is at first treated expan-
sively in large format; then it
is compressed into smaller
canvases and finally gives way
to closely adjacent views in
series. It was not long before a
woman moved into the studio.
From now on she would be the
dominant motif, until the
theme was absorbed into the
greater context of painter and
model.*

easily overlooks the chance events which have a determining function in Picasso's life
and which especially affect the late work. Often, as we have seen, they precipitate
whole groups of pictures. Never have Picasso's involvements, his contact with people,
rooms, and objects, been so directly reflected in his creations as after World War II.
Picasso's often obsessional urge to create is not merely uninhibited enthusiasm but a
pressing need to pit his involvement against the discipline of work. Just as Picasso
never repeats himself, he mistrusts the media he uses. The shift from painting to
ceramics, from drawing to montages, from sculpture to graphics, represents a break
which the benevolent viewer dismisses in the cliché that Picasso "can do anything."
In 1966 Picasso did not paint a single picture, but between March and October
1968 he produced 347 etchings. A year later, between 1969 and 1970, he did
nothing but paint, as though his brush, colors, and canvas had to make up for lost
time. This resulted in 165 paintings, after which he devoted himself chiefly to
drawing.

Seen in this context, the *La Californie* studio-pictures take on added significance
because the studio to Picasso represents an investigation of his own position,
comparable to the self-portrait. In 1955, at a crucial moment in his work, Picasso
laid claim to this theme. Matisse had died the previous year—one of the few painters
with whom Picasso maintained a friendship based on the utmost artistic respect, and
also one of the few to use the interior as a major subject. Picasso's own capacity for
involvement (sustained at first purely by temperament) led him to take possession of the
studio-painting theme as he had taken possession of *La Californie*. He had immedi-
ately sensed the unusual amount of space afforded by the rooms of this summer villa,
built in the upper-bourgeois style of the early twentieth century. He could cram the
studio full of apparatus without diminishing the impact of the space.

Picasso accepted the challenge, and the pictures he began to paint of the studio
show the fascinating effect of this strong environment. The first ones are large in
format, but he soon realized that he could organize space just as effectively on smaller
canvases. In three separate stages he gradually gained control of the studio at *La
Californie*. Between 1955 and 1956, using three different approaches, he transposed
the stylistic arabesques of the architecture into the geometrical arabesques of the
picture. He reduced the close view, with its Baroque articulations and details, to
almost schematic two-dimensional values. Nearness and distance kept changing
position: Objects in the foreground were sometimes incorporated in a larger perspec-
tive, only to be suddenly moved forward again. An early series of tall pictures was
followed by wide-angle views with marked development in depth, until in the end the
picture form triumphed over space and model.

In October, 1955, Picasso painted the first twelve views of the studio, with the *art
nouveau* window in the center, the palm tree in front of the house, the table and chair,
and, on the modeling stand, the sculptured head that characterizes this whole group of
paintings (Plate 139). The space is filled with light. The cool colors, chiefly green,
gray, and brown, sustain the loose, almost illustrative treatment. Despite many
reminders of Matisse, all the large forms, such as the window and the head, are
drawn large and dominate the composition as a whole. The emphasis on the window

142
Woman in the Studio
Femme dans l'Atelier
1956
Oil on canvas, 25.35 × 31.6 inches
Galerie Beyeler, Basle

persists throughout all the variants, although certain shapes combine in different graphic patterns of planes. The ornamental tendency dominates a feeling for the solid and the sensual.

The following month brought portraits of Jacqueline in oriental costume, as though the painter no longer found the empty studio a satisfying subject, but he continued the arabesquelike treatment of forms. In April, 1956, he painted four versions of the studio. His stage had expanded, and all the objects were rearranged in a new disorder: samovar, easel, several pictures, a small table with an abstract sculpture on it, another easel—for here again Picasso presented an exact record of his studio. Nothing was painted that was not visible to the eye. But the significant value of the objects was altered and redetermined by changes of scale or by duplication or reduction.

Once the painting had moved into the studio—the painter himself being absent—it was only a small step (which Picasso took from one day to the next) to bring Jacqueline herself into the picture in eight more paintings. The studio is no longer empty but oriented toward the woman, seen in severe profile sitting in the rocking chair. In the last version of *Woman in the Studio* (Plates 140 ff.), beside the seated woman stands an easel with a picture of the studio including an easel bearing an empty white canvas: a picture within a picture, the studio-picture in the studio. Here the colors are organized in bigger planes, and less than four weeks later, in a final series of more than ten studio-pictures, Picasso reformed the composition also. The easel has been placed between the woman and window. Its rectangular frame fixes the dominant geometrical pattern from which the space (now reduced to signs) derives its reality.

Picasso's interest in his studio as a subject outlasted his move to *La Californie* by barely a year. But the intensity with which he went at it justifies us in regarding these pictures as a distinct cycle whose keynote is a happy one. In a larger context their significance transcends even their aesthetic and biographical importance. They appeared exactly one year after the first great interior scene, *The Women of Algiers,* and exactly one year before the second, equally important one (also a studio-portrait): the *Meninas* after Velázquez. Picasso's *paysages d'intérieur* take their place in an "art history" where Delacroix and Velázquez are his immediate neighbors. Finally the studio at *La Californie* is also the point of intersection with the furthest-reaching theme of the late work: painter and model. To be sure, the painter himself (well known from the drawings of 1953) is absent, but the model has already taken her place in the studio.

The Absorption of the Old Masters

"All the documents of all the periods are false! They all represent life 'as seen by the artists.' Every image we have of nature we owe to the painters. It is through their eyes that we see it. That alone would be enough to make it suspect." (BRASSAÏ)

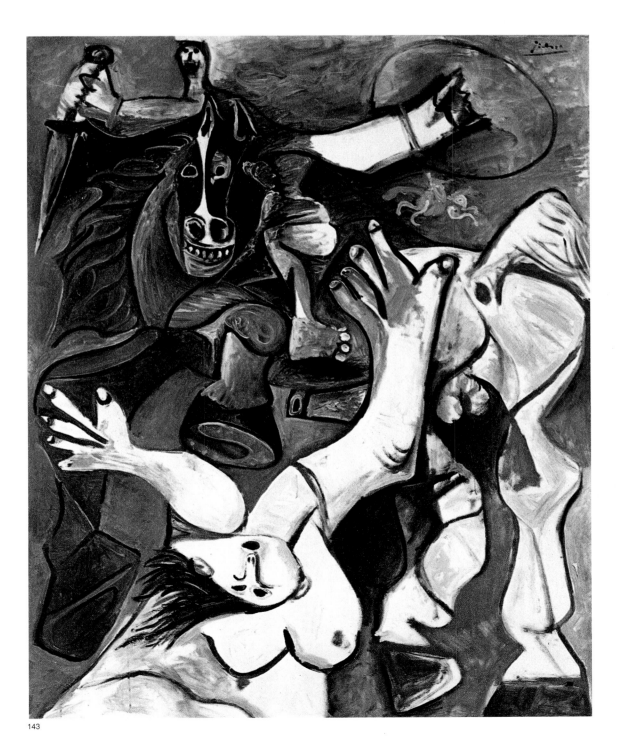

143
The Rape of the Sabine Women
L'Enlèvement des Sabines
2.4.II 1962
Oil on canvas, 63.2 × 50.7 inches
Norman Granz, New York

143

144

145

146

Every artistic step forward represents a rejection of the technique and content of earlier art and also of its vision and its concepts of form and color. One might think that Cubism in seeking a radical break with the past thereby freed itself from all mirroring of earlier art. But its antitraditional arguments went along with its liking for primitive sculpture, so that Picasso's "période nègre" became the germ of Cubism in his painting.

Later, too, nothing fascinated him more than other artists' art, provided he could reshape their works according to his own principles. He measured himself against their achievements. But he was challenged only by certain ones: those whose claims he was eager to test against a whole set of problems in his own work. Other painters' pictures are second nature to Picasso; they are as real to him as the face he is painting or the goat's skull he is modeling. Picture and copy are on an equal footing; he never interposes any element of parody or polemic. In fact, through intensive examination of a model he constantly forces himself to discover more about his own potentials. One sign of his analytical approach to the pictures of other painters is the number of versions of his own that the model compellingly suggests to him.

Even though this process of measuring himself against other artists does not imply imitating them in his own style or "copying" them in any way, it does imply appropriating them to his own use and often leaving the original point of departure far behind. Picasso himself asked rhetorically: "What is a painter after all?" And he replied: "A collector who creates his collections by painting other people's pictures that he admires." The egoism of this definition is in itself an unmistakable declaration of loyalty to painting and its tradition. But Picasso, always self-contradictory, has followed the opposite procedure too and acquired works he wanted in the conventional way: by buying them or by exchanging paintings with his fellow-artists.

Even during World War II pictures by other painters, including Renoir, Cézanne, Rousseau, Matisse, Derain, and Miró, were stored in a bank along with his own.

"The funny thing is that I have never been able to paint a picture! I begin with an idea, and then it turns into something quite different. What is a painter after all? A collector who wants to acquire a collection by painting other people's paintings that he admires. That's how I begin, and then it turns into something else."

(LE POINT, 42, 1952)

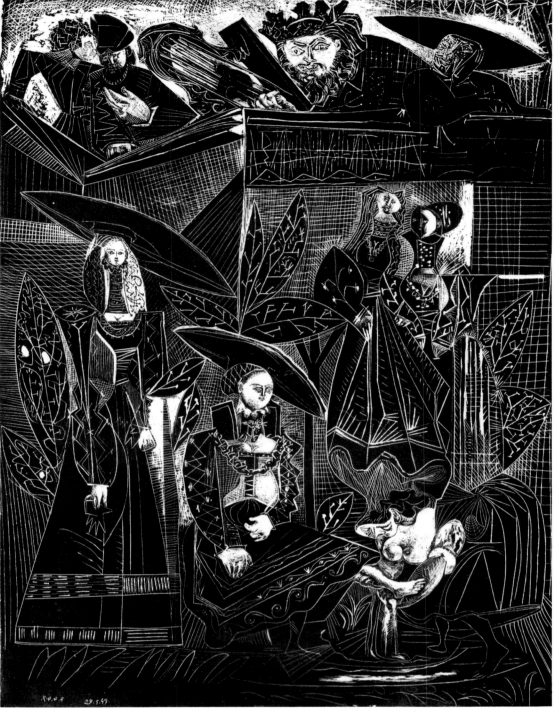

147

144
Rembrandt and Heads of Women
Rembrandt et Têtes de Femme
27. 1. 1934
Etching, 5.4 × 8.1 inches
From the Vollard suite

145
Rembrandt with Palette
Rembrandt à la Palette
27. 1. 1934
Etching, 10.8 × 7.7 inches
From the Vollard suite

146
Rembrandt and Two Women
Rembrandt et Deux Femmes
31. 1. 1934
Etching and mezzotint, 10.8 × 7.7 inches
From the Vollard suite

147
Rembrandt and Woman with a Veil
Rembrandt et Femme au Voile
31. 1. 1934
Etching, 10.8 × 7.7 inches
From the Vollard suite

148
David and Bathsheba
David et Bethsabée
7. 4., 29. 5. 1949
Lithograph, 29.6 × 21.8 inches
After Lucas Cranach

They formed part of a collection which he had not "manufactured" himself but which nonetheless influenced his judgment and his relation to other artists. Ever since the Bateau-Lavoir days he had felt an instinctive need to exchange ideas with other painters, and this had been a constant source of stimulation. These friends dropped in on one another and shared each other's problems, both artistic and material. Without an understanding of this free camaraderie, many of the inspirations and connections which show themselves in Picasso's pictures would not be understandable. The influence Picasso's famous collaboration with Braque in Céret and Avignon had on the form of Cubism in the work of both painters may be controversial or exaggerated, but it is quite concrete. We know that the banquet in honor of Henri Rousseau held in Picasso's studio in 1908 was a practical expression of the Cubists' respect for the naïve painter who, as Léger and Picasso always insisted, was a major source of productive inspiration to them. The Cézannes Picasso saw in a memorial exhibition at the *Salon d'Automne* of 1907 influenced the development of Cubism for years. Cézanne and Ingres are the key witnesses to his art, and he is constantly appealing to their authority.

In 1906 Picasso made the acquaintance of Matisse, who, as one of the spokesmen of the Fauves, was under violent attack at the time. Picasso's important relationships (which were not necessarily lasting) all date back to the time of his first independent steps. Some friendships cooled—the one with Braque for instance; others survived all personal vicissitudes.

Matisse had moved to the Midi after World War I and was living in Nice, not far from Picasso. Their reunion developed into a regular dialogue which lasted until Matisse's death in 1954 and was extremely stimulating to Picasso. The conversations, unfortunately never recorded, between these two painters so dissimilar in temperament and style, prompted some remarks and reflections by Picasso which are echoed in his work. He had never hesitated to appropriate other people's ideas if he could use them or to exploit details (sometimes even the total composition of a picture) for his own purposes. Although Braque always found this disturbing, it did not make the old Matisse any more reticent. Picasso's liking for Matisse stemmed partly from the essential differences between the Northern Frenchman and himself. Picasso's words when Matisse died: "Matisse is dead and he's left me his odalisques," were an unqualified claim to his artistic heritage. In the mid-1950's Delacroix and Matisse strongly influenced Picasso's studio-pictures, his *paysages d'intérieur,* as well as his portraits of Jacqueline in Turkish or Provençal dress. Despite the rapid changes in Picasso's forms, we still catch glimpses of the coloristic richness of Matisse's palette.

149

The circle of friends and fellow-seekers diminished with the years. However out of touch Picasso may have been with a friend, the news of his death always bridged any gap in time or artistic development. Picasso felt that his own generation was dwindling away. He got some satisfaction out of surviving, but he hated death and avoided all contact with it. In his art, however, he looked death in the eye. In his private life, where the mere idea of illness and dying terrify him, the subject is never mentioned. But in his paintings, drawings, and sculptures he has taken it upon himself to challenge death as no other twentieth-century artist has done, to show all the protean faces behind which this inexorable reality masks its terror and magnitude.

During the war, when Picasso heard of the death of his compatriot Julio González, the sculptor, he painted a grim epitaph in the form of a still life with an animal skull in front of dark, closed windows. In 1952 Paul Eluard died, a friend whose ironic conversation he had enjoyed, followed not long afterward by André Derain and Maurice Raynal, friends from the Bateau-Lavoir days. The same year, 1954, he lost Laurens and his neighbor and partner in dialogue, Matisse. Then Léger died, and in 1963 Braque, who had been particularly close to him in the early days. Picasso triumphed over his generation but felt a growing dislike of official pomp and ceremony, always slightly funereal in tone, typified by the tribute to Braque in Paris. Long before this he had left the capital, where fewer and fewer of his old friends and enemies now lived.

149
Rembrandt van Rijn
Bathsheba at Her Toilet
1654
Oil on canvas, 55.4 × 55.4 inches
Louvre, Paris

150
Bathsheba
Bethsabée
30. 1. 1960
Oil on canvas, 54.6 × 76 inches

Picasso's capacity to spend years pursuing the artistic questions that concern him and examining them in the light of what other painters of his generation are doing inevitably leads to a broadening of his dialogue with the artists of the past. As his own generation died out, he cleared the ground for a spontaneous, far-reaching study of masterworks of painting. The old revolutionary, who thought that he and his likeminded friends had broken radically with the past in getting rid of the pictorial illusionism that had existed for centuries, now brought his lifetime's experience to bear on history, paraphrasing it legibly and authentically. His transpositions are analogous to the attempt to find a new place for these "monuments of the past" in the present day. The changes which Picasso makes in the model disrupt the conventional manner of looking at it, which often obscures the painting like a dull yellow varnish. His urge to preserve history and make it available through word and reproduction is unmasked when he deciphers classical works in his own way, producing a critical adaptation rather than a reproduction. Every one of Picasso's paintings is a challenge to see the

150

works of the old masters in this way. Through him the imaginary museum acquires a new content, ever changing and productive.

These reevaluations of art history are quite compatible with his reluctance to visit real museums. He avoids his own exhibitions as rigorously as he avoids galleries and other cultural institutions. Shortly after the war he was invited to hang some of his works in the Louvre alongside masterworks of French and Spanish painting. He nervously accepted and was able to prove to himself—and to announce with pride—that his paintings had stood the test. "It's the same thing. It's the same thing," he exclaimed excitedly yet soberly.

But the insight which asserted itself so dramatically in this incident had long been maturing within Picasso's work, even though it had not yet inspired direct transpositions. His absence from Paris and its museums precipitated a need to measure his art against that of other artists. All he needed was a photograph or reproduction, and these were again becoming available through postcards, art books, and color prints. Along with catalogues of his own exhibitions, Picasso's mail brings art literature

prospectuses from every continent. It was easy enough for him to get what he needed. As naturally as he picks up pieces of trash—bits of wood, broken glass or pottery, or the remains of a metal frame, because he immediately recognizes a specific use for them—he can accept a half-tone or glossy print as an adequate vehicle for his vision. Picasso is by no means a unique example of the fact that one artist's important insights into another artist's work may actually be aided rather than distorted by imperfect reproductions. His recapitulation of his own arguments through the arguments of great masterworks is one of the most important processes in his late work. He took the shortest possible route to it, without detours.

Four etchings including the portrait of Rembrandt and nudes or heads of women appear in the Vollard suite (Plate 144 ff.). Although this head of Rembrandt is not based on any specific model from the Dutch painter's work, the face is unmistakable. It shows Rembrandt as he painted himself in middle life—when he was about the age of Picasso in 1930—with puffy cheeks and a bristly mustache above small, soft lips, and a cloud of curly hair springing from under a velvet cap. Something in the glance of the small, rolling eyes of this splendidly attired Baroque head recalls the Minotaur, whose "animalic humanness" is the subject of another series of etchings in the Vollard suite. Here, however, Rembrandt is presented wholly as a painter, with brush and palette or framed by a profile. The women are present as nude models. The simple, classical lines of their white bodies—they might have been painted by Ingres—make a contrast with the curly-haired Dutchman. Here Picasso's ingenious efforts to unite disconnected elements contrapuntally rather than eliminate them or smooth them over stylistically leads to the first typical painter-and-model constellation. The beauty and the monster—Picasso had always been aware of both. Aesthetically too they are the two poles of his art.

One of the Rembrandt etchings, a particularly vigorous drawing, shows a grinning faun instead of a girl standing beside the artist. In the late work Picasso would go much further in freely combining historical and mythological figures. Twenty years later, looking at these prints with Françoise Gilot, he offered this explanation: "You see this truculent character here, with the curly hair and mustache? That's Rembrandt. Or maybe it's Balzac; I'm not sure. It's a compromise, I suppose. It doesn't really matter. They're only two of the people who haunt me. Every human being is a whole colony, you know."[*]

What interested Picasso in the Rembrandt "colony" was the exemplification of the artist's nature and also the obvious problem of old age and late works in Rembrandt's development. Finally, he was interested in the change in the way Rembrandt saw the same objects—a striking characteristic in the evolution of his art. He himself saw exactly the same sort of changes. In the later work this new vision pervades more and more of his art. Picasso knew his Rembrandt, and it is quite possible that he had the famous etching of Rembrandt and Saskia (1636) clearly in mind. Rembrandt, looking out of the picture with his deeply shadowed face, might have been the direct inspiration of Picasso's Rembrandt. When he takes up the burin, Picasso works together with Rembrandt in a common intent which is not easily defined.

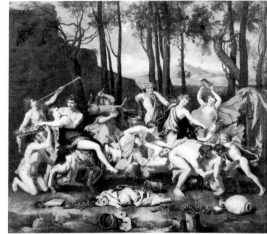

151

[*] *Life with Picasso*, p. 49.

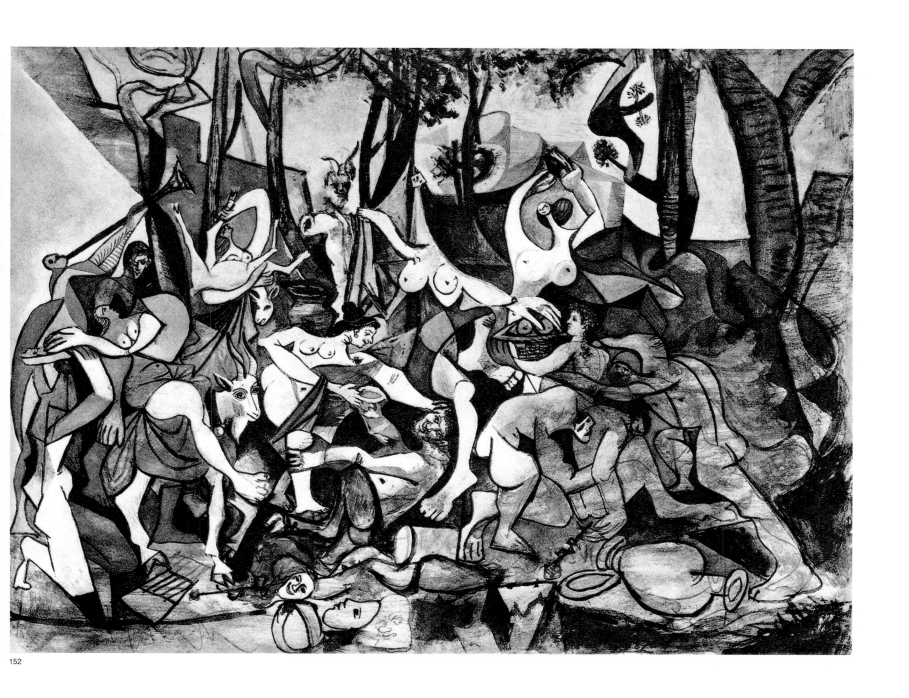

152

"*I painted it* [*the* Bacchanale] '*after Poussin' during the bloody days of the liberation, in the month of August. There was shooting going on everywhere. The tanks going by shook the house* ... *In the first days after the liberation, an American photographer made a reproduction of it in colors. He was the first American who came to see me.*"

(BRASSAÏ)

153

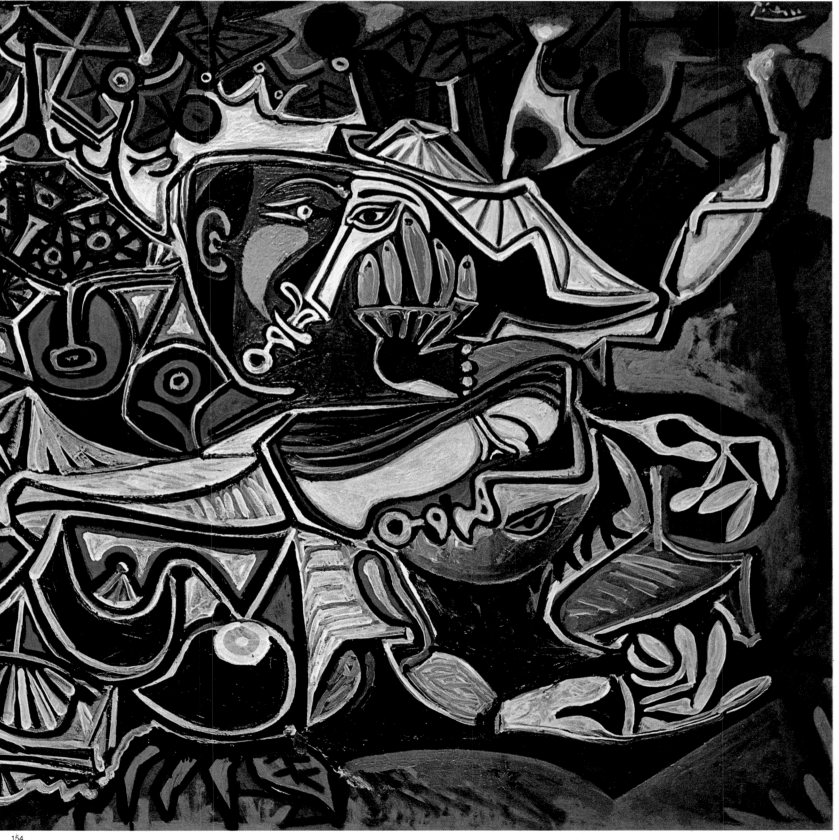

155
El Greco
Portrait of a Painter
About 1594
Oil on canvas, 31.6×21.8 inches
Museo Provincial, Seville

156
Portrait of a Painter, after El Greco
Portrait d'un Peintre, d'après El Greco
22.2.1950
Oil on plywood, 39×31.6 inches
Collection Angela Rosengart, Lucerne

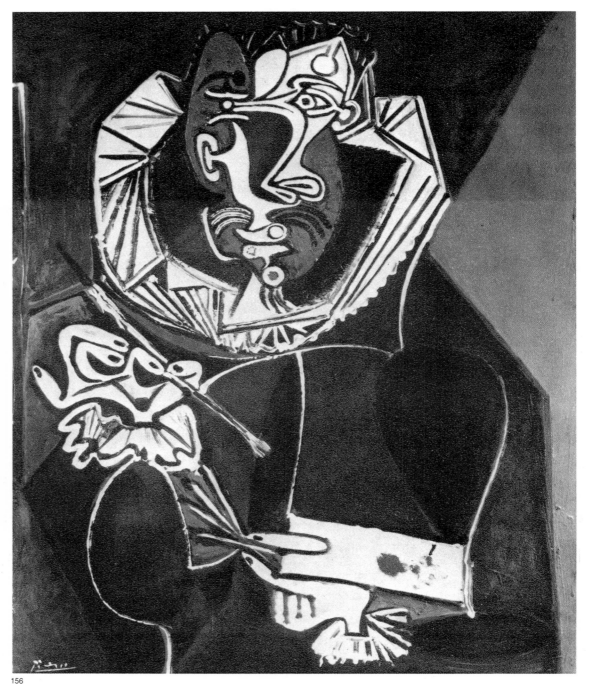

156

"I use the language of construction, and in a fairly traditional manner, the manner of painters like Tintoretto or El Greco who painted entirely in camaïeu, *and then, once their painting was about finished, would add transparent glazes of red or blue to brighten it up and make it stand out more."* (GILOT)

In a room at *La Galloise* Picasso hung a reproduction of a portrait of a woman by Cranach flanked by a self-portrait of his friend Henri Rousseau and a portrait of Rousseau's wife. The naïve stolidity of the Douanier's pictures underlined the courtly attitude of the Cranach lady. But the juxtaposition revealed something that Picasso finds by no means incompatible, something he even hoped to achieve with the "help" of these painters: sophisticated and primitive line, sublime and realistic treatments standing side by side.

Cranach's ambivalent talent for mixing ceremonial and human categories, eroticism

157

158

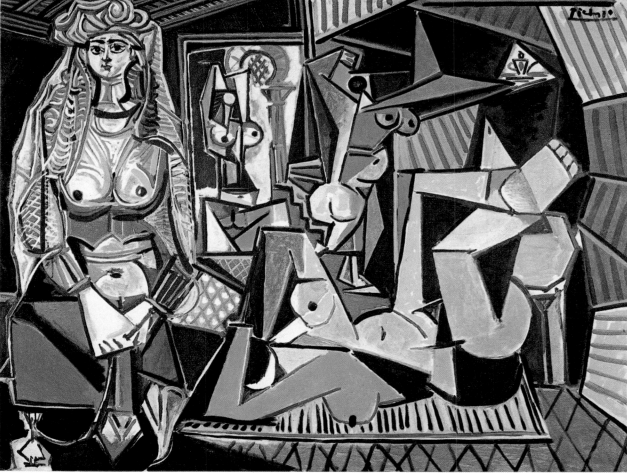

159

157
Eugène Delacroix
The Women of Algiers
Les Femmes d'Alger
1833
Oil on canvas, 69×88.5 inches
Louvre, Paris

158
Eugène Delacroix
The Women of Algiers
1849
Oil on canvas, 32.8×43.2 inches
Musée Fabre, Montpellier

159
The Women of Algiers
14.2.1955
Oil on canvas, 43.5×56.9 inches

and decorum, found an echo in Picasso's four lithographic variations on the David-Bathsheba story (Plate 148), which he compressed by drawing all the figures together into one plane. His treatment stresses the dramatic aspects of the story. Archaic stiffness is enlivened with folkloric elements. In the final versions line is emphasized even more strongly, so that the distinction between plane and line, black and white, is as sharp as in a woodcut.

In 1960, after a long hiatus, Picasso again modified the erotic element he introduced into the Bathsheba story. This time the subject is limited to Bathsheba and the maidservant washing her feet. Cranach's David and his retinue are omitted, so that it is not David who surprises Bathsheba but the viewer—as is also the case in Rembrandt's treatment of the subject (1654) in the Louvre (Plate 149). In a group of paintings and drawings Picasso explored the variations on this two-character scene, and then suddenly omitted the maidservant, thus arriving back, from a totally different starting point, at a subject which had prompted many significant works in the past: the nude washing her feet. (The most beautiful treatment of it is perhaps the big drawing of 1944 in Chicago.) In his paraphrases, made in 1960, Picasso combined this theme, borrowed from Cranach or Rembrandt, with the formal theme of the Greek statue of the boy pulling a thorn out of his foot. In this last phase, which

concentrates on the front view of the nude, all narrative details have disappeared. The Biblical story, adapted by Cranach into a courtly intrigue in Renaissance Saxony and humanized by Rembrandt to include erotic intimacy, is finally reduced in Picasso's three different treatments to the purposeless self-revelation of the female nude, free of all literary allusions—a play on the body itself.

Even Cézanne used to go to the Louvre "to paint a Poussin from life." Countless painters have gone there to see and copy the classic painter of the *Grand Siècle*.

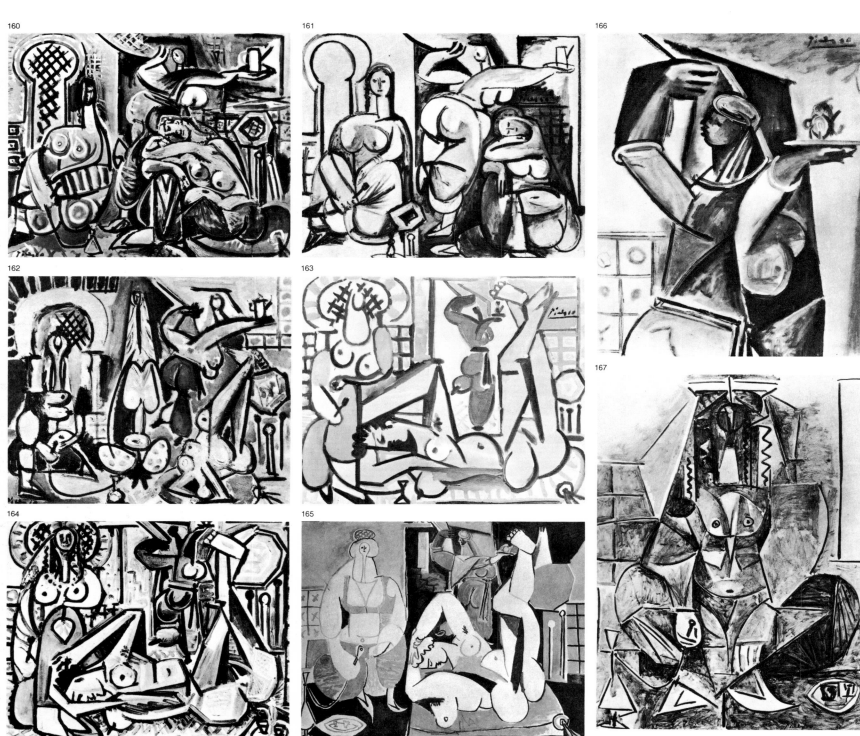

160—168 The Women of Algiers Les Femmes d'Alger

160
13.12.1954 Oil on canvas, 23.4×28.5 inches

161
13.12.1954 II Oil on canvas, 23.4×28.5 inches

162
28.12.1954 Oil on canvas, 21×25.35 inches

163
16.1.1955 Oil on canvas, 17.9×21.45 inches

164
17.1.1955 Oil on canvas, 21×25.35 inches

165
24.1.1955 Oil on canvas, 43.5×56.9 inches

166
18.1.1955 Oil on canvas, 25.35×21 inches

167
9.2.1955 Oil on canvas, 50.7×37.8 inches

168
1.1.1955 Oil on canvas, 17.9×21.45 inches

Picasso had given no inkling of his attitude to Poussin until August, 1944, the day of the liberation of Paris, when, without setting foot in the Louvre, he painted "his" Poussin: *The Triumph of Pan* (Plates 151 f.), based on a reproduction of a Poussin Bacchanale. He found the reproduction in the studio and made a quick preliminary sketch in watercolor to "catalogue" Poussin's frolicking figures. This he immediately transposed into an elaborate gouache in the same format. No detail of the Poussin is lost or suppressed. The landscape, the animals, the bacchantes are all there; the only difference is that everything is caught up in a far more violent, general movement,

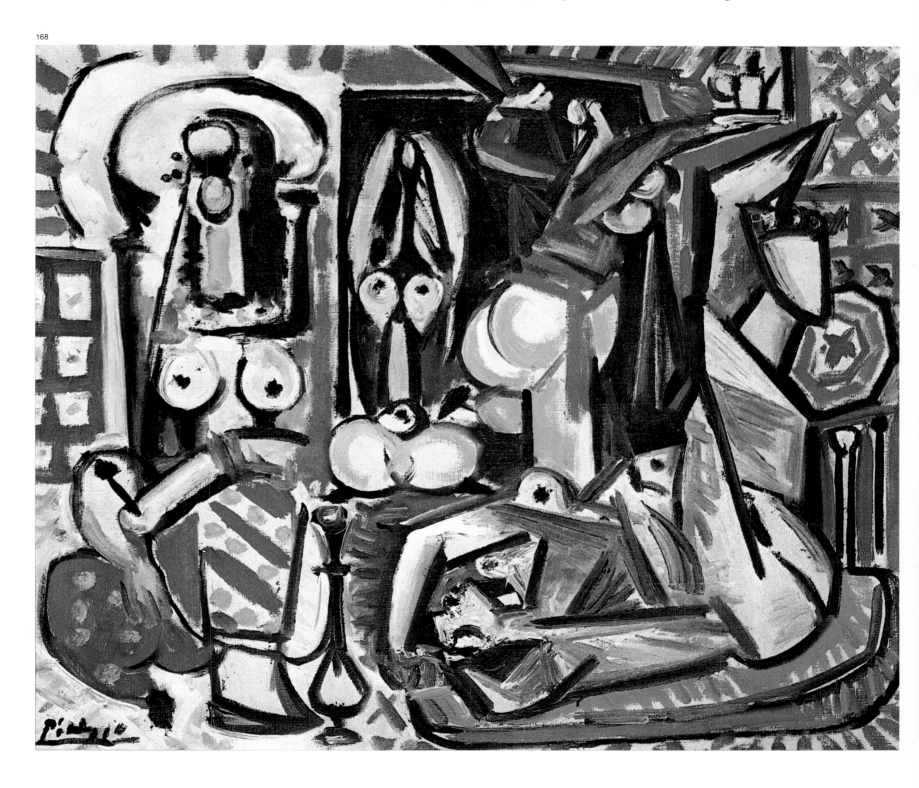

168

Between December 13, 1954, and February 14, 1955, Picasso painted his fifteen paraphrases of Delacroix's Women of Algiers. *They were first shown the following summer at the*

Musée des arts décoratifs in Paris, later in Munich, Cologne and Hamburg. The cycle was bought by an American collector but has since been dispersed.

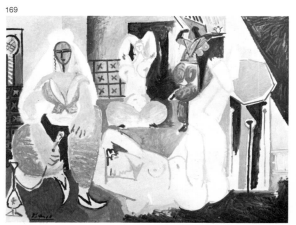

169

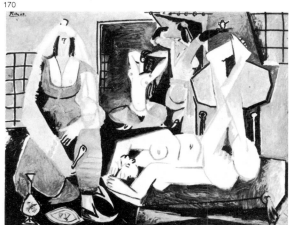

170

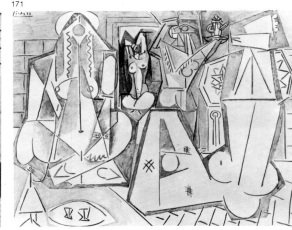

171

which knits Poussin's sophisticated compositional pattern into a great ornamental plexus. The bright colors of the light parts of bodies alternate with patterns of dark planes. Drastic distortions side by side with beautifully drawn heads of curling hair and some highly stylized groupings heighten the gay disorder of these revelers. Picasso had thrown Poussin's choreography overboard without any loss of clarity or exuberance.

In this gouache Picasso combined the most diverse stylistic reminiscences in a sort of collage technique. Some of the figures reach far back into his own work, celebrating a joyous return in this motley, orgiastic company. Others anticipate inventions still to come. This talent for playful juxtaposition is one more example of the mastery of media that marks Picasso's late work. Poussin used a classical motif as a vehicle for his programmatic art. Picasso was perfectly aware how far Poussin was from classical art, but he enjoyed making a meticulous adaptation of his formalized stage setting. When it came to individual figures, however, he drew upon his own reserves. The turbulence of the whole scene is heightened by the tendency we have already noted in Picasso to bring the subject closer to the viewer. Poussin's landscape, which frames the scene, has the function of creating an almost metaphysical order. In Picasso's version it has been trimmed and flattened, making the pictorial impact stronger and more direct.

As the years go by, maenads and fauns, horned creatures with cloven hoofs, goats, minotaurs, and centaurs emerge from the classical iconographical system of the Bacchanale. But to Picasso in those late August days of 1944 they symbolized liberation, and Poussin's model inspired him because it seemed to fit his own situation so exactly.

Not until 1950, when Picasso had been living in Vallauris for some time, did he turn back to art history. In the midst of family scenes, children's portraits and heads, paraphrases of two masterworks suddenly appeared. His models were Courbet and El Greco. In transforming the originals, Picasso chose the linear, two-dimensional style we have already described, which he had developed most extensively from about 1949 on in a series of portraits and figure paintings and which is still an essential element in the important *Still Life with Goat Skull* of 1952. In using it for his Courbet and El Greco models, he proved once again that to him a work of art or a

169–173
The Women of Algiers
Les Femmes d'Alger

169
25. 1. 1955
Oil on canvas, 43.5 × 56.9 inches

170
26. 1. 1955
Oil on canvas, 43.5 × 56.9 inches

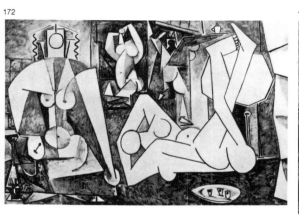

172

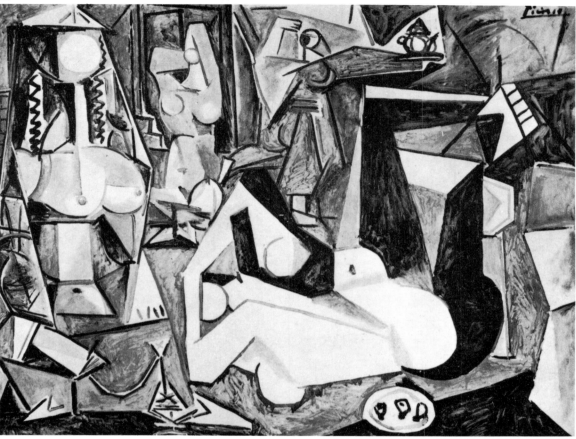

173

171
6. 2. 1955
Oil on canvas, 50.7×63.2 inches

172
11. 2. 1955
Oil on canvas, 50.7×76 inches

173
13. 2. 1955
Oil on canvas, 43.5×56.9 inches

reproduction is no different in kind from a living creature or a physical object, but just another part of physical reality.

There is little to suggest that Picasso began his replica of Courbet's *Demoiselles des Bords de la Seine* (Plate 153; painted in 1856 and since long in the Petit-Palais) after seeing the original, or that after deciding to paint it he made a study of his model. Probably here again he was content with a reproduction which chance brought to hand. Courbet's tremendous picture demanded that Picasso work in large format too: about three by six feet. What probably attracted him was the subject—two girls lying on a riverbank. Picasso admired Courbet's decision to free his models from the repressive atmosphere of art school and studio and paint them in a natural setting, not so much because this was the beginning of realism but because he himself "relocated" them in a similar way.

Courbet's theme of the reclining couple became a major subject in Picasso's late work. He made infinite variations on it, especially in the 1960's—couples asleep, thinking, or eating melons. But even in 1947, shortly before Courbet's girls invaded his painting, he had made lithographs of nudes or couples lying on the beach. He was in just the right mood for Courbet's magnificent work. Even in the reproduction he must instantly have recognized its vigorous eroticism, since he gave it a more austere, less suggestive form. Where Courbet painted the rustle of skirts, Picasso used their lines as structural elements. The legibility of Courbet's restless girls is encoded in an almost abstract oriental carpet pattern, which extends to the water and vegetation.

187/191/192/196/197/198

175/178/180/181/182/183/185/188/189/190

176/200/202/212

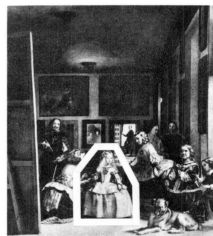

177/179/184/193

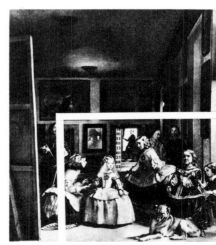

186/195/210/211

174
Diego Velázquez
Las Meninas
1656 Oil on canvas, 124×107.6 inches
Prado, Madrid

175—217 Las Meninas Les Ménines, all oil on
 canvas
175 The Infanta Margarita L'Infante
 Margarita 20.8.1957 39×31.6 inches
176 Doña Maria Augustina Sarmiento
 20.8.1957 17.9×14.8 inches
177—185 The Infanta Margarita
177 21.8.1957 39×31.6 inches
178 22.8.1957 12.9×9.4 inches
179 26.8.1957 16×12.9 inches
180 27.8.1957 16×12.9 inches
181 27.8.1957 12.9×9.4 inches
182 27.8.1957 12.9×9.4 inches
183 28.8.1957 9.4×7.4 inches
184 28.8.1957 9.4×7.4 inches
185 4.9.1957 13.65×10.5 inches
186 Doña Maria Augustina Sarmiento, the Infanta
 Margarita, and Doña Isabel de Velasco. At right,
 the dwarf and the dog 4.9.1957
 13.65×10.5 inches
187 Whole composition 4.9.1957 17.9×14.8
 inches
188—190 The Infanta Margarita
188 5.9.1957 13.65×10.5 inches
189 6.9.1957 16×12.9 inches
190 6.9.1957 17.9×14.8 inches
191 Whole composition 17.8.1957 75.6×93.6
 inches
192 Whole composition 18.9.1957 50.7×63.2
 inches
193 The Infanta Margarita 14.9.1957
 39×31.6 inches
194 Doña Maria Augustina Sarmiento and the
 Infanta Margarita at right 17.9.1957
 12.9×16 inches

195—198 Whole composition
195 19.9.1957 50.7×63.2 inches
196 19.9.1957 63.2×50.7 inches
197 2.10.1957 63.2×50.7 inches
198 3.10.1957 50.7×63.2 inches
199 Doña Isabel de Velasco 9.10.1957
 25.35×21 inches
200 Doña Maria Augustina Sarmiento
 9.10.1957 25.35×21 inches
201 Doña Maria Augustina Sarmiento and the
 Infanta Margarita 10.10.1957
 35.9×28.5 inches
202 Doña Maria Augustina Sarmiento
 10.10.1957 28.5×21 inches
203 Doña Maria Augustina Sarmiento
 10.10.1957 45.2×34.7 inches
204 Child 24.10.1957 23.8×19.5 inches
205 Doña Isabel de Velasco, the dwarf, child and
 dog 24.10.1957 50.7×37.8 inches
206 Doña Isabel de Velasco, the dwarf, child and
 dog 24.10.1957 50.7×37.8 inches
207 Doña Isabel de Velasco, the dwarf, child and
 dog 24.10.1957 50.7×37.8 inches
208 Doña Isabel de Velasco and the dwarf
 8.11.1957 50.7×37.8 inches
209 Doña Isabel de Velasco and the Infanta
 Margarita 15.11.1957 50.7×37.8 inches
210 Doña Maria Augustina Sarmiento, the Infanta
 Margarita and Doña Isabel de Velasco, at right,
 the child 15.11.1957 50.7×37.8 inches
211 Three persons from the center of the composition,
 at right the child below the dog 17.11.1957 I
 13.65×10.5 inches
212 Doña Maria Augustina Sarmiento
 17.11.1957 II 9.4×7.4 inches
213—215 Doña Isabel de Velasco
213 17.11.1957 III 9.4×7.4 inches
214 17.11.1957 IV 10.5×8.6 inches
215 17.11.1957 V 9.4×7.4 inches
216 Doña Isabel de Velasco and the child
 17.11.1957 VI 9.4×7.4 inches
217 Doña Isabel de Velasco 30.12.1957
 12.9×9.4 inches

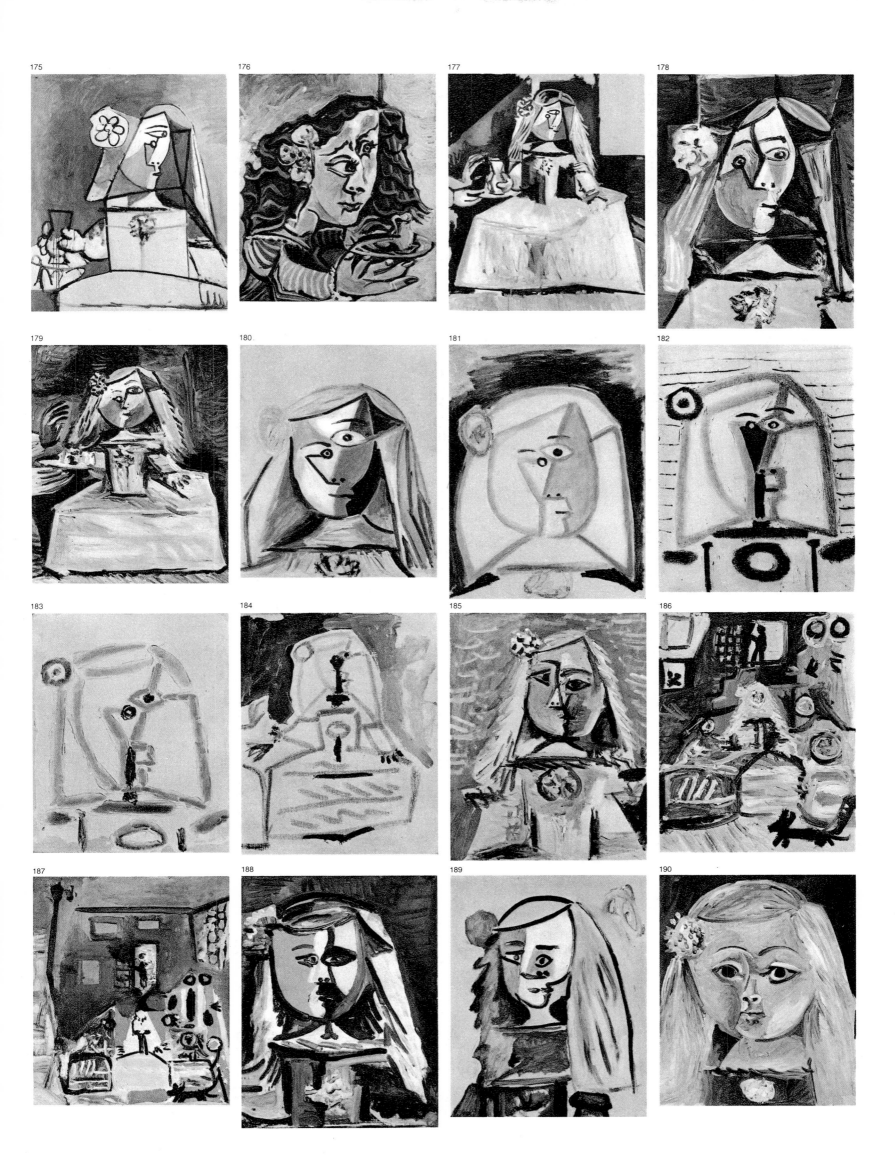

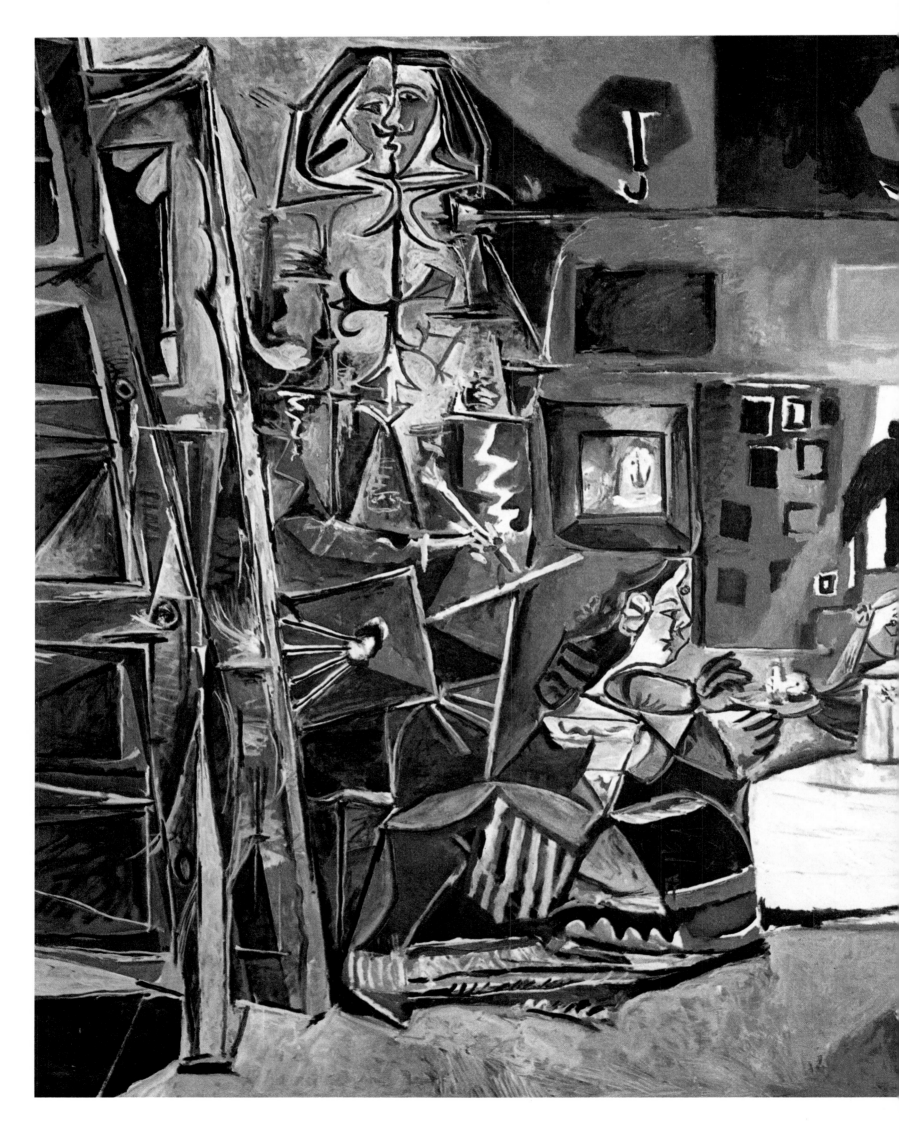

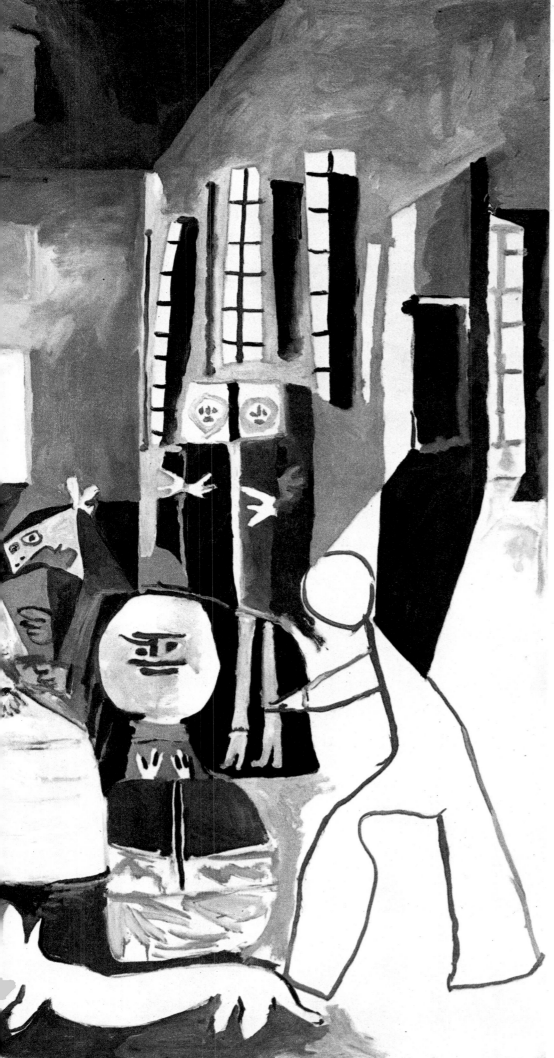

191

192

193

194

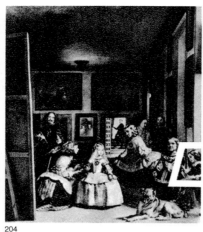

204

194

195

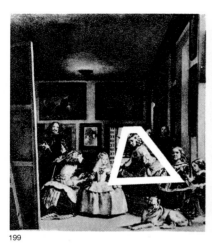

199

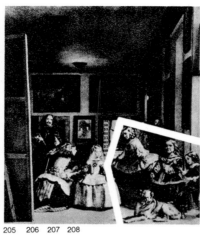

205 206 207 208

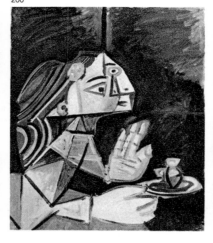

200

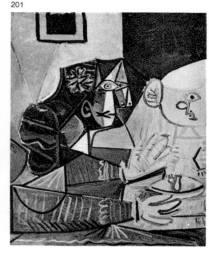

201

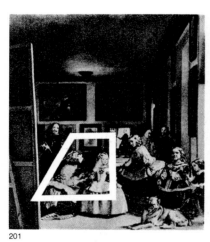

201

209

206

207

203

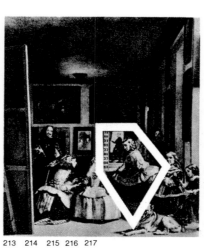

213 214 215 216 217

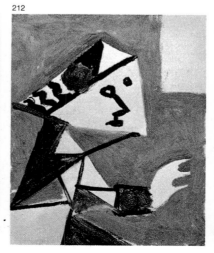

212

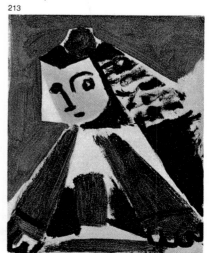

213

196

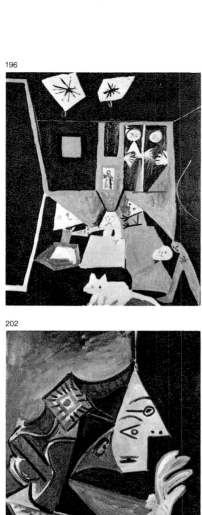

197

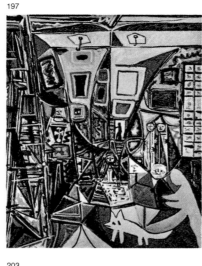

198

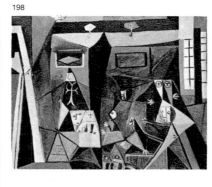

199

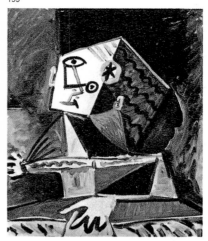

202

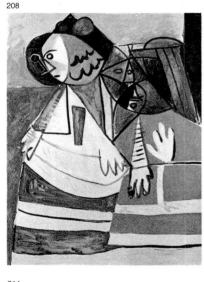

203

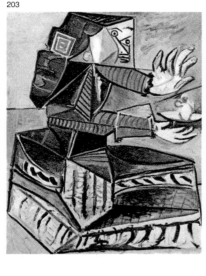

204

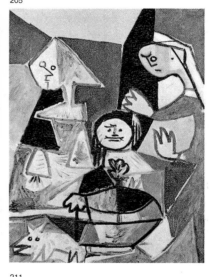

205

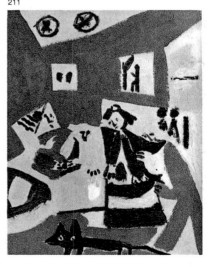

208

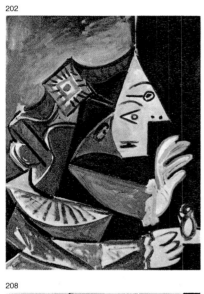

209

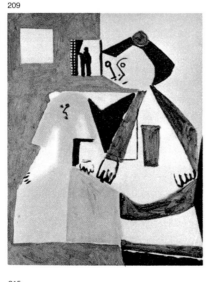

210

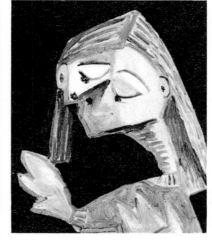

211

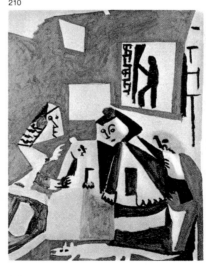

214

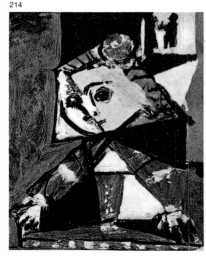

215.

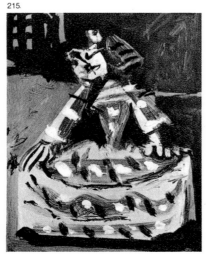

216

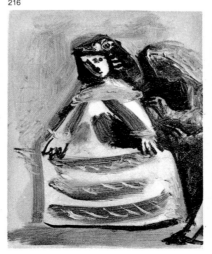

217

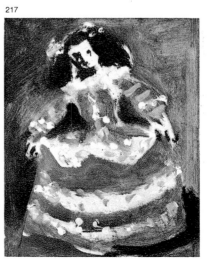

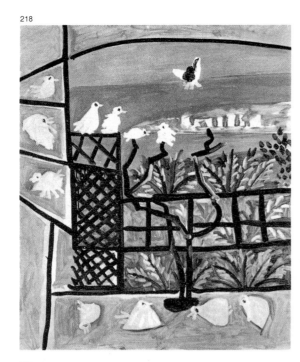

218

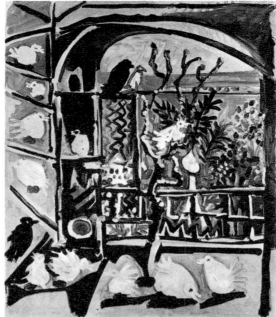

219

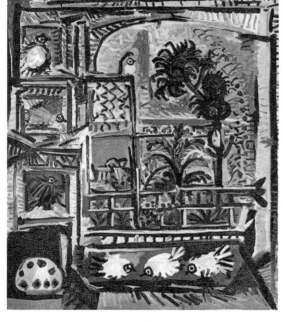

220

221

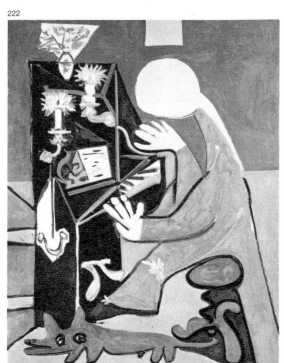

222

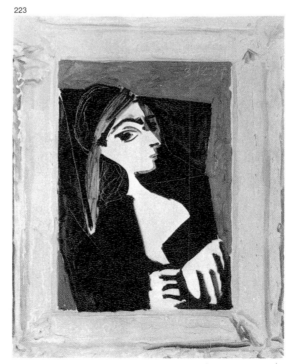

223

218
The Pigeons
Les Pigeons
6.9.1957
Oil on canvas, 39×31.6 inches

219
The Pigeons
6.9.1957
Oil on canvas, 39×31.6 inches

220
The Pigeons
12.9.1957
Oil on canvas, 39×31.6 inches

221
The Pigeons
12.9.1957
Oil on canvas, 56.9×43.5 inches

222
The Piano
17.10.1957
Oil on canvas, 50.7×37.8 inches

223
Portrait of Jacqueline
3.12.1957
Oil on canvas, 45.2×34.7 inches

In September, 1957, while working on the Meninas series, Picasso painted several pictures of the view from the attic window of his house. Their size alone shows that these are no mere "by-products." Their strong, serene colors rank them with the portraits of the Infanta Margarita painted a few days earlier. These pictures show all the details of the setting in which Picasso painted the Meninas—pigeons, palm trees and eucalypti, the terraces, the improvised pigeon cote, the view across the sea to the Iles de Lerins.

Courbet's huge genre picture led Picasso back to a form which is festive yet strictly hieratic.

This picture, like the later *Women of Algiers* (Plates 159 ff.), based on Delacroix, cuts the ground from under the assertion that Picasso's late work is totally eroticized. Both original models far exceed Picasso's paraphrases in erotic allusion. Their erotic content, strengthened as well as legitimized by the choice of theme, was directly related to the recognized role of eroticism among the bourgeoisie of Louis-Philippe's time. Courbet and Delacroix were well aware of the limits they were transgressing in their pictures. Picasso's much-criticized overstressing of erotic subjects in his late work is in no way provocative in this sense. His sexual quotations are neither sociologically motivated nor exaggerated according to bourgeois moral standards. The alleged shock many people feel when they confront the naked sexuality of Picasso's recent works can only be explained by the absence of the speculative element which, even today, is tacitly assumed to be indispensable in treating erotic subjects.

On February 22, 1950, Picasso painted the *Portrait of a Painter, after El Greco* (Plate 156). This is not a portrait of just anyone, neither is it a portrait of El Greco. It is the portrait of a man whose brush and palette show him to be a painter. In this anonymous portrait Picasso returns for the first time since World War II to the theme of the artist's portrait. Although he did not immediately pursue his discovery, it announced the imminent subject of painter and model.

For the El Greco picture Picasso as usual used a photograph or print. His vow never to set foot in Spain so long as Franco was in power stood between him and the original, painted between 1594 and 1604 and now in Seville. Nonetheless, with his move to Vallauris, his native Spain had come to seem closer and more tangible. He was now living on the same sea on which his birthplace, Málaga, is situated. The ceremonial dignity of the El Greco picture reflected his readiness to pursue this side of his own nature in painting as well as by attending bullfights and entertaining Spanish *toreros* making guest appearances in France. Sitting in the arena of Arles or Nîmes or painting his Spanish portrait after El Greco, Picasso was affected by the somberness in the ritual of the bullring which only a Spaniard can fully understand.

The portrait may be called a Nocturne, for it is indeed a "night picture," and as such it stands apart from the nocturnal scenes which, though never very numerous, reappeared in Picasso's work in the early 1950's, now in the form of a still life with a candle or lamp, now as a garden by night. For Picasso night was always a favorite time for working, because the single electric light in the studio excluded all the disturbances and distractions that crowded in upon him by day. Otherwise he mistrusted the "dark side" of day, refusing to admit it to his painting except as a symbol of death or of his familiar state of sadness and melancholy.

In the *Portrait of a Painter, after El Greco* he was challenged by the problem of reproducing the "moonlike" light that characterizes the work of the master of Toledo. Following his model, he concentrated the "moonlight" on the painter's face, collar, and hands. But Picasso's light, rendered in almost unbroken white, has a magical quality. It floats in tiny planes on the face, seen in front view, on which Picasso has drawn a sharp left profile. The light on the collar and cuffs articulates structure and form by transforming the fabric into an abstract geometry. The hands, spread out flat

like fans, are drawn as freely as arabesques in what might be called *peinture écrite,* or written painting. In this "spread out" treatment, the elegant, mannered expression captures a quality implicit in the original El Greco. The three properties of white: as a reflection of light, as cubistically dissected local color, and as a graphic gesture, suffice to show the subtle differences Picasso introduced. Black and brown ranging to light ochre give the picture both solidity and depth. The naked plywood can be seen in the palette, where Picasso left bare a surface usually covered with layers of paint in a thick relief.

How radical this painting actually is is brought home to us by the almost conventional tone of something Picasso said to Françoise Gilot at the time he was working on it: "I use the language of construction, and in a fairly traditional manner, the manner of painters like Tintoretto or El Greco who painted entirely in *camaïeu* [monochrome], and then, once their painting was about finished, would add transparent glazes of red or blue to brighten it up and make it stand out more."[*] The extraordinary meticulousness of the painting in this portrait guarantees it a leading place among contemporary works. The secret nervousness of the hands heightens the tension of the head, surrounded by a wheellike ruff, which is the focus of attention.

After the famous "Louvre test" Picasso said several times that he wanted to paint a free version of Delacroix's *Women of Algiers.* (Plates 157f.). After comparing his pictures with the Spanish school in the Louvre, he had asked Georges Salles if he might try them out beside Delacroix's works too. But not until he was back in the studio on the Rue des Grands-Augustins in the winter of 1954 to 1955 did he return to this idea. Between December 13 and February 14 he made fifteen paraphrases of *The Women of Algiers* (Plates 159ff.). They are all different in format, half of them being of medium size, the others relatively large. None of them is signed. But on the back of every picture is the date when it was painted, along with a letter from *A* to *O* denoting its place in the chronological order. Obviously Picasso's model was the Louvre painting of 1834, supplemented by a second, slightly smaller version of the theme, with minor variations of detail, painted in 1849 and now in the Musée Fabre in Montpellier. Picasso followed the Louvre painting but incorporated from the second version the little polygonal table (which he placed in a different position) and the pose of the maid raising the curtain.

All the roles in this drama in fifteen scenes are constantly being altered, cut down or expanded. The series was exhibited in its entirety only once: in the summer of 1955, first in Paris, then in Munich, Hamburg, and Cologne. The pictures are now dispersed in many different collections. Precisely for this reason it is tempting to retrace the genesis of the series, although the point we made at the outset about the essential "open endedness" of Picasso's art is just as applicable to *The Women of Algiers.* Picasso's *opus inchoatum* is one of the signatures of his confrontation with Delacroix, Manet, or Velázquez.

It is equally productive to compare the way Picasso prepared and followed up this theme with the development of the studio-picture. Unlike the studio-pictures, which

"A painting has to be transformed slowly and sometimes I can't get to the point of adding that last weight of reflection that it needs. My thought moves rapidly and since my hand obeys so fast, in a day's work I can give myself the satisfaction of having said almost what I wanted to say before I was disturbed and had to abandon that thought. Then, being obliged to take up another thought the next day, I leave things as they are, as thoughts that came to me too quickly, which I left too quickly and which I really ought to go back to and do more work on. But I rarely get a chance to go back. Sometimes it might take me six months to work over that thought in order to reach its exact weight." (GILOT)

[*] *Ibid.,* p. 271.

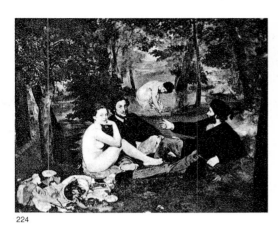

224

224
Edouard Manet
Le Déjeuner sur l'Herbe
1863
Oil on canvas, 83.5 × 105.3 inches
Musée du Jeu de Paume, Paris

225
Le Déjeuner
27. 2. 1960
Oil on canvas, 43.5 × 56.9 inches

226
Le Déjeuner
28. 2. 1960
Oil on canvas, 43.5 × 56.9 inches

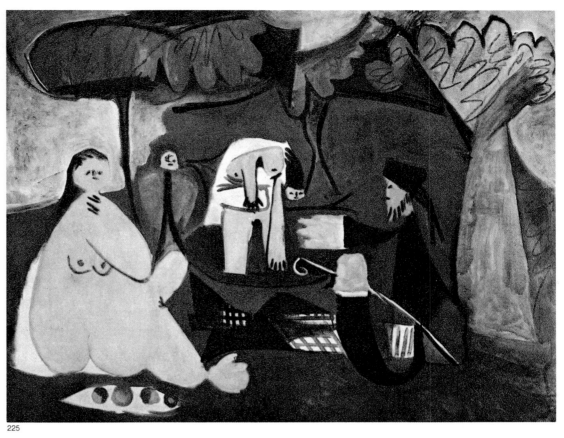

225

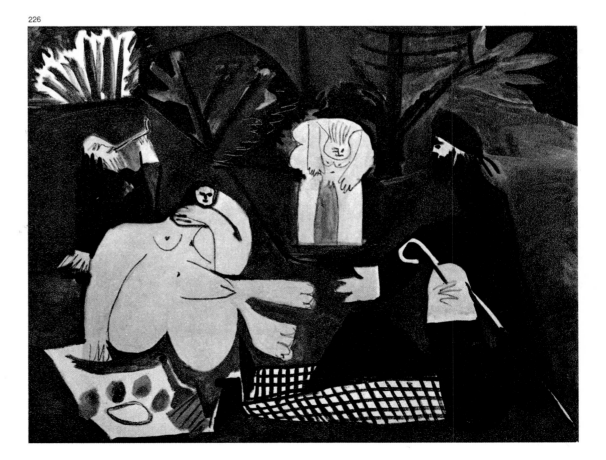

226

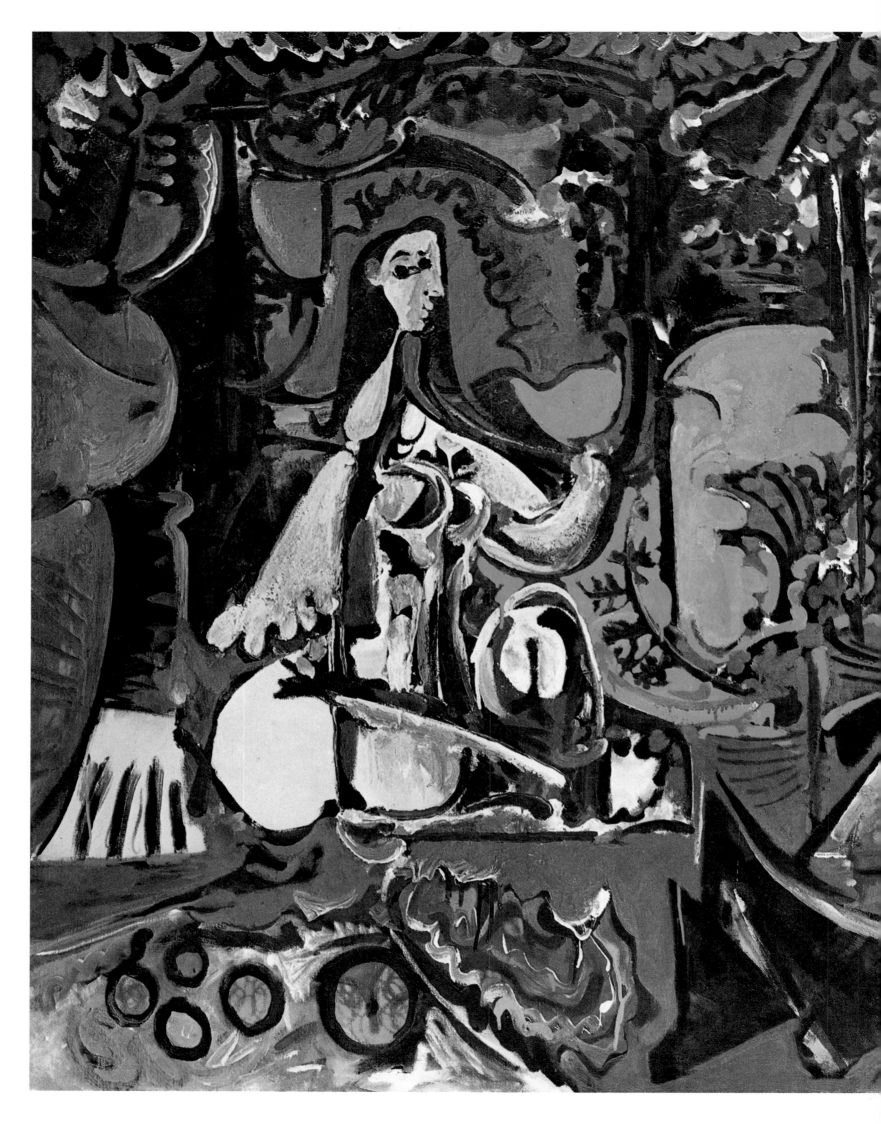

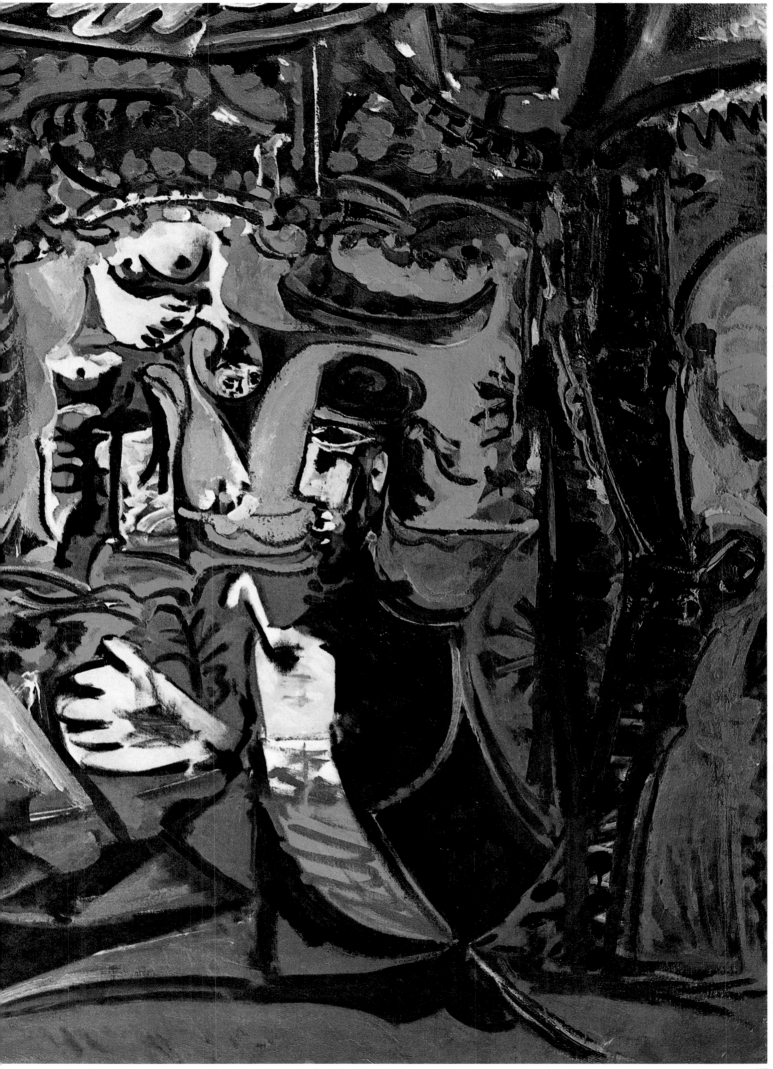

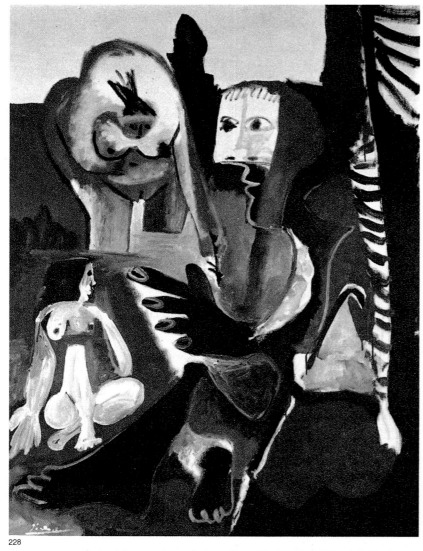

228

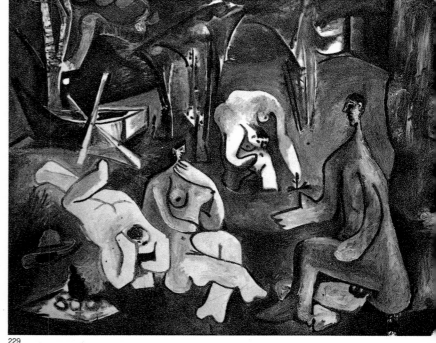

229

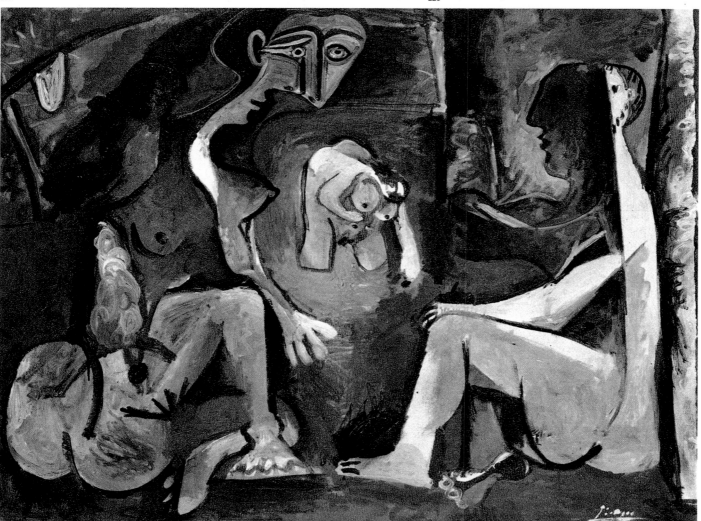

230

231

232

227
Le Déjeuner
3.3., 20.8.1960
Oil on canvas, 50.7 × 76 inches

228
Le Déjeuner
30.7.1961
Oil on canvas, 50.7 × 37.6 inches
Galerie Rosengart, Lucerne

229
Le Déjeuner
10.7.1961
Oil on canvas, 43.5 × 56.9

230
Le Déjeuner
16.7.1961
Oil on canvas, 34.7 × 45.2 inches
Galerie Rosengart, Lucerne

231
Le Déjeuner
10.8.1959 IV
Pencil, 12.7 × 16.4 inches

232
Le Déjeuner
22.8.1961 I
Pencil, 10.5 × 14.4 inches

233
Study for the Bather
Etude pour la Baigneuse
30.7.1960 IV
Pencil, 16.4 × 12.7 inches

233

were reduced from large to small format, the versions of *The Women of Algiers* almost doubled in size after six "preliminary" smaller ones. While the studio-picture tends to generalize space into a geometric abstraction, in the Delacroix paraphrases Picasso attempted to establish his distance in small-scale versions before embarking on a full-scale solution. In these fifteen pictures he tried out another "regulating factor," which he would return to again in *The Rape of the Sabine Women* (Plate 247), after having used it in the Sylvette series and in some of the studio-pictures: namely, grisaille. Five versions of *The Women of Algiers* are painted in gray on gray; color is renounced for the sake of formal and compositional clarity. Two of them are treatments of an isolated detail: in one case the Negress, in the other the seated woman with a water pipe. Picasso is most apt to neglect color when he thinks that a new discovery is within his grasp. Some of his most successful pictures are grisailles, which, besides making a step forward, also deepen and widen the theme in direct proportion to the primacy of drawing over color. As he said to Françoise Gilot: "The fact that in one of my paintings there is a certain spot of red isn't the essential part of the painting. The painting was done independently of that. You could take the red away and there would always be the painting; but with Matisse it is unthinkable that one could suppress a spot of red, however small, without having the painting immediately fall apart."*

An outline of the fifteen paraphrases shows the following evolution. The first two versions (Plates 160 and 161) were made on the same day, December 13, 1954. They present three figures: the two harem ladies and the maid (who will in future be relegated to the background). The second of these two variations, in gray, already attempts to solve the problem of the figures. Two weeks later, on December 28, the inventive process had obviously reached a crisis (Plate 162). The fourth figure, suggested in the Delacroix original, now comes "disturbingly" into play, while the two principal figures undergo a change which will influence all the rest of the series: the woman with the narghile assumes a relaxed, isolated pose, and her companion, who up to now has been of equal importance, is no longer sitting but reclining, nude, almost upside down, with her feet resting on a little octagonal table. Picasso has cut himself loose from Delacroix. The pent-up eroticism with atmospherically fused local colors has given way to a sharp antagonism of form and color.

The fourth version (Plate 168), painted on January 1, 1955, presents a logical reorientation of the space. The door on the left is now worked in with the left-hand figure, and from now on there is another door to her right. The fifth and sixth pictures (Plates 163 and 164), made on January 16 and 17, develop the color range on a basis of green, red, and blue, heightened by yellow. Both these versions have a poetic tone which in later pictures will alternately diminish and increase. The tall grisaille

Ibid.

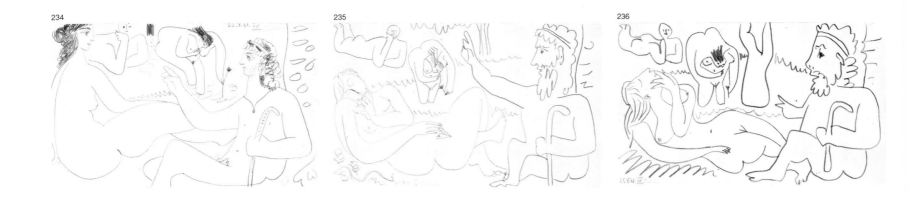

234 235 236

picture of January 18 (Plate 166) uses the Montpellier Delacroix as a model in pursuing the motif of the Negro woman. The eighth (Plate 165), dated January 24 and presenting three figures, is the first painting in the large format which Picasso retained for Pictures IX and X (Plates 169 and 170), painted on January 25 and 26. The last two, however, again use four figures; they are richer and freer in color, and the poetic elements are stronger again. In the eleventh version, another grisaille, painted on February 6 (Plate 171), Picasso tried to acquire distance from his work through a new graphic pattern. The shapes strive toward a more two-dimensional relationship; their spatial functions are objectivized to fit the linear composition. The seated figure on the left is obviously now the major one, while a plausible solution is beginning to emerge at the right-hand edge of the painting. In the twelfth formulation (Plate 167) the big seated woman with the water pipe is reparaphrased in a tall grisaille.

The last three steps (Plates 172, 173, and 159) follow on February 11, 13, and 14. The tendency to fix the three figures on the right in the two-dimensional plane contrasts with the detailed treatment of the big figure on the left. In the last version this figure finally establishes her preeminence, completing the decisive change initiated by the sleeping woman in the third version (Plate 162). The ornamental tendency also reaches its peak in the last picture: by means of black all the planes of red, green, blue, and yellow that have taken possession of the picture as a whole are tied together in bigger masses.

Delacroix's oriental interior became almost unrecognizable in the course of its evolution, although Picasso diverged from his model only by gradual degrees. Step by step he arrived at final decisions, as for instance in the fourth version, which establishes that the reclining woman is to be blue, the seated one red. Three big-format versions (Plates 165, 169, and 170) seem to bear the stamp of Matisse, as though Picasso wanted to preserve the heritage of the friend he had recently lost. Picasso's increasingly free formulation stabilizes the visual invention, which typifies the *paysages d'intérieur* as well as influencing the formal articulation of the *Meninas* paraphrases and which will even leave its mark on the *Déjeuner sur l'Herbe.* In the antithesis of reclining and seated forms Picasso recapitulated a theme which has long held a special place in his art and which is conspicuous for its regular recurrence: the woman sitting on the ground watching a man or another woman sleeping. Even the girls on the bank of the Seine after Courbet are a case in point. The changes Picasso made in Delacroix's models were more decisive; his "hardening" of the scene for his own purposes was more drastic. But we shall understand the stages in the tortuous process better if we see Picasso's adaptation of Delacroix's model as his own reinterpretation of the mysterious human relationship between a sleeping woman and one who watches her sleep.

Although *The Women of Algiers* series was painted in Picasso's Paris studio, it may be said to mark the end of the Vallauris period. In the spring of 1955 Picasso moved from *La Galloise* to *La Californie*—a necessary preliminary to the continuation of the *Women of Algiers* interior in the studio-picture, a theme which would reach its climax

234–243
Le Déjeuner

234
22.8.1961 IV Pencil, 10.5×14.4 inches

235
25.8.1961 II Pencil, 10.5×14.4 inches

236
25.8.1961 IV Pencil, 10.5×14.4 inches

237
25.8.1961 VI Pencil, 10.5×16.4 inches

238
22.9.1961 Pencil, 12.5×16 inches

239
14.6.1962 V Pencil, 10.5×16.4 inches

240
14.6.1962 X Pencil, 10.5×16.4 inches

241
27.7.1962 I Crayon, 9.4×12.5 inches

242
27.7.1962 III Crayon, 9.4×12.5 inches

243
29.7.1962 II Mixed media, 9.4×12.5 inches

240

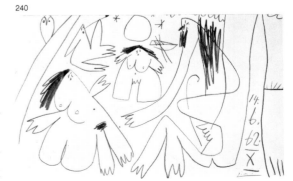

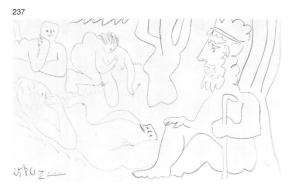

237

238

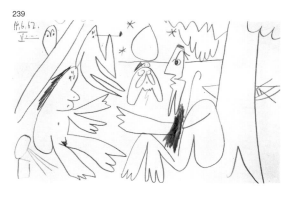

239

in 1957 in Picasso's forty-four paraphrases of *Las Meninas* by Velázquez (Plates 175 ff.). This is not to say that Picasso went about it systematically; he still worked as fitfully as ever. Nevertheless it is delightful to see how inevitably and inexorably his late work moves toward the apotheosis of the painter and his model. The link between the *Women of Algiers* and *Meninas* series is in fact the *La Californie paysages d'intérieur,* which, as we have seen, deal with Picasso's own concern: the subject of the painter and his studio.

Picasso once said of Velázquez's great painting: "What a picture, the *Meninas!* There we have him, the true painter of reality!" His sudden decision to undertake a version of his own was like taking the inescapable step through a door which has long been standing open. Already before he began work, he showed how clearsighted he was about the project. Even for this colossal painting by Velázquez in the Prado he was content with a reproduction to facilitate—or perhaps even to make at all feasible—an audacious undertaking which would lead him further and further away from the magic realism of the master's court scene toward his own "discovery."

Picasso immediately recognized that if he was to paint the studio of Velázquez he would have to leave his own. In August, 1957, he turned his back on the studio on the ground floor of *La Californie.* Leaving behind finished and blank canvases, samovar, caged owl, rocking chair—in short, everything that had just found a place in his pictures—he moved up to the top floor, hitherto inhabited only by pigeons. In a huge empty room with tattered, faded wallpaper, without furniture or comfort of any kind, Picasso worked for weeks and months, accompanied in the daytime by the cooing and fluttering of the pigeons, sometimes watched at night by Jacqueline, as he painted with extreme concentration and rapidity under the naked light of an electric bulb hanging from the ceiling.

The *Meninas* pictures were painted between August 17 and December 30, 1957, interrupted only once, in September, by a series of paintings of his immediate surroundings: the attic window with the pigeons, and the view of the sea with the palm tree in the foreground and the islands in the distance. This harmless idyll alternated with the figure of the young Infanta. Picasso worked on two levels, as though checking one against the other. The view from his studio, with the fluttering

Even numerically the Déjeuner sur l'Herbe *series is impressive. In the space of four years, between 1959 and 1962, Picasso made twenty-seven paintings and more than 150 sketches and drawings after Manet's famous painting of 1863, now in the Musée du Jeu de Paume. The drawings in particular vary the theme inexhaustibly by constantly shifting the accent from one figure to another or from landscape to groups of figures. The almost simplistic treatment of the setting shows Picasso's masterly skill in translating an eminent painterly model into a rigorously linear, abbreviated style, which is clearly legible in the outline of every figure.*

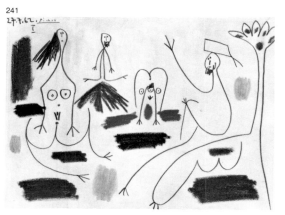

241

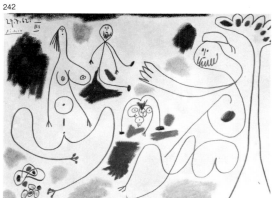

242

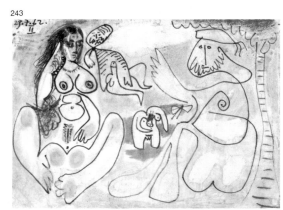

243

of the birds and the brilliant sunshine, is one reality; against it is ranged the artificial reality of the *Meninas,* rigorous and monochromatic.

In the very first variation Picasso hit upon the right formulation to encompass his aim. Here the definitive version, the complete picture, came not at the end of the series, as with *The Women of Algiers,* but at the beginning. Here again Picasso decided on a narrower pictorial frame for the sake of figural development, just as he did in his paraphrases of Poussin, Courbet, and Delacroix. In *Las Meninas* he reduced the height of the studio, which in Velázquez introduces mysterious distances into all the complicated relationships between painter, model, visitor, and viewer. He exchanged the tall format for a wide one. The essential "story" of Velázquez's painting is retained, along with the characters. The viewer, who occupies the model's position, watches the company assembled beside the painter. In an important sense *Las Meninas* is his own self-portrait.

Without going into the shades of meaning in the original, Picasso focused from the outset on the painter. In the first version he towers toward the top of the canvas in an over-lifesize, many-faceted front-view presentation. The subtly varied organization of the planes becomes simpler toward the right, where for the first time the depth dimension of the space dominates, and sharp light-dark drawing accents the arrangement of the figures. At the greatest distance from the painter we find the greatest formal schematism, the sketchiest silhouettes. The figures have the generality of signs. Read from the right, they become more substantial as they approach the center of the picture. This allowed Picasso to make a new artistic paraphrase of the various levels of reality that Velázquez alluded to, both socially and "typographically." By immediately renouncing color in favor of grisaille in the first and biggest version, Picasso gained the scope which Velázquez acquired by other means.

In the works of both artists the painter's studio represents a stage where a spectacle is being performed. Picasso approached it in as complex a manner as possible before isolating the individual scenes and their actors in his long series of paraphrases: the Infanta, the Infanta among her ladies-in-waiting, the little page, the fool, and the dog.

Picasso in his compositions drew away from Velázquez; detail became independent; even the painter's big dog was replaced by Picasso's dachshund, Lump. Velázquez's studio began to look more and more like Picasso's own abode. In five versions Picasso adapted himself to the overall structure of his model; several times he accommodated himself to its tall format. But even the versions that conform to the model reveal the intensive kaleidoscopic scrutiny to which he subjected all his themes.

The whole *Meninas* cycle was shown at the big Picasso exhibition of 1960 at the Tate Gallery in London, but its permanent home, at the painter's own wish, is the Picasso Museum in Barcelona. The dialogue with Velázquez is a dialogue not only between painters but between Spanish painters, whose concept of reality has always been ambivalent, ranging from prosaic object-fetishism to cool, speculative abstraction.

The *Meninas* paraphrases were closely linked with the lonely, empty attic of *La Californie,* which Picasso furnished in three months with forty-four versions of the

"Nowadays people talk about painting in the same way they do about mini-skirts. Next season it'll be longer, or it'll have a fringe on... We want something they've never seen. Something that'll really puzzle them. But when you look for that something, everybody's already seen it, everywhere, with a crease in its trousers."

(PARMELIN)

"Everything I ever made I made for the present, in the hope that it would always live on in the present. I was never interested in experiments. If I came across something I wanted to express I expressed it without bothering about past or future. I don't think I made use of radically different elements in my various methods of painting. If the subjects I wanted to paint demanded a different mode of expression I didn't hesitate to adopt it. I never experimented. If I had something to say I said it in the way I felt it had to be said. Different subjects inevitably call for different methods. That has nothing to do with development or progress; it is simply a matter of matching the idea you want to express with the most appropriate means of expressing it."

(THE ARTS, 1923)

244
Le Déjeuner
29. 7. 1962 III
Crayon, 9.4×12.5 inches

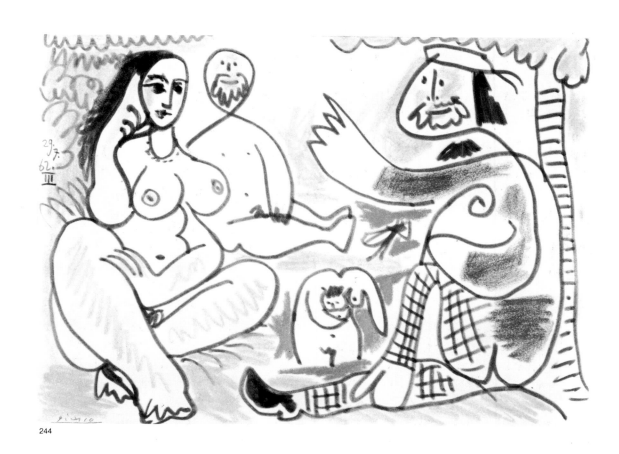

244

Velázquez picture. When he bought *Château Vauvenargues* a year later, it was hardly to be expected that Manet's *Déjeuner sur l'Herbe* (Plate 224) would undergo new metamorphoses there. Picasso worked on this theme between 1959 and 1962. Manet's famous picture of 1863 yielded some 150 drawings and twenty-seven paintings. The two women bathers and their companions from the *Déjeuner* made their first appearance in Picasso's work even before he painted his last version of Bathsheba.

Now, in the Mont-Sainte-Victoire country of Cézanne's landscape, Picasso remembered Manet, whose *Execution of Maximilian* he had disparagingly called "anecdote without painting" in comparison with Goya's *Executions of the Third of May*. While Picasso had no interest in Manet as the forerunner of Impressionism, their common admiration of Velázquez attracted him to the French painter. Although the free, painterly landscape in Manet's *Déjeuner* was not particularly stimulating to Picasso's strongly formalistic interests, the sophisticated composition of the figure group was exactly right for what he had in mind. In Manet's time it was daring to show two gentlemen, engaged in nonchalant conversation, deliberately ignoring the scandal of a nude woman in their company. Actually, her pose is by no means as casual as it looks; Manet borrowed his group of reclining figures from an engraving by Marc Anton Raimondi after Raphael. Picasso was no more excited than any modern viewer by the provocative pose. What he was interested in is the dialogue of the seated figures, and the conversational tone of Manet's painting.

245

246

In the studio of Velázquez the subject of "the painter and his model in the studio" was a recognizable theme, even though it was treated, so to speak, in code. Using *Le Déjeuner sur l'Herbe* as his model, Picasso now pursued the theme of "the painter and his model in the open air." Subsidiary as the landscape may appear throughout these paraphrases (which outnumber any series he has yet made), it is now more than a framework. It offers the painter a welcome opportunity to mythologize the passionate confrontation of painter and model. This becomes clear when we compare the paintings of the *Déjeuner* with the sets of sketches and drawings, which vary widely in execution. In the paintings Picasso never discarded the landscape elements: tree, water, and grass. The figures, isolated at first, later become almost an organic part of this "nature" (Plates 225 ff.). The drawings tend to explore variations in the positions of the four actors and their location. The figures' relation to the landscape-space is only hinted at (Plates 231 ff.).

The series begins on a strong coloristic note, with the luminous local color of the masculine figures and the still life of the picnic luncheon, set off by the blue and green of the water and the woods. This disappears almost completely in the last versions. These are dominated by a green with many shadows, which extends to the figures too. The gentlemen have taken off their clothes, which in Manet had the indispensable function of setting the men apart from the reclining nude and thus "exposing" her. Their very nakedness now places them on the same level of reality as the woman. The painter-model dialogue no longer takes place in Manet's erotic setting but in a more complex "archaic" state. The element of defiance, which in Manet is a concern of the artist, comes more and more clearly to reside in the figures themselves. Even though Picasso—as usual—kept arriving back at his starting point after following one new direction after another, only to take off again on a new track, it was Manet's example that inspired his most sustained explorations.

It can hardly have been the austere landscape around Vauvenargues that made Picasso attach so much painterly significance to landscape in his paraphrases of *Le Déjeuner sur l'Herbe*. In the portraits and still lifes of the same period the colors, and

In the winter of 1962–1963 Picasso made several large paintings based on Jacques-Louis David's Rape of the Sabine Women *in the Louvre. Poussin had treated this classical subject before David. Picasso, however, changed the moral tenor of the theme as he*

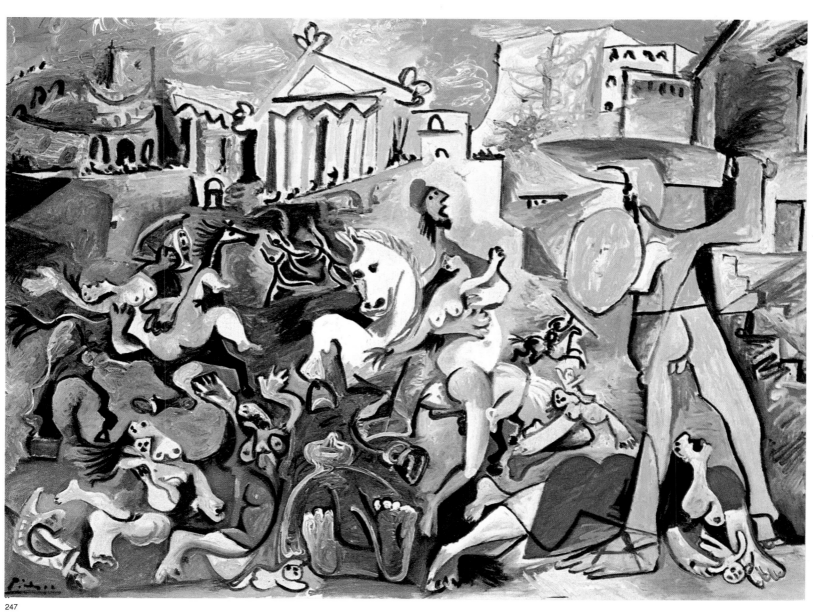

247

worked on it. David's cool academicism gives way to a vivid portrayal of brutality and force in the struggle for the women. A few props suffice to suggest the historical background, so that nothing detracts from the more universal and tragic aspect of the theme.

Picasso's handling of them, are weightier and carry a greater expressive—not to say emotional—charge than ever before. Even in the early versions, before color penetrates the figures from outside as well as inside, color is assigned an integrating function. As though the colored light and shade of the Impressionists were celebrating a late renaissance, Picasso presented a painterly structure which transforms the free rhythms of Manet's colors.

In the version painted between August 3 and August 20, 1960, the double outline and two-dimensional form of the painters' bodies are filled with green. In the same way the sitting and bathing women are pervaded and surrounded by colorful zones which transform the play of light and shade on the skin into painterly form. Picasso did not ignore Manet's gift for dissolving the boundary between bodies and adjacent space by painterly means, his conscious illusionism; rather he changed it in a way which recurs in the treatment of the foliage, tree trunks, and bushes, as well as in his rendering of the figures.

One year later, between July 30 (Plate 228) and August 10, 1961, Picasso painted six big versions of this subject. All of them omit the second man and use a markedly tall format instead of the wide format of Manet's picture. On July 16 (Plate 230) Picasso had already reduced the group to three, besides limiting the colors of the nudes to green, black, a little ochre and blue, and a much-broken white. The seated figure, disproportionately large, is moved into the left half of the canvas; her uncomfortably bent body threatens to break out of the picture. Opposite her, sitting up straight against the tree trunk, is the painter, his face in such deep shadow that it looks masked. Between them, by a tiny pool in the far distance, is the little figure of the bathing woman. Despite Picasso's restriction of the landscape, it still asserts itself, pervading everything, surrounding all the figures and providing a ground and stage for them.

Two weeks later Picasso has drawn the scenic conclusion from this three-figure picture. The painter now moves into the dominant position. His foot, hand, and forehead cut through the diagonal extending from lower left to upper right. The seated nude has shrunk to a hieroglyphic statue, while the bathing woman has moved forward in large, bulging forms. The black, white, and green pull apart even more distinctly with the unpainted chalky ground assuming the function of white and constantly breaking through the spatial and plastic development of the picture. Black and green have lost all sensual qualities. The painter is explaining the scene like some seer or storyteller, raising his big, shadowy hand, which looks black against the light ground. His assertive black and white head liberates the *Déjeuner* from all anecdotal associations. Vision has superseded impression. Through repeated reversals Manet's parallelogram of artistic and erotic allusions has become a transcendental exegesis of the painter-model theme. Picasso's constructive solution needs no attribute and no sociological paraphrase. The figures in their ghostly solitude now celebrate nothing but themselves.

Between 1962 and 1963 Picasso broke the haunting, tense silence of the *Déjeuner sur l'Herbe* series with the deliberately heightened turbulence of *The Sabine Women.* He took David's historical scene (Plate 246) and delivered it over to his own demons. Just as he disrobed Manet's picnickers, he unmasked the heroes of the Roman myth, whose equipment David had portrayed with such loving care, by making their armor look as flimsy as stage armor. He paid even less attention to David's carefully composed stage setting. Picasso's compositional scheme is as violent as the story of the rape of the Sabine women itself, whether he treated it as a broad perspective or a steep, two-level structure.

Fighting, wars and brutality, victor and victim, force and persecuted innocence recur in various forms and guises throughout Picasso's work. The most famous examples inspired by actual happenings are *Guernica* (1937), *The Charnel House* (1945), *The Massacre in Korea* (1951), and the paintings of *War* and *Peace* in the Vallauris chapel (1952). In *The Rape of the Sabine Women* the essential element—the struggle for possession of the women—carries strong dramatic aspects which far transcend the aggressive simplicity of the colors. Picasso was immediately aware of the multiple levels. He himself said: "It's never been like this before. This is the most difficult thing I've ever done. I don't know if it's any good. Perhaps it's terrible. But

"It's rubbish to think of cutting out the subject; it's impossible. It's as if you said: 'pretend I'm not there.' You just try it."

"A warrior, naturally, if he has no helmet and no horse and no head, he's much easier to do. But for my part, at that point he simply doesn't interest me. At that point he might just as well be a chap getting onto a train. What interests me in a warrior is the warrior." (PARMELIN)

248
The Rape of the Sabine Women
L'Enlèvement des Sabines
9. 1., 7. 2. 1963
Oil on canvas, 76.2 × 50.7 inches
Museum of Fine Arts, Boston

148

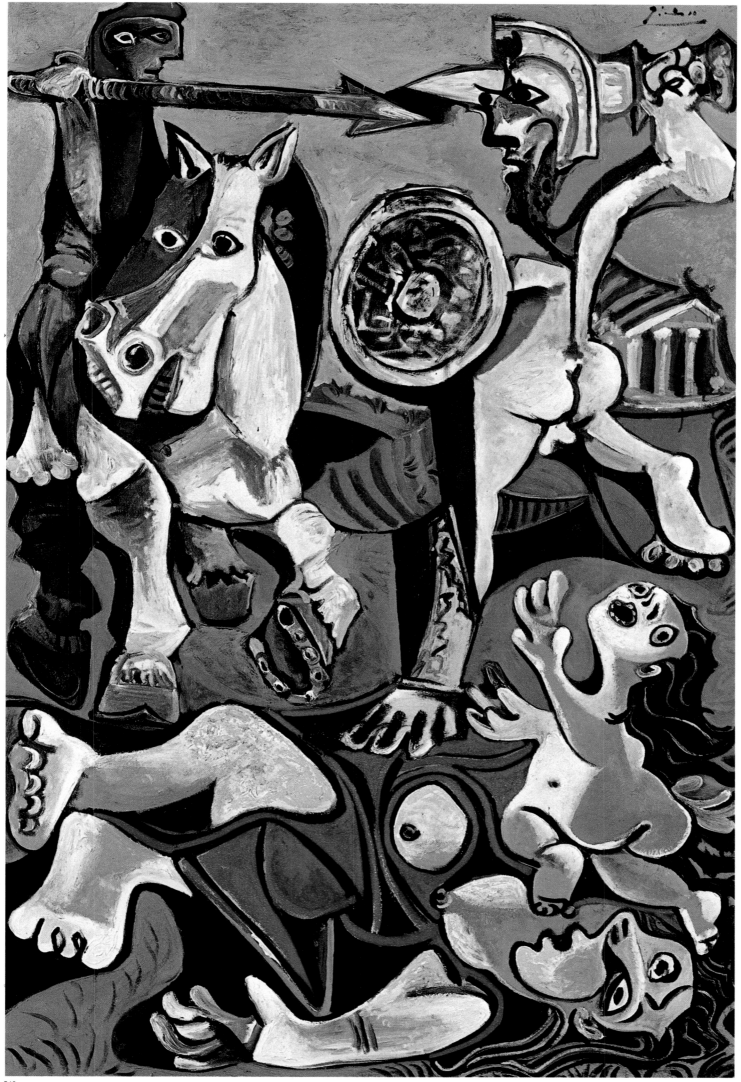

I'm going to do it anyhow. I'll do thousands of them." Nevertheless he devoted only the winter of 1962 to 1963 to this project.

Freely adapting his model (for which David too tried out several different formulations), Picasso tackled the story in a picture painted early in November, 1962 (Plate 247), presenting it as a crowd scene in a sort of forum. Even here he diverged from David by stretching the proportions. Tiny figures and gigantic ones universalize the historic spectacle into an extraordinary panopticum. The stagy architecture could as well be American as Roman; it merely brings out the urban character of the square. Panic has broken out in the center section, where knights are grabbing the women. Their leader, wearing a Jacobin *bonnet rouge,* dominates the center of the picture. A bellicose giant in the right foreground reveals the global meaning of the event. This triumphant colossus, his body at full stretch as he raises his brutal arm to strike, towers over the woman cowering at his feet, lamenting the murder of her child. The conflict between the Sabines and the Romans, which according to legend was settled peacefully by the women, is whipped up in Picasso's version into a massacre by bloodthirsty conquerors.

As if to clarify this tampering with the facts, Picasso isolated a group of figures in a monumental grisaille (Plate 143). Here again the monochromatic gray heightens the wild, intrepid figure of the suddenly wheeling horse, which obviously symbolizes controlled force. Rearing up at the command of its shadowy rider, whose only physical reality is in his arms carrying his sword and shield, it kicks and tramples the falling woman with its forefeet. She flings up her arm, half defending herself, half begging for mercy—a figure of hunted terror. By means of this uncontrolled gesticulation Picasso created a tremendously vehement movement, which is paralleled by the drastic foreshortening. The horse's massive hoof, seen from below, has such suggestive force that the falling woman appears to be flung out into our space, while the rider falls upon her out of distant clouds. Rarely has Picasso used painterly techniques more boldly.

The next picture (Plate 248) separates the still interlocked positions into two distinct horizontal zones. In the lower one the woman has fallen to the ground and her child is screaming and trying to force its way into the "upper world" of the fighting warriors. The drama of this duel is played out in sharply defined areas. Grass, field, landscape, temple, and sky are treated as unrelated trappings. The wooden tenacity of the fighters gives them a solidity. No narrative details diminish the scenic impact of the colliding blocks of figures. As a result the presentation has a barbaric force and the greatness of universality.

In demolishing the legend of the rape of the Sabine women Picasso opened the abyss of all tragic experiences of the fight of the strong against the weak, of unpunished triumph and innocent suffering. Ancient accounts of the battle of the Amazons are preserved, along with the traditional story of the Massacre of the Innocents. Few painters have made these myths and their human visions so true in visual conception.

Painter and Model

"I paint the way some people write their autobiography. The paintings, finished or not, are the pages of my journal, and as such, they are valid. The future will choose the pages it prefers. It's not up to me to make the choice. I have the impression that time is speeding on past me more and more rapidly. I'm like a river that rolls on, dragging with it the trees that grow too close to its banks or dead calves one might have thrown into it or any kind of microbes that develop in it." (GILOT)

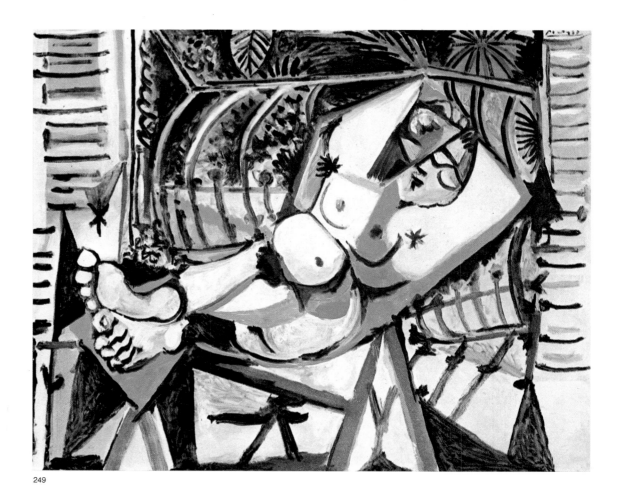

249
Nude against the Garden
Nu devant le Jardin
1956
Oil on canvas, 50.7×63.2 inches
Galerie Beyeler, Basle

249

As we saw in Picasso's wide-ranging treatment of the portrait in the postwar period, the themes and content of his figure paintings constantly shift back and forth between the subjective and the objective. He was a portraitist when he painted Sylvette; he was still a portraitist in his pictures of Françoise and later Jacqueline, although here an imagined concept of the model was already emerging. Finally there is the large group of paintings where the generalized, non-individual statement clearly preponderates. Their anonymity is a summary of all the impressions Picasso has accumulated from a face.

The constant interchange of reality and subjective interpretation in Picasso's painting reminds us that figure painting assumed diverse functions for him. During his years with Françoise the model remained within his intimate world, private and portraitlike. Picasso painted few nudes between 1945 and 1953. Suddenly, in the winter of 1954, came a spate of about eighty drawings which tackle the theme of painter and model with surprising single-mindedness—a preliminary to the big paintings of nudes which in the next few years would free themselves from all private ties.

Many factors coincided to precipitate the painter-model theme. Similarly, the female nudes, and later the portraits of the painter, again and again received new impulse from the great erotic tension between painter and model. In the mid-1950's everything interacted: the studio-picture contributed to the painter-model formulations, just as it prepared the way for the *Women of Algiers* cycle. The latter, along with the paraphrases of the *Déjeuner sur l'Herbe* and Rembrandt's *Bathsheba,* helped the nude to establish itself as an independent theme before it was absorbed into the context of painter and model.

The nude left her place in the studio to pose in the garden and later in the open landscape, under a pine tree or on the beach. In the *Déjeuner* series she becomes part of a group. Then she returns to the painter's studio, to join him in front of the easel or under a parasol in the garden. She sits beside a flute player or lies beside a man engaged in writing. The sleeping couples strike a bucolic note.

All the pictures devoted to the nude have one thing in common: The body is usually seen directly from above and is brought as far as possible into a foreground plane. As Picasso developed his new "plein air" style, his nudes lost the multidimensional structure of a body separated into different perspective views. The monumental scale of the *Nude against the Garden* (Plate 249) or the *Reclining Woman with Plant* (Plate 251) reached its climax in the almost brutal forms of the *Woman Lying under a Pine Tree* of 1959 (Plate 252). Bodies and landscape are closely linked; the nude itself has become a mountain, with nature reduced to an echoing motif behind it. After the *Demoiselles d'Avignon,* the great archaic women at the well, and the surrealist monsters on the beach, Picasso called to life another race of giantesses. These Cyclopean nudes are shown lying, crouching, and sitting, but never standing. Despite their tremendous bulk and the oppressively close view, their massive calm gives their bodily presence a certain unapproachability.

In the 1960's Picasso began to dissolve the solid cubism of these figures in a painterly calligraphy. True, the hands and feet of a reclining nude of 1964 (Plate 254) still

250
Seated Nude
Nu accroupi
3.1.1956 I
Oil on canvas, 45.2×34.7 inches

251
Reclining Woman with Plant
Femme couchée au Bouquet
1958
Oil on canvas, 50.7×76 inches

252
Woman Lying under a Pine Tree
Femme nue sous un Pin
20.1.1959
Oil on canvas, 76×109.2 inches
The Art Institute of Chicago

253
Seated Nude
Nu accroupi
24.6.1959
Oil on canvas, 56.9×43.5 inches
Collection Dr. A. Blum, Erlenbach/Zürich

254
Great Nude
Grand Nu
20., 21., 22.2., 5.3.1964
Oil on canvas, 54.6×76 inches
Kunsthaus, Zürich

255
Reclining Nude
Nu couché
9.1.1964
Oil on canvas, 25×39 inches
Galerie Rosengart, Lucerne

256
Seated Woman with Cat
Femme assise au Chat
4.5.1964
Oil on canvas, 50.7×31.6 inches
Galerie Beyeler, Basle

257
Nude Woman and Flautist
Femme nue et Flûtiste
20.6.1967
Oil on canvas, 50.7×76 inches

258
Watermelon Eaters
Mangeurs de Pastèque
30.10.1967
Oil on canvas, 43.5×56.9 inches
Galerie Rosengart, Lucerne

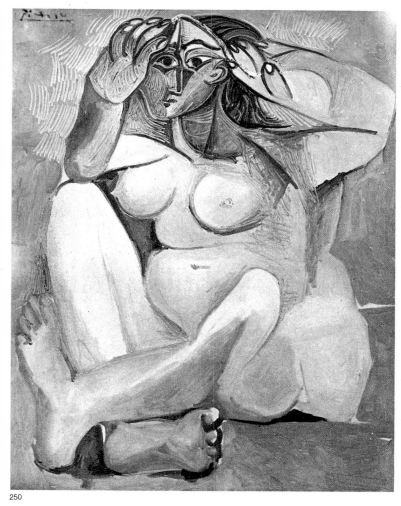

250

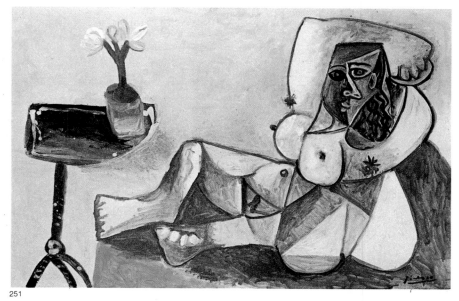

251

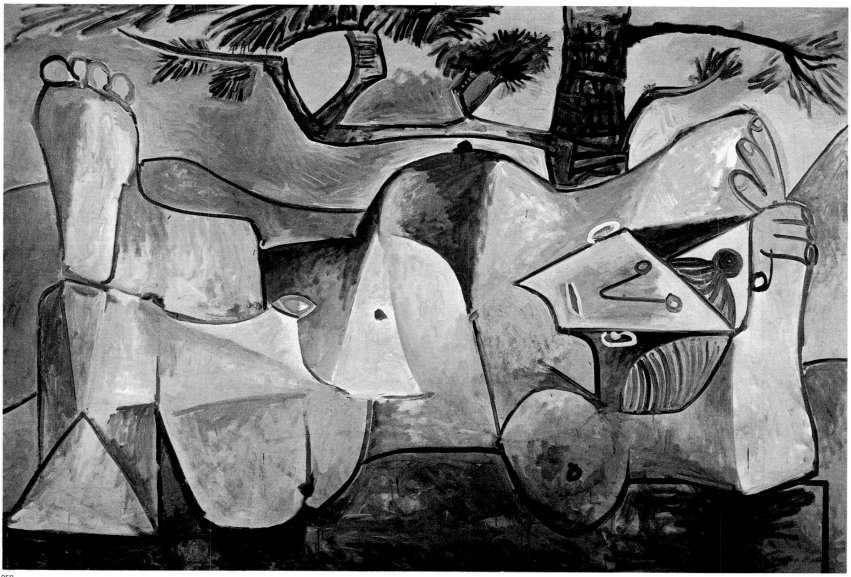

252

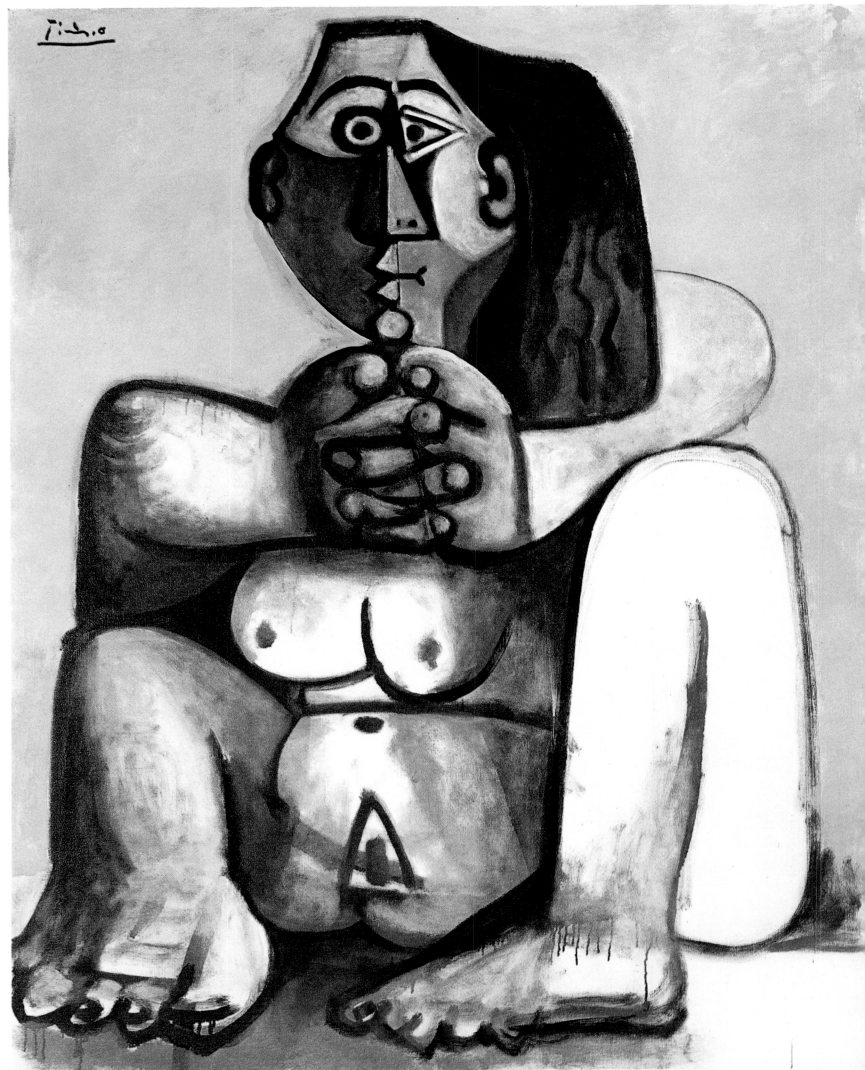

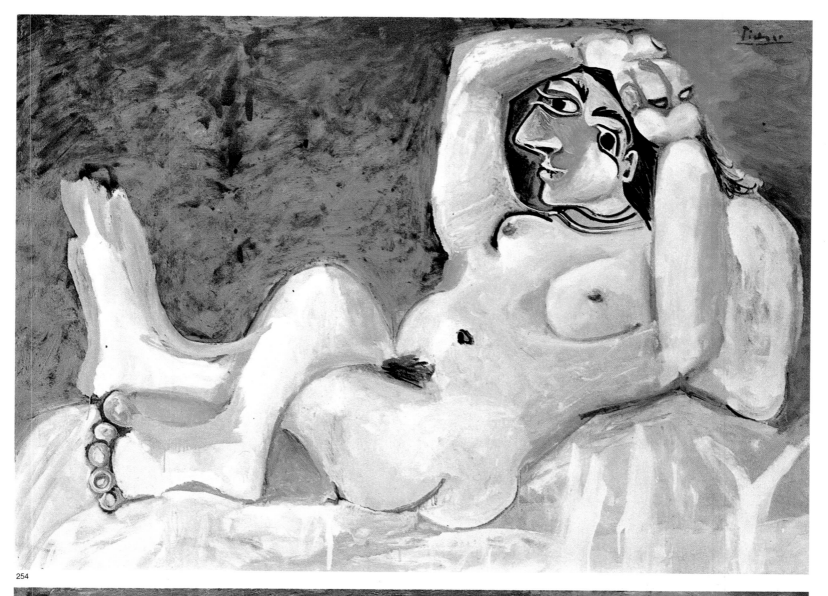

254

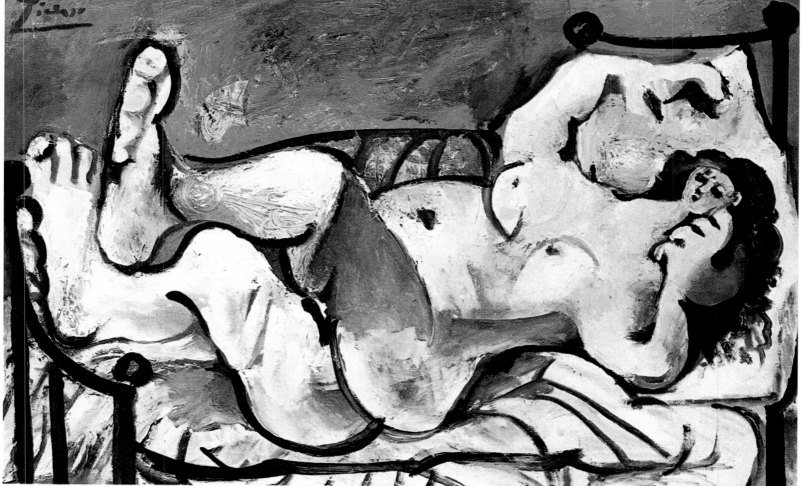

255

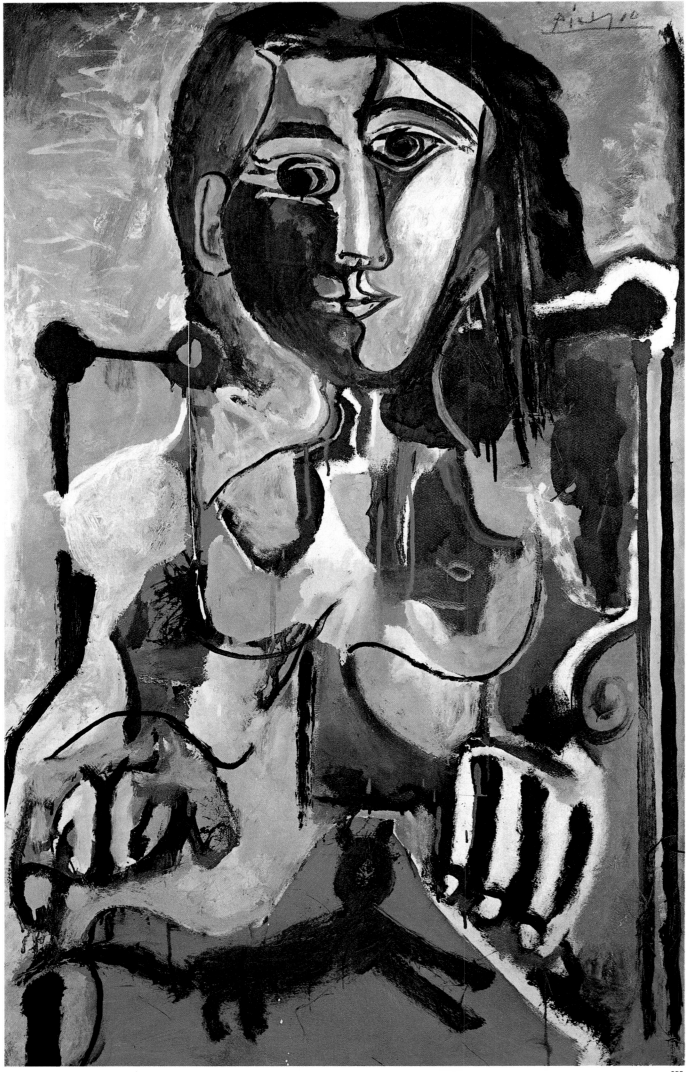

256

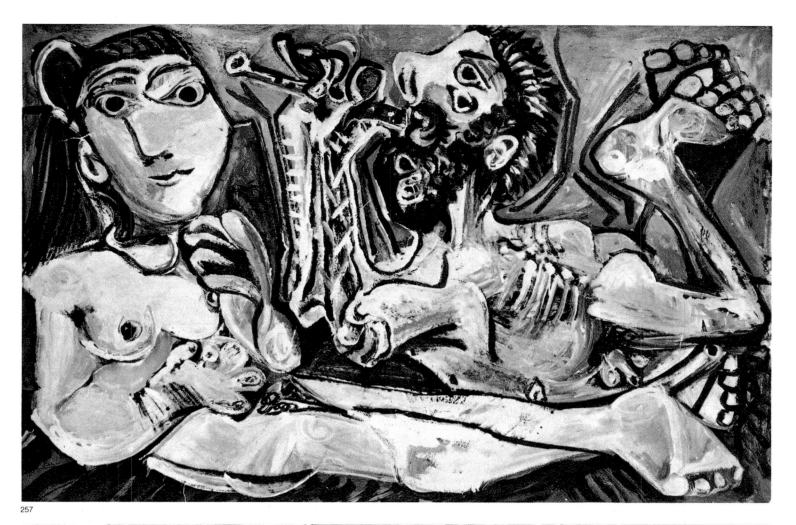

257

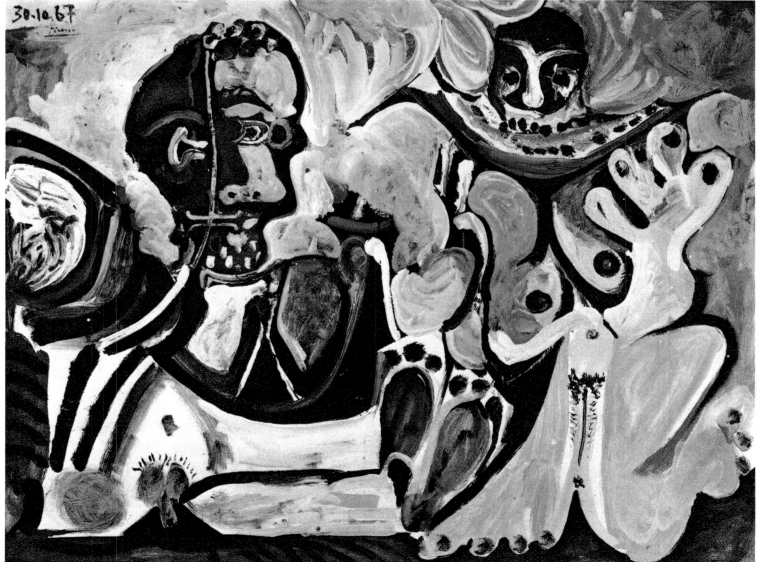

258

259

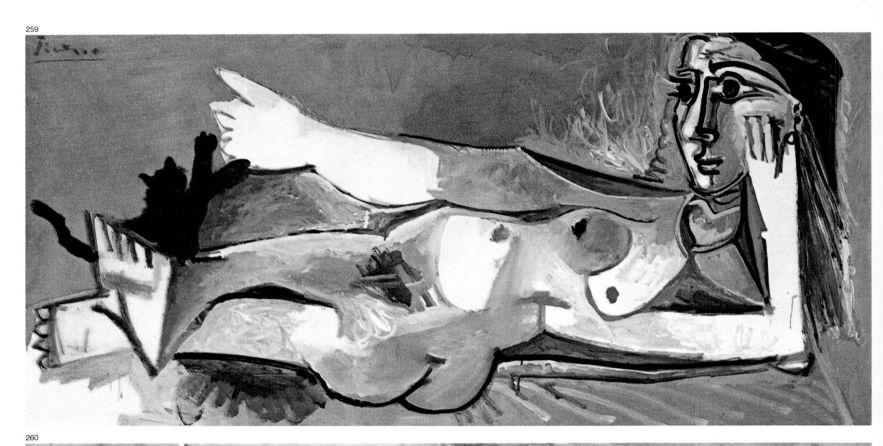

260

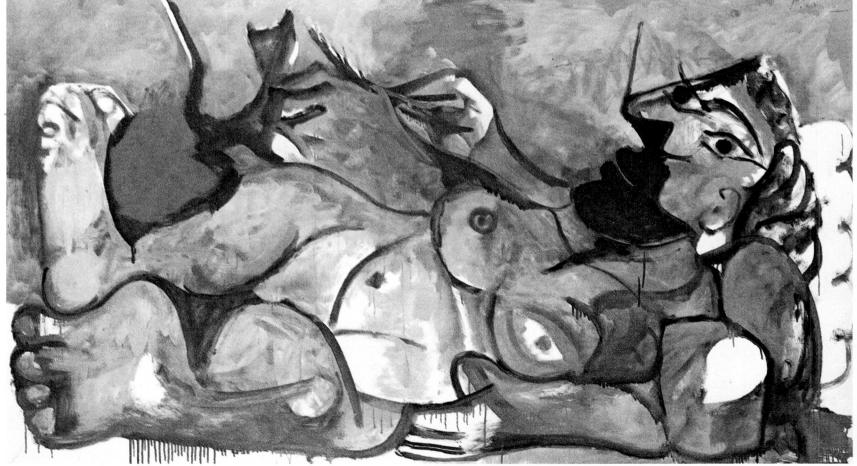

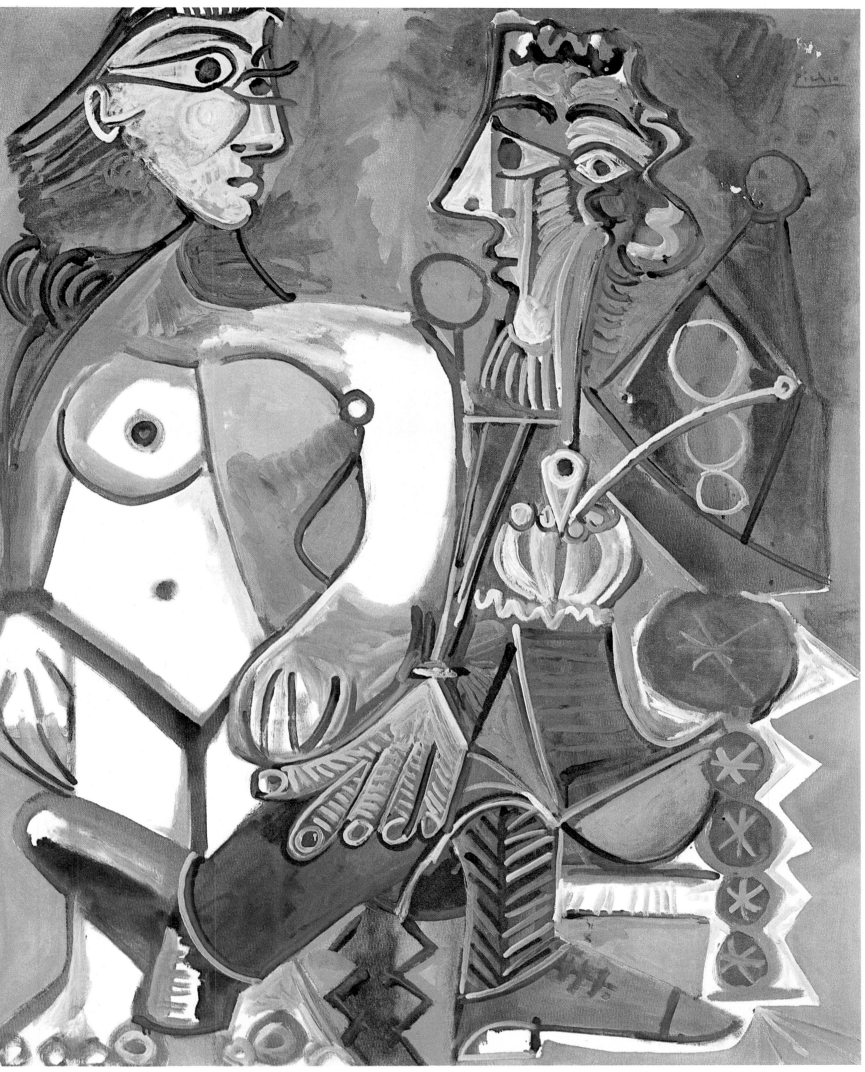

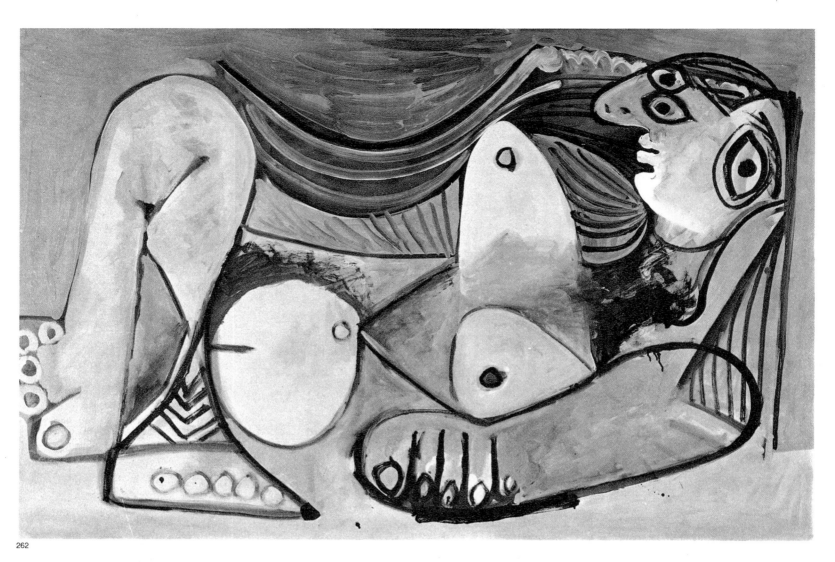

262

263

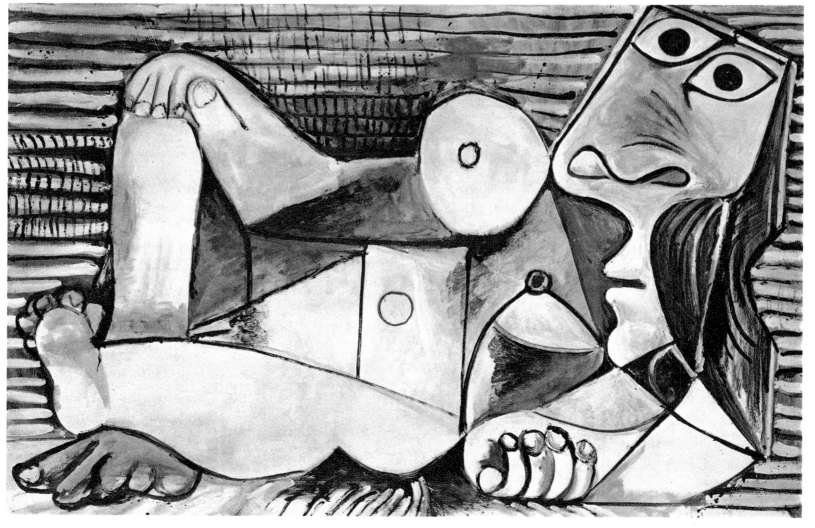

betray the colossal scale. But the vitality that pervades the picture stems from a gentle, painterly handwriting. The movements are free and intimate, the contours loosely drawn against a surface held together by color. The recurrent motif of the arm resting on the head, which can be traced through many of the painter-model pictures, introduces a special note of poetry. The stenographic style becomes a kind of anecdotal abbreviation. As it grows freer, Picasso turns more often to private themes like the woman playing with the cat. He stimulates erotic suggestiveness while diverting it to physical objects or actions, as he does again later with the melon-eaters and flute players. Fauns and musketeers again provide company for the nude, making advances to her or awaiting the solicitations brought by a grotesquely disguised cupid.

The nudes are no longer solitary; they no longer occupy the center of the studio or the landscape. The dispute with the painter is over too. The nudes again become part of the openly exposed sensuality which all Picasso's figures partake of, whether they are new inventions or old familiar friends. The innocence of sex pursues young and old alike. Strophe and antistrophe alternate in serene, mysterious, and gloomy groupings. In Picasso's latest paintings and drawings, classical antiquity and the Middle Ages, the ritual of Dyonisiac feasts and the Christian dance of death are condensed into a confessional procession celebrating both the triumph and death of the mobilized senses.

Among the many incarnations of the world-theater, which for Picasso may just as well be located in the bullring as the studio, is the two-character play of painter and model. We may ask why it appears so late, for, apart from a few preliminary essays in his early years, this is the most private domain of his late period. Obviously even Picasso could not fathom these almost impenetrable relationships earlier. Paul Valéry said that in his old age the writer takes writing itself for his subject. Only with advancing years did Picasso recognize in painter and model the radical point of departure which elevates the physical process of painting to the subject of painting itself. Confrontation of the model unexpectedly leads to the artistic monologue, to reflections on realms which, far more even than the studio, are part of the artist's "inwardness." The quintessence of painting acquires a new meaning when the model returns the painter's glance and begins to pose questions which have previously been the prerogative of the artist. Parody, irony, self-irony, and paradox are the catalysts in this reversal, as the artist begins to justify himself before his work. Picasso accepted this self-formulated challenge. His paintings and drawings on the painter-model theme encompass all imaginable forms of the confrontation of his own self and his art.

When he was illustrating Balzac's *Chef-d'œuvre inconnu,* Picasso had an inkling of the relationship between artist, model, and work. He widened the multilevel relationships between the model as what the artist's eye sees, its image on the canvas, and the artist himself by placing in the studio a portrait of the artist or a sculpture whose model was no longer visible. He tried out different levels of realization, even to the point of showing a picture of the model and the painter looking at it, without the model being present in person. In this series of etchings Picasso encompassed Balzac's story of the imperfectibility of the absolute work of art.

In the Vollard suite Picasso carried the argument into the sculptor's studio, not least because in the early 1930's he was particularly concerned with sculptural problems himself (Plates 264 ff.). Here again the model often exchanged her dependent role for the role of an observer evaluating the emerging image of herself. Despite the constantly changing positions of artist, work, and model, the situation was always classical in feeling. The artist's features are often heroicized. The model is young and beautiful—at once a beloved and a fleeting apparition. These nude figures of the bearded, godlike sculptor and the beautiful young model were often wreathed with flowers; sometimes the sculptures were too. Picasso's love of Ingres showed itself in the long lines of the bodies. The classicistic drawing contributed to the Arcadian

259
Reclining Woman with Cat
Femme couchée au Chat
7., 23. 3. 1964
Oil on canvas, 37.8 × 76 inches
Galerie Beyeler, Basle

260
Reclining Nude Playing with a Cat
Femme couchée jouant avec un Chat
10., 11. 5. 1964
Oil on canvas, 43.5 × 76 inches

261
Nude and Smoker
Nu et Fumeur
10. 11. 1968
Oil on canvas, 63.2 × 50.7 inches
Galerie Rosengart, Lucerne

262
Reclining Woman
Femme couchée
8. 10. 1968
Oil on canvas, 50.7 × 76 inches

263
Reclining Nude
Femme nue couchée
2. 11. 1969
Oil on canvas, 50.7 × 76 inches

mood of the settings: Sculptor and model themselves became a work of art. The pastoral mood was only marginally "disrupted" with surrealistic sculptures on pedestals, modeled on Picasso's own works. All that remains of the sculptor himself is a disproportionately large head—itself a sculpture.

The appearance of the curly-headed Rembrandt introduced a graphic restlessness into the classicistic harmony of line (Plates 144 ff.). The studio was transformed into a scene of bacchanalian revels. The minotaur thrust himself into the models' company.

264

265

His story concludes the Vollard suite—an early prelude to the close linking in later works of painter and model with the artistic ritual of the bullfight.

When Picasso returned to the painter-model theme in 1953–1954 the mythic tranquility of the Vollard suite had vanished (Plates 267 ff.). The ironical or satirical slant revealed rather than concealed the artist's personal engagement. The contrasts were sharply defined: The painter is the old man and the model the young girl. This disparate pair—a favorite theme of medieval German art—was the opening cast in a play which will question Picasso's identity, his self-image, from behind hundreds of different masks.

These drawings all have one thing in common: they always present the painter at a moment of great tension, as he is transferring the model's image to the canvas. Easel and canvas separate two worlds which art can no longer reconcile: here the model in her brilliant beauty, there the myopic, busy—and often vain and pedantic—gnome of an artist, who is sometimes replaced by a monkey crouching on a stool.

In other drawings painter and model wear the masks of Pierrot and Colombine. Then a clown appears, sometimes replacing the painter (Plate 271). Art dealers and voyeurs make themselves at home in the studio. The indiscretions of these "connoisseurs" know no bounds; the studio becomes a public battleground for personal conflicts. But the sarcasm which seems to guide Picasso's pen, sometimes to the point of anecdotic exaggeration, is far transcended by the freedom of the drawing. The "pure" line, painterly blacks, calligraphic pointing up of effects, and ingenious economy of detail are evidence of the heightened tension with which Picasso approaches this theme.

A series of paintings and drawings of a cat and a cock also belong to this context. The predatory cat stalks and eats the dead bird. Its strength and litheness anticipate the challenging femininity of the model, while the disheveled cock, sometimes plucked

264
Sculptor, Model and Statue
Sculpteur, Modèle et Buste sculptée
17.3.1933
Etching, 10.3 × 7.6 inches
From the Vollard suite

265
Sculptor and Model before a Window
Sculpteur et son Modèle devant une Fenêtre
31.3.1933
Etching, 7.6 × 10.4 inches
From the Vollard suite

266
Sculptor and Model Admiring a Statue of a Head
Sculpteur et Modèle admirant une Tête sculptée
23.3.1933
Etching, 10.4 × 7.6 inches

267
Masked Cupid
L'Amour masqué
5.1.1954
Ink, 12.5 × 9.4 inches

268
Woman and Cupid
Femme et Amour
5.1.1954
Ink, 12.5 × 9.4 inches

269
Masked Cupid
L'Amour masqué
5.1.1954
Ink, 12.5 × 9.4 inches

bare, hints at the pathetic, senile artist to come. In other drawings the painter is left out and the model is playing with a cat or a monkey. The animals pounce on the string she dangles for them, just as the painter's glance pounces on her coolly displayed charms. Picasso now began a series showing the model outdoors, half expectant, half fleeing from a swarm of cupids who are threatening her with the ludicrous mask of the ugly old man (Plates 267 ff.). Circus folk enter the studio, with a billy goat and a monkey in their train. The monkey takes up paintbrush and palette. A little later artist and model begin the game of exchanging masks. Then suddenly, in the spring of 1954, the appearance of Sylvette puts an end to the whole phantasmagoria.

As is often the case with Picasso, a biographical turning point—his separation from Françoise Gilot—was the start of a new exploration. The eighty-odd drawings he made during the winter of 1953 to 1954 burst out in a flood of pent-up energy which sweeps these first-rate works beyond the trivial. Picasso immediately discovered the most diverse points of reference. The arena was staked out; it already encompassed all possible metamorphoses. He devised a new iconography. The model became the richly associative subject of an abstraction which opened up to the artist the secret areas of the "inner world."

Not until 1963, ten years later, did Picasso return to the theme of painter and model: this time in paintings, without any preliminary drawings (Plates 274 ff.). We have seen how the studio-picture, and especially the paraphrases of Delacroix, Velázquez, and Manet, relate to Picasso's œuvre. By using other painters' works as models Picasso objectivized his approach. So when he returned to the theme in the spring of 1963 even his first formulations were already much more "artistic" than the intimate stenographic images of 1953. The strong emotional quality of the drawings of 1953–1954 was now neutralized. The passionate drawing yielded in painting to the free variability of colors. Later Picasso made drawings too, but preferably in colored pastel or with colored washes.

One day in February, 1963, he began work on two big canvases. In the first two versions a sculptured head replaces the model. Art as the theme of art—its self-portrait—is obviously the first step toward a reformulation of painter and model. Many pictures in this series retain the sculptured head along with the model. The painter-model dialogue widens into a four-way conversation between painter, model, the

266

267 268 269

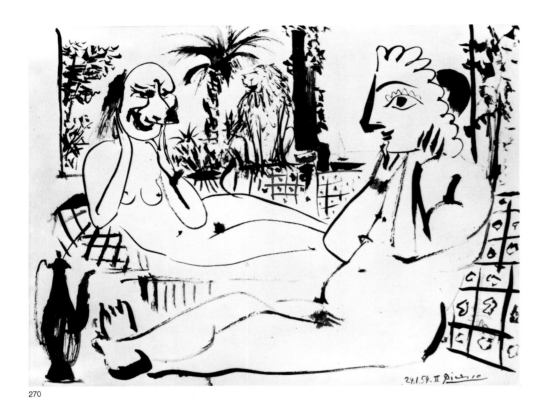

270

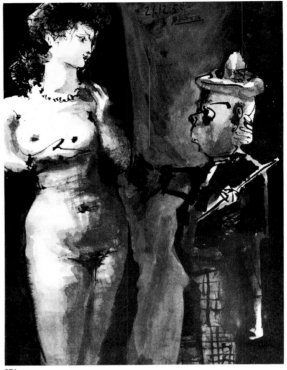

271

existing work of art, and the one in process of creation. Here again every version shows the painter actually at work. The only difference is that his work can no longer be accomplished in the studio.

Hélène Parmelin, a friend of Picasso's, has written a vivid account of the genesis of the painter-model series of 1963:

In February 1963 Picasso broke loose. He painted "The painter and his model." And from that moment he painted like a madman. Perhaps he will never paint again with such frenzy. — On February 22nd, he painted a painter seated at the easel. A plaster or stone head, standing on a chest of drawers, watches the painter. — From the 22nd to the 26th he worked on another canvas with the same theme. — On March 2nd, he painted four canvases: the painter and his model with a green nude. — On the 4th he painted a white nude, plus two canvases with the painter's head. — And on the 10th, a canvas of the painter alone in front of his canvas. — On the 13th, the nude is holding a glass at arm's length while the painter goes on working. — On the 14th the nude is elsewhere, sleeping perhaps, at any rate the painter is alone, working at the easel in the studio. — On March 25th, the painter is all alone. On the canvas of the 26th, it is the model's turn to be alone, standing triumphant on a large canvas, and, the same day, on another canvas, the painter is working in front of the bust, which is growing in size, while the model has moved away and looks tiny at the far end of the studio. — On the 27th the nude is becoming larger. On the 28th it has come near enough to the painter's easel to touch it. On the 29th, the painter puts on his hat. On the 30th his easel and his beard are blue, O Bluebeard of a thousand wives, hung in all the picture-galleries of the world. And the same day the chest of drawers becomes

270
Masks and Ape
Grotesques et Singe
24.1.1954 II
Ink, 9.4×12.5 inches
National Museum, Stockholm

271
Clown and Female Nude
Clown et Femme nue
21.12.1953
Wash, 13.65×10.3 inches

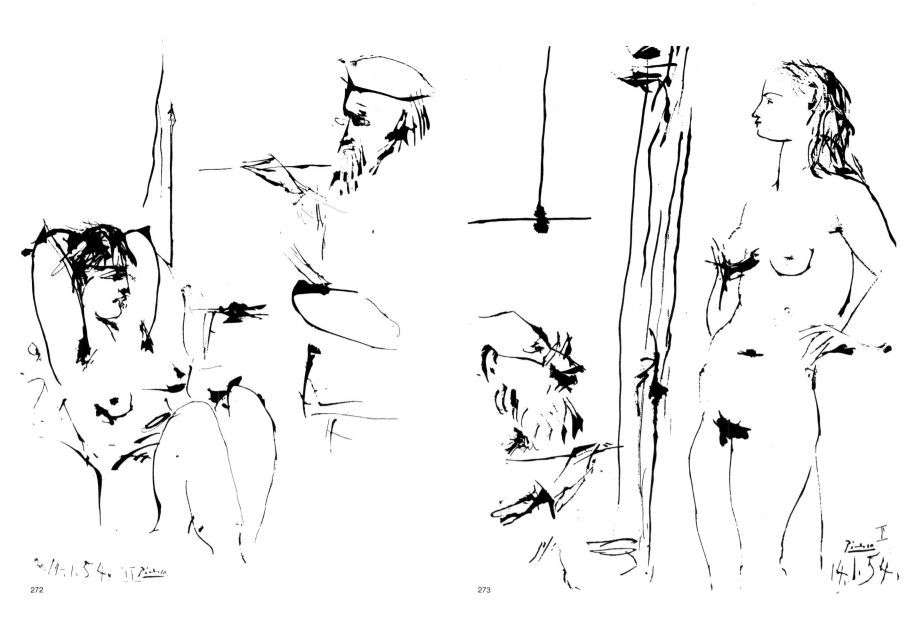

272

273

272
In the Studio
Dans l'Atelier
14.1.1954 II
Wash, 12.5×9.4 inches
Gustav Schürfeld, Hamburg

273
In the Studio
Dans l'Atelier
14.1.1954 I
Wash, 12.5×9.4 inches

orange for another canvas and the nude takes on vast proportions. — On April 2nd, the Afghan hound Kaboul comes and lies at the painter's feet. — And on the 3rd, the painter puts on a fawn-colored hat to work. — And the rhythm quickens desperately, the canvases accumulate. — On April 28th, on one canvas, the painter is painting at night by electric light, but on another, the same day, he dresses warmly from top to toe and poses his model naked under the apple-tree in the garden. — On May 1st, there they are, both of them, deep in the forest, but on the same day a green nude on a red chair is posing for the painter in the studio, in the studio where Picasso is painting the painter painting and the model posing. — On the 5th the weather is mild, and the painter is in the garden in summer clothes, painting the nude relaxing in the sun on a chaise-longue. — On the 10th the painter has put Jacqueline's coolie-hat on his head, and posed his model lying in the forest thick with trees. — On the canvas of the 11th they have come back into the studio. — But on the 16th they go out again. And so on.[*]

As he did in the *Meninas* series, Picasso switched back and forth between tall and wide formats. Several of the big paintings begun in spring were brought out again in September to be reworked and finished. He left their formal composition more or less unchanged but gave the colors new accent and weight.

Even in the first few weeks Picasso began to sharpen the confrontation. At first everything is relaxed and pervaded by the milieu. The model lies on a sofa, naked. On a chest of drawers stands the bearded bust. The painter is sitting on a chair at the left

* Hélène Parmelin, *Picasso Says...*, translated by Christine Trollope (London, 1969) pp. 85—86.

of the canvas. The viewer is at sufficient distance from the vast space of the studio to adopt an observer's position. This arrangement remains unchanged throughout the first series of paintings. The rich scale of generously used colors creates so much atmosphere that even the *contre-jour* lighting from the studio window in the background softens all firm contours and permits a wide variety of coloristic effects.

In a later phase (though actually still in March, 1963) Picasso enlarged the pictorial frame by pushing the space back, directly opposing the painter on the left and the model on the right, reducing the color scale accordingly. Complementary yellow and blue planes were deliberately juxtaposed. The shapes within them, however, gained in coloristic differentiation, so that the nude attains plastic life through countless little gradations of color. The painter, by contrast, was reduced to hieroglyphic forms. The movement of the painting arm expresses itself in the construction of the body. The double profile, with the broad line outlining the head, adds to the feeling of concentration and energy. Here and in later pictures the emphatic vertical of the easel separates painter and model, as it did in many of the 1953–1954 drawings.

In late April Picasso began the first version of this theme in an open-air setting (Plate 275). The painter's position is still to the left, the model's to the right. She is lying under a tree in a field—almost an integral part of the landscape. The nude is as brightly luminous as the houses, her breasts as round as the leaves of the tree. The painter, dark and dignified in the background, has placed himself and his easel outside the tableau. But once again it is not long before painter and model move closer together. The pictorial frame is enlarged. All that is left of the tree is its trunk. The figure of the painter reaches from top to bottom of the canvas.

Picasso painted the most important version of this phase in June, in a tall, monumental format (Plate 278). Again he moved painter and model up close into the foreground. Again the easel divides the elongated proportions vertically, so that both figures have to act or pose in deliberately narrow areas. The painter, shown in profile, is one of the hieratic figures of the late work: a painting seer, while the nude, turned full face to the viewer, is one of Picasso's most beautiful imaginative conceptions of the model. Her arms are raised above her head in the pose he so often used. Her glance seems to come from some remote distance. In this picture Picasso has extracted all his previous experiences with the painter-model theme and in a sense invented the prototype for further variations on it. In this economical yet gesturally rich treatment, which entirely eliminates episodic detail, he achieved a classic blending of all the ritual, erotic, dialectical, and meditative aspects the theme has to offer.

In the following two years he split up the rich associations of the subject. Now model and painter alike can free themselves from the context. The painter's field of action is no longer studio or garden but merely the canvas on which the picture of the model takes form—and this precisely when she herself no longer appears in the picture (Plate 279). In the next step, however, the subject of the painting—the painted model—disappears, leaving the painting painter as an isolated figure. Without giving up his anonymity, the distance he has maintained throughout this whole series, Picasso is drawing steadily closer to himself. He is always the painter—no one could possibly overlook that—but,

"It's the movement of painting that interests me, the dramatic movement from one effort to the next, even if those efforts are perhaps not pushed to their ultimate end. In some of my paintings I can say with certainty that the effort has been brought to its full weight and its conclusion, because there I have been able to stop the flow of life around me. I have less and less time, and yet I have more and more to say, and what I have to say is, increasingly, something about what goes on in the movement of my thought. I've reached the moment, you see, when the movement of my thought interests me more than the thought itself." (GILOT)

274
The Painter and His Model in the Studio
Le Peintre et son Modèle dans l'Atelier
17.3.I, 9.4.1963
Oil on canvas, 25.35×35.9 inches
Galerie Leiris, Paris

275
Painter and Model
Le Peintre et son Modèle
28.4.II, 4.5.1963
Oil on canvas, 34.7×50.7 inches
Holger Graffmann, Danderyd, Sweden

276
Painter and Model
Le Peintre et son Modèle
29.3., 1.4.1963
Oil on canvas, 50.7×63.2 inches
Galerie Beyeler, Basle

277
Painter and Model
Le Peintre et son Modèle
28.3., 7.5.1963
Oil on canvas, 50.7×63.2 inches

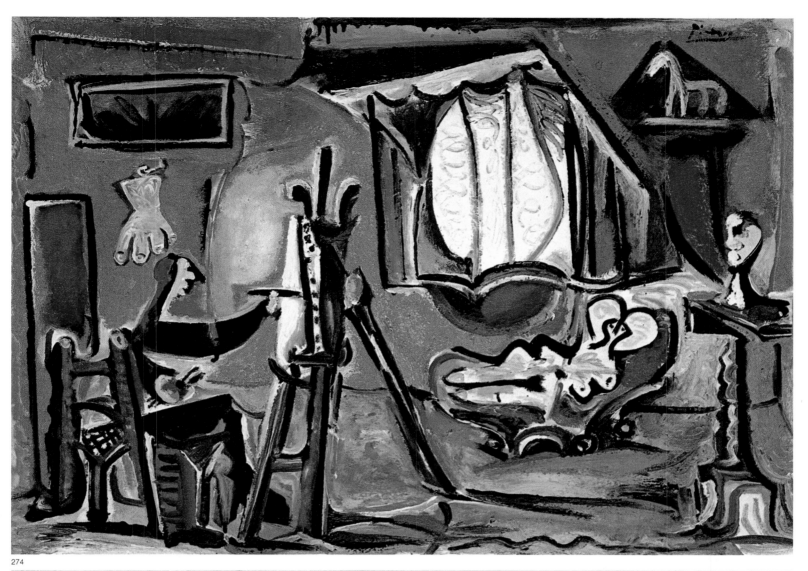

274

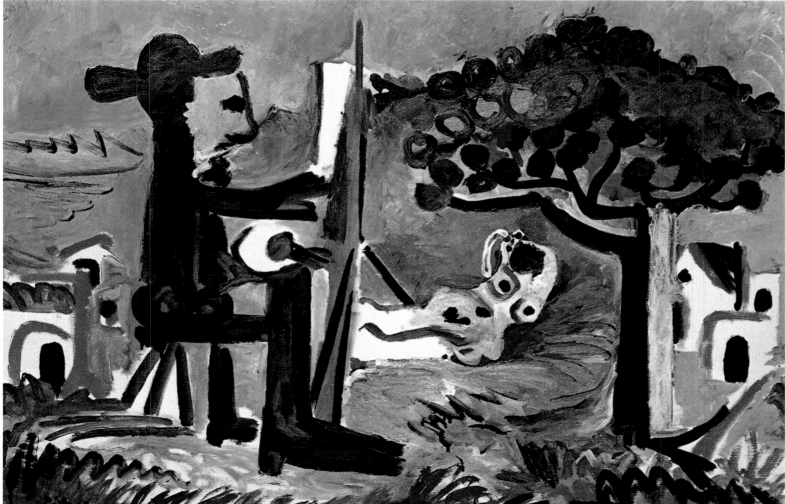

275

167

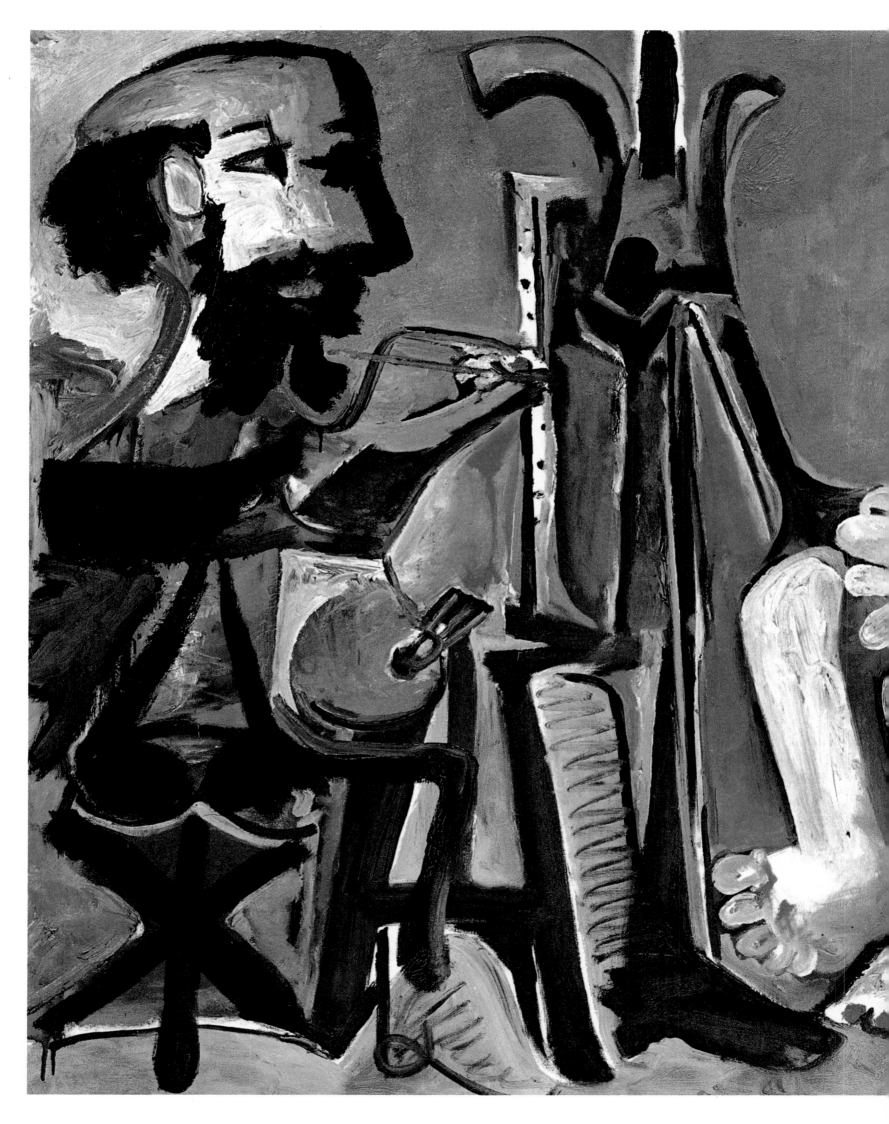

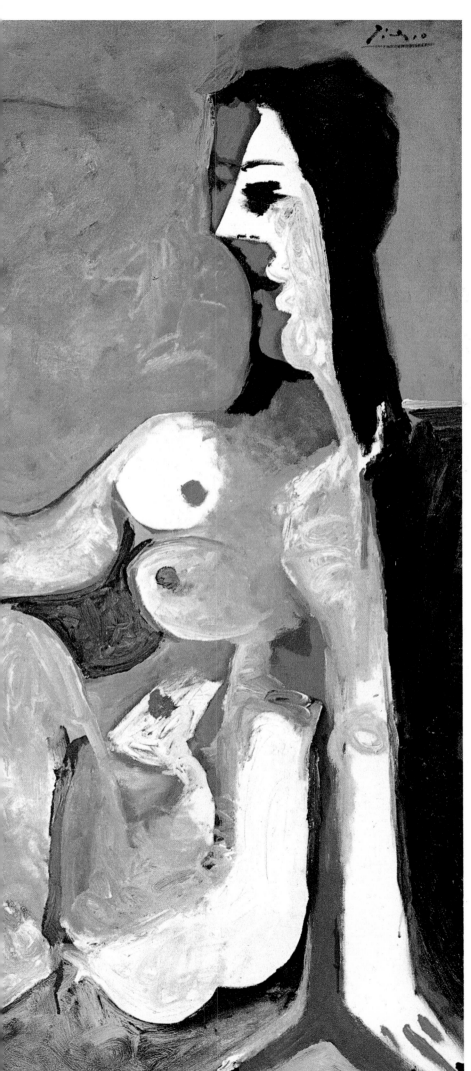

276

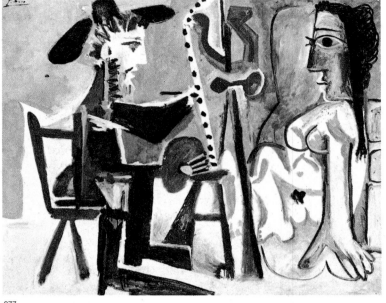

277

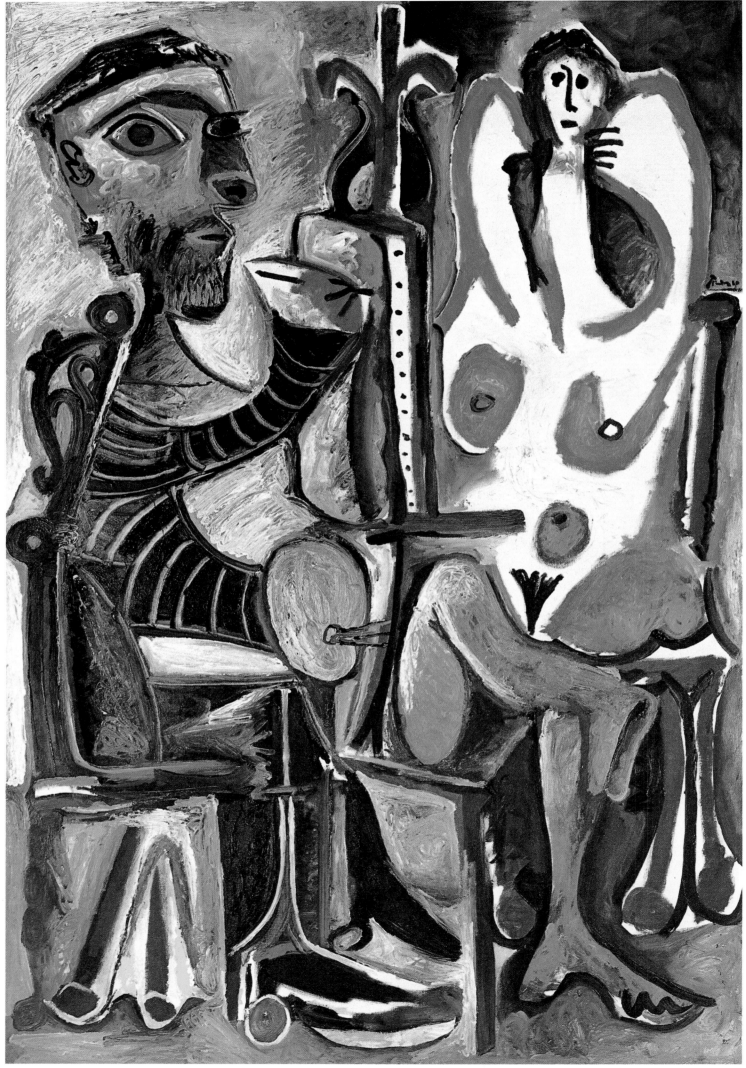

"Painting isn't a question of sensibility; it's a matter of seizing the power, taking over from nature, not expecting her to supply you with information and good advice." (Gilot)

278
Painter and Model
Le Peintre et son Modèle
10., 12.6.1963
Oil on canvas, 76×50.7 inches

279
Painter at Work
Peintre au Travail
26.10.II, 3.11.1964
Oil on canvas, 56.9×34.7 inches

280
Painter at Work
Peintre au Travail
3.4.1965 III
Oil on canvas, 23.8×19.5 inches
Galerie Beyeler, Basle

281
Model in the Studio
Modèle dans l'Atelier
1965
Oil on canvas, 14.8×17.9 inches
Galerie Beyeler, Basle

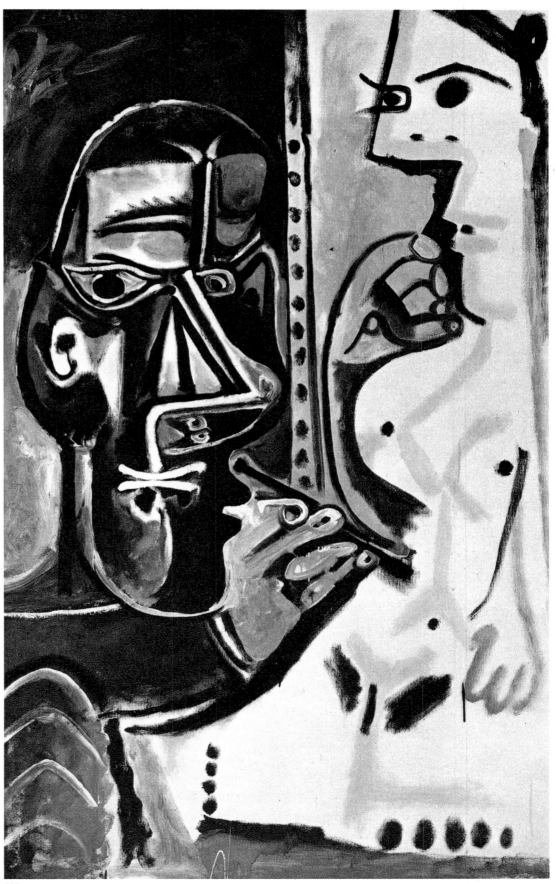

279

280

281

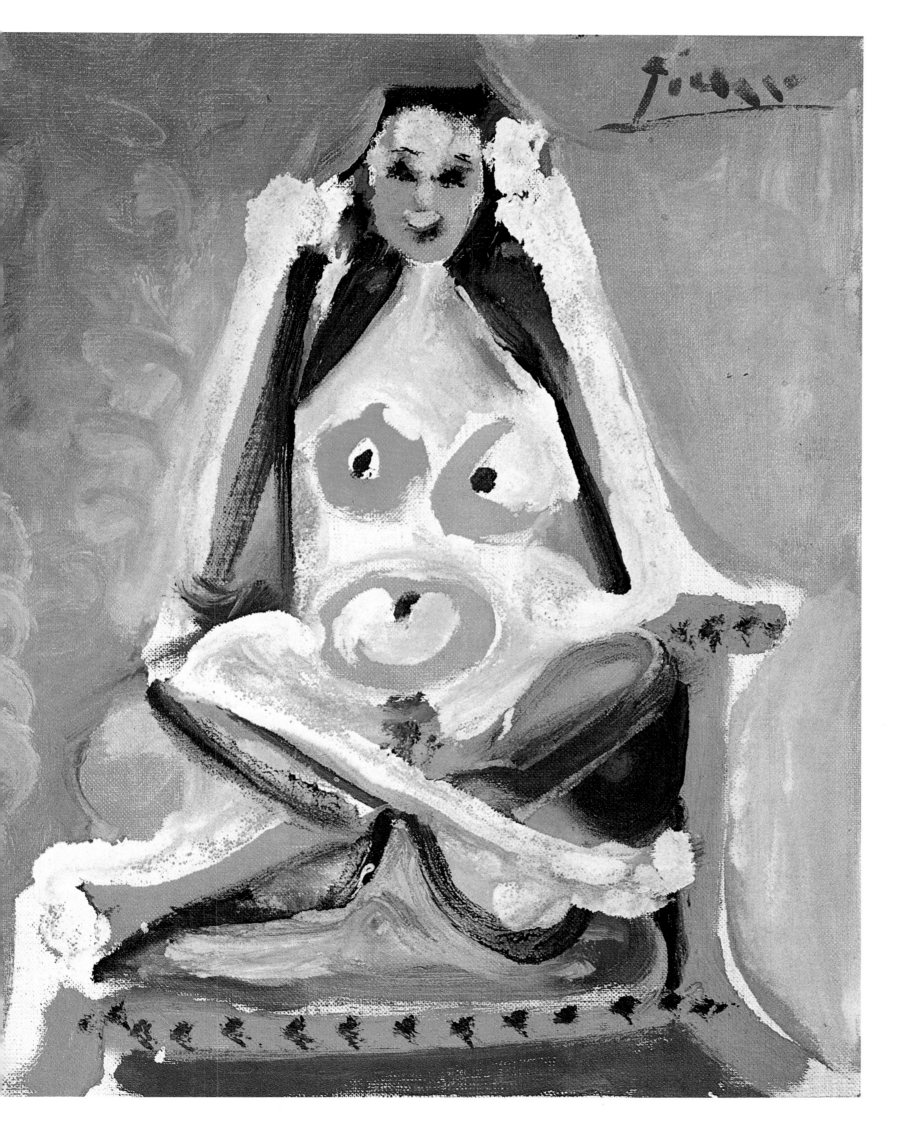

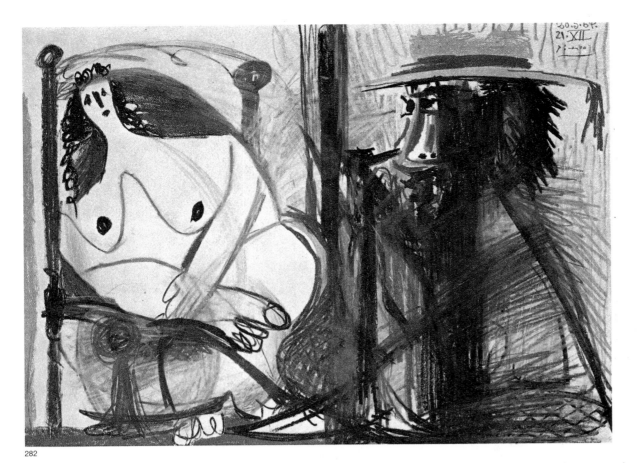

282

283

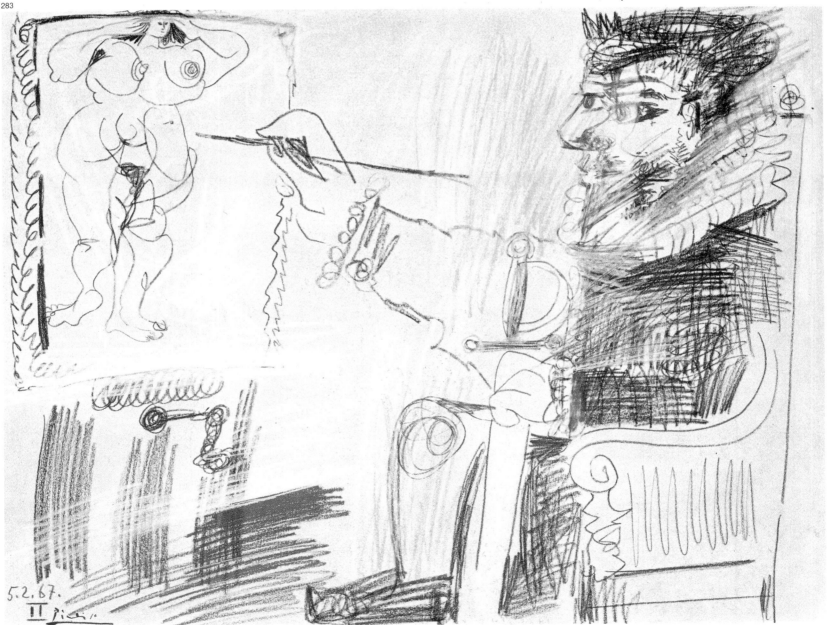

still more important, the investigation of painting, the monologue with himself, has achieved such validity for his late work that he can now deal with this comprehensive topic, the very core of painting, in a description as private as it is detached.

In spring, 1965, he painted two small pictures, chronologically very close, which might almost be mutually related side panels for the big central motif. One of them shows on the left the painter's torso, again in profile, holding his palette and brushes in one hand and a paintbrush in the other (Plate 280). He holds them in the tiny space between his face and the easel, as he works on the picture which, like its model, is beyond our field of vision. Picasso put in the accents in thin, cool, watercolorlike hues. Most of the canvas is blank; the indifferent brightness of the chalk white ground remains untouched. The light, delicate detail, the colors, and above all the easy, unforced spatial relationships produce an almost Chinese effect.

The "counterpart," showing the model in the studio (Plate 281), is based on delicate pink and yellow tones. The model is dressed as festively as a bride. Her raised arms are hardly distinguishable from her light veil. She is enthroned in a frontal, symmetrical pose, on a red and yellow sofa. At her left is an easel with a canvas which, being blank, does not compete with the intimate portrayal of the nude.

In the spate of drawings and prints that began in 1966 Picasso eliminated in turn the painter, the model, and the work of art. In often shadowy semidarkness, then again in

284

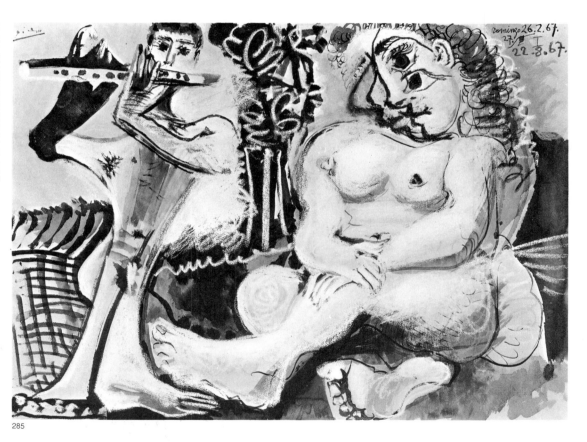

285

282
The Painter and His Model
Le Peintre et son Modèle
20., 21. XII 5. 1964
Crayon, 19.5 × 26.1 inches
Galerie Beyeler, Basle

283
Painter as Musketeer
Peintre mousquetaire
5. 2. 1967 II
Crayon, 19.5 × 25.35 inches

284
Painter at Work
Le Peintre au Travail
5., 7. 10. 1967 II
Pen and colored pencil, 12.9 × 19.7 inches
R. S. Johnson, Chicago

285
Woman and Flautist
Femme et Joueur de Flûte
26., 27. 2. I, 22. 8. 1967
Wash and crayon, 18.1 × 24.6 inches

bright light, enclosed in sharp clear lines, painter and model engage in endless interplay, which often makes it impossible to distinguish any individual motif. It is fascinating to see how many diverse sources Picasso draws on in formulating painter and model. The result is a self-portrait of painting, and precisely at this point Picasso has deprived it of every pretext to be splendid for its own sake, beautiful and satisfying. In dealing with this theme, favored in French tradition above all others, Picasso has, as it were, erected an "off limits" sign before this concept of painting. Painter and model also offer him, perhaps more than any other subject, the opportunity to complete his psychological return to Spain. When, at the end of the

series, he introduced the pimp Celestina, followed by the whole family, the *torero* and the grandees, he provided outward proof that he had crossed the frontier. Only the travesty brings to light the passion Picasso has put into this theme.

Quite unexpectedly the musketeer now takes over the artist's place (Plate 283). The soldier, with his big ruff and his sword at his left side, has set himself up as a painter. Sitting in an old-fashioned armchair in front of the easel, he is painting the model—or rather, his memories or wishful dreams. Not only has the painter turned into an old

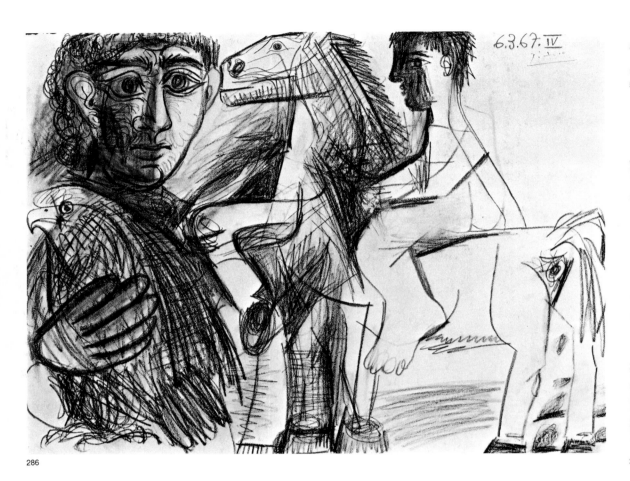

286

287

man, but painting itself is old—a piece of art history in the Baroque costume of the musketeer figure, which, half old soldier, half cavalier, seems to hark back to the portraits and figure pictures of the Golden Age of Spain, between El Greco and Velázquez. The dense hatching in crayon and the linear flourishes make the musketeer look like a heavily armored figure, while the nude on the easel, her well-rounded body drawn in long contour, smiles in wonder and provocatively watches the gallant or martial masquerade. Through the model Picasso is interrogating history, which is being projected backwards in historical dress. It is no longer the painter who gives the answer; the musketeer is now the actor and creator of these scenes. The interweaving patterns of his multiprofile reveal, behind the old soldier's mask, the face of a clown. Through simple linear techniques Picasso achieves a mobility of mimic expression which changes with every stroke and strives for forceful and ambiguous effects.

Now it is no longer the painter but the man playing a flute who shares the model's company outdoors (Plate 285). The flute replaces the paintbrush; music replaces painting. But this is not simply a return to an Arcadian motif. Something else is happening: Art, personified by painter and model, is giving itself over to the saber-rattling, flute-blowing, or melon-devouring representatives of history and "eternal youth." In every statement he ever made Picasso invoked his right to the present. In these late paintings and drawings he widens the present to include the symbols of past and future. The model remains the center of all visions. The intensive documenting of

the studio, the painter's self-interrogation, are imperceptibly transformed into an apotheosis of the model, who, omnipresent, now assembles around her all her admirers of yesterday and tomorrow.

The more interlocked and complicated the painter-model theme grows, and the further-reaching and more universal its references, the more plainly these changes are reflected in mysteriously allegorical or mythological groupings. Alongside familiar figures from the circus world appear fabulous heads, such as the one of a young man

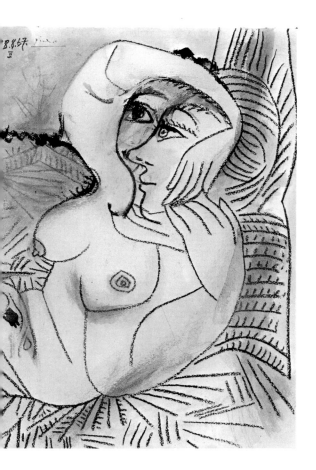

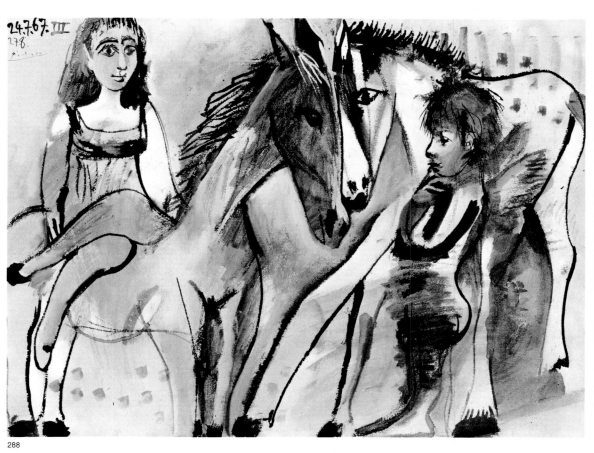

with eagle, horse, and rider (Plate 286). The ugly, expressive head of a spectator watches wide-eyed from behind the circus ring barrier a girl rider chatting with an old, seated clown (Plate 289). Here again the woman's silhouettelike portrait increases in size toward the background, in reverse perspective. Wash drawing and gouache colors are juxtaposed so roughly as to create an impression of multiple exposure or double projection, giving physical reality an almost surreal, transient character. Typically, in these free, colorful drawings the elegiac melancholy of Picasso's early paintings reappears, though on a more theatrical level. The play no longer depicts a limited social milieu; it has become Picasso's paraphrase of "the great theater of the world."

Just as painter and model left the house and went out into the garden or the landscape, Picasso shifts the scene of his couples' meetings to the beach or a meadow. But the model is not always accompanied by a painter, a flute player, or a writer. The couples are not always eating melons. All "action" has disappeared. No suggestion of genre or parody diverts attention to any kind of happening. The scene is rendered quite contemplatively, as though the painter had divorced himself from his activity and were now no more than an observer of the model. Picasso, usually so quick to respond to any pretext for playfulness, renounces it now for the sake of tense silence, perfectly expressed in the clarity of line and the few simple colors.

Freed from all substantial relationships, *The Three Graces* (Plate 290) now appear, the most sublime self-presentation of the nude since antiquity. They are yet another

286
Young Man with an Eagle and a Rider
Jeune Homme à l'Aigle et Cavalier
6. 3. 1967
Crayon, 19.3 × 25.5 inches
Galerie Rosengart, Lucerne

287
Couple in a Meadow
Couple dans un Pré
18. 8. 1967 II
Ink, crayon and gouache, 22 × 29.25
inches

288
Circus Scene
Scène de Cirque
24. 7. III, 27. 8. 1967
Wash and gouache, 22 × 29.25 inches

tribute to Ingres' line, to the delicacy of his drawing and the clarity of his contour. The nudes of this profane trinity are highly individualized. The fascinating thing about these three very different graces shown in differently "graceful" poses is the uneven development of the individual parts, first of all in the graphic line but also in the painterly implementation. Particularly well developed is the head of the center figure. It is set against a beautiful ochre background, and this color encloses the whole group like a shadow. The cloaklike background underlines the nakedness of the figures. In the self-awareness of these graces, whose faces bear no trace of a smile, we catch a glimpse of the austere physiognomies of the *Demoiselles d'Avignon* and immediately realize how much more gracefully conceived these nudes are than their predecessors. Even the exaggeratedly large hands of the kneeling figure accentuate the delicacy of her body.

The classicism Picasso chose as his vehicle for the theme of the three graces is broken at one point. At the right edge crouches a fourth figure, part servant, part cupid, part observer delighting in the scene. Here Picasso breaks with tradition, just as a medieval artist would place in the lower corner of a picture a figure that is often difficult to identify. We may read the figure as himself, the author of the drawing, or as a subsidiary figure like those we find in the old masters, or even as the donor. No explanation is forthcoming. Even if this fourth member of the group did not keep showing up in other drawings, his appearance here would give us sufficient cause to marvel anew at Picasso's untiring and mysterious inventiveness. The graces are not goddesses, and the fourth figure is not Paris. Picasso despises that kind of pat allegory

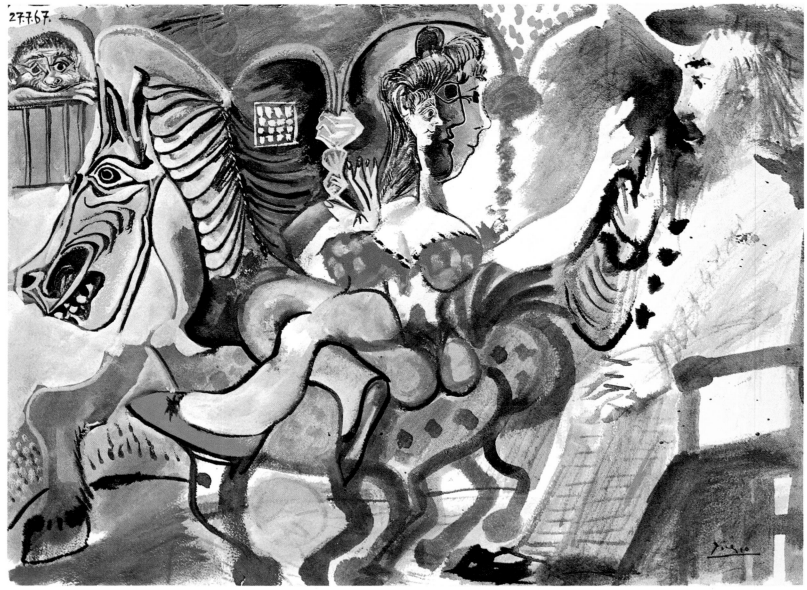

289

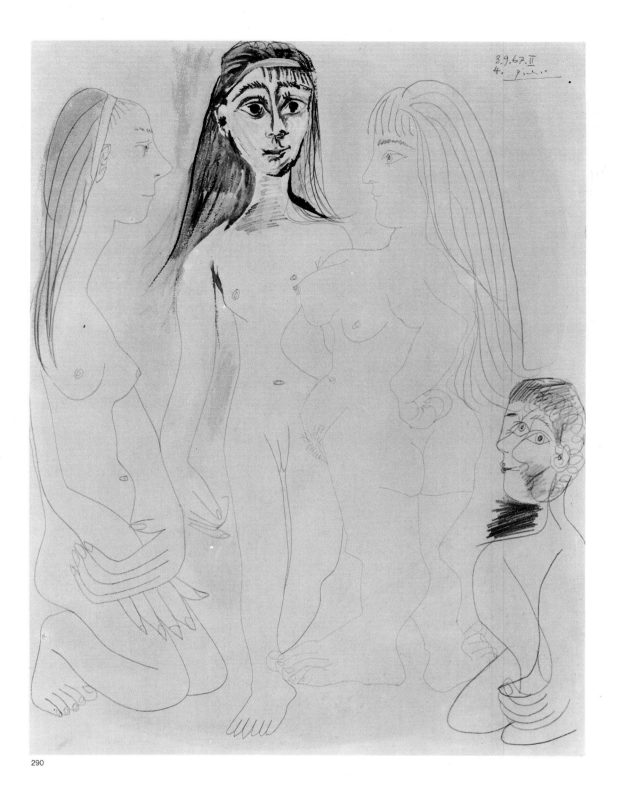

290

289
Circus Scene
Scène de Cirque
27. 7. 1967
Wash and gouache, 22×29.25 inches

290
The Three Graces
Les Trois Grâces
3. 9. II, 4. 9. 1967
Pencil and gouache, 29.25×22 inches

"I hate that aesthetic game of the eye and the mind... played by these connoisseurs, these mandarins who 'appreciate' beauty. What is beauty, anyway? There's no such thing. I never 'appreciate,' any more than I 'like.' I love or I hate. When I love a woman, that tears everything apart —especially my painting. Everybody criticizes me because I've had the courage to live my life in broad daylight—with more destruction than most others, perhaps, but certainly with more integrity and truth, also.'' (GILOT)

with no loose ends. His final judgment is obscure, despite its serenity, and even his contemporaries have trouble deciphering it.

The formulation of the painter-model theme marks a climax in Picasso's late work. From the standpoint of today whole chapters of his post-World War II painting look like preparations for this confrontation, while his most recent groups of paintings—the musketeers and melon-eaters, the pipe-smokers, couples and *saltimbanques*—might be an epilogue to the intense, lengthy dialogue between painter and model. In the serial paintings, and especially in the vigorous, incomparably productive burst of etchings and drawings, we catch a hint of the tremendous tension this theme arouses in Picasso.

Indeed, the graphic work reveals even more plainly than the paintings the hallucinatory sureness of his hand. His dark fantasy populates the "comédie humaine" with one new role after another, turning it into a sort of satyr play. The costumes of the actors and extras, which in Picasso's early days used to reveal so much about their wearers and about the painter himself, are now quite inconsequential—

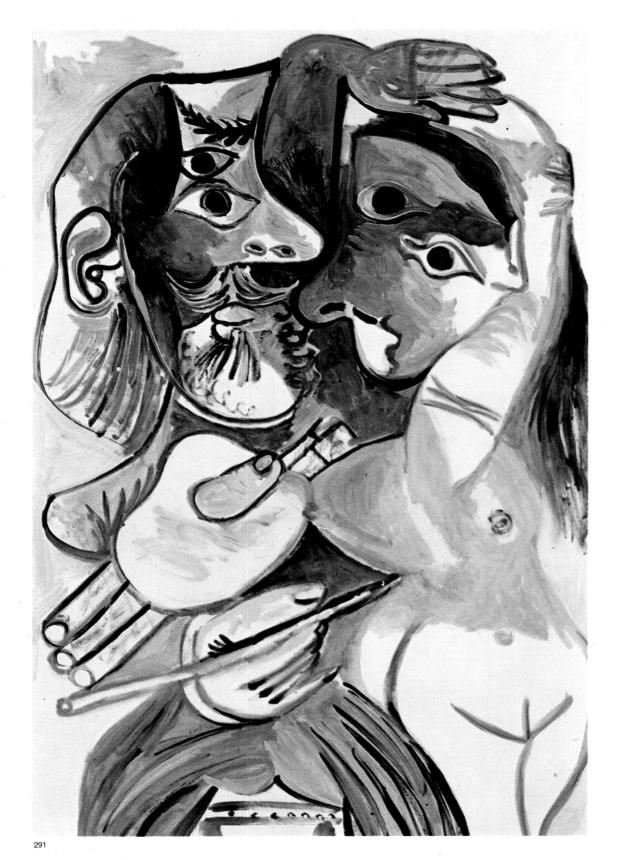

291

sometimes even ludicrous—relics. Fragments of classical antiquity stand side by side with quotations from the European Baroque or from Spanish history; memories of Diaghilev's Russian ballet of the 1920's—autobiographical visions—insinuate themselves. While the painter is now to be found only on the margins of this motley company, the model is nearly always present, though she has again assumed the role of nymph or equestrienne in the mock-dramatic dénouement of the play.

As the company, the fantastic trysts and erotic rendezvous become more extraordinary, Picasso makes freer use of formal abbreviations. A love of strong, sometimes clashing colors fits the painter's "handwriting," which has abandoned all illusionist concessions. With almost destructive vehemence Picasso's brush disregards the conventional categories of pictorial order and two-dimensional structure. Dribbles, splotches,

291a

291
Painter and Model
Peintre et Modèle
14.7.1969
Oil on canvas, 76× 50.7 inches

291a
Etching
8.9.1968 I
5.85×8 inches

292
Painter and Model
Peintre et Modèle
21.10.1969 II
Oil on canvas, 50.7×76 inches

spatters, and flecks of paint, scratched-in backgrounds, and patches of carelessly unpainted canvas challenge all the standards hitherto applied to Picasso's painting. In an unmistakable gesture he has swept away all tried and true stylistic and pictorial principles. The deliberate "artlessness" of the paintings of recent years is not only a new expression of ironical skepticism toward notions of the perfection and harmony of old age but also a radical polarization of his pictorial world. Only through his unconcerned and unadorned technique (which sometimes seemed almost "makeshift") did Picasso reach the threshold of freedom where his stock figures embody their naïve being. The obvious elimination of "pretexts" such as composition and brushwork forces us yet again to correct our concepts of the phenomenon of Picasso.

292

*"When I was their age I could draw like Raphael,
but it took me a lifetime to learn to draw like them."*

Herbert READ quoting Picasso's comment on an exhibition of children's drawings,
letter to *The Times* (London), October 26, 1956

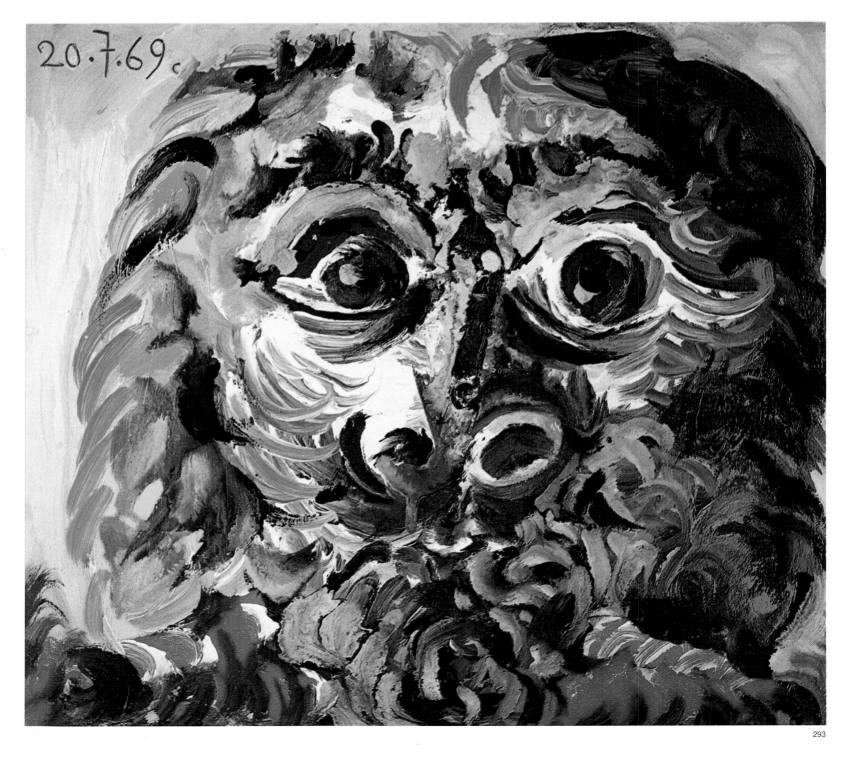

293

Avignon 1970

In the summer of 1970 the Palace of the Popes in Avignon was invaded by an assemblage such as it has never seen before, which took over the walls of the Gothic chapel, filling the vast warm space with its presence. The new tenants were 165 paintings, hung in rows, two- or sometimes three-deep, like tiers of balconies. Their figures were cupid with musketeers, musketeers with pipes, men sitting in chairs, reclining women, wreathed heads, painters with children, embracing couples, Pierrot and Harlequin, women in chairs and women with a bird, and finally a man with a golden helmet. Picasso had deployed his own Swiss Guard in Avignon (Plates 1 ff. and 291 ff.).

Picasso painted these 165 large- and medium-size canvases between January 5, 1969, and February 2, 1970. The mathematics alone are overwhelming, working out to the almost absurd statistical proposition that for thirteen months Picasso painted a picture every fifty-two hours. No other painter can match this pace—or even compete. The work of these last years is too vast for a precise view, it can only be compared to the multiple branching of a great river as it pours into the sea. The banks are lost on the horizon. Orientation calls for a new scale of measurement.

No book—and certainly no inventory—can keep track of this production. The provisional catalogue of Christian Zervos, regularly brought up to date, already fills twenty-three volumes but has only reached the paintings and drawings of the early 1960's.

Picasso eludes his biographers and historiographers, even when they craftily dog his footsteps. Then, in the papal chapel in Avignon, he suddenly flung wide his arms and said: "Voilà!"—one year's work, the work of a painter whose physical strength and health are the envy of young men, the exhibition of an unabridged shorthand diary. The pictures are arranged in chronological order—permutations of figurative subjects seen in static front view and counterpointed only occasionally by scenes of lively activity. The colors are glowing blues, reds, and saffron yellows. Many of the pictures are painted on unprimed wrapping paper.

All summer long the streets of Avignon were full of free, footloose young people in colorful garb, attracted to the festival from all over Western Europe. Meanwhile Picasso's troop of equally bizarre characters made itself at home inside the palace. Only the palace walls separated these two worlds, which shared the same free-and-easy spirit, the same casual self-presentation and capacity for regeneration. Picasso's subjective eccentricity found an echo in the whole colorful youthful scene, which sometimes recalled a medieval kermess.

293
Head
Tête
20. 7. 1969
Oil on plywood, 12.5 × 14 inches

183

The contemplative element in Picasso's latest pictures, expressed in the quiet pose of the seated figures, the large form of the heads and the absence of all activity, is challenged by the rapid, almost frantic notations of the brush. No picture is "finished." None of the bodies, flowers, or birds are "properly" painted. Hurried execution, the evidence of Picasso's famous rapid painting technique, marks every single work and at the same time brings out the striking overall unity of the paintings as a whole. The broad, often brutal brushstroke is not the only constant element: A pronounced colorfulness also characterizes most of the works.

294 295

Fifty-five drawings made during the same period (which Picasso has given to Avignon) provide a contrast to the economical, urgent concentration of the paintings. The drawings are scenically composed, transforming the awkward contours of the paintings into the free play of pure line. The infinite variety of their storytelling contrasts with the stern appeal of the paintings.

Picasso in Avignon. The picture which made him world-famous as a revolutionary painter bears that name as part of its title: *Les Demoiselles d'Avignon.* Two generations and more than sixty years later Picasso returned to the city with daring, wild inventions. The place is consecrated. The group of *demoiselles* which signaled the first Cubist experience of 1906—1907 finds its descendants in the musketeers of 1970. In 1970 Picasso gives us fresh proof that he is a traditionalist; what he paints today is just what he was painting seventy years ago—human beings and their relation to a reality for which his own life furnishes the paradigm.

The new works fall into groups. If we look at the paintings in sequence, we find leaps, reversals, repetitions, just as in a musical score main and secondary themes are stated, alternate, run parallel, and reappear in a new form. If we break the chronological order here and there and group the pictures by subject, the richness of materials is even more striking. The shifts of objects and colors shade off into nuances so that the internal structure of a theme often undergoes a subtle change. Or Picasso may set

down complementaries, geometry instead of arabesques, light instead of dark or line instead of plane. However alike or unlike the "ornateness" of two works may be, the painter's incomparable sureness of touch, which he communicates to his creations, emerges from every variation. Now unequivocal, now ambiguous, yet always clear and decisive, they personify their temperaments. A grimace, a nose, the reaching out of a hand, a wreath of flowers in the hair or a hat pulled down over the ears, boots and bare feet—every detail is given objectivity and weight and loses its aggressive willfulness within its thematic context.

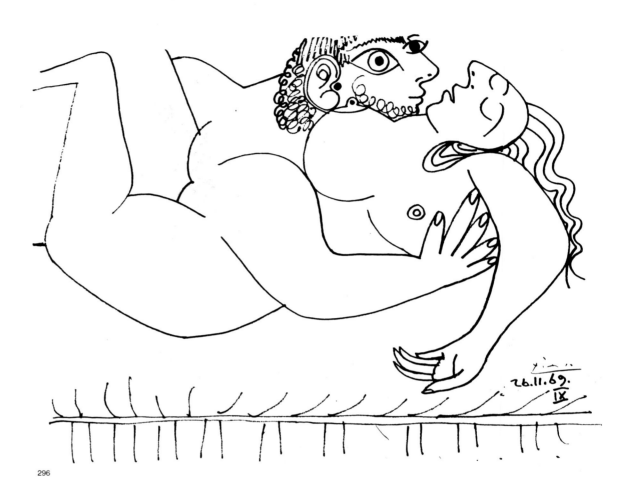

296

All portraits, couples, and scenes from Picasso's most recent period have one thing in common: They move out to the very edge of the painting or are posed on the apron of the stage. Their field of action is narrow compared to earlier works. If they do not fill and dominate it completely, it is cut off by a background which Picasso characterizes clearly—as a papered wall, a curtain, a sky, a landscape or garden backdrop. Often this plane is not evenly developed but simply placed behind the figures as an indefinite spatial backdrop. Whatever techniques Picasso may use to suggest surroundings and space, nothing detracts from the "up front" position of the motif.

Physical objects are represented as sketchily as stage props. Only the articles the figures hold in their hands or that are necessary to identify the figures claim full validity. The whole emphasis and weight of the picture centers in the hands, feet, and heads. Often enlarged to gigantic proportions, they intensify the effect of an extremely close view. Picasso uses these exaggerating perspectives (familiar to us from photographic close-ups of feet or hands stretched out toward the camera) to achieve an even greater intensity. By eliminating the usual distance from the subject, he forces the viewer to confront the picture directly. Liberties he seems to have taken in combining details, parts of the body, or movements turn out to be compelling and "natural" when we place ourselves in the painter's position, who no longer tolerates any separating gap.

Now the viewers as well as the pipe-smokers and musketeers, lovers and portrait heads are forced into the almost frightening situation of having to "squint down their

294
Ink 26.11.1969 XI 8.2×11.9 inches

295
Ink 26.11.1969 X 8.2×11.9 inches

296
Ink 26.11.1969 IX 8.2×11.9 inches

185

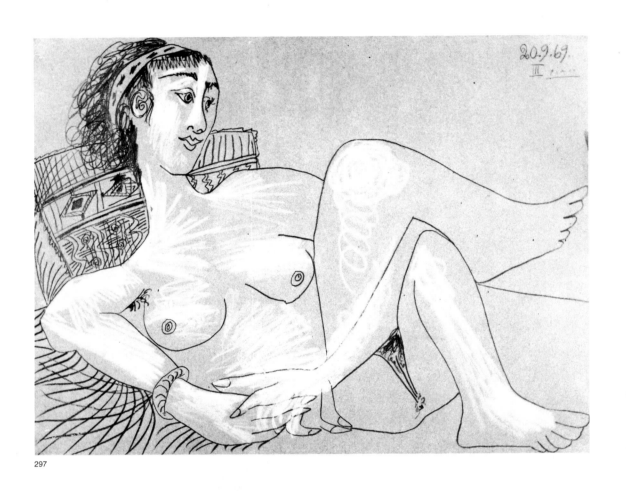

297

In Picasso's most recent draw-
ings, exuberantly over-
crowded sketches stand next to
ones which seem to be filled
with nothing but space and
atmosphere. Something that a
moment ago was pure line
suddenly presents itself as a
black, spectral shadow, the
mere projection of a figure
whose movement and life seem
to be thrown on a wall in
blurred, enlarged silhouette.
Picasso lets mysterious spaces,
exaggerated realism, flat and
solid elements interpenetrate.
One nude is ethereal and
spectral, another drastic and
grotesque. Anecdote suddenly
issues into the great spectacle
of the world. Picasso likes to
make bodies appear weight-
less, as equilibrists do, by
shifting the center of gravity
slightly. Mythology and
circus are constantly exchang-
ing costumes.

298

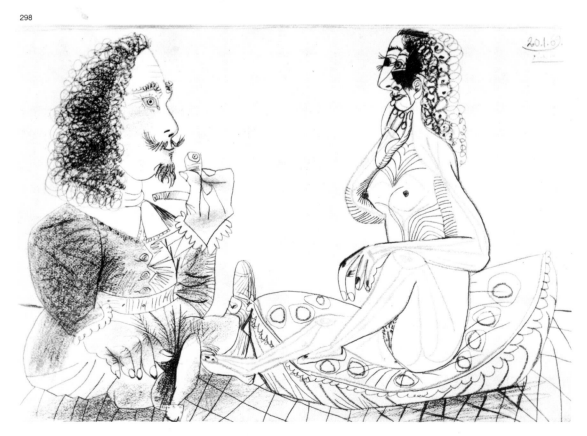

297
Reclining Woman
Femme couchée
20.9.1969 III
Pencil and chalk, 18.7×24.8 inches

298
Nude Woman and Musketeer
Femme nue et Mousquetaire
20.1.1969
Crayon, 22.2×31 inches

299
Blue ink 19.12.1969 17×21 inches

300
Pencil, 1.8.1969 I 19.7×25.5 inches

299

300

noses." These figures are held up to us like a mirror pressed into our face, enlarging and distorting the image. But the unusually large and searching eyes and their glance, which, for all its manifold variations, nearly always looks out from the picture, sharpen our own eye to an awareness of this foreign yet intimate anti-world. We are the privileged observers of human phenomena, close yet removed, like the ungraspable yet tangible shadows Odysseus encountered on the Styx. Picasso's full-blooded figures seem to have been conjured up in the same way in an act of evocation which gives them presence and defines the viewer as eyewitness.

We may conclude that Picasso's almost plotless and only occasionally allegorical "comédie humaine," divorced from all conventional genres and concepts, seeks—and in these late pictures attains—a "concrete" subjectivity which is keyed to the subjectivity of the viewer, appeals to it, and makes it conscious. The language, austere and insistent as it often is, is also delicate and subtle; it is the language of a storyteller. We catch the voice, see the movement of the lips, and hear the intonation and stress of syllables, words and sentences. The truth of these pictures lies in our willingness to recognize them as true, and the episode—in Avignon the presentation of a year's work in its entirety—gains duration in proportion to the conformity that unites these pictures despite their diversity. The bewildering multiplicity of figures reveals an imagination of almost oriental richness. The constantly changing pageant, the repetition or modification of types of painting or themes, is dictated by the ingenious yet apparently quite natural "stage management" of chance, whose signature we recognize in fairytales. Every episode and every character is given a symbolic value which reveals that Picasso is as much magician as poet.

The wheel has come full circle. Picasso has returned to his starting point. There is no "summer after the death of Picasso." Instead, Picasso, with his talent for dramatic surprises, has captured the famous place of his Cubist revolution, the *Demoiselles d'Avignon.* His radical departure of 1906 is no different from that of 1970. The youth of today, who came to the festival at Avignon, can bear witness to that.

"The point is, art is something subversive. It's something that should not *be free. Art and liberty, like the fire of Prometheus, are things one must steal, to be used against the established order. Once art becomes official and open to everyone, then it becomes the new academicism."* (GILOT)

300 a

300a
Nude
11.8.1969 VI
Colored pencil,
19.7 × 25.5 inches

301
Man, Sword, and Flower
Homme, Epée et Fleur
2.8.II, 27.9.1969
Oil on canvas, 56.9×43.5 inches

302
Man with Sword
Homme a l'Epée
26.6.1969 III
Oil on canvas, 45.2×34.7 inches

303
Man with Gun
Homme au Fusil
17.9.1969 II
Oil on canvas, 56.9×43.5 inches

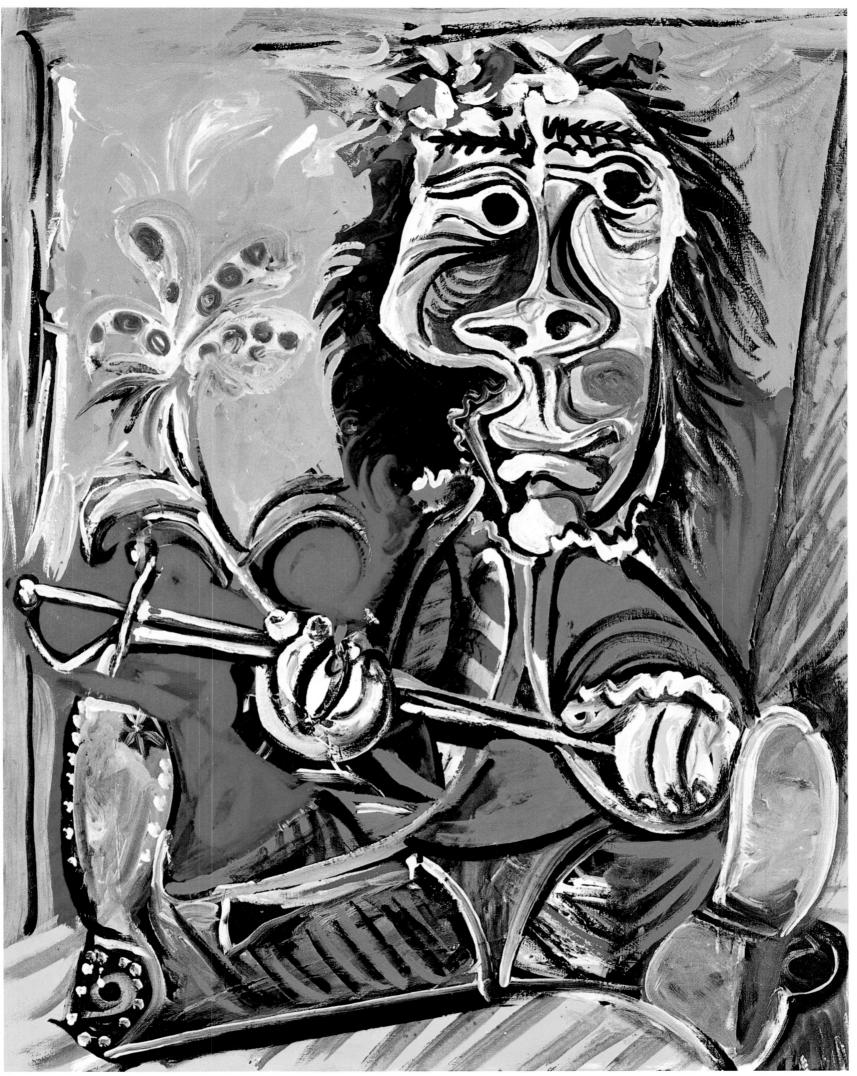

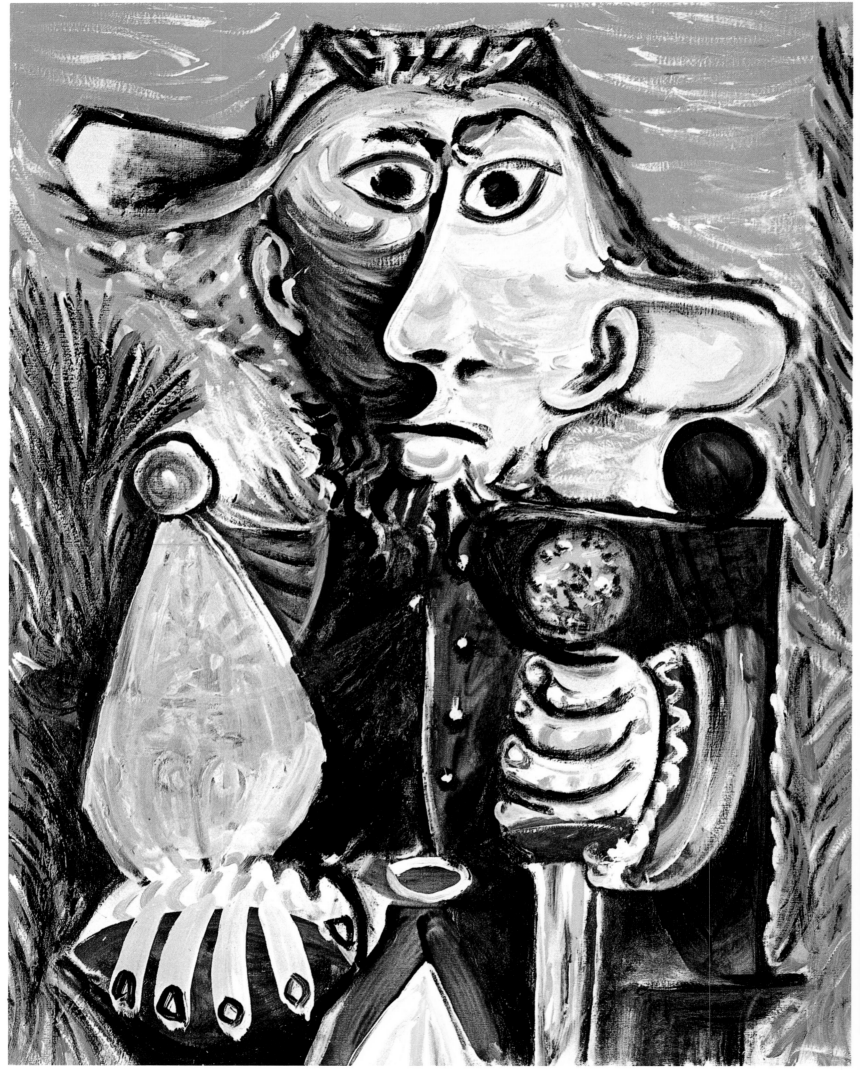

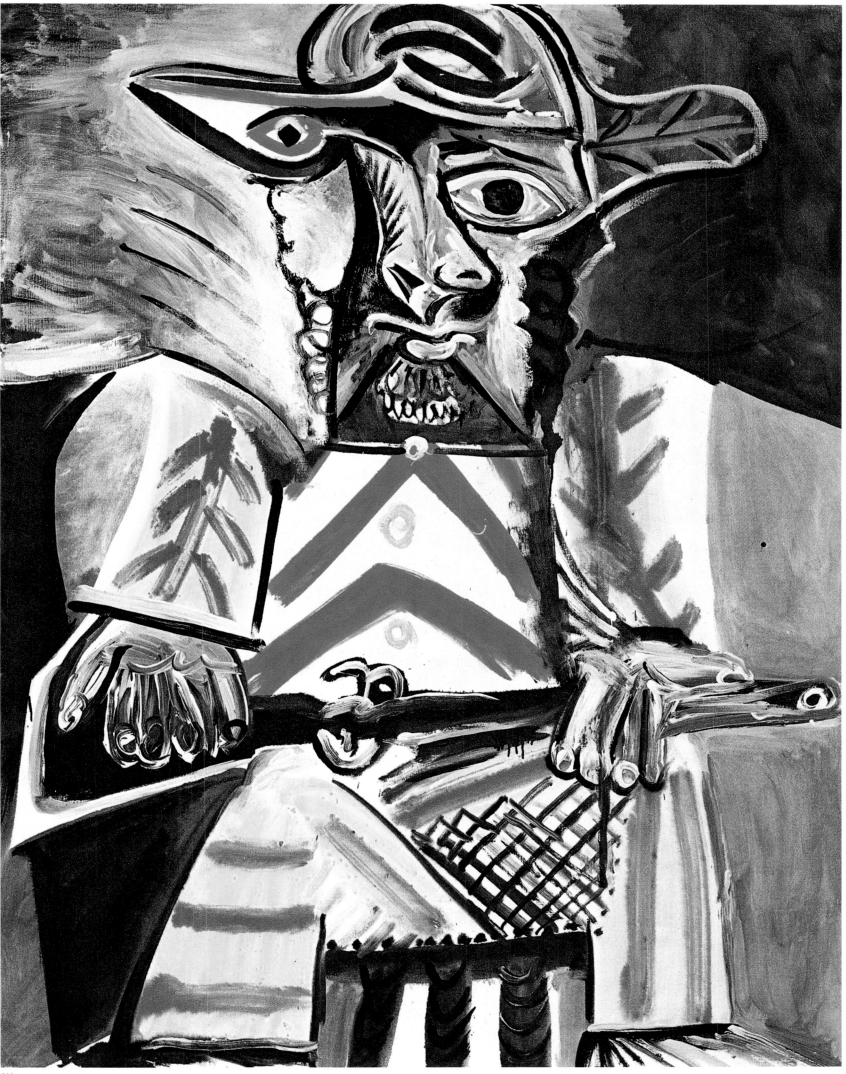

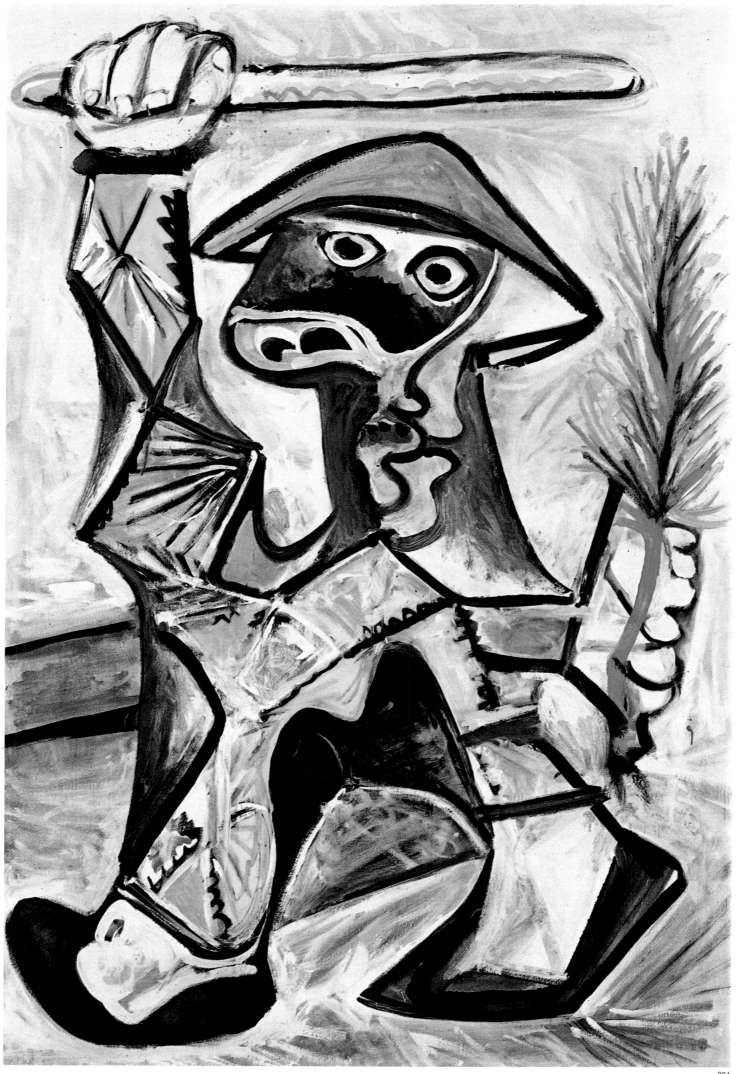

The Final Years

"That's enough, isn't it? What more do I need to do? What more could I add? Everything has been said." <small>(PARMELIN)</small>

Until his death on April 8, 1973, Picasso lived as an artist of our century. His life and work have already become part of history. A few years ago, one of his most celebrated paintings, *Guernica,* was transferred from New York to Madrid. There, in an annex to the Prado, it was shown to the Spanish public for the first time since its creation in 1937. Picasso did not see the return of the famous painting, a homecoming meticulously prepared and yet accompanied by many political and legal wrangles. In a sense, this was *his* return to Spain in an official capacity: Franco's death and the end of the dictatorship in Spain had opened the gates for his mission.

As a unique historical painting without parallel in our century, it has added a chapter of history to the Prado's collection. *Guernica* was a commissioned work of art, as we know such works from the nineteenth century. The Spanish Republic had invited Picasso and his friend, the sculptor Julio González, to participate in the artistic creation of its pavillion at the 1937 World's Fair in Paris. We are told of the artist's long hesitation to accept the commission – until the bombing attack on the Basque town of Guernica hurtled him into feverish creative activity in which the painting was completed within a few weeks.

Guernica became the anti-war painting of our century. No other artwork has addressed and reflected the feelings of several generations to such a degree. The most impressive artistic reminder of its time, it had hung in the Museum of Modern Art in New York since 1940. It was regarded as a pledge, an art form that publicly denounces the brutality and imprisonment rampant in the world, and symbolizes the innocence of the weak and suffering. Over the decades, *Guernica* has served as an acknowledgement of the moral and artistic consensus accepted by Western democracies. The painting and its content touch upon experiences common to viewers from all over the world.

The painting's spectacular journey from New York to Madrid – occasioned by Picasso's one hundredth birthday in 1981 – was, strictly speaking, not a homecoming; *Guernica,* painted in Paris, was now allowed to be exhibited in Spain for the *first* time. In Madrid, the painting was received as a national trophy and has since become part of a center for cultural and artistic events.

The demands on art have changed since the creation of *Guernica*. We now seek different attributes in our response to a work of art. Paintings are judged in a new way. They are being taken literally, especially by the younger generation. The artistic element in a work of art loses in expressiveness. Instead, qualities are preferred that contain identifiable quantities. Suddenly we are no longer ashamed to put forward

304
Harlequin
Arlequin
12.12.1969
Oil on canvas, 76 × 50.7 inches

arguments of a patriotic or provincial content to define a "claim to art". In the face of new demands, the "universal language" of art, which for a long time was a criterion of its validity and supposed timelessness, is veering more and more off course.

The personal and obvious, the legend or tellable tale, become the center of interest. The Prado is different from the Museum of Modern Art, and when looking at Picasso the question arises: What can this artist, who with his Cubism formulated a new definition of our comprehension of reality, what can he say in reply against these new, yet traditionally Spanish, demands and encounters? The untiring apostles of the so-called regeneration philosophy have always hailed him as "the eternally young Picasso" because of his inventions and tricks. Might it not be that these very inventions and tricks were the cause of an impulse toward self-examination and self-expression? Many regressive, anecdotal, and pointed traits of his later work imply this.

Long before the triumphant "return" of *Guernica,* Picasso had worked out a strategy for a homecoming. Although he himself did not return to Madrid, one felt, in the late work, as if a ghost from another world had returned. The Spanishness of the old master's articulation and argumentation became progressively more pronounced. The automatic and sporadically restless productivity of his eighties and nineties, his preference for open, vivid definitions brought him increasingly closer to his compatriot Francisco Goya. Goya finally lived as an exile in Bordeaux. In his

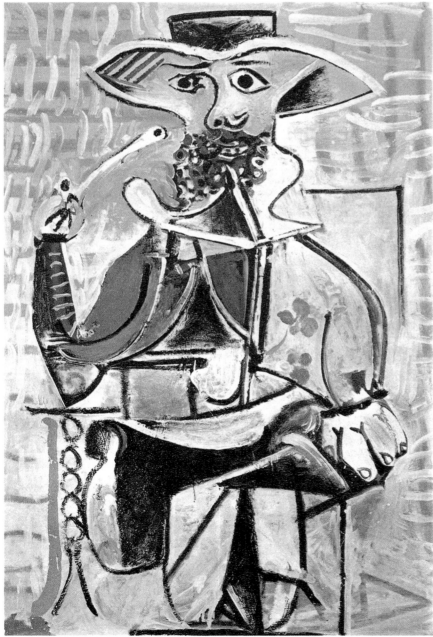
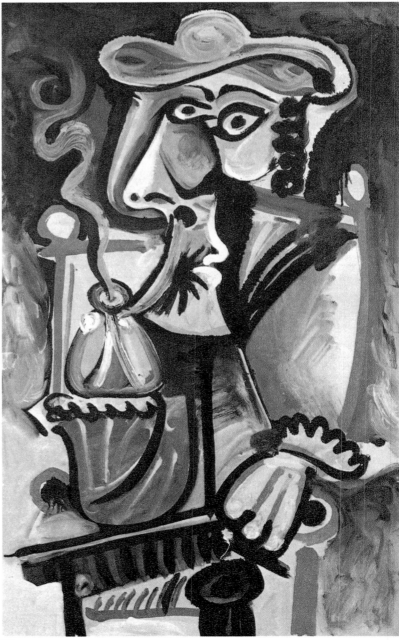

305 306

later years, Picasso sent unpredictable signals of his art to Spain, to his predecessors in the Prado and his countrymen in Barcelona.

Until the end, he fought against indifference and loss of reality. Throughout his life, the subjects and objects of his creation had to satisfy his needs and requirements. The poet and critic Guillaume Apollinaire had already recognized this in 1913, when he wrote: "This Malagueno bruised us like a brief frost. His meditations bared themselves silently. He came from far away, from the rich composition and brutal decoration of the seventeenth-century Spaniards ... His insistence on the pursuit of beauty has since changed everything in art. Newborn, he orders the universe in accordance with his personal requirements, so as to facilitate his relations with his fellows."*

This is how Apollinaire saw him at height of his so-called synthetic Cubism. But the poet's criticism of him also applies more comprehensively as well as consistently. For Picasso always found it easy to form new relationships: always with women and, for a time, with the objects and instruments in his still lifes. But his "fellows", his equals were also the animals, the faun and the bull, and finally the Minotaur, in whom Picasso recognized himself. Its blindness opened the artist's eyes.

In his later years, these equals came to include the artists depicted in his works: the clown and the gnome, the musketeer and the old man, the king and the painter.

* Guillaume Apollinaire, *The Cubist Painters,* translated by Lionel Abel. New York: 1962, pp. 21–23.

305
Man with Pipe
Homme à la Pipe
8. 5. 1969
Oil on canvas, 76 × 50.7 inches

306
Smoker
Fumeur
21. 11. 1968, 18. 12. 1969
Oil on canvas, 56.9 × 34.7 inches

307
Man with Flag
Homme au Drapeau
8. 9. 1969
Oil on canvas, 45.2 × 34.7 inches

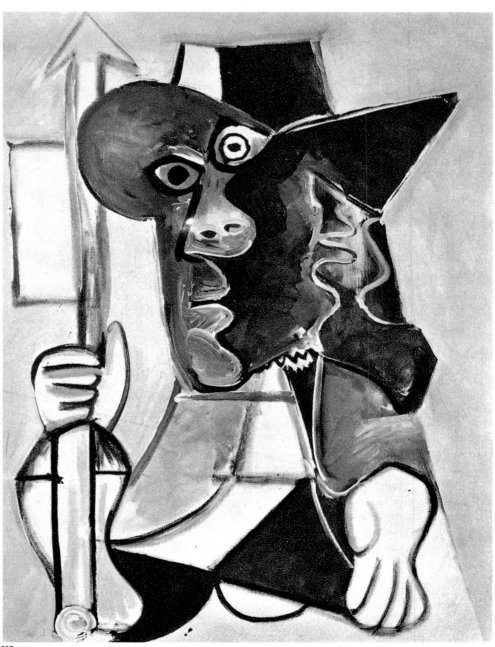

307

In their disguises and infinite varieties, they all step onto the stage that is the theater of the world, a universe that is something between circus and bordello. The last chapters of his opus are the most crowded ones, filled with the richness of his material, the extravagance and intensity of his observation. The human comedy manifests itself once more as a vast erotic play, with a constantly changing cast.

During the last five years of his life, over a thousand paintings, drawings, and graphics were created in dizzying succession. When Picasso died in Mougins in 1973, the public was not shocked. At first, the market reacted cautiously, still numbed by the enormous output of his later years. It did not mobilize a clearance sale. There simply was too much of it: the vast, almost dismaying, quantity of his works and the subsequent disclosure of his immense estate – works from his own hand that had never been released. Indeed, Picasso's death was almost the event of the century. But his contemporaries were much more interested in watching the grass grow than in tackling the vast complexity of his later works.

What actually happened? During the summer following Picasso's death, the Palais des Papes in Avignon once more became the showcase, as it had three years earlier, for the artist's latest paintings: 201 produced between 1970 and 1972. An incomprehensible mass of canvases, a nightmare for art critics as well as for many friends. The advanced age combined with the enormous output was somewhat crushing. Only the artist's close friends and relatives were able to comprehend what had happened in the studio at Mougins.

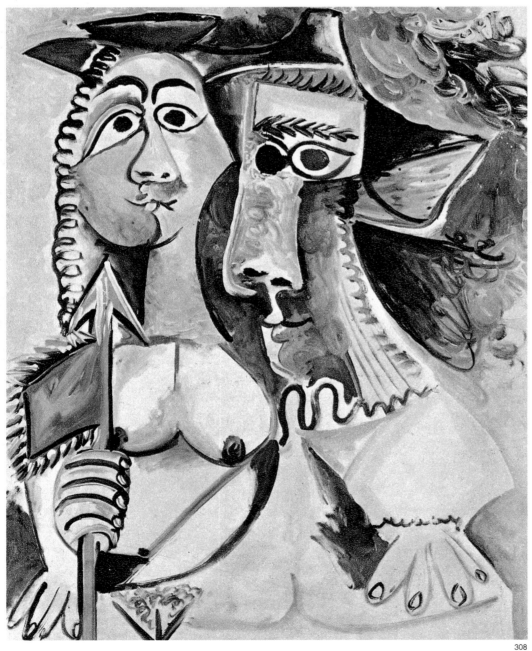

308

308
Man and Woman with Flag
Homme et Femme au Drapeau
29.7.1969
Oil on canvas, 63.2 × 50.7 inches

309
Couple
19.11.1969
Oil on canvas, 63.2 × 50.7 inches

310
Seated Woman
Femme accroupie
6.4.1969 II
Oil on canvas, 50.7 × 34.7 inches

311
Adolescent
2.8.1969
Oil on canvas, 50.7 × 37.8 inches

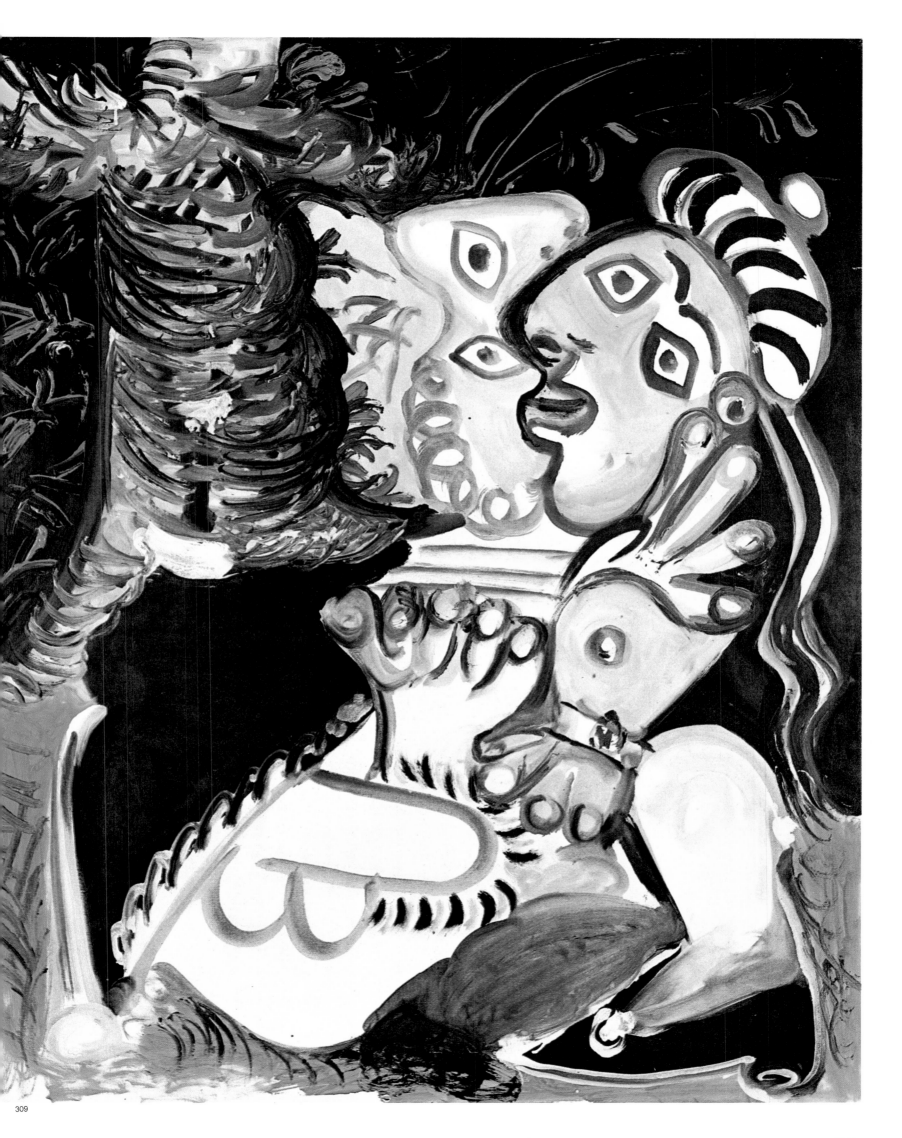

309

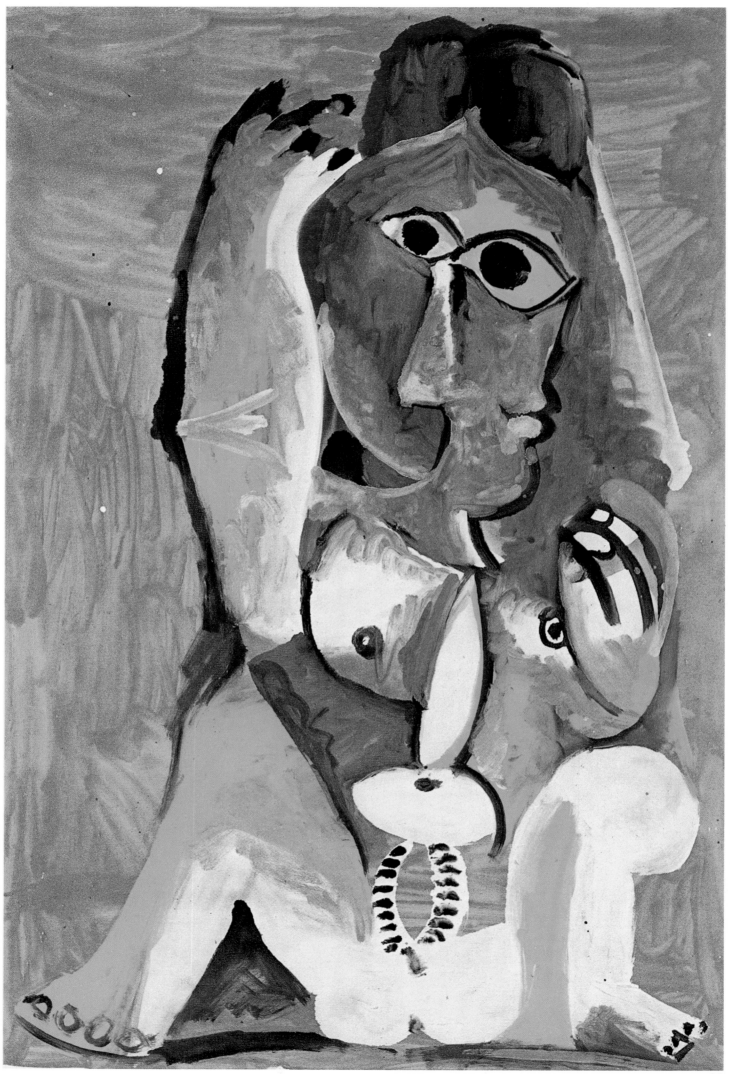

310

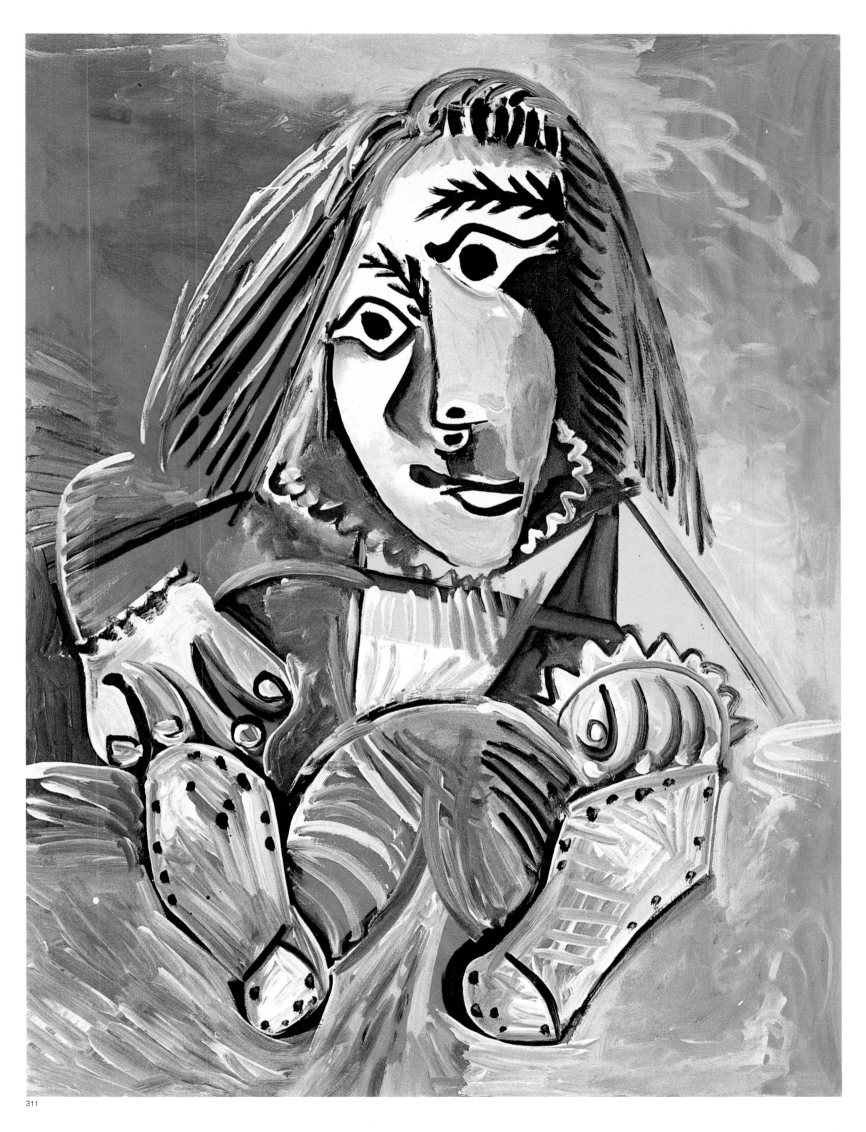

311

312
Kiss Baiser 1.12.1969 IV Oil on canvas, 28.5 × 23.4 inches

313
Kiss Baiser 24.10.1969 I Oil on canvas, 37.8 × 50.7 inches

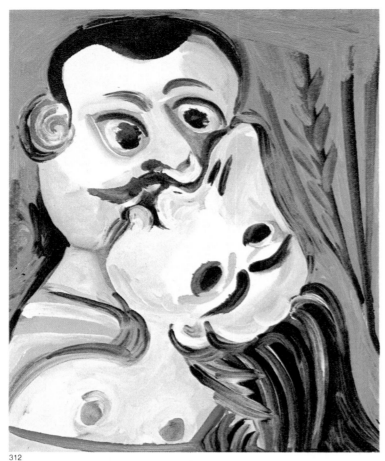

312

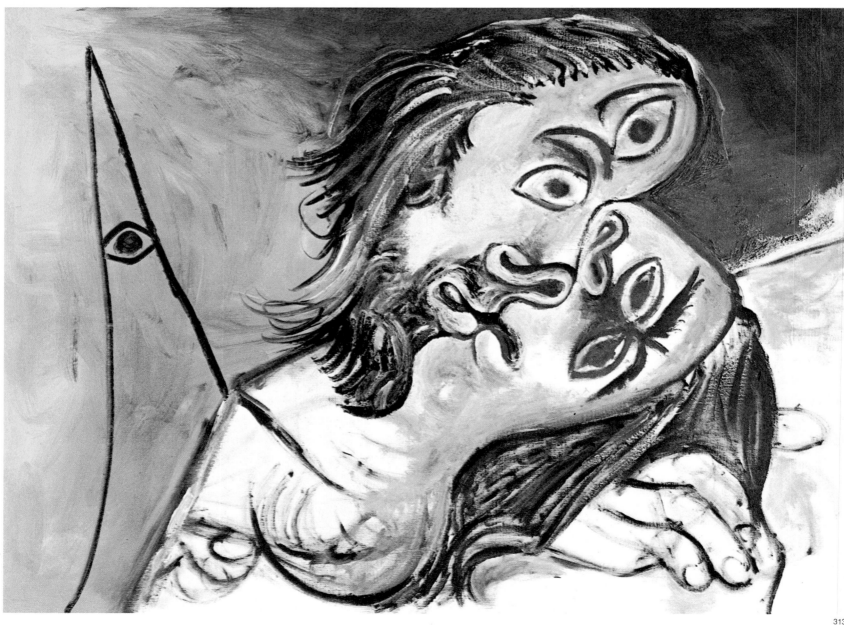

313

"It takes a lifetime to learn how to paint like a child." Until the very end, the old painter worked obsessively in his country home, Notre-Dame-de-Vie, toward this realization – an endless undertaking. In his drawings and paintings the artist degenerated to the point of ridicule. In them he presented an ego and paraded his zest for painting and showmanship. Here was a younger brother of the knight of the Sorrowful Countenance, who let his paintings speak, rather than the people represented in them.

Thus he increasingly renounced as an artistic goal the perfection of motifs in the conventional sense, as might normally be expected from a "classicist" or be found in a "mature, later style." It was the transitory, the unfinished that he now examined. In the works shown at Avignon, the renunciation of style is final; or, rather, all that is recognizable, is a style moving restlessly, yet with absolute confidence, between the decorative and the pornographic. Brush strokes and colors are applied in a savage, vulgar, and artless manner. The whole process is controlled by his eye alone; yet that eye manages to balance the grimace or obscene gesture aesthetically.

He remembered everything, but he always revived his memories strictly for his own needs. They were his only guide. It was his nature to destroy his own inventions in order to find new ones. He oriented himself solely toward his insatiable need for creativity, and to this end he tirelessly and without hesitation reexamined his use of every shape and form. In this way he became a traditionalist and was, therefore, able to go on creating until the end, as each statement expressed a new experience. He worked closer and closer to his canvas and etching plate, even as he put the confessions of an old man at a greater distance from the object of his obsession – the sensuous experience and perception of woman. In an ironic and despairing, cheerful and reflective gesture, the act of painting replaces the act of love. The peculiar theatricality of this process is reflected in all facets of Picasso's late rage and cheerfulness.

In the home of the ninety-year-old painter there were no longer the comings and goings of previous years. All that was left was a carefully chosen circle of friends. His wife, Jacqueline, protected him from intruders. And he protected himself through masquerades, which he so loved and which so often were the object of visits by friends and photographers. The occasional article that appeared in the media depicted him as a very private person, master of his manor, but always the good host. However, he was disinclined to play host to the public at large under any circumstances. It almost seemed as if Picasso had cast himself, in the role of an old movie star. He distanced himself from his surroundings. He became moody. Illness interrupted his stay at home.

But the weeks and months of intensive and uninterrupted activity in his studio had a healing effect on him. Biographers and collectors have hardly been able to keep up with his frantic output, the persistent need to communicate through canvas or the sheet of paper – or the etching plate. Picasso's printers, Aldo and Piero Crommelynck, wearily kept up the pace, for days on end pulling proofs, which Picasso repeatedly revised. (This proves that, despite the complications involved in producing an etching, the final proof may gain rather than lose in quality.) Until the end, Picasso made use of his great expertise in the graphic medium. The loops and curves of a network of lines never become tangled like the threads of the weblike wrapping that covers the *"chef d'œuvre inconnue"* in the story of that name by Balzac, a tale Picasso illustrated. In the story, Master Frenhofer declares, nearly mad at the sight of the paintings he has created: "That's no canvas, that's a woman." As if to prove Frenhofer's point, Picasso asserts the same thing in his later graphics. Nothing stands in the way or hides from view. All power envolves from sex. Every line is aimed at the solar plexus. Between impatience and exhaustion, the stimulated senses drove the hand to extreme forms of expression.

Picasso presents Rembrandt as a male prototype; another time, as the baroque musketeer – a remembrance of Velázquez. Since the inventor of these figures had almost become a legend, he hides behind stories and their protagonists. For Picasso, the artist as monkey was once a radical allegory of age. In the final works, this satirical

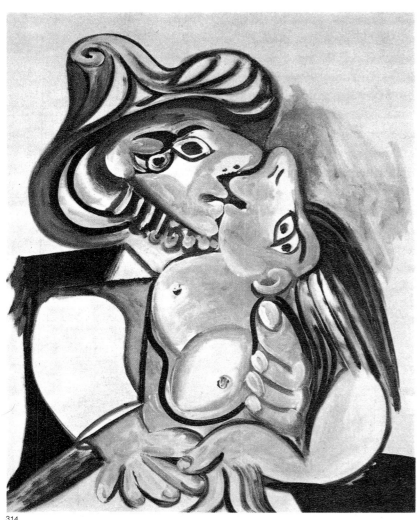

314

314
Couple 19.11.1969 II Oil on canvas, 63.2 × 50.7 inches

315
Couple 26.11.1969 Oil on canvas, 50.7 × 76 inches

316
Couple 5.1.1970 Oil on canvas, 63.2 × 50.7 inches

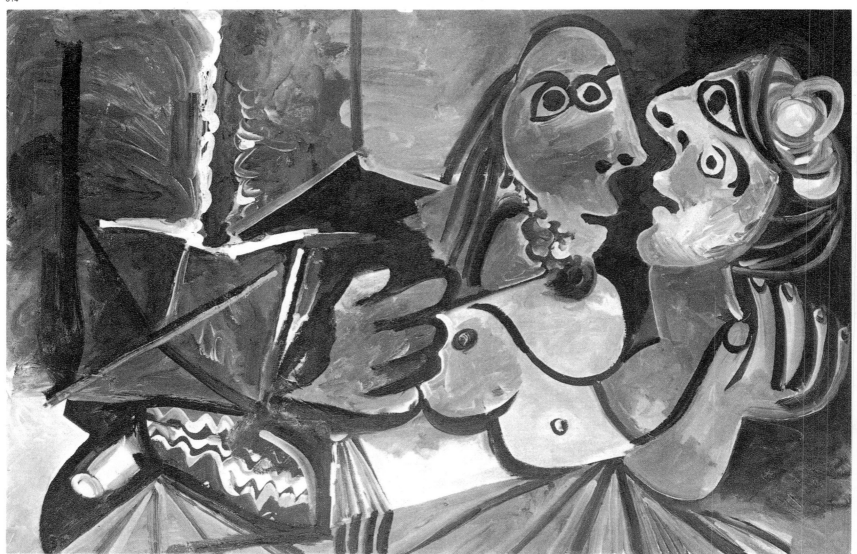

315

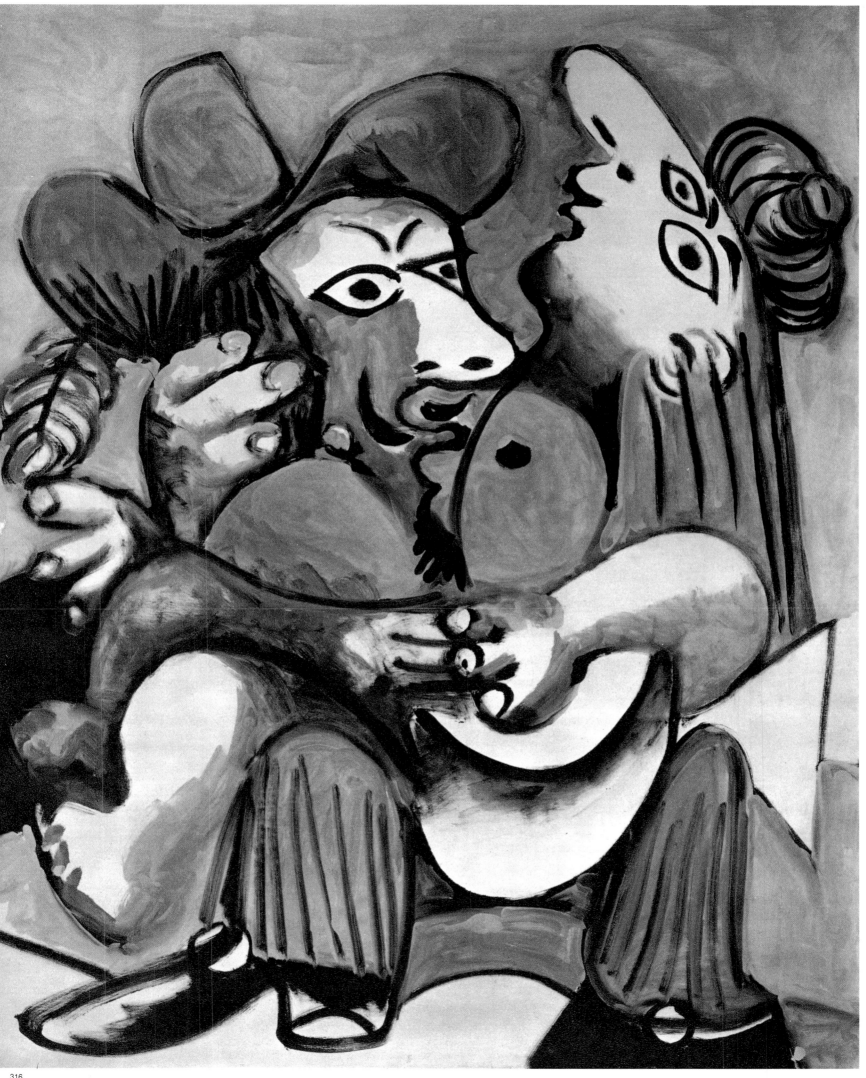

trait diminishes before the boundless imagination expressed in female idols, couples, and joyfully narrative groups.

The *orbis pictus* of the old painter, which twice was exhibited in the Papal Chapel in Avignon, received little praise either time. It seemed that Picasso's century had wearied of him. Ninety years with Picasso was not easy to bear, and even respectful comments about his later work did not conceal that people would rather he had been somewhere else. For the problems of art had virtually "minimalized" themselves. A Cartesian way of thinking inspired new fundamental research. Art reflected on art. But Picasso's works gave the impression of tattered, automatically produced paintings, executed with an unconcealed, brutalizing gesture.

Many were convinced they saw an ominous sign on the walls of the Papal Chapel and pointed out that Avignon had once been witness to a beginning, two generations earlier, when the same painter had created the leitmotif of Cubism with his *Demoiselles d'Avignon*. From this perspective, the town of Avignon, rich in its traditions, papal seat for sixty-eight years of the fourteenth century, proved to be kind of Babylonian exile. And now, here a Pope of Painting had painted himself into a corner of isolation. His later themes manifest this, as well as the break with the authoritative position he had maintained for so long.

The symptoms of the world's weariness of Picasso were evident at the time of the artist's death. They were the symptoms of an innovation-orientated art criticism that remained aloof or turned away the moment the last manifestation in Avignon so powerfully demonstrated Picasso's role as an exile.

The breach between Picasso and the world and Picasso and the critics could no longer be ignored, let alone bridged. The notorious and increasing velocity of Picasso's creation aroused feelings of futility. The peculiar colorful visions – between dance of death and lust for life – had many interpreters, but few viewers.

When the Museum of Modern Art presented its famous retrospective in 1980 – surely one of the most unusual Picasso exhibitions – the late work was inadequately represented. The exhibition at the Grand Palais in Paris, staged some thirteen years earlier as homage to the eighty-year-old artist, had shown the same disregard. The museums notably refrained from purchasing as well. Museums in Munich, Bremen, Zurich, and in Basel – to which Picasso had donated two later paintings – only displayed few works of the sixties, and nothing later. The quarrels about Picasso's estate ensured that the uncertainty of the art market would last even longer. People adhered to value and quality that had been established long ago.

The particular importance of the later style became evident only through a few exemplary exhibitions. The first of these took place in the Kunsthalle, Baden-Baden, in 1968, when the artist was still alive. In response to the exclusion of the later work at the Museum of Modern Art, the Pace Gallery, New York, in 1981 gathered fiftythree works executed between 1969 and 1972 that had all been part of the first exhibition at Avignon. Subsequently, the Kunstmuseum in Basel followed in 1981 with a stronger statement that, above all, united the artist's later work in one exhibition. The Pace initiative started a revisionary movement in America, too, culminating in a 1984 exhibition of late work at the Guggenheim Museum in New York.

The moment for a new assessment seemed to have arrived. The rehabilitation, which started around 1981, found strong support in new artistic impulses that manifested themselves in predominantly in Europe. An open, often untidy, even messy style of painting, with powerful statements and coloristic tendencies, was emerging in Italy and Germany and drew attention to itself. "A New Spirit in Painting" was the title and password of an exhibition at the Royal Academy in London, which provided a forum for these new painters and employed Picasso's later work as star witness on their behalf. Four representative works testified that the New Generation was drawing its inspiration to a considerable extent from the later works of Picasso. His style served as a model argument for an emotional and primitively

317
Figure with a Shovel
Personnage à la Pelle
July 17 and November 14, 1971
Oil on canvas, 195 × 130 cm

318
Self Portrait
June 30, 1972
Chalk and crayons, 65.7 × 50.5 cm

319
The Young Painter
Le jeune Peintre
April 14, 1972 III
Oil on canvas, 92 × 73 cm
Paris, Musée Picasso

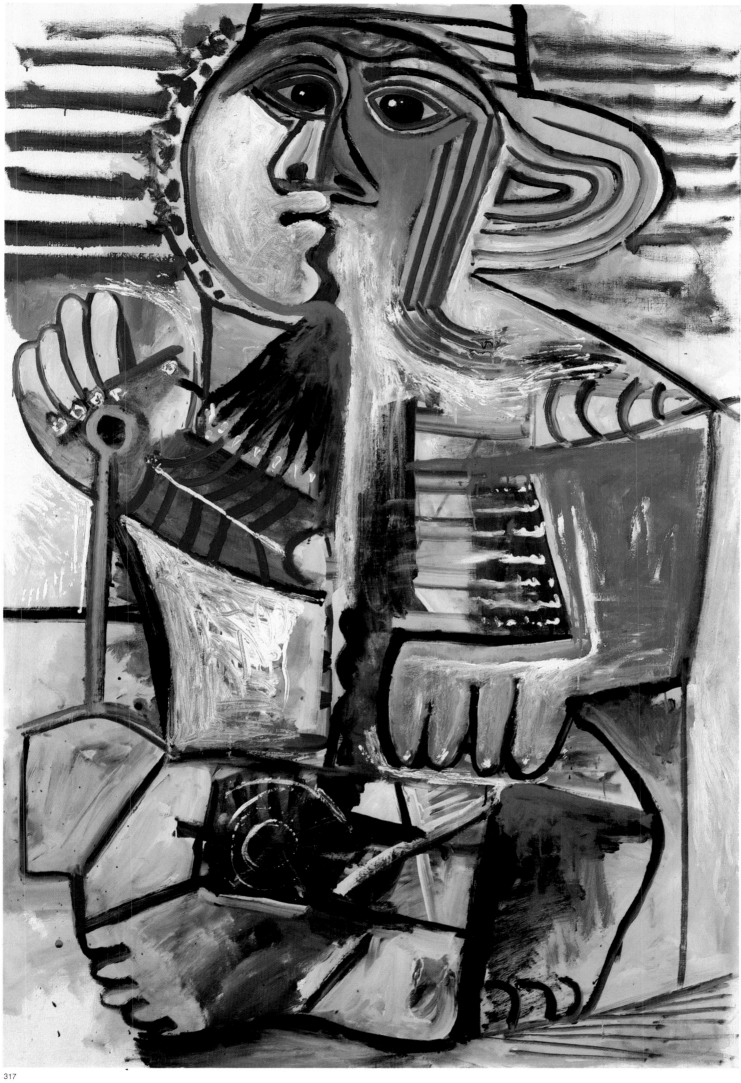

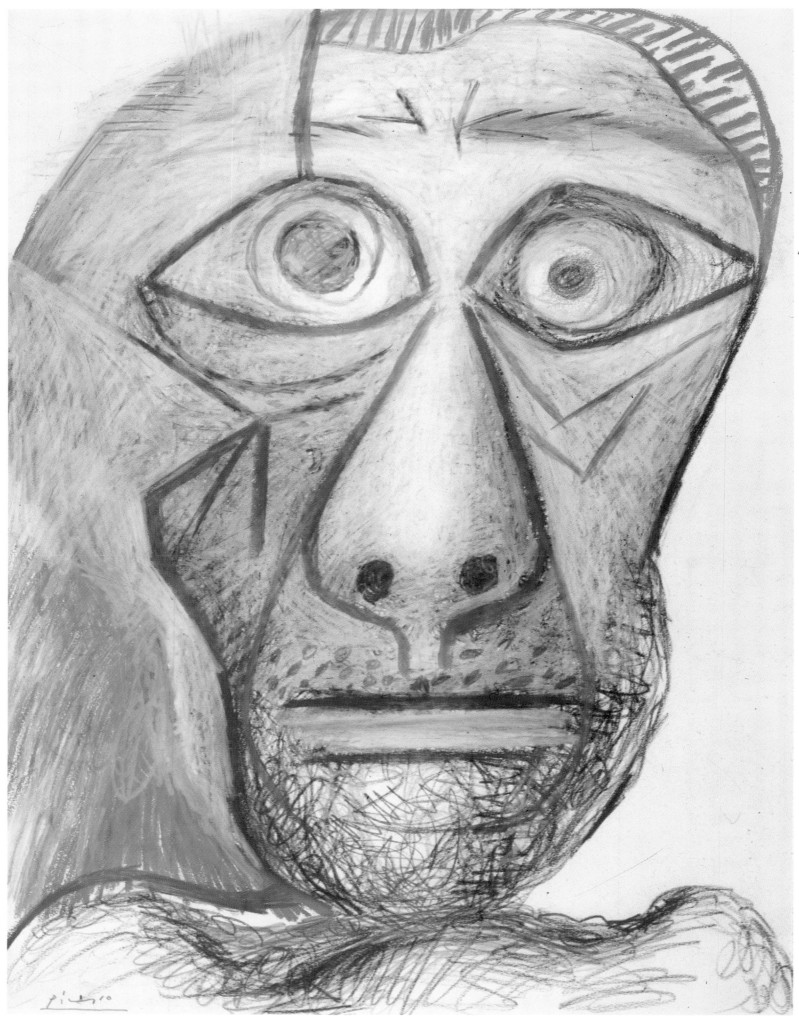

319

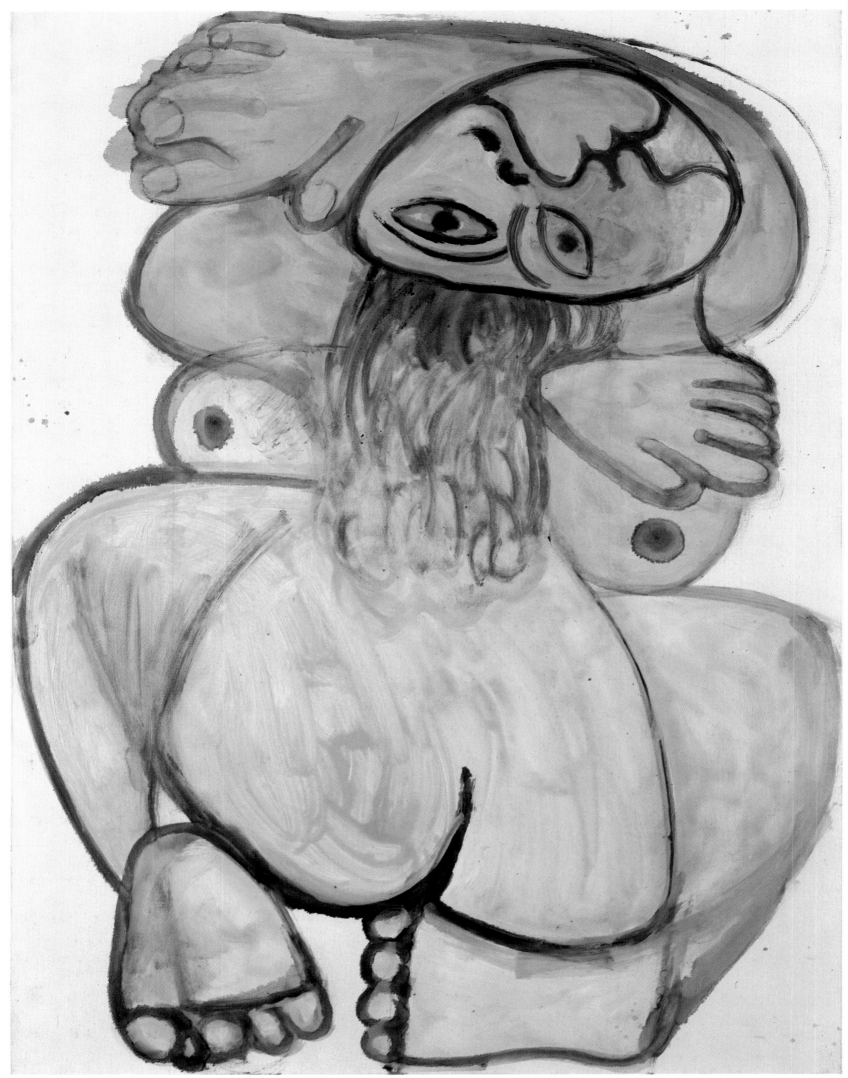

executed kind of painting. In fact, among the works of the artists exhibited, Picasso's maintained a position of superiority. They once more conveyed their ability to reveal themselves immediately in the power of the image, in the ruthlessness of the expression. The random, open brush strokes once more demonstrated that comparable works of other artists do not stand up to Picasso's challenge.

Monet painted water lilies, and Matisse, in his later years, discovered *"Papiers découpés."* In both cases, it was thought at the time that there was something rather childish about these later works. Picasso's drive for the extreme was equally strong as Monet's or Matisse's. In his last four years, he created more than at any other comparable period of his life. His life instinct became the urge to paint. The crude incompleteness of his shapes made use of an almost infantile pallet: pink and pale blue mixed with milky shades between beige and ochre, and then again, pure colors straight from the bucket, applied with a wide brush. It is remarkable to what extent Picasso abandoned his sense of color, mocked the culture of his pallet, and demanded the coarsest articulation and position of his figures. Deformed members of the body, amorphous forms, noses squashed flat and caricatured, buffoonish eyes and hands mark the animalism of his vigorous half-wits. Primitive but matchless, these paintings are superior to their expressive descendants of today. Resembling members of a burlesque troupe, they demand everyone's attention. What painter has not profited from this one, who contributed to every form of expression in our century? Dubuffet, Pollock, de Kooning – in comparison to these archaic creations, their's undoubtedly look brilliant, but also almost complacent. And aesthetic appreciation has embraced them, and long ago given each its unique place in art history.

Picasso, who created so much, at the end reclaimed what was his due. He reaped so much from his children, that he occasionally seems to devour them orgiastically. It is not Goya's terrifying painting that comes to mind, but rather that of a Gargantua, who insatiably consumes life in order to get the materials necessary to house his creatures.

However, he did not draw only on those impulses he himself had created. In his old age, he allowed himself a freedom that, at the very end of his life, he did not try to justify. He saw next to himself the ghostly companion, whom he acknowledged as *The Young Painter* (Plate 319) on April 14, 1972, with the round face and the soft outlines of a doll. Button eyes and an exotic hat with a wide brim, the demonstratively raised hand with the thin brush do not conceal that this portrait shows the ancient painter with childlike features. The tenderness and uncertainty of the facial expression give the portrait a quality of ghostly isolation, which claims as its parallel the later works of Goya.

In a pitiless confrontation with the mirror, on June 30, 1972, Picasso once more looked himself in the face (Plate 318). In that mirrored image he saw, with wide eyes, death. For this drawing he used chalks in the same blue, mauve, and black he had employed thirty years earlier in a still life with cow's skull, created after he had been stunned by the news of the death of his friend and countryman Julio González. Now Picasso was preparing his own skull for such an event, and he stared with motionless intensity.

This visage pauses at the frontier that separates life from death. Nothing else is expressed in the features, which in their rigidness reveal the extreme receptiveness of the eyes. And there is no doubt that these eyes are Picasso's.

In other respects, too, the portrait stands at a crossroads. A few weeks earlier the painter had completed the series of 201 paintings that were to be his last *"œuvre."* The isolation of the figures, which appear here and there in twos and threes, was his constant identifying characteristic. In broad and reckless strokes, Picasso had outlined these creatures and in each case he fitted them into a suitable format. The robust driving force of the painting style corresponds to the appearance of the archetypal figures depicted therein. The painter's head, too, is drawn in this spirit, which extends into the sphere of the graphic art that occupied Picasso in the ensuing months. He moved away from painting, moved in an opposite direction, toward the etchings and

320
Crouching Nude
Nu accroupi
July 26, 1971 II
Oil on canvas, 116 × 89 cm
Collection of Paloma Picasso-Lopez

engravings. The scenes become more and more lively and articulate. The clever distribution of brush stroke layers, in all shades between light and dark, consciously respond to the garish colors. A pandemonium of the senses emerges like a stage production, revealing the most diverse insights (Plate 321). The cramped, often bizarre line, as well as the masquerade theme, is reminiscent of Ensor's vision of the Entrance of Christ. And, again, there is Goya, who by similar means in his later graphics interwove the banal with the metaphysical to an almost unbearable degree.

This last tableau, something like a large and generally comprehensible vision. No descent into Hell or ascent into Heaven, but rather the closing image of an Oriental fairy tale: the family of man in clear light on an open stage. The feelings of perfection

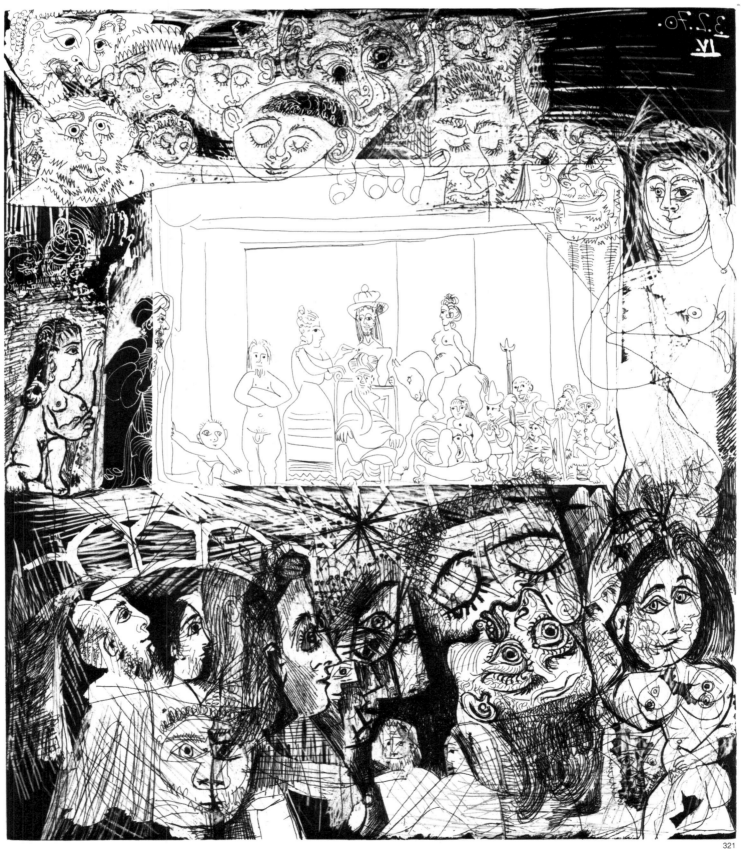

321

321
Untitled
February 3, 1970 IV and March 5 and 6, 1970
Etching and aquatint, 50 × 42 cm

322
Untitled
April 30, 1971
Etching, 37 × 50 cm

323
Untitled
April 1 to 5, 1971
Engraving, 37 × 50 cm

and yet familiarity it exudes are almost beyond comprehension. All around, in front of the forestage on Mount Olympus and among the scenery, the colorful bustle, and curious crowd, the inspiration abounds. No other representation in Picasso's later years has been able to unify the human condition of his art more freely and enthusiastically. The signature of our century could not have found a more appropriate repository than here.

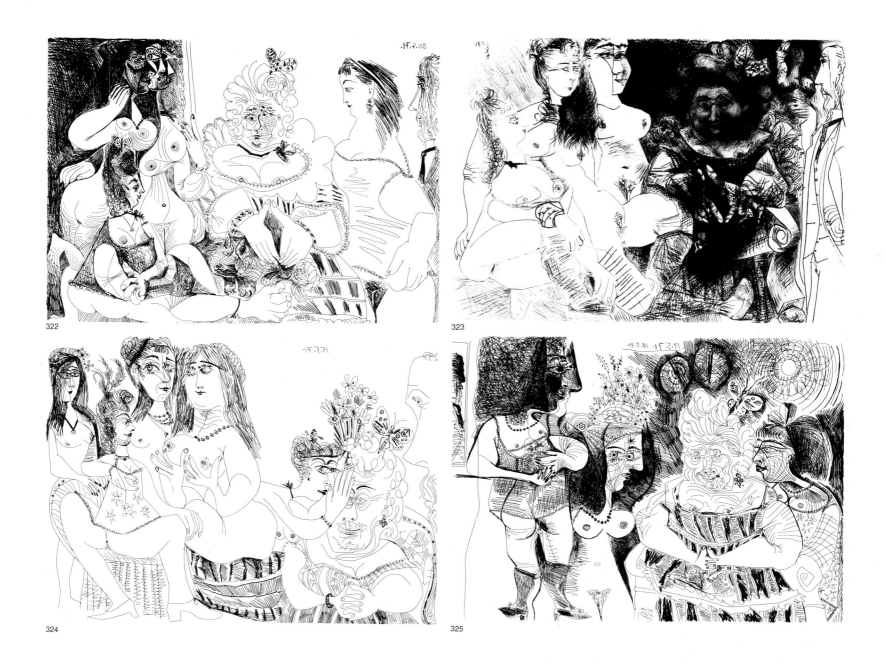

322

323

324

325

324
Untitled
May 15, 1971
Etching, 37 × 50 cm

325
Untitled
May 17 and 18, 1971
Etching, 37 × 50 cm

326
Picasso in the Livingroom of his Country House,
Notre Dame de Vie, Mougins, December 20, 1967
Photo: Kurt Wyss

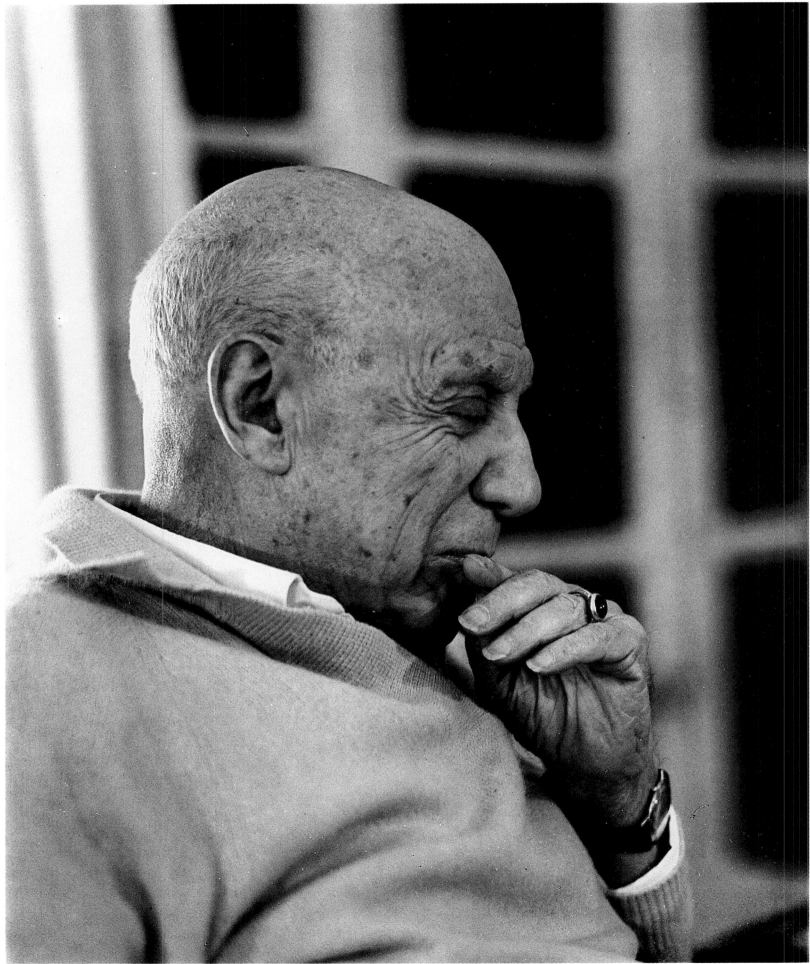

A Picasso Chronology

1881

Pablo Picasso born in Málaga, Spain, on October 25, the first child of José Ruiz Blasco and his wife Maria Picasso Lopez. His father was descended from an ancient family from the historic province of Léon whose family tree includes a famous archbishop, a viceroy and a general who died in Lima. His mother, Maria, born in Andalusia, had Arabian blood. His father, José, was a drawing teacher at the provincial college of applied art, the *Escuela de San Telmo* in Málaga. According to Spanish custom the young Pablo was known by both his father's and his mother's names and signed his earliest paintings "Ruiz Picasso."

1889

At the age of eight Picasso paints his first picture—a *torero*.

1891

The Ruiz Picasso family moves to La Coruña, where the father continues to teach drawing and young Pablo does more painting.

1894

Picasso's father is so impressed by the boy's extraordinary talent that he gives up the practice of art himself and solemnly hands over his paintbrush to his son.

1895

The family moves to Barcelona, where Picasso enters the art academy *La Lonja*.

1896

First studio in Barcelona.

1897

Picasso's first exhibition, held at the *Hostal d'Els Quatre Gats* in Barcelona. The first article on Picasso appears in *La Vanguardia*.

1900

First visit to Paris. Picasso sets up his first studio at 45 Rue Gabrielle.

327 Doña Maria de Ruiz Picasso, the artist's mother.
328 Don José Ruiz Blasco, the artist's father.
329 Pablo Picasso at the age of four.
330 Portrait of his mother, painted by Picasso in 1895.
331 Portrait of his father, painted by Picasso in 1895.
332 Self-portrait, 1896.
333 Pablo Picasso at the age of seven with his sister Lola.
334 The house in Málaga where Picasso was born.
335 Pablo Picasso at the age of fifteen, 1896.

1901-1909

336

1901
Returns to Madrid in February to become copublisher of the journal *Arte Joven*. The first issue is devoted entirely to Picasso, who from now on signs his works "Pablo Picasso." Beginning of the Blue Period. Second visit to Paris.

1903
Return to Barcelona.

1904—1905
Picasso moves to Paris. Studio in the Bateau-Lavoir, Place Emile-Goudeau. In the next few years his friends will include Jarry, van Dongen, Gris, Matisse, Braque, Henri Rousseau, Derain, Utrillo, Suzanne Valadon, Apollinaire, Gertrude and Leo Stein, Kahnweiler, the art dealer, and Wilhelm Uhde, the art critic. (See the latter's memoirs, *Von Bismarck bis Picasso,* Zürich 1938.) The Russian art collector Stchoukine buys fifty paintings, later shown (in summer, 1914) in an Impressionist exhibition in Moscow. Liaison with his model, Fernande Olivier. (See her *Picasso et ses Amis,* Paris 1933, *Picasso and His Friends,* London 1964.) First sculptures. Beginning of the Rose Period.

1907
Picasso paints *Les Demoiselles d'Avignon,* one of his major paintings and the most important work of early Cubism. He is deeply impressed and influenced by the commemorative exhibition of Cézanne at the Paris Salon d'Automne. Systematic development of Cubism.

1908
Picasso's studio in the Bateau-Lavoir is the scene of the legendary banquet in honor of Henri Rousseau, the Sunday painter discovered by Wilhelm Uhde. (See *Fünf Primitive Meister,* Zürich 1947.) The name "Cubism" is born when the critic Vauxelles writes in *Gil Blas* that Braque reduces his pictures to cubes.

1909
Picasso leaves the studio in the Bateau-Lavoir and moves to 11 Boulevard de Clichy. He spends the summer with Fernande Olivier in Horta de San Juan, painting in the style of analytical Cubism.

337

338

339

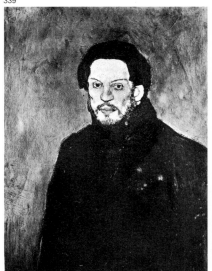

340

341

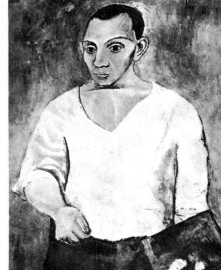

336 Self-portrait, 1902.
337 Picasso, 1904.
338 Picasso in the French Army uniform of his friend Georges Braque. Taken by Braque in Picasso's studio at 11 Boulevard de Clichy in Paris.
339 Self-portrait, Paris, 1901.
340 Picasso's studio in the Place Ravignan, Paris, 1901.
341 Self-portrait, 1906.

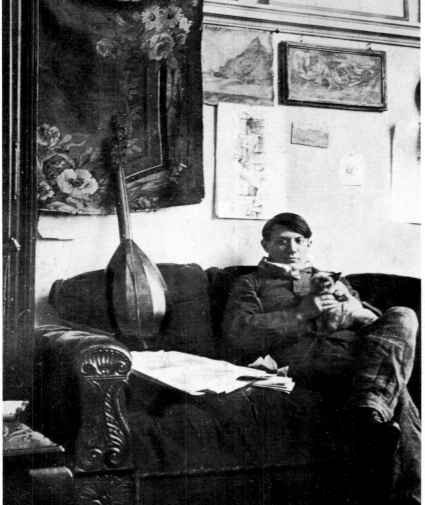

1910
Picasso spends the summer with Fernande Olivier and Derain in the Spanish village of Cadaqués, where he makes a series of etchings illustrating Max Jacob's *Saint Matorel.* He paints Cubist portraits of Vollard, Uhde and Kahnweiler.

1911
Picasso first uses letters of the alphabet as decorative elements in his paintings. He spends the summer with Fernande Olivier, Braque and the sculptor Manolo in the little town of Céret in the French Pyrenees. The first Picasso exhibition in the United States is held in New York at the Photo-Secession Gallery.

1912
Picasso meets Marcelle Humbert, and she accompanies him to Avignon and Céret. Beginning of synthetic Cubism. Picasso makes his first collages and uses sand and scraps of paper and fabric as decorative elements in his paintings. Participates in the "Blue Rider" exhibition in Munich.

1913
Studio at 1 bis Rue Schoelcher, Paris. Picasso spends the summer with Juan Gris, Max Jacob and Manolo in Céret. The Russian Constructivist Tatlin visits him.

1914
Picasso spends the summer with Braque and Derain in Avignon. His painting *Les Saltimbanques* is auctioned for 11,500 francs. Marcelle Humbert dies in the fall.

1915–1916
Picasso paints Cubist pictures and draws naturalistic portraits (including portraits of Vollard and Apollinaire.)

1917
Picasso goes to Rome with Cocteau to work for Diaghilev's Russian ballet (an association which continues until 1924). Meets Stravinsky in Rome. Visits Naples, Pompeii and Florence.

1918
Picasso marries the Russian dancer Olga Khoklova, moves to 23 Rue de La-Boétie and continues his Cubist works.

342 Picasso in his apartment at
 11 Boulevard de Clichy, 1910.
343 Picasso in 1912.
344 Picasso in his studio in the Rue
 Schoelcher about 1915.
345 Picasso, late 1916 or early 1917.
346 Picasso and his associates in Rome,
 where he designed the costumes and
 scenery for Jean Cocteau's ballet
 Parade in 1917.

1919-1927

1919
Picasso designs the scenery and costumes for de Falla's ballet *Tricorno* and goes to London for its première at the Alhambra Theater. Meets Juan Miró in Paris. First lithographs.

1920
Neoclassical Period. Designs scenery and costumes for Stravinsky's ballet *Pulcinella.* Spends the summer months at Juan-les-Pins where he paints monumental nudes and makes lithographic portraits of Radiguet and Valéry. Picasso's son Paolo is born. The mother and child theme makes its appearance.

1921
Picasso designs the scenery and costumes for de Falla's *Cuadro Flamenco.* During the summer he paints the two versions of *Three Musicians.* Maurice Raynal publishes the first book on Picasso.

1922
Picasso spends the summer at Dinard in Brittany. Designs scenery for Jean Cocteau's *Antigone.*

1923
Picasso paints his classic harlequin pictures. Meets the surrealist poet André Breton in Cap-d'Antibes.

1924
End of the Neoclassical Period. During the summer at Juan-les-Pins Picasso paints a series of big still lifes.

1925
End of the Cubist and Neoclassical periods. Participates in the first surrealist exhibition in Paris.

1926—1927
Picasso spends most of his time in the Midi (at Juan-les-Pins and Cannes), working chiefly on etchings.

347 Picasso and his wife Olga with Madame Errazuriz at a ball given by Count Etienne de Beaumont in Paris, 1924.
348 Picasso with his son Paolo, 1922.
349 Drawing by Picasso of the villa in Fontainebleau where he spent the summer of 1921.
350 Picasso, 1922.
351 Impromptu beach party at La Garoupe, Antibes, in 1926. Picasso (wearing hat) is disguised as a civilian. The guests in fancy dress include Count and Countess de Beaumont.

348

349

350

351

1928-1935

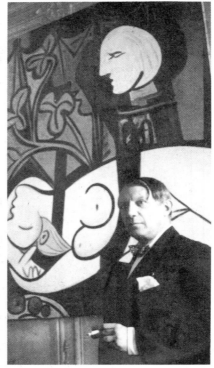

1928
Picasso spends the summer in Dinard, which gives its name to the work of this period.

1929
Summer in Dinard. With the sculptor Julio González makes sculptures and abstract constructions in iron.

1930
Summer in Juan-les-Pins. Picasso begins the etchings for Ovid's *Metamorphoses* to be published by Albert Skira.

1930–1931
Vollard publishes Picasso's illustrations for Balzac's *Chef-d'œuvre inconnu*. Picasso begins the etchings for the Vollard suite.

1932
Christian Zervos begins his monumental catalogue of Picasso's œuvre. Big retrospective exhibition at the Zürich Kunsthaus.

1933
Cover design for the first issue of the surrealist journal *Minotaure*.

1934
Picasso visits Spain. Paints and draws numerous bullfight scenes. Illustrates the *Lysistrata* of Aristophanes.

1935
Picasso and Olga separate. Picasso's daughter Maja born to Therese Walter. His boyhood friend Jaime Sabartés becomes his secretary. Picasso writes a number of surrealist poems, which appear in *Cahiers d'Art* with commentaries by Breton and Sabartés.

352 Picasso, 1928.
353 Picasso, 1935.
354 Picasso in his apartment in the Rue de La-Boétie, Paris, 1931.
355 Picasso with his wife Olga in Cannes, 1933.
356 Picasso at Mougins, 1935 or 1936.
357 *Château Boisgeloup* in Gisors which Picasso bought in 1930.

1936-1943

1936

Traveling exhibition of Picasso's works opens in Spain in February. On the outbreak of the Spanish civil war Picasso offers his services to the lawful government of the Spanish Republic and is appointed director of the Prado in Madrid. Liaison with Dora Maar begins.

1937

Picasso makes his two big etchings of *Sueno y Mentira di Franco* (Dream and Lie of Franco). He moves into the studio in the Rue des Grands-Augustins in Paris and paints *Guernica*, intended for the Spanish Pavilion at the Paris World Exhibition. Makes fifty-three watercolor illustrations for Georges Buffon's *Histoire naturelle*. Summer in Mougins. Visits Paul Klee in Bern.

1938

Picasso works on a series of expressive portraits of women, depicting them in a flat end manner.

1939

Big Picasso exhibition at the New York Museum of Modern Art. When World War II breaks out Picasso returns to Paris from Antibes, then moves to Royan near Bordeaux.

1940

Picasso returns to the Rue des Grands-Augustins when the Germans occupy Paris. The Nazis leave him alone. His refusal to collaborate becomes a symbol to the French resistance.

1941–1943

Picasso writes the play *Le Désir attrapé par la Queue* and illustrates Georges Hugnet's *La Chèvre-feuille* and *Non-vouloir*. Lives in seclusion with Dora Maar in his studio. In May, 1943, he makes the acquaintance of Françoise Gilot.

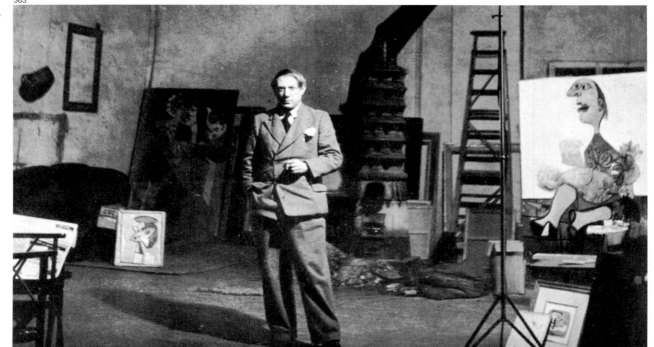

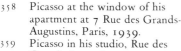

358 Picasso at the window of his apartment at 7 Rue des Grands-Augustins, Paris, 1939.
359 Picasso in his studio, Rue des Grands-Augustins.
360 Picasso in his studio, 1937.
361 7 Rue des Grands-Augustins.
362 Picasso in Mougins, 1937.
363 Picasso in his studio, Rue des Grands-Augustins, 1938.

1944-1950

364

365

366

1944
During the battle of Paris, between August 24 and 29, Picasso paints *The Triumph of Pan*. In autumn he joins the Communist Party and says in an interview: "I am proud to say that I have never regarded painting as an art to delight the eye or as a mere pastime.... I've always used my painting to fight for something, like a true revolutionary."

1945
Picasso leaves Paris, going first to Antibes, later to Vallauris.

1946
Begins to make ceramics in Vallauris, discovering new technical possibilities. He makes a large gift of important works to the Musée Grimaldi in Antibes.

1947
First exhibition of Picasso's ceramics in Paris. He attends the international congress of Intellectuals for Peace in Breslau. Françoise gives birth to his son Claude.

1948
Works on lithographs in Vallauris.

1949
Designs the famous "peace dove" poster for the Paris peace congress. Alain Resnais and Paul Eluard make the film *Guernica* based on his work. Picasso's daughter Paloma is born.

1950
Picasso is made an honorary citizen of Vallauris and presents his sculpture *Man with the Sheep* to the town, where it is installed in the main square.

367

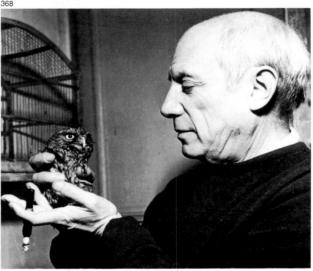

368

369

370

364 Picasso, 1945.
365 Picasso with a portrait bust, 1944.
366 Picasso in his room at the Rue des Grands-Augustins.
367 Picasso in the pottery shop, 1948.
368 Picasso with owl, 1947.
369 Picasso at the time he made his first film, 1949.
370 At Golfe-Juan, 1947.

1951-1957

1951
Picasso exhibits his *Massacre of Korea* at the Salon de Mai in Paris.

1952
Picasso's bronze sculpture of a goat, for which his own goat, Esmeralda, was the model, is exhibited in Paris at the Salon de Mai.

1953
Big exhibitions in Rome, Milan and Lyons. Picasso and Françoise Gilot separate.

1954
Big Picasso exhibition in São Paulo. In spring Picasso paints the series of portraits of Sylvette David. Spends the summer in Collioure and Perpignan. In December he begins the variations on Delacroix's *Women of Algiers.* Jacqueline Roque comes to live with him.

1955
Picasso moves from Vallauris to his new villa *La Californie* in Cannes. Big retrospective exhibition in Munich from October to December. Olga Khoklova, from whom Picasso had never been legally divorced, dies in Cannes.

1956
Premiere of *Le Mystère Picasso,* Henri-Georges Clouzot's film made at *La Californie.*

1957
February exhibition at the Galerie Leiris of the pictures painted at *La Californie.* Picasso paints his paraphrases of Velázquez's *Meninas.*

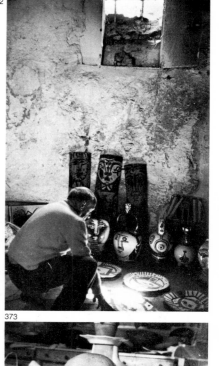

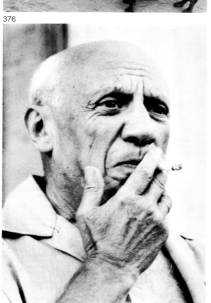

371 Picasso and his son Claude, 1951.
372 Picasso making ceramics, Vallauris, 1953.
373 Picasso and Esmeralda, 1956.
374 Picasso and Jacqueline, summer, 1957.
375 Picasso in Vallauris, about 1957.
376 Picasso, 1951.
377 Paloma, Picasso and Claude in the new villa at Cannes, 1955.

1958-1966

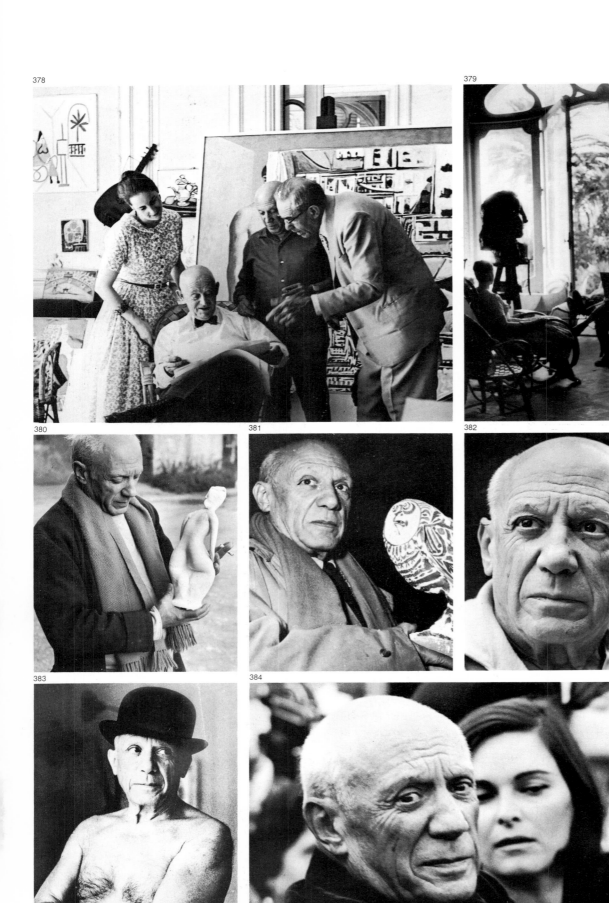

380 381 382

383 384

1958
Picasso paints *The Fall of Icarus* for the U.N.E.S.C.O. building in Paris. He marries Jacqueline Roque and buys *Château Vauvenargues* on the Mont-Sainte-Victoire near Aix-en-Provence. Exhibition at the Philadelphia Museum of Fine Arts.

1959
Exhibition at the Musée Cantini in Marseilles. His *Bathers* sculptures are shown at "Documenta II" in Kassel.

1960
The British Arts Council organizes a comprehensive exhibition at the Tate Gallery in London. Picasso works on his paraphrases of Manet's *Déjeuner sur l'Herbe*. Begins a series of sheet iron sculptures.

1961
Picasso moves to *Notre-Dame-de-Vie* in Mougins. Exhibition at the University Art Gallery in Los Angeles.

1962
Various exhibitions in New York. Picasso paints several pictures on the theme of the *Rape of the Sabine Women*.

1963
Painter and Model series of paintings and graphics.

1964
Comprehensive exhibitions at the Montreal Musée des beaux-arts and the Toronto Art Gallery. Exhibitions in Tokyo, Kyoto, and Nagoya.

1965
Exhibition entitled "Picasso and the Theater" at the Musée des Augustins in Toulouse.

1966
Picasso's eighty-fifth birthday arouses worldwide notice. Exhibition at the Helena Rubinstein Pavilion in Tel Aviv. The French government organizes the great "Hommage à Pablo Picasso" exhibition at the Grand- and Petit-Palais in Paris, where 508 of his works are shown.

378 Angela Rosengart, Daniel-Henry Kahnweiler, Picasso, and Siegfried Rosengart.
379 Picasso making a drawing of Angela Rosengart at *La Californie*, October 2, 1958.
380 Picasso with small sculpture, 1958.
381 Picasso on his eightieth birthday.
382 Picasso, 1963.
383 Picasso—unconventional.
384 Picasso with the Italian actress Lucia Bose, 1964.

1967
Big Picasso exhibition at the Stedelijk Museum in Amsterdam. Exhibitions of drawings, pastels and watercolors in the United States. Big sculpture exhibition at the London Tate Gallery and the New York Museum of Modern Art. Beginning of the *Musketeers* series.

1968
Traveling exhibition "Pablo Picasso: 347 Etchings" opens in Paris in March and is later shown in cities all over the world. Exhibition of graphic works at Zürich Kunsthaus. Exhibition in Baden-Baden entitled "Pablo Picasso, the Late Work. Paintings and Drawings since 1944." Retrospective exhibition in Humlebaek near Copenhagen.

1969
Exhibition of *Painter and Model* series of paintings and graphics in Baden-Baden. "Pablo Picasso: 347 Etchings" opens at the Zürich Kunsthaus.

1970
Picasso's entire production for the year 1969 is shown in the Gothic chapel of the papal palace in Avignon.

1971
Exhibition of 194 drawings from the years 1969 to 1971 in the Galerie Louise Leiris, Paris. The Grand Palais in the Louvre, on the occasion of Picasso's ninetieth birthday, simultaneously exhibits selected works.

1972
At the Museum of Modern Art, works by Picasso in the possession of New York museums are exhibited. In the Galerie Leiris, Paris, 172 additional drawings from the years 1971 and 1972 are shown.

1973
Again in the Galerie Leiris, Paris, an exhibition takes place, with 154 prints from the period 1970 to 1972. On April 8, the artist dies in his country home, Notre Dame de Vie, in Mougins. The funeral is at the cemetery of the Château de Vauvenarges.

385 Picasso at *Notre-Dame-de-Vie* in Mougins on his birthday, 1970.
386 Picasso with a *découpage,* 1965.
387 Picasso at the age of eighty-eight.
388 Picasso at the opening of an exhibition of his works at the Galerie Madoura in Vallauris, 1969.
389 Picasso congratulating the victorious *torero* in the Arena at Fréjus, summer, 1970.
390 Picasso and Jacqueline during a bullfight in the Fréjus Arena, 1970.

385
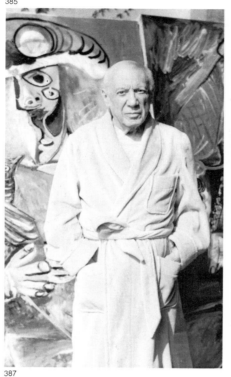

386
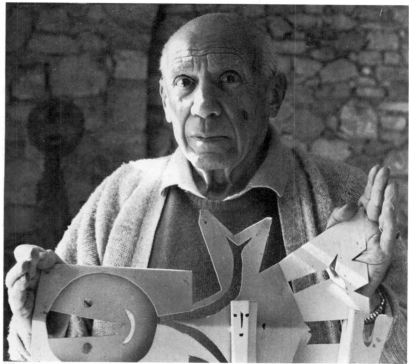

387

388
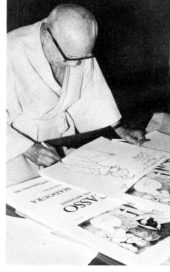

389
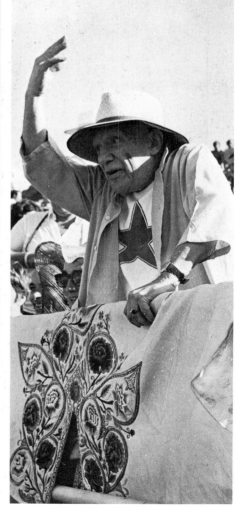

390
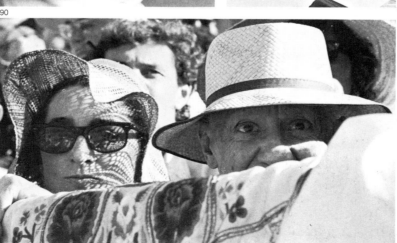

Bibliography

ABRIL, Manuel, *De la naturaleza al espiritu*. Madrid 1935.

ALBERTI, Rafaël, *Imagen primera di Picasso (1940–1944)*. Buenos Aires 1945.

APOLLINAIRE, Guillaume, *Les Peintres cubistes; Méditations esthétiques*, Paris 1913; American ed.: *The Cubist Painters*. New York 1962; German ed.: Zürich 1956.

APOLLINAIRE, Guillaume, *Tendre comme le Souvenir*. Paris 1952.

ARAGON, Louis, *La Peinture au Défi*. Paris 1930.

ARGAN, Giulio Carlo, *Scultura di Picasso*. Venice 1953; Italian and English text.

ARMITAGE, Merle, *Accent on America*. New York 1944.

ARNHEIM, Rudolf, *Picasso's Guernica. The Genesis of a Painting*. Los Angeles 1962.

ARP, Hans, and NEITZEL, L. H., *Neue französische Malerei*. Leipzig 1913.

ASHTON, Dore, *Picasso on Art: A Selection of Views*. New York 1972.

ASKENOV, Ivan Aleksandrovich, *Picasso i okrestnosti*. Moscow 1917.

BANDMANN, Günter, *Pablo Picasso: Les Demoiselles d'Avignon*. Stuttgart 1965.

BARR, Alfred H., *Picasso. Forty Years of His Art*. New York 1939.

BARR, Alfred H., *Picasso. Fifty Years of His Art*. New York 1946.

BAUMANN, Felix Andreas, *Pablo Picasso: Leben und Werk*. Stuttgart 1976.

BAZIN, Germain, *Pablo Picasso dans l'Histoire de l'Art contemporain. La Peinture*. Paris 1935.

BERGER, John, *Success and Failure of Picasso*. London 1965; French edition: *La Réussite et l'Echec de Picasso*. Paris 1968.

BERTRAM, Anthony, *Pablo Picasso*. New York 1934.

BERTRAM, Anthony, *Picasso. The World's Masters*. London 1930; American ed.: New York 1934.

BLOCH, Georges, *Pablo Picasso. Catalogue de l'œuvre gravé et lithographié. Tome I: 1904–1967*. Bern 1968. Text: French, English, and German.

BLOCH, Georges, *Pablo Picasso. Catalogue de l'œuvre gravé et lithographié. Tome II: 1968–1970*. Bern 1971. Text: French, English, and German.

BLOCH, Georges, *Pablo Picasso. Catalogue de l'œuvre gravé et lithographié. Tome III: 1970–1972*. Bern 1979. Text: French, English, and German.

BLOCH, Georges, *Pablo Picasso. Catalogue de l'œuvre gravé et lithographié. Tome IV: 1970–1972 Suppléments Tome I + II*. Bern 1979. Text: French, English, and German.

BLUNT, Anthony, and POOL, P., *Picasso, the Formative Years. A Study of His Sources*. London 1962.

BOECK, Wilhelm, and SABARTÉS, Jaime, *Picasso*. Paris 1955; German ed.: Stuttgart 1956; American ed.: New York, 1955.

BOUDAILLE, Georges, *Picasso, première Epoque, 1881 à 1906*. Paris 1964.

BOURET, Jean, *Picasso, Dessins*. Paris 1950.

BRASSAÏ, *Conversations avec Picasso*. Paris 1964; American ed.: *Picasso and Company*. New York 1966. German ed.: *Gespräche mit Picasso*. Hamburg 1966.

BRETON, André, *Le Surréalisme et la Peinture*. Paris 1928; American edition: New York 1945. Expanded new edition: Paris 1965; German edition: Cologne 1967.

BRETON, André, *Entretiens*. Paris 1952.

BUCHHEIM, Lothar G., *Picasso, eine Bildbiographie*. Munich 1958; English ed.: London 1959.

CAMÓN AZNAR, José, *Picasso y el cubismo*. Madrid and Barcelona 1956.

CASSOU, Jean, *Picasso*. Paris 1940; English ed.: London 1940; New ed.: Paris 1946. New expanded ed.: Paris 1958.

CHAMPRIS, Pierre de, *Picasso, Ombre et Soleil*. Paris 1961.

CIRICI-PELLICER, Alejandro, *Picasso antes de Picasso*. Barcelona 1946; French ed.: *Picasso avant Picasso*. Geneva 1950.

COCTEAU, Jean, *Ode à Picasso*. Paris 1919.

COCTEAU, Jean, *Picasso*. Paris 1923.

COCTEAU, Jean, *Le Rappel à l'Ordre*. Paris 1926; English ed.: *A Call to Order*. London 1926.

COOPER, Douglas, *Picasso. Carnet catalan*. Paris 1958.

COOPER, Douglas, *Picasso Théâtre*. Paris 1967. Italian ed.: Milan 1967.

COSSIO DEL POMAR, Felipe, *La rebelión de los pinteros*. Mexico 1946.

CZWIKLITZER, Christoph, *290 Affiches de Pablo Picasso*. Paris 1968; second, expanded edition: Paris 1970.

DAIX, Pierre, *Picasso*. Paris 1964; American ed.: New York 1965.

DAIX, Pierre, and BOUDAILLE, Georges, *Catalogue raisonné de l'Œuvre peint*. Paris 1966; German ed.: *Picasso, Blaue und Rosa Periode*. Munich 1966; American ed.: *Picasso: Blue and Rose Periods. A Catalog Raisonné of the Paintings*. Greenwich, Conn. 1967.

DAIX, Pierre, and BOUDAILLE, Georges, *Picasso 1900 à 1906*. Neuchâtel, Paris 1966.

DALE, Maud, *Picasso*. New York 1930.

DANGERS, Robert, *Pablo Picasso. Darstellung und Deutung*. Munich 1958.

DANZ, Louis, *Personal Revolution and Picasso*. New York 1941.

DÄUBLER, Theodor, *Der neue Standpunkt*. Leipzig 1919.

DESCARGUES, Pierre, *Picasso, Témoin du XXᵉ Siècle*. Paris 1957.

DESNOS, Robert, *Picasso: Seize Peintures. 1939–1943*. Paris 1943.

DIEHL, Gaston, *Picasso*. Paris 1960; American ed.: New York 1960.

DOMINGUIN, Luis Miguel, and BOUDAILLE, Georges, *Toros y toreros*. Paris 1961; German ed.: Cologne 1961; American ed.: *Bulls and Bullfighters*. New York 1961.

DUFOUR, Pierre, *Picasso 1950–1968*. Geneva 1969; German ed.: Geneva 1969.

DUNCAN, David Douglas, *The Private World of Pablo Picasso*. New York 1958; German ed.: Offenburg n.d.; French ed.: *Le Petit Monde de Pablo Picasso*. Paris 1959.

DUNCAN, David Douglas, *Picasso's Picassos*. New York 1961; French ed.: *Les Picassos de Picasso*. Paris 1962; German ed.: *Der unbekannte Picasso. Die Schätze von La Californie*. Düsseldorf 1961.

DUNCAN, David D., *Goodbye Picasso*. New York 1975.

EHRENBURG, Ilja, *Lindi, gody, gizn*. Moscow 1960. Italian ed.: *Uomini e anni*. Rome 1960–1963; German ed.: *Menschen, Jahre, Leben*. Hamburg 1962.

EINSTEIN, Carl, *Die Kunst des 20. Jahrhunderts*. Berlin 1926.

ELGAR, Frank, and MAILLARD, Robert, *Picasso*. Paris 1955; German ed.: Munich 1956; American ed.: New York 1960.

ELUARD, Paul, *Donner à voir*. Paris 1939.

ELUARD, Paul, *A Pablo Picasso*. Geneva/Paris 1944; English ed.: London 1948.

ELUARD, Paul, *Picasso, Dessins*. Paris 1952.

ERBEN, Walter, *Picasso und die Schwermut*. Heidelberg 1947.

ESTRADA, Genaro, *Genio y figura de Picasso*. Mexico 1936.

FOSTER, J. K., *The Posters of Picasso*. New York 1964.

FRANCASTEL, P., *Peinture et Société*. Lyons 1951.

FRY, John Hemming, *Art décadent; sous le Règne de la Démocratie et du Communisme*. Paris 1940.

GASCAR, Pierre, *Picasso et le Béton*. Paris 1966.

GEISER, Bernhard, *Picasso, Peintre-graveur. 1899–1931*. Bern 1930; New ed.: 1955.

GEISER, Bernhard, *Pablo Picasso, Lithographs 1945–8*. New York 1948.

GEISER, Bernhard, *Pablo Picasso, Fifty-five Years of His Graphic Work*. New York and London 1955.

GEISER, Bernhard, and BOLLIGER, Hans, *L'Œuvre gravé de Picasso*. Lausanne 1955; German ed.: Stuttgart 1955.

GEORGE, Waldemar, *Picasso*. Rome 1924.

GIEURE, Maurice, *Initiation à l'Œuvre de Picasso*. Paris 1951.

GILOT, Françoise, and LAKE, Carlton, *Life with Picasso*. New York 1964; London 1965; French ed.: *Vivre avec Picasso*. Paris 1965; German ed.: *Leben mit Picasso*. Munich 1965.

GOMEZ DE LA SERNA, Ramón, *Completa y veridica historia de Picasso y el cubismo*. Turin 1945.

GULLÓN, Ricardo, *De Goya al arte abstracto*. Madrid 1952.

GUNTHER, L., *Picasso: A Pictorial Biography*. New York 1959.

HAESAERTS, Paul, *Picasso et le Goût du Paroxysme*. Antwerp 1938.

HAESAERTS, Paul, *Da Renoir a Picasso*. With an introduction by Umbro Apollonio. Rome 1960.

HAUERT, Roger, and VERDET, André, *Les Grands Peintres. Die großen Maler*. German and French text. Geneva 1956.

HORODISCH, Abraham, *Pablo Picasso als Buchkünstler*. Frankfurt on Main 1957.

JACOB, Max, *Chronique des Temps héroïques*. Paris 1956.

JAFFÉ, Hans, *Picasso*. Cologne 1964. American ed.: New York 1964; Italian ed.: Florence 1969.

JANIS, Harriet, and JANIS, Sidney, *Picasso, the Recent Years. 1939–46*. New York 1946.

JEDLICKA, Gotthard, *Picasso*, Zürich 1934.

KAHNWEILER, Daniel-Henry, *Der Weg zum Kubismus*. Munich 1920. American ed.: *The Rise of Cubism*. New York 1949.

KAHNWEILER, Daniel-Henry, *Sculptures de Picasso*. Paris 1948.

KAHNWEILER, Daniel-Henry, *Picasso. Dessins 1903 à 1907*. Paris 1954.

KAY, Helen, *Picasso. Le Monde des Enfants*. Grenoble 1965; German ed.: *Picassos Welt der Kinder*. Munich and Zürich 1965.

LARREA, Juan, *Pablo Picasso. Guernica*. New York 1947.

LASSAIGNE, Jacques, *Picasso*. Paris 1949.

LEIRIS, Michel, *Brisées*. Paris 1966.

LEONHARD, Kurt, and BOLLIGER, Hans, *L'Œuvre gravé de Picasso 1955–1965*. Lausanne 1966; German ed.: Stuttgart 1966.

LEVEL, André, *Pablo Picasso. Œuvres*. Paris 1928.

LEYMARIE, Jean, *Picasso. Zeichnungen*. Geneva 1967.

LIEBERMAN, William S., *Pablo Picasso. Blue and Rose Periods*. New York 1952.

LIEBERMAN, William S., *Picasso and the Ballet*. New York 1946.

LUDWIG, P., *Das Menschenbild Picassos*. (Diss.) Mainz 1950.

MAHAUT, Henri, *Picasso*. Paris 1930.

MARCHIORI, G., *L'ultimo Picasso.* Venice 1949.
MELVILLE, Robert, *Picasso, Master of the Phantom.* London 1939.
MERLI, Joan, *Picasso. El artista y la obra de nuestro tiempo.* Buenos Aires 1942; New ed.: 1948.
MICHELI, M. de, *Picasso.* Florence 1967.
MOHOLY-NAGY, László, *The New Vision.* New York 1930; third, revised ed.: New York 1946.
MOURLOT, Fernand, *Picasso Lithographe, 1919–1963.* 4 vols. Monte Carlo 1949–1964; new expanded ed.: 1919–1969 in 1 vol. Paris 1970.
MUSEO PICASSO, *Catálogo 1. Ayuntamiento de Barcelona.* Barcelona 1971.
O'BRIAN, Patrick, *Pablo Ruiz Picasso.* Paris 1979.
OLIVIER, Fernande, *Picasso et ses Amis.* Paris 1933, German ed.: *Neun Jahre mit Picasso.* Zürich 1957; English ed.: *Picasso and His Friends.* London 1964.
D'ORS, Eugenio, *Pablo Picasso.* Paris 1930.
PADRTA, Jiri, *Picasso, Charmeur des Formes.* Prague 1960.
PALAU I FABRE, Josep, *Picasso en Cataluña.* Barcelona 1966. Text in Spanish, French, English, and German.
PALENCIA, Ceferino, *Picasso.* Mexico 1945.
PARMELIN, Hélène, *Picasso sur la Place.* Paris 1959.
PARMELIN, Hélène, *Les Dames de Mougins.* Paris 1964.
PARMELIN, Hélène, *Le Peintre et son Modèle.* Paris 1965; American ed.: *The Artist and His Model.* New York 1965.
PARMELIN, Hélène, *Notre-Dame-de-Vie.* Paris 1966.
PARMELIN, Hélène, *Picasso dit...* Paris 1966; English ed.: *Picasso Says...* London 1969; German ed.: *Picasso sagt.* Munich 1967.
PENROSE, Roland, *Homage to Picasso on His 70th Birthday.* London 1951.
PENROSE, Roland, *Portrait of Picasso.* London 1957; German ed.: *Picasso und seine Zeit.* Zürich 1957.
PENROSE, Roland, *Picasso, His Life and Work.* London 1958; French ed.: *La Vie et l'Œuvre de Picasso.* Paris 1961; German ed.: Munich 1961.
PENROSE, Roland, and QUINN, Edward, *Picasso at Work.* London 1965; French ed.: *Picasso à l'Œuvre.* Paris 1965; German ed.: *Picasso. Werke und Tage.* Zürich 1965.
PENROSE, Roland, *The Sculpture of Picasso.* New York 1967.
PENROSE, Roland, and GOLDING, John, *Picasso in Retrospect.* New York 1973.
PICASSO, Pablo, *Poemas y declaraciones.* Mexico 1944.
PICASSO, Pablo, *Le Désir attrapé par la Queue.* Paris 1945; German translation in: *Pablo Picasso. Wort und Bekenntnis.* Zürich 1954.
PICASSO, Pablo, *Peintures 1955–1956.* Paris 1956.
PICASSO, Pablo, *Suite Vollard.* With an introduction by Hans Bolliger. Stuttgart 1956; French ed.: Teufen, Switzerland 1956; American ed.: New York 1956.
PICASSO, Pablo, *Ballettzeichnungen.* With an introduction by Herbert Asmodi. Feldafing 1956.
PICASSO, Pablo, *Carnet de La Californie.* Cologne 1957.
PICASSO, Pablo, *Keramik.* With a preface by Daniel-Henry Kahnweiler. Hannover 1957.
PICASSO, Pablo, *Les Ménines.* Paris 1957.
PICASSO, Pablo, *Peintures 1955–1956.* Paris 1957.
PICASSO, Pablo, *Der Maler und sein Modell.* Feldafing 1958.
PICASSO, Pablo, *Zeichnungen.* Stuttgart 1959.
PICASSO, Pablo, *45 Gravures sur Linoléum.* Paris 1960.
PICASSO, Pablo, *Dessins.* Paris 1960.
PICASSO, Pablo, *Toros y toreros.* With a preface by Luis Miguel Dominguin. Cologne 1961; American ed.: *Bulls and Bullfighters.* New York 1961.
PICASSO, Pablo, *Peintures.* Paris 1961.
PICASSO, Pablo, *Le Déjeuner sur l'Herbe.* Paris 1961.
PICASSO, Pablo, *Peintures.* Paris 1963.
PICASSO, Pablo, *Dessins.* Paris 1967.
PICASSO, Pablo, *347 Gravures.* Paris 1968.
PICASSO, Pablo, *Le Goût du Bonheur.* Bremen, Paris, New York 1970.
PICASSO, Pablo, *Les Quatre Petites Filles.* Paris 1969; German ed.: *Vier kleine Mädchen.* Zürich 1970.
PICASSO, [Contributions by] Maurice Raynal, Daniel-Henry Kahnweiler, Pierre Reverdy, George Besson, Tristan Tzara, Paul Gay. (Le Point [No.] XLII, October 1952). Souillac and Mulhouse 1952.

PICASSO, by Michel Del Castillo, Paul Guinard, André Fermigier, Denis Milhaud etc. Paris 1967.
POWER, J. W., *Éléments de la Construction picturale.* Paris 1932.
PRADOS Y LOPEZ, M., *Pintores malgueños contemporáneos.* Málaga 1934.
PRAMPOLINI, Enrico, *Picasso scultore.* Rome 1943.
PRÉVERT, Jacques, *Portraits de Picasso.* Milan 1959.
RAMIÉ, Suzanne, and RAMIÉ, Georges, *Céramiques de Picasso.* Geneva 1948.
RAPHAËL, Max, *De Manet à Picasso.* Paris 1920; German ed.: Munich 1920.
RAPHAËL, Max, *Proudhon, Marx, Picasso; trois Etudes sur la Sociologie de l'Art.* Paris 1933.
RAYNAL, Maurice, *Picasso.* German ed.: Munich 1921; French ed.: Paris 1922.
RAYNAL, Maurice, *Picasso.* Text in German, French and English. Geneva 1953; English trans. Geneva 1953.
REVERDY, Pierre, *Pablo Picasso.* Paris 1924.
RICHARDSON, John, *Pablo Picasso. Aquarelles et Gouaches en Couleurs.* Paris 1964.
ROSENBLUM, Robert, *Cubism and Twentieth Century Art.* New York 1966.
ROSENTHAL, E., *Picasso, Painter and Engraver.* San Francisco 1952.
ROY, Claude, *Picasso. La Guerre et la Paix.* Paris 1953.
RUSSOLI, Franco, *Pablo Picasso.* Milan and Paris 1954.
SABARTÉS, Jaime, *Picasso. Retratos y recuerdos.* [Original text.] Madrid 1953; French ed.: *Picasso. Portraits et Souvenirs.* Paris 1946; American ed.: New York 1948; Italian ed.: *Buongiorno Picasso. Ritratti e ricordi.* Milan 1953; German ed.: *Gespräche und Erinnerungen.* Zürich 1956.
SABARTÉS, Jaime, *Picasso ceramista.* Milan 1953.
SABARTÉS, Jaime, *Picasso. Documents iconographiques.* Geneva 1954.
SABARTÉS, Jaime, *Les Ménines et la Vie.* Paris 1958.
SABARTÉS, Jaime, and ELUARD, Paul, *Picasso à Antibes.* Paris 1948.
SALMON, André, *La Jeune Peinture française.* Paris 1912.
SALMON, André, *La Négresse du Sacré-Cœur.* Paris 1920.
SALMON, André, *Souvenirs sans Fin. Première Epoque 1903 à 1908.* Paris 1955.
SCHIFF, Gert, *Picasso in Perspective.* Englewood Cliffs (N. J.) 1976.
SCHIFF, Gert, *Picasso. The Last Years, 1963–1973.* New York 1984.
SALMON, André, *Souvenirs sans Fin. Deuxième Epoque 1908–1920.* Paris 1956.
SCHMIDT, Georg, *Pablo Picasso.* Basel 1952.
SCHÜRER, Oskar, *Pablo Picasso.* Leipzig 1927.
SOBY, James Thrall, *After Picasso.* New York 1935.
SOFFICI, A., *Ricordi di vita artistica e letteraria.* Florence 1942.
SOUCHÈRE, Dor de la, *Picasso à Antibes.* Paris 1960; German ed.: Munich 1960; American ed.: *Picasso in Antibes.* Munich 1960.
STEIN, Gertrude, *Autobiography of Alice B. Toklas.* New York 1933; French ed.: Paris 1934; New edition: Zephyr Books, Vol. 125, New York 1947; German ed.: Zürich 1955.
STEIN, Gertrude, *Pablo Picasso.* London 1938; German ed.: *Picasso. Photos. Dokumente. Bibliographie.* Zürich 1958.
SUTTON, Denys, *Picasso, Peinture, Epoques bleue et rose.* Paris 1948; German ed.: *Picasso, Gemälde, Rosa und Blaue Periode.* Saarbrücken 1948.
TAKASHINA, S., *Picasso.* Tokyo 1964.
TZARA, Tristan, *Pablo Picasso et les Chemins de la Connaissance.* Geneva 1948.
TZARA, Tristan, *Picasso et la Poésie.* Rome 1953.
UHDE, Wilhelm, *Picasso et la Tradition française.* Paris 1928; American ed.: *Picasso and the French Tradition.* New York 1929.
UHDE, Wilhelm, *Von Bismarck bis Picasso.* Zürich 1938.
VALERI, Diego, *Da Racine a Picasso: nuovi studi francesi.* Florence 1956.
VALLENTIN, Antonina, *Pablo Picasso.* Paris 1957; German ed.: Cologne and Berlin 1958.
VANDERPYL, Fritz R., *Peintres de mon Epoque.* Paris 1931.
VERCORS, *Picasso. Œuvres des Musées de Leningrad et de Moscou.* Paris 1955.
VERDET, André, *Faunes et Nymphes de Pablo Picasso.* Geneva 1952.
VILAR, Esther, *Der Sommer nach dem Tod von Picasso. Ein Spiel.* Munich 1969.

VOLLARD, Ambroise, *Souvenirs d'un Marchand de Tableaux.* Paris 1948; American ed.: *Recollections of a Picture Dealer.* Boston 1936. German ed.: Diez 1949.
WALTHER, Gerhard, *Picasso.* Stuttgart and Constance 1949.
WEILL, Berthe, *Pan!... dans l'Œil.* Paris 1933.
WRIGHT, Willard H., *Modern Painting.* New York 1915.
WITTGENS, Fernanda, *Picasso.* Milan 1954.
ZERVOS, Christian, *Picasso: Œuvre 1920–1926.* Paris 1926.
ZERVOS, Christian, *Picasso.* Paris 1949. Milan 1932.
ZERVOS, Christian, *Dessins de Picasso 1892–1948.* Paris 1949.
ZERVOS, Christian, *Cahiers d'Art. Revue d'Art... Directeur Ch' Z'.* Paris 1936/1960.
ZERVOS, Christian, *Pablo Picasso.* [Catalogue of the paintings and drawings.] Paris 1932 ff.

EXHIBITION CATALOGUES

PARIS: Galerie Ambroise Vollard, *Picasso.* 1901.
NEW YORK: Photo-Secession Gallery, *Pablo Picasso.* 1911.
MUNICH: Galerie Thannhäuser, *Pablo Picasso.* 1913.
LONDON: The Leicester Galleries, *Picasso and Matisse.* 1919.
LONDON: Leicester Galleries, *Pablo Picasso.* 1921.
MUNICH: Galerie Thannhäuser, *Picasso.* 1922.
CHICAGO: Arts Club, *Picasso.* 1923.
BERLIN: Flechtheim Galerie, *Pablo Picasso; Zeichnungen, Aquarelle, Pastelle, 1902–1927.* 1927.
CHICAGO: Arts Club, *Pablo Picasso.* 1930.
HANNOVER: Kestner-Gesellschaft, *Schlemmer und Picasso.* 1932.
ZÜRICH: Kunsthaus, *Picasso.* 1932.
HARTFORD, CONN.: Wadsworth Atheneum, *Pablo Picasso.* 1934.
MADRID: Amigos de las Artes nuevas, *Picasso.* 1936.
BOSTON: Museum of Modern Art, *Picasso; Henri Matisse.* 1938.
LONDON: New Burlington Galleries, *Guernica.* 1938.
LONDON: London Gallery, *Picasso in English Collections.* 1939.
NEW YORK: Museum of Modern Art, *Picasso, Forty Years of His Art.* 1939.
MEXICO: Sociedad de Arte moderna, *Picasso.* 1944.
LONDON: Victoria and Albert Museum, *Picasso and Matisse.* 1945.
NEW YORK: Museum of Modern Art, *Picasso. Fifty Years of His Art.* 1939.
LONDON: The London Gallery, *The Cubist Spirit and its Time.* 1947.
LONDON: The Arts Council, *Picasso, 55 Lithographs 1945–1947.* 1948.
ROME: Galleria nazionale d'arte moderna, *Picasso.* 1953.
LYONS: Musée des beaux-arts, *Picasso.* 1953.
MILAN: Palazzo Reale, *Picasso.* 1953.
ZÜRICH: Kunsthaus, *Pablo Picasso. Das graphische Werk.* 1954.
SÃO PAULO: Museo de Arte moderna, *Picasso.* 1954.
PARIS: Maison de la pensée française, *Picasso, Œuvres des Musées de Leningrad et de Moscou, 1900 à 1914.* 1954.
PARIS: Maison de la pensée française, *Picasso, Deux périodes, 1900–1914 et 1950–1954.* 1954.
GENEVA: Musée Rath, *L'Œuvre gravé de Pablo Picasso.* 1954.
PARIS: Musée des arts décoratifs, *Picasso 1900–1955.* 1955.
MUNICH: Haus der Kunst, *Picasso 1900–1955.* 1955.
BRUSSELS: Palais des beaux-arts, *Picasso: Guernica.* 1956.
LONDON: The Arts Council, *Picasso: Fifty Years of Graphic Art.* 1956.
NEW YORK: Museum of Modern Art, *Picasso: 75th Anniversary Exhibition.* 1957.
ARLES: Musée Réattu, *Picasso. Dessins, Gouaches, Aquarelles 1898–1957.* 1957.
PHILADELPHIA: Museum of Art, *Picasso.* 1958.
MARSEILLES: Musée Cantini, *Picasso.* 1959.
LONDON: Tate Gallery, *Pablo Picasso.* 1960.
NEW YORK: Museum of Modern Art, *Picasso. An American Tribute.* 1962.
NEW YORK: Cooperating New York Galleries, *Picasso. An American Tribute.* 1962.

MONTREAL: Musée des beaux-arts, *Pablo Picasso.* 1964.

TOULOUSE: Musée des Augustins, *Picasso et le Théâtre.* 1965.

TEL AVIV: Helena Rubinstein Pavilion, *Pablo Picasso.* 1966.

PARIS: Grand-Palais et Petit-Palais, *Hommage à Pablo Picasso.* 1966, 2 vols.

NEW YORK: Museum of Modern Art, *The Sculpture of Picasso.* 1967.

AMSTERDAM: Stedelijk Museum, *Picasso.* 1967.

ZÜRICH: Kunsthaus, *Pablo Picasso. Das graphische Werk.* 1968.

BADEN-BADEN: Staatliche Kunsthalle, *Pablo Picasso. Das Spätwerk. Malerei und Zeichnung seit 1944.* 1968.

AVIGNON: Palais des Papes, *Picasso. Œuvres de 1969 à 1970.* 1970.

AVIGNON: Palais des Papes, *Picasso 1970–1972. 201 peintures.* 1973.

KARLSRUHE: Badisches Landesmuseum, *Picasso und die Antike.* 1974.

BASEL: Kunstmuseum, *Picasso aus dem Museum of Modern Art New York und Schweizer Sammlungen.* 1976.

PARIS: Grand Palais, *Picasso. Œuvres reçues en paiement des droits de succession.* 1979/80.

NEW YORK: The Museum of Modern Art, *Pablo Picasso. A Retrospective.* 1980.

NEW YORK: The Pace Gallery, *Picasso. The Avignon Paintings.* 1981.

MÜNCHEN: Haus der Kunst, *Pablo Picasso. Eine Ausstellung zum hundertsten Geburtstag. Werke aus der Sammlung Marina Picasso.* 1981.

BASEL: Kunstmuseum, *Pablo Picasso – Das Spätwerk – Themen 1964–1972.* 1981.

SOURCES OF THE QUOTATIONS

BRASSAÏ, *Picasso and Company.* New York 1966.

GILOT, Françoise, and Carlton Lake, *Life with Picasso.* New York 1964.

KAHNWEILER, D.-H., «Gespräche mit Picasso» in *Jahresring* 59/60. Stuttgart 1959.

PARMELIN, Hélène, *Picasso Says...* London 1969.

PICASSO, Pablo, *Wort und Bekenntnis.* Zürich 1954.

Index

228

The author and publishers wish to thank all members of the graphic and technical studios of C. J. Bucher and Company of Lucerne for their magnificent contribution to this book. Particular thanks are due to Hans Peter Renner, who was in charge of production, and Willy Starke, who, together with the reproduction specialists and printers, is responsible for the remarkable quality of the illustrations.

We also thank the following individuals and institutions that have helped to make the book possible: Siegfried and Angela Rosengart, Lucerne; Galerie Leiris, Paris; Maurice Jardot, Paris; Christian Zervos, Paris; Mila Gagarine, Paris; Hans Bolliger, Zürich, and the Lucerne Zentralbibliothek.

Gratitude is expressed to Editions Cercle d'Art for permission to reproduce illustrations and quote citations, and to the following publishers for the right to make quotations: Verlag Die Arche, Zürich (Picasso, *Wort und Bekenntnis*); G. Allen and Unwin, London (Parmelin, *Picasso Says...*); McGraw-Hill Book Company, New York, and Thomas Nelson and Sons Ltd., London (Françoise Gilot and Carlton Lake, *Life with Picasso.* Copyright © 1964 by McGraw-Hill, Inc.); Doubleday and Company, New York, and Thames and Hudson Ltd., London (Brassaï, *Picasso and Company;* published in French under the title *Conversations avec Picasso* by Editions Gallimard, Paris © Editions Gallimard 1964).

Picture credits